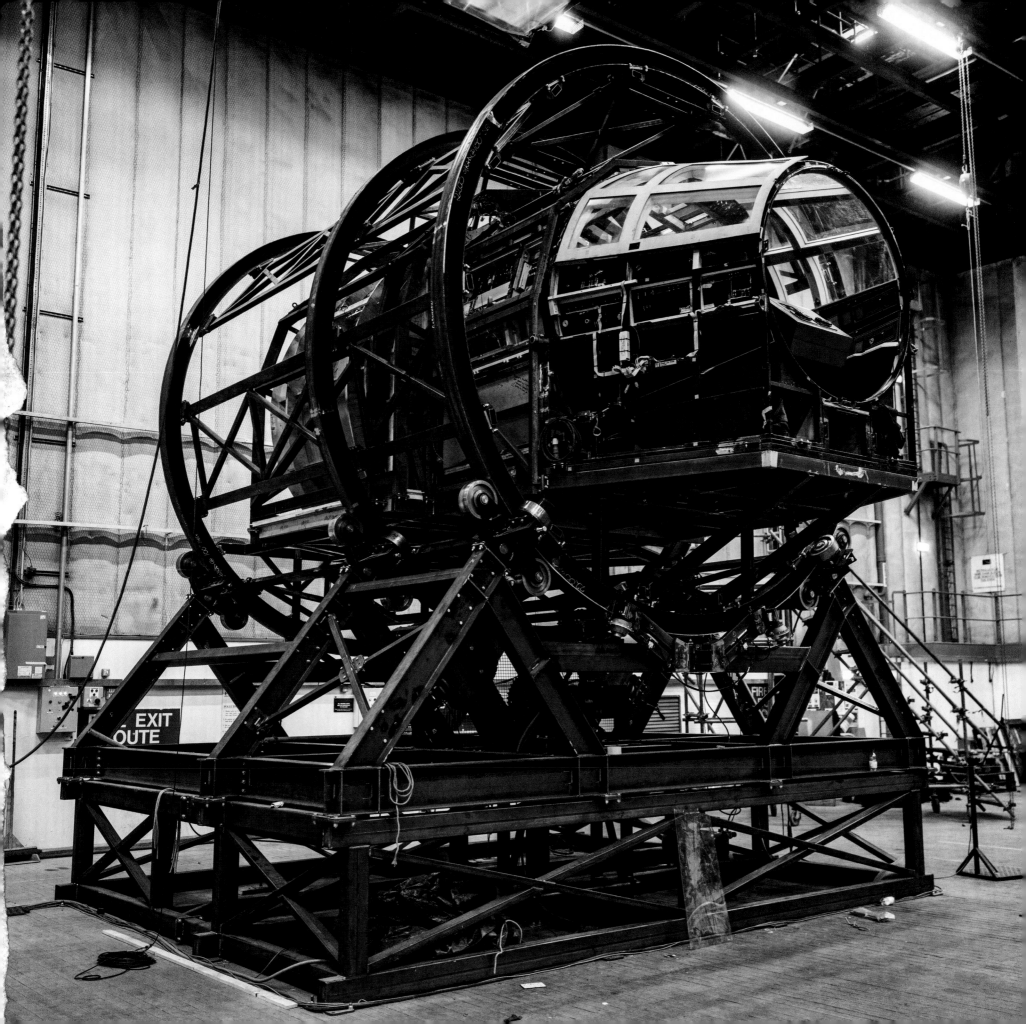

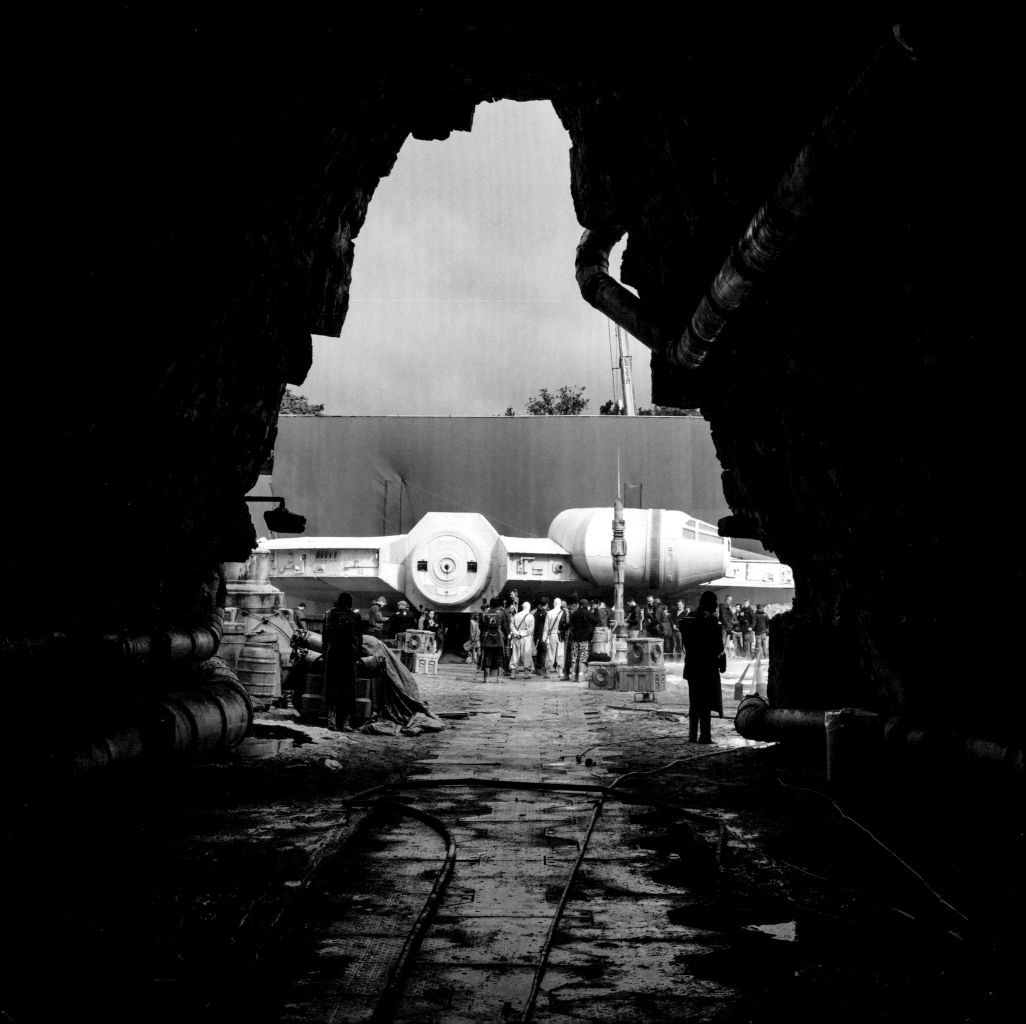

INDUSTRIAL LIGHT & MAGIC

PRESENTS: MAKING

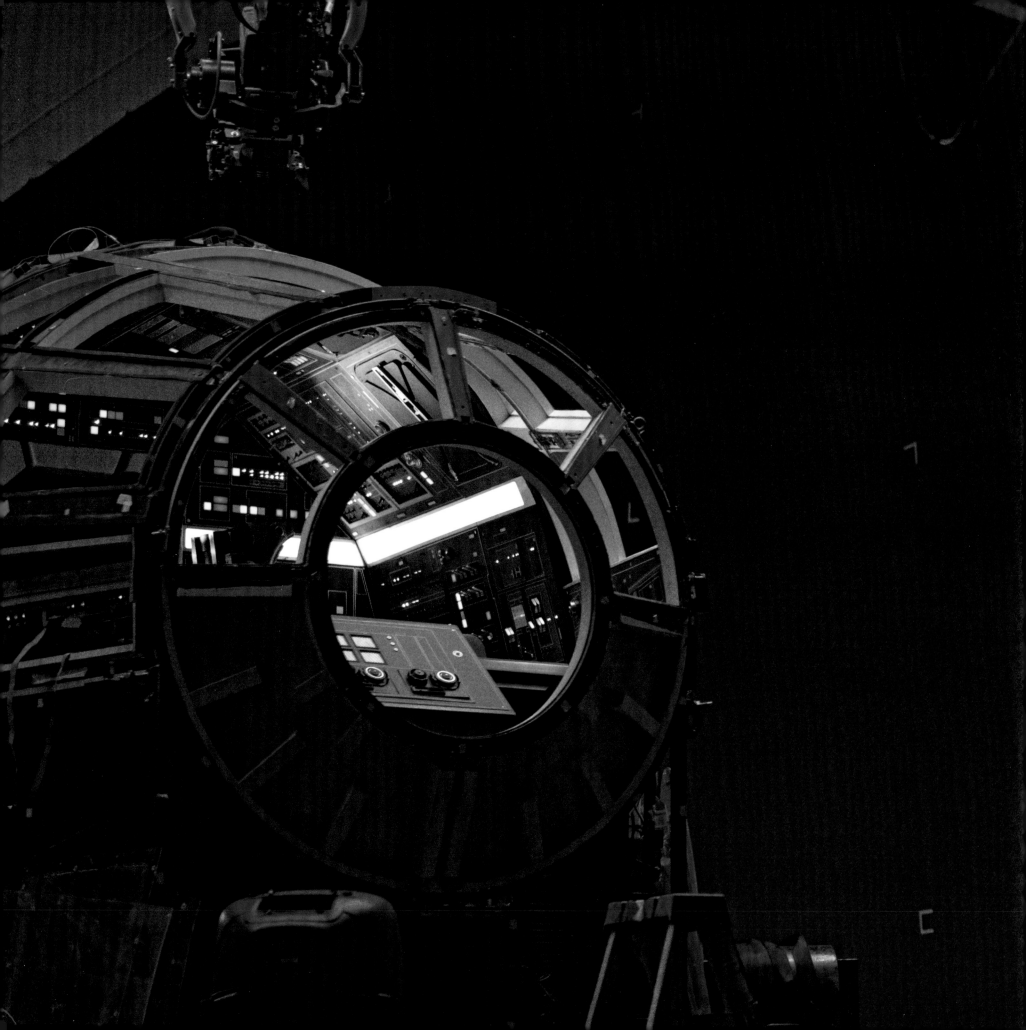

INDUSTRIAL
LIGHT & MAGIC
PRESENTS: MAKING

SOLO

A STAR WARS STORY™

BY **ROB BREDOW**
FOREWORD BY **RON HOWARD**

ABRAMS, NEW YORK

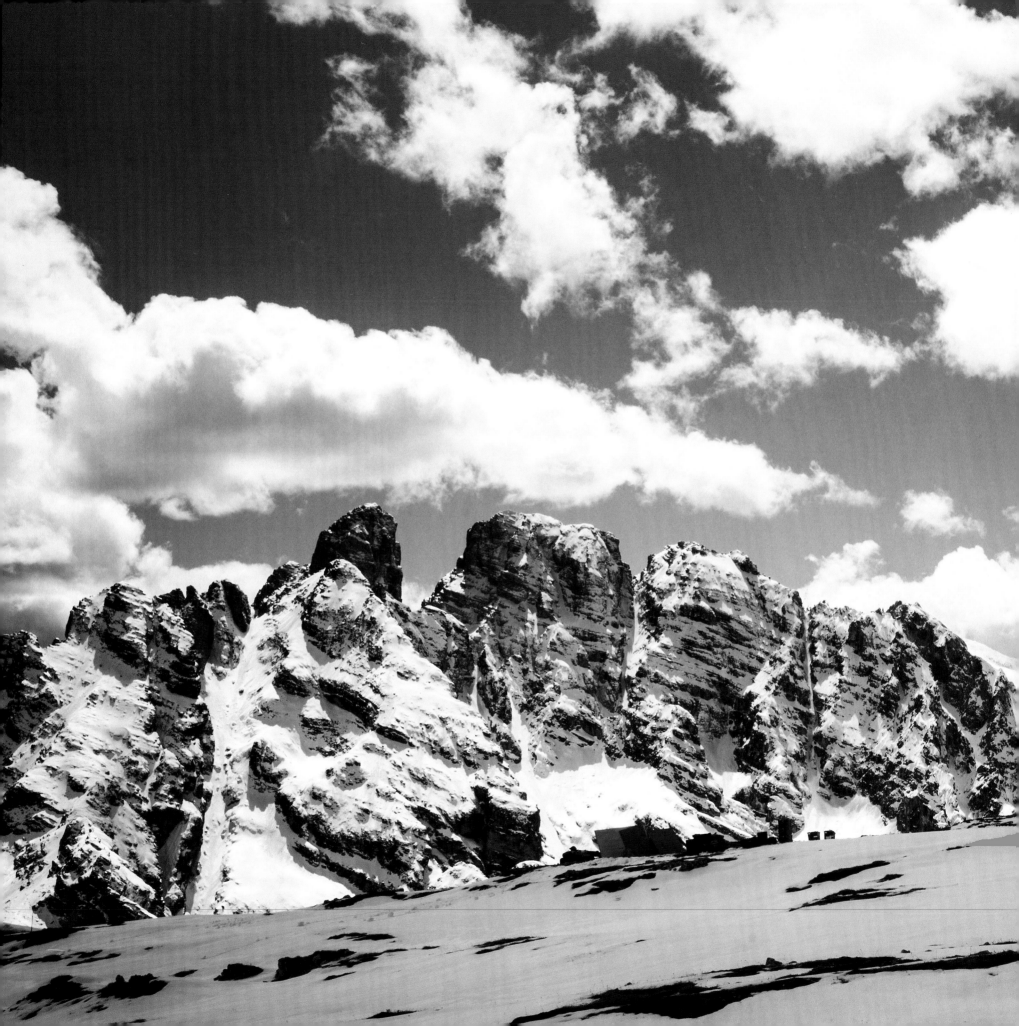

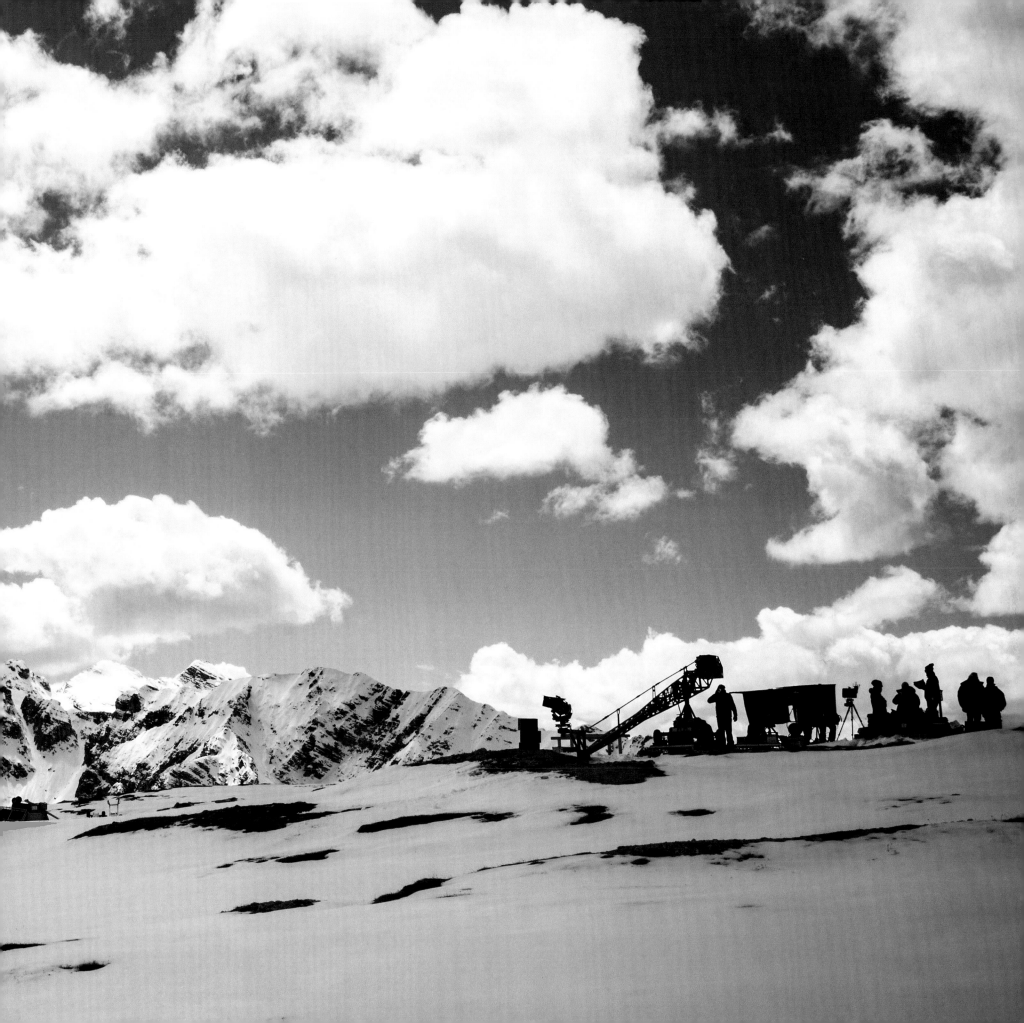

12 **Foreword** by Ron Howard

15 **Introduction** by Rob Bredow

16 **The Journey**

18 **PRE-PRODUCTION**

19 **Defining the Tenets of** *Solo*

22 **The Dolomites**

48 **The Canaries**

56 **Fawley Power Station**

70 **Pinewood**

86 **PRODUCTION**

87 **The Shoot**

95 **Sabacc**

106 **The Train Heist**

110 **Mimban Battle**

119 **Vandor**

126 **Speeder Chase**

132 **The** *Falcon*

142 **Savareen**

158 **Kessel**

170 **Characters Evolve**

196 **POST-PRODUCTION**

196 **Bringing It All Together**

211 **Additional Photography**

251 **Wrap**

252 **Acknowledgments**

Foreword

BY RON HOWARD

My connection to *Star Wars* goes back a long way. In 1973, while on the set of *American Graffiti* at around three A.M., I remember asking George Lucas what his next project was going to be. He said, "I think it's going to be a sci-fi film. Kind of like *Flash Gordon* or *Buck Rogers*, but with better special effects, more like *2001*." For the record, though I nodded politely, I thought it sounded pretty lame. I didn't get it until I saw it on opening weekend. In fact, I instantly loved it so much that I saw it a second time that very day.

I had an unusual start on *Solo*, joining as director well into production. It's a little like boarding a train moving at full speed down the tracks. I loved the screenplay, I liked much of what had been shot, and I had a gut feeling, as someone with a fresh perspective on the film, that I could be a real help on a movie that already had so much going for it. It passed my primary litmus test: It was undeniably a movie I wanted to see on a big screen. After careful consideration, I dove in.

Before my first day on the movie, I decided I'd work with the existing department heads and crew to maintain the continuity the film needed. And, on every project I work on, I end up identifying a small, trusted group of people who clearly understand the story of the film and can help me execute it to a high degree of quality. On my very first day, Kathy Kennedy (president of Lucasfilm and producer of the film) sat down with me and a small team in editorial to watch the current assembly of the film.

That's when my interactions with some of the players who would become that core team began: screenwriter Jon Kasdan, who I asked to stay on set to script the creative refinements I wanted to explore; coproducer John Swartz, who I soon asked to take over directing duties on our versatile splinter unit; and VFX supervisor Rob Bredow, who was helping with the visual storytelling for the complicated Train Heist and Kessel Run Sequences.

It had been a while since I had been able to work with Industrial Light & Magic, though I've always found that collaboration exciting. On *Willow* in 1988 we worked together creating the first morphing shot ever seen. The company continues to blaze new ground today, and I was thrilled to be engaged with them again.

I remember one specific screening where a few of the supervisors from ILM flew down to LA to watch an early cut of the film. Editor Pietro Scalia, writers Larry and Jon Kasdan, and I all sat down with them together. Given the history ILM has with this universe, we had expected we might get a lot of technical, *Star Wars*–specific kinds of notes. But what I got was much better: Great storytelling comments and a discussion that helped clarify in my mind changes that I was going to make as we refined the cut of the film and shot additional material. That day helped underscore one of the things that really stands out at ILM: The creative leads are all truly sophisticated filmmakers. They love the medium and are, first and foremost, passionate about making great films.

I'm proud to have directed *Solo: A Star Wars Story*, and I'm glad to have been able to contribute to the *Star Wars* universe. It's often said that filmmaking is a collaborative process, and I was especially appreciative of the leadership of Rob Bredow and all that ILM brought to this movie. It simply wouldn't be the same without them. Not to mention, they are really good at blowing stuff up!

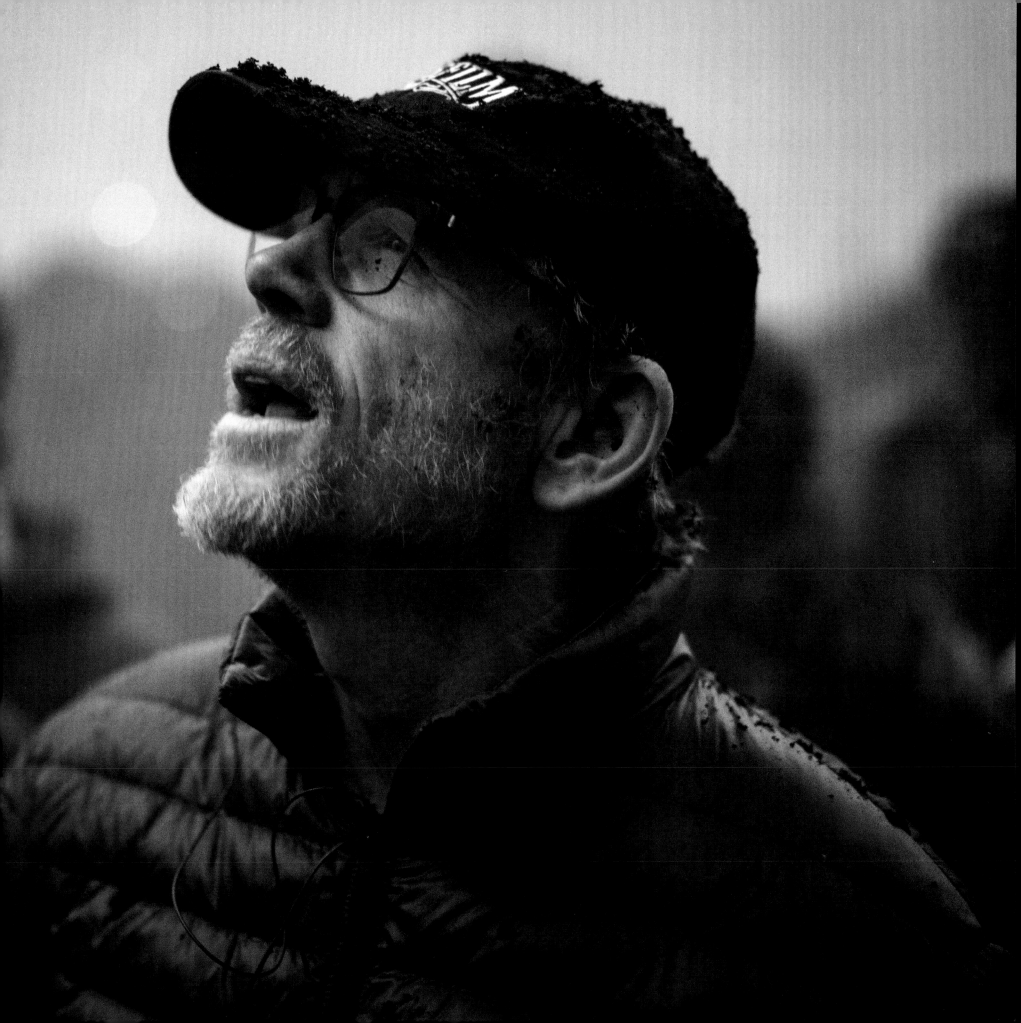

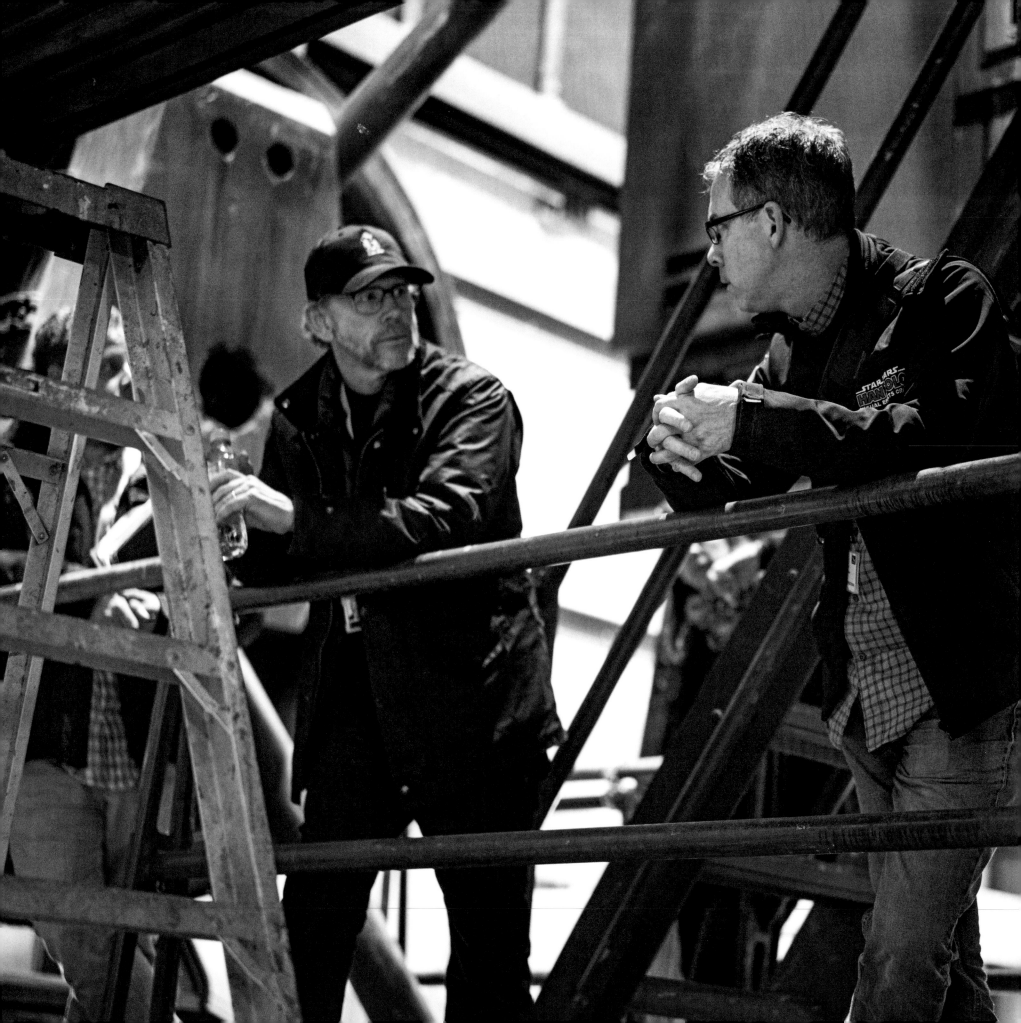

Introduction

BY ROB BREDOW

I know I'm not alone when I tell people *Star Wars* was the most important movie of my childhood. One summer, when I was probably six or seven, my brother and I watched that movie nearly every day. Over and over and over again on a neighbor's VHS deck, wearing out the tape. Some days three times in a row.

Later, when deciding what I wanted to do with my life, I was inspired by the image of Dennis Muren animating the stop-motion AT-AT for *The Empire Strikes Back*—it was like making magic . . . As a kid, it motivated me to create stop-motion animation with my toy AT-ST and my dad's Super 8mm camera. Once I learned it was possible to use computers to make visual effects, I was hooked. I knew what I wanted to do when I grew up.

After honing my craft working as a visual effects artist on various TV shows, including *Star Trek: Deep Space Nine*, I got my first big feature film break as a computer graphics supervisor on *Independence Day* (1996). I wrote the software and animated hundreds of F/A-18 Interceptors and Alien Attackers to fill out the background of the huge dogfight shots in the film. I also blew up the Alien Mothership. The film won the Academy Award for Best Visual Effects that year and really kicked off my career as an artist in film. More than twenty-five years after starting in visual effects, Industrial Light & Magic's chief creative officer, John Knoll, approached me to ask if I'd be interested in being a VFX supervisor on an upcoming *Star Wars* film. I jumped at the chance.

Being the visual effects supervisor and a coproducer on *Solo: A Star Wars Story* was a dream come true for me. Working side by side with the incredible production team and some of the best artists in the world at ILM and getting notes from Dennis Muren himself was an unbelievable touch.

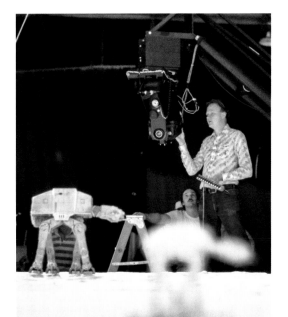

As part of my job, I take a lot of reference photos for our artists. In the early days of the production, I realized I was often the only person in the room with a camera, and I started to formulate a plan—I would document my experience of working on a *Star Wars* film from beginning to end, and perhaps create an image that will inspire the next generation of artists, engineers, and producers who want to tell stories with moving pictures, like that image of Dennis Muren animating the AT-ATs did for me.

I invite you to join me on my journey through *Solo: A Star Wars Story*. I hope you'll find inspiration within.

—Rob Bredow, VFX supervisor & coproducer

ABOVE Dennis Muren photographing AT-ATs for *The Empire Strikes Back*

The Journey
ABOUT THIS BOOK

Throughout this book I endeavor to tell my story, as I experienced it, working every day in pre-production, on set during principal photography, and during our compressed post-production schedule, giving you a glimpse into the life of putting together a huge film like *Solo* from a seat at the table.

Before we start, a little context. Films are usually shot out of order, for a myriad of practical and logistical reasons. Actor availability, weather in various locations, and the readiness of a stage are just a few of the many complex factors that drive the shooting schedule. I've elected to present this book in the order that I experienced it throughout production, which will give you a real feel for how the film was created, rather than a summary of the story of the film.

More than twenty years ago, I created a short list of directors that I dreamed of working with someday. That list has gotten shorter over the years as I've had the opportunity to work with many of my favorites in the business. The last director on that original list was Ron Howard. Now, mid-production, as the director change was announced, Ron Howard was on a train to London to lead the charge on *Solo*.

A few days later, as we started working together, Ron approached me in the hallway outside of editorial. He asked if I was going to be available to be with him on main unit during principal photography. He said, "I know you'll be watching out for the visual effects, and that's important. But you seem to be pretty tuned-in to this movie overall. If you see anything that doesn't work—even outside the visual effects—let me know."

Ron Howard had invited me into his creative process.

Getting to work closely with him was an amazing learning experience and a real honor. He's an absolute professional and brought this film together on a short schedule in complicated circumstances in a way that I think few could have.

The schedule was very aggressive. With the director change, Ron had a list of things we needed to revisit to finish the story. Every additional day of principal photography meant one less day in the post-production process for us to create the visual effects. The pressure was really on.

I remember Kathleen Kennedy, producer and president of Lucasfilm, approaching me soon after Ron joined while we were shooting inside the *Falcon*. She asked, "Do you think we can really make this date?" I was pretty nervous then, so I hedged, "I think we've got the best possible chance with this team, but it's going to be tight." It was going to be tight.

Making a film is tricky business. It includes wrangling a ton of factors outside of any single person's control. Making a great film requires a great team, and for all of those factors to come together beautifully.

A bit of luck doesn't hurt either.

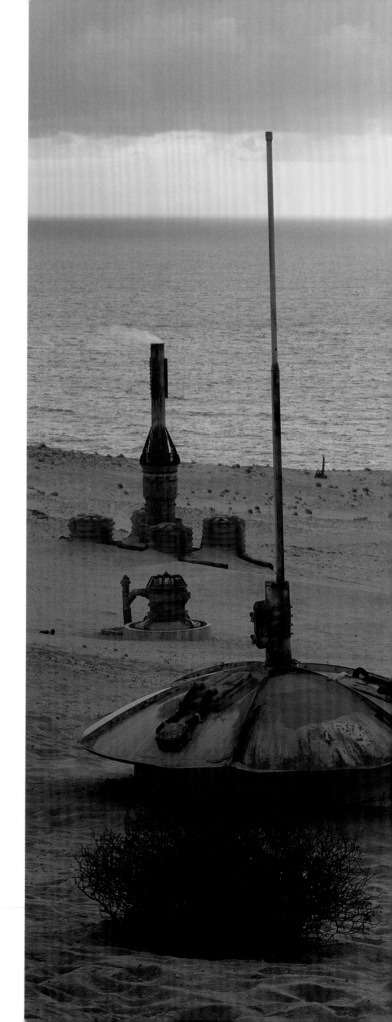

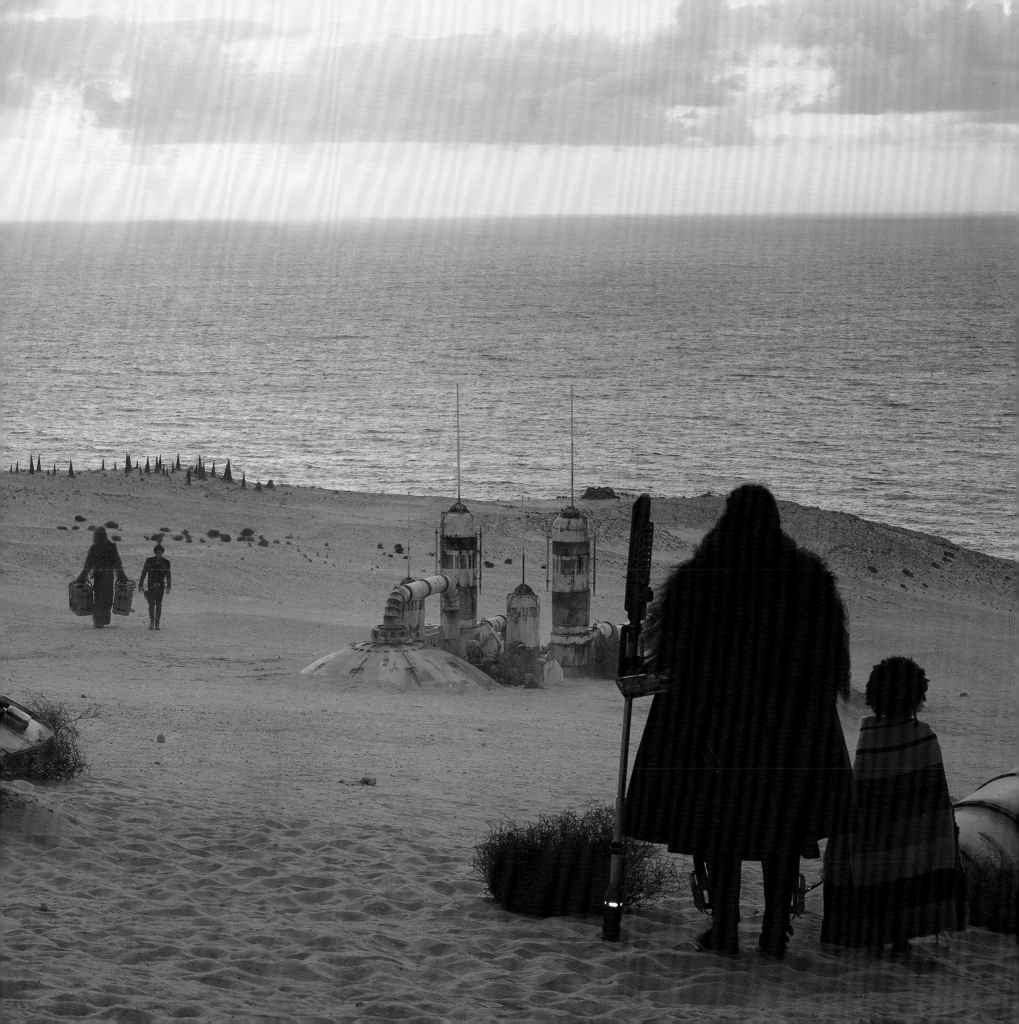

PRE-PRODUCTION

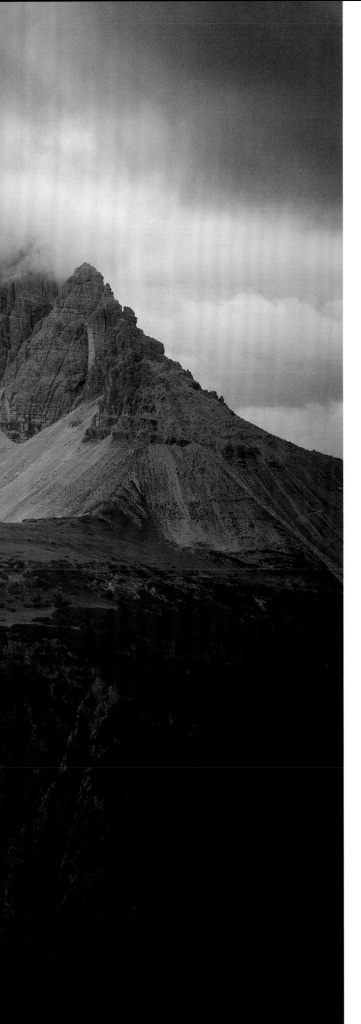

Defining the Tenets of *Solo*

The story of the film centers on a young Han Solo and how he became the scoundrel we all love in *Star Wars: A New Hope*.

My first interactions on the film were as the script was still being developed. We started with making a list of what we really wanted to see in a Han Solo film. How did Han get the *Falcon*? Check. How did Han and Chewie meet? Check. How did Han get in trouble with Jabba? Not every great idea was going to fit in these two hours.

Then, the approach. From the very start, we knew we wanted real locations, real stunts, grounded photography. Those were our tenets. If we are going to drive speeders, we want real 500 horsepower cars driven by some of the best stunt drivers in the world. For a tilting train running through the mountainous snow-covered planet of Vandor, let's shoot aerial photography in the most spectacular mountains on Earth and build a thirty-ton rig on set for the actors. From the very first designs, *Solo* set out to establish a visceral realism grounded on our Earth, but set in a galaxy far, far away. . . .

For visual effects, this gave us a great opportunity to collaborate with every other department on the show. Our goal was to capture everything possible in-camera, live on the set, sometimes inventing new techniques to make an effect play in-camera.

One example: the central MacGuffin of the film, the hyperspace fuel coaxium. It is a complex prop that takes several different forms in the movie. We really wanted to use a practical prop, but nothing existed. Creating it meant a close collaboration between a number of departments. The props team found a real life material, ferrofluid, which was first invented in 1963 by NASA to pull rocket fuel through an ignition in zero gravity—that was the starting point. It could be puppeteered through glass with magnets and made terrific otherworldly shapes. Then, I worked with the camera department to shoot elements of the ferrofluid in the canister at multiple frame rates and in various states of activity. The artists at Industrial Light & Magic used that footage to create seamless looping animations of the moving fluid that we provided to the on-set video playback team. They built custom software to remote-control iPads on set and then the props department squeezed those iPads into slots cut into the portable canister props you see in the film. To make it appear to be inside a glass tube, we tested various lenses and settled on the best shape that could be placed in front of the iPad and would warp the coaxium as you looked at it from various angles. The traditional lines across departments were completely blurred, with everyone working hand-in-hand to create this featured in-camera illusion.

In comparison to the rest of the film, the coaxium was actually a simple effect. This chapter will show some of the planning that went into all of the moving parts where we worked with Camera, Creatures, Art, Props, Special Effects, Stunts, and every other department on the show to have an illusion ready to run on set, be adjustable on the day for the shot, and hold up on camera without causing delays. After shooting, the artists and engineers at ILM took over to digitally complete the film. On a *Star Wars* film, there's plenty to do in post and the clock was already ticking.

But we're at the beginning. During pre-production, it's the time to work out all those plans. Scout the locations. Test the cameras. Choose the lenses. Both traditional storyboarding and computer pre-visualization help to work out the storytelling angles and plan for the shoot. Art Department starts to design the sets. Special Effects starts building the rigs to move our cockpits and trains. And I work with the rest of the VFX department to plan our approach scene-by-scene and shot-by-shot, pitching different ways to achieve every illusion. In short, we work out the creative and technical approach for every beat of the film.

LEFT Tre Cime di Lavaredo in the Italian Dolomites, photographed from a helicopter during an early scouting flight.

LUCASFILM ARCHIVES

Director of photography Bradford Young and I started the show with a research trip to the Lucasfilm Archives. Getting to see the craftsmanship in the original matte painting (on glass) for the opening shot of *Star Wars: A New Hope*, the Death Star II, the famous four-foot *Millennium Falcon*, and all the other props and models was incredibly inspiring. We also took some time to look through a lot of the original artwork for the early films, much of which has never seen the light of day. Those early days started to get us oriented to the '70s aesthetic that would influence both Bradford's photography and the way I would help design the camera work and other building blocks for the action sequences.

Not to mention, it's fun getting to hold an original DL-44 blaster!

THIS SPREAD Director of photography Bradford Young and me touring the Lucasfilm Archives

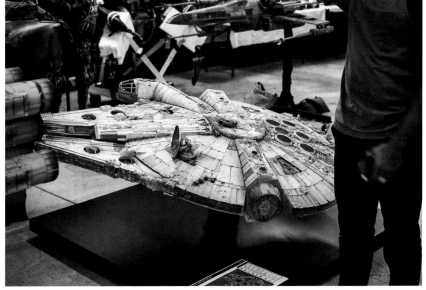

4 FOOT
FALCON PARTS

The Dolomites

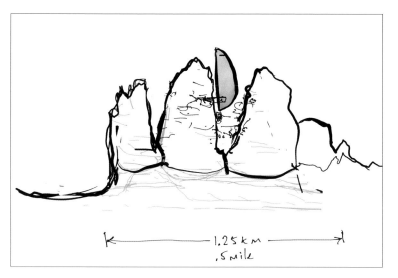

VANDOR: THE TRAIN HEIST

The Train Heist was one of the most ambitious set pieces of the film and would test us both from a creative storytelling perspective and in technically achieving each of the shots. The sequence has a number of moving parts, including telling the story of our heist team working together for the first time, introducing Enfys Nest on-screen, and even losing a couple of important characters. Each of these stories needs to land clearly, while keeping the action sequence moving forward quickly.

After the script and initial storyboards had us underway, the next step was to find an epic location for the sequence. I remember the meetings where location scout Mark Somner presented amazing photographs from pre-scouts around the world. We were looking for locations for several of the big sequences in our film, but the Dolomites stood out for the spectacular scope of the environment. In fact, the mountain ranges were so enormous it was difficult to get a sense of the scope from the photography. Our first big scout was scheduled—the planes took off for an early connection in Venice the next morning.

ABOVE A quick sketch of Tre Cime di Lavaredo I made while on location to pitch a possible layout of the town built into the mountains. I drew hundreds of these simple images while shooting to help me talk through various visual storytelling concepts for the film.

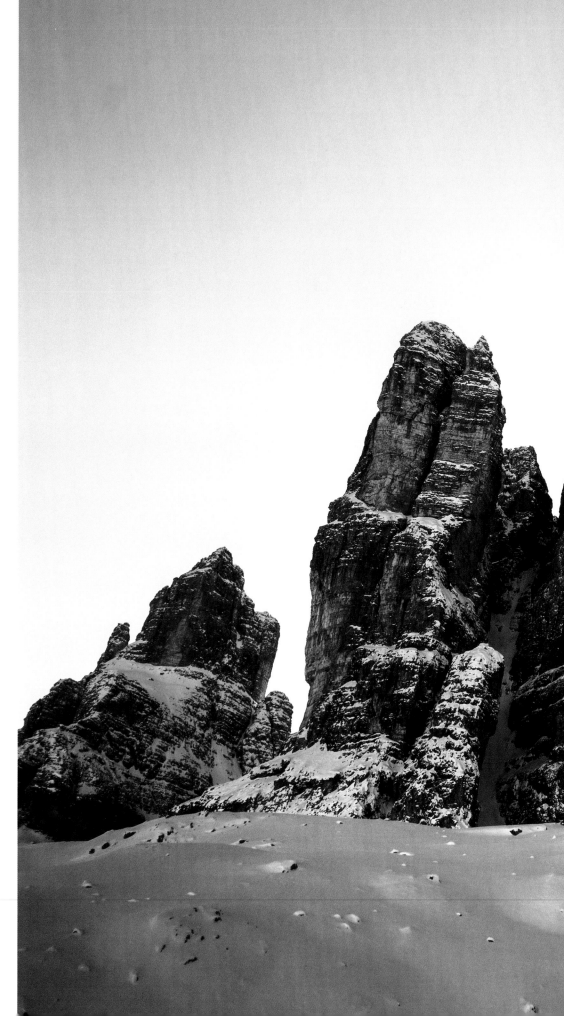

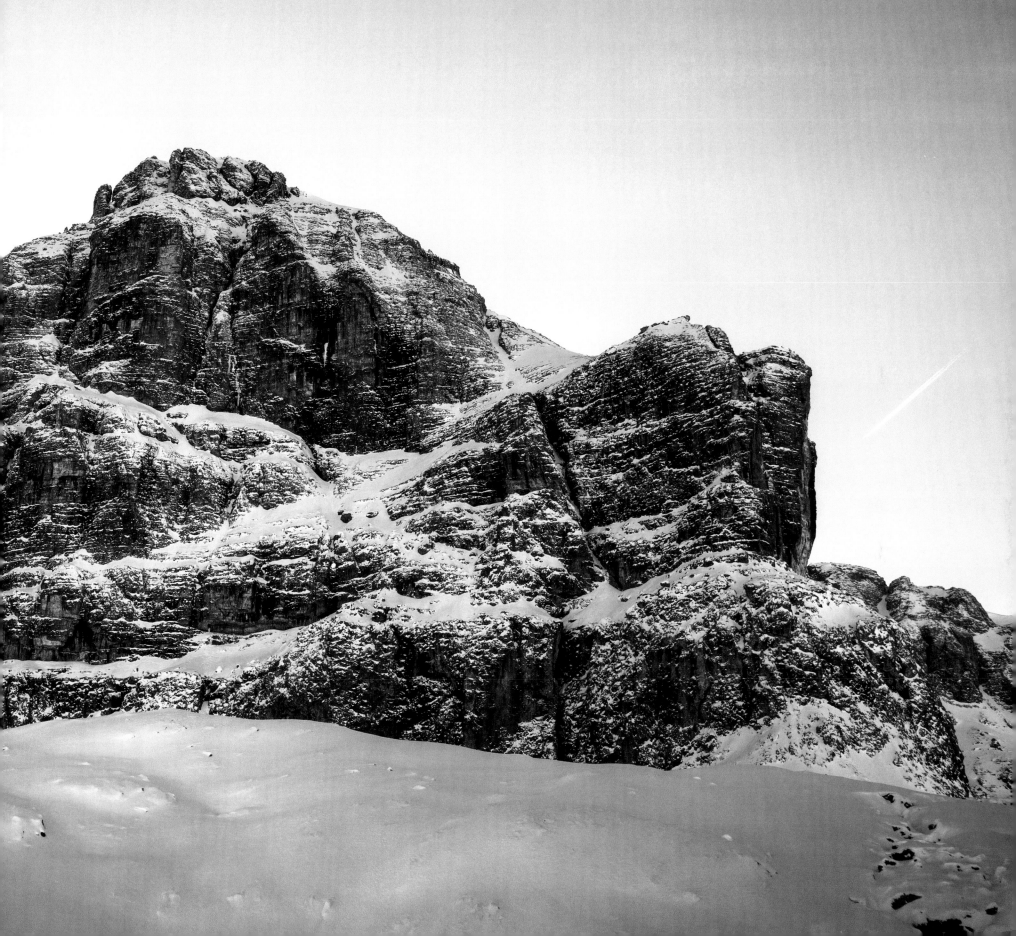

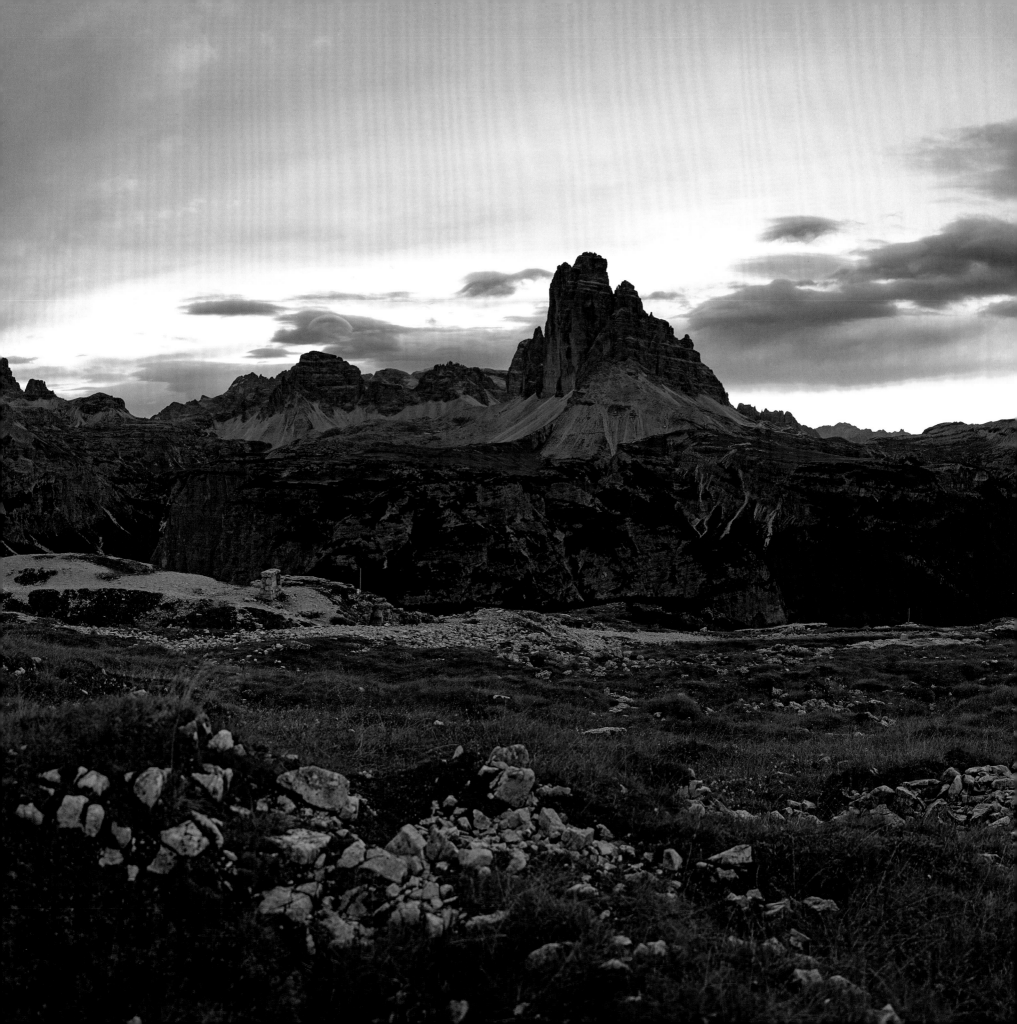

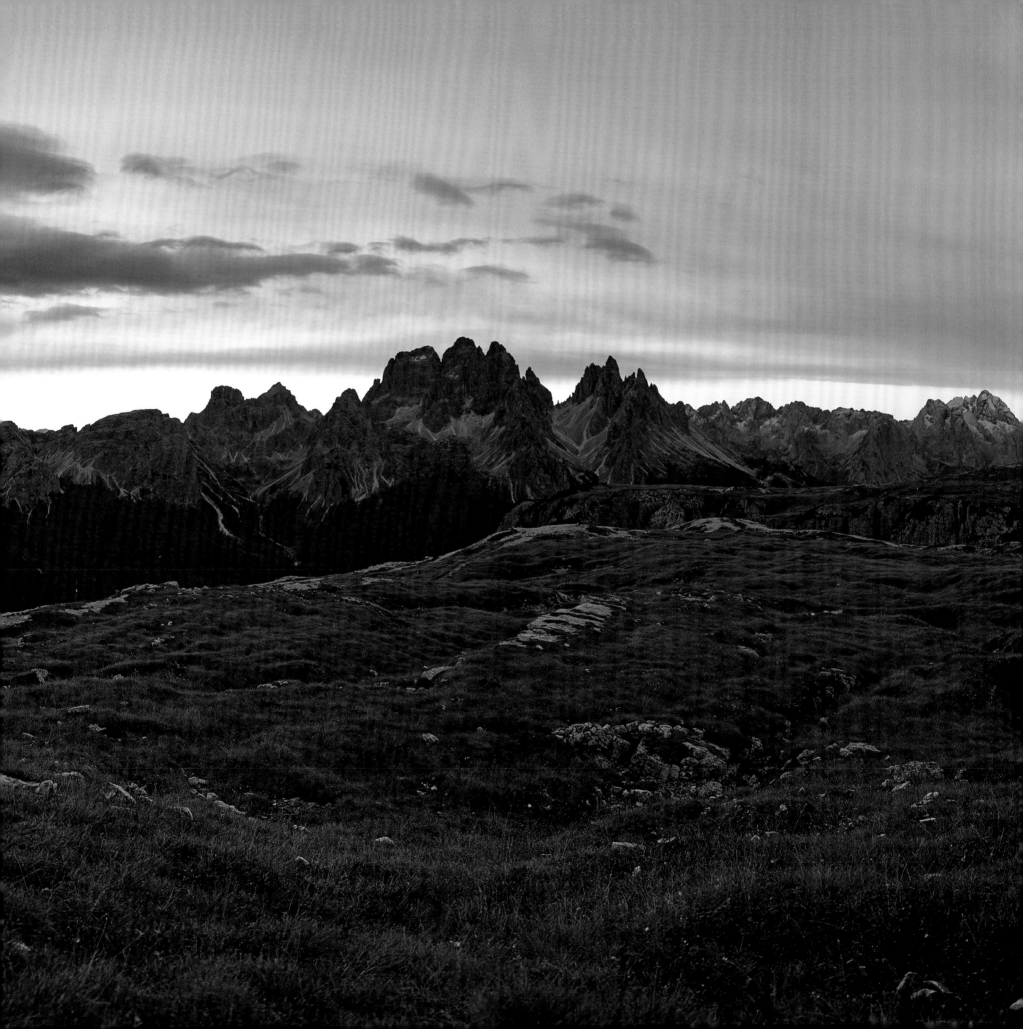

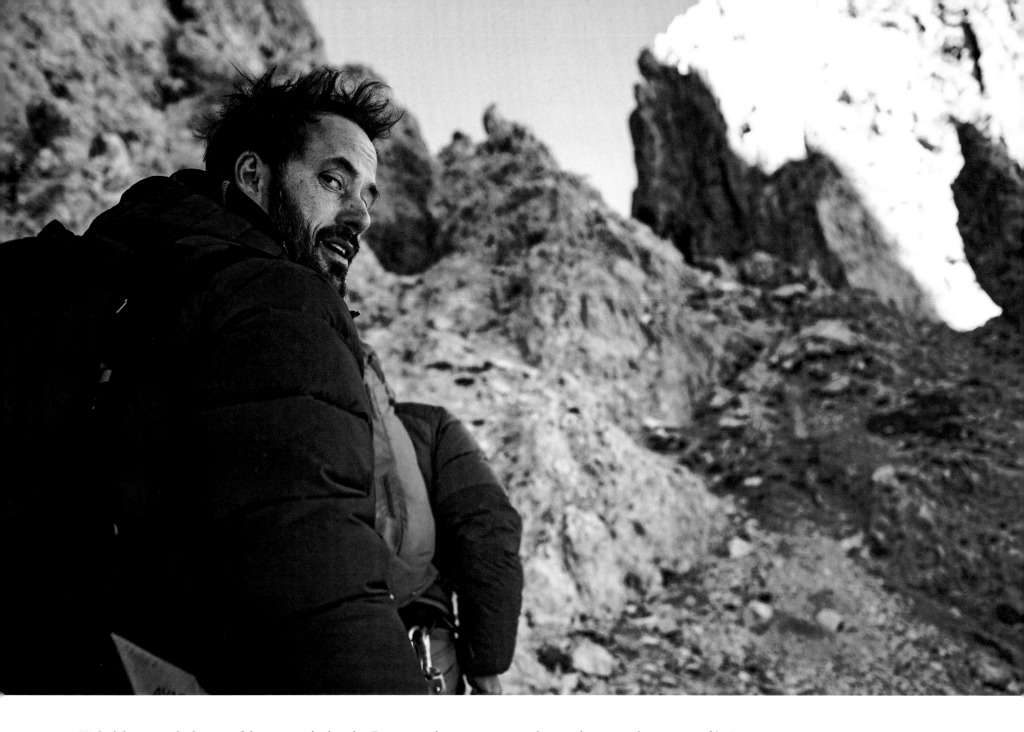

We had done enough planning of the sequence both with 3-D pre-visualization (pre-vis) and storyboards to know which types of mountain passes we were looking to find. Here our assistant director, Toby Heffer-man, scales the side of a mountain with Bradford Young and me. We were hoping to find a narrow pass over which the train could bank while being shot at by stormtroopers.

Access was challenging. The helicopter could only lightly touch down on one skid on the side of the mountain for us to jump out. We had two expert mountain guides who tied us in. Once we got near the peak you see in the above photo, it was clear that even though the pass was spectacular, there was no good way to bring even a small unit in here to shoot, nor any way to bring in the associated equipment safely. So we climbed carefully down and called in the chopper to continue the search.

Bradford and I were exhilarated by the search and the climb. Toby, we learned, really doesn't like heights.

OPPOSITE, TOP Bradford Young testing lenses on an Alexa 65mm camera in the Italian Dolomites. Bradford worked closely with Panavision to find old lenses that suited the gritty look of picture he was going for and refined them for use on the film. Removing anti-glare coatings and slightly de-tuning the lenses added exactly the imperfections he was looking for. Here, he is testing a lens pointed at the photogenic Tre Cime di Lavaredo.

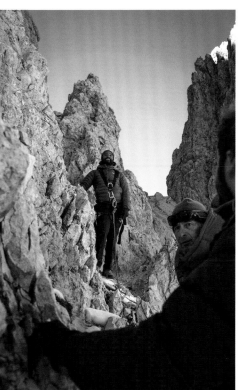

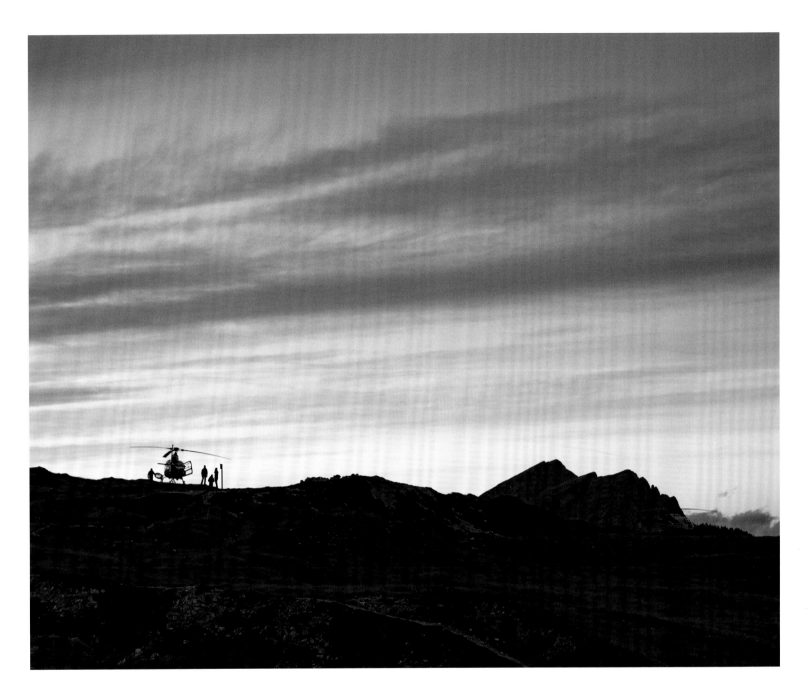

It's hard to imagine anything more fun than flying around in a high-performance helicopter through some of the most beautiful landscapes on earth, searching for inspirational scenes for a new *Star Wars* film. Due to the vastness of the location, the choppers were the best possible way to get from point A to B, but also provided amazing, unique vantage points like the one pictured at left. The weather patterns were dramatic and unpredictable, so the images I took during those scouting days were useful for us throughout the film for reference. We got a sense of which canyons and mountain ranges gave us the best options for lighting and enough space to block the actions we were looking for. In total, the visual effects department would later digitally build more than twenty miles of track and bridges through these landscapes.

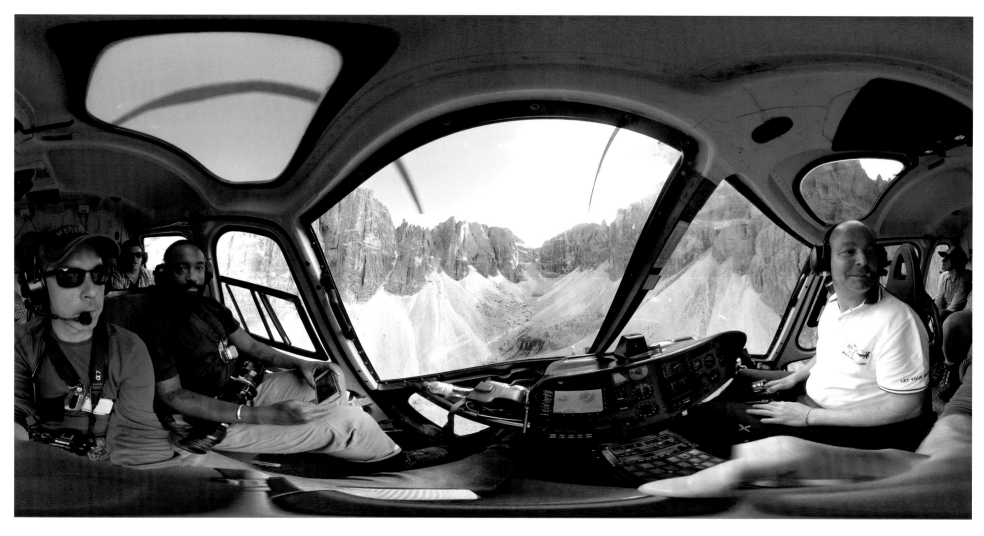

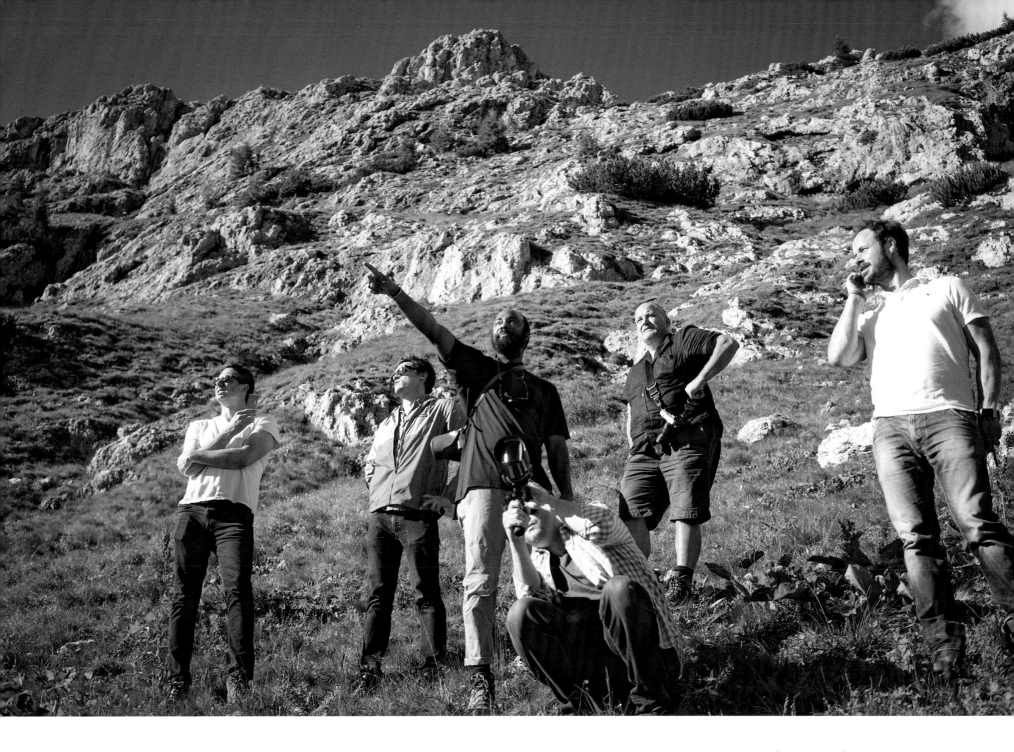

Our scout crew was searching for a location for a scene we called the "Wookiee Wash." In the original script, after arriving on the planet Vandor from Mimban, both Han and Chewie are still covered with mud. Beckett tells them to get cleaned up, and a bonding scene between Han and Chewie takes place in a freezing cold lake surrounded by snow. We imagined a pretty funny water fight with a couple of very cold actors in this beautiful location.

When we returned to the Dolomites for the shoot, the lake we identified was frozen solid. Both Alden Ehrenreich (Han Solo) and Joonas Suotamo (Chewbacca) were probably very relieved. Later, Ron Howard revived the scene during a re-shoot with Han and Chewie in an impromptu shower on the AT-hauler and accomplished much of the same idea—only in a much warmer environment.

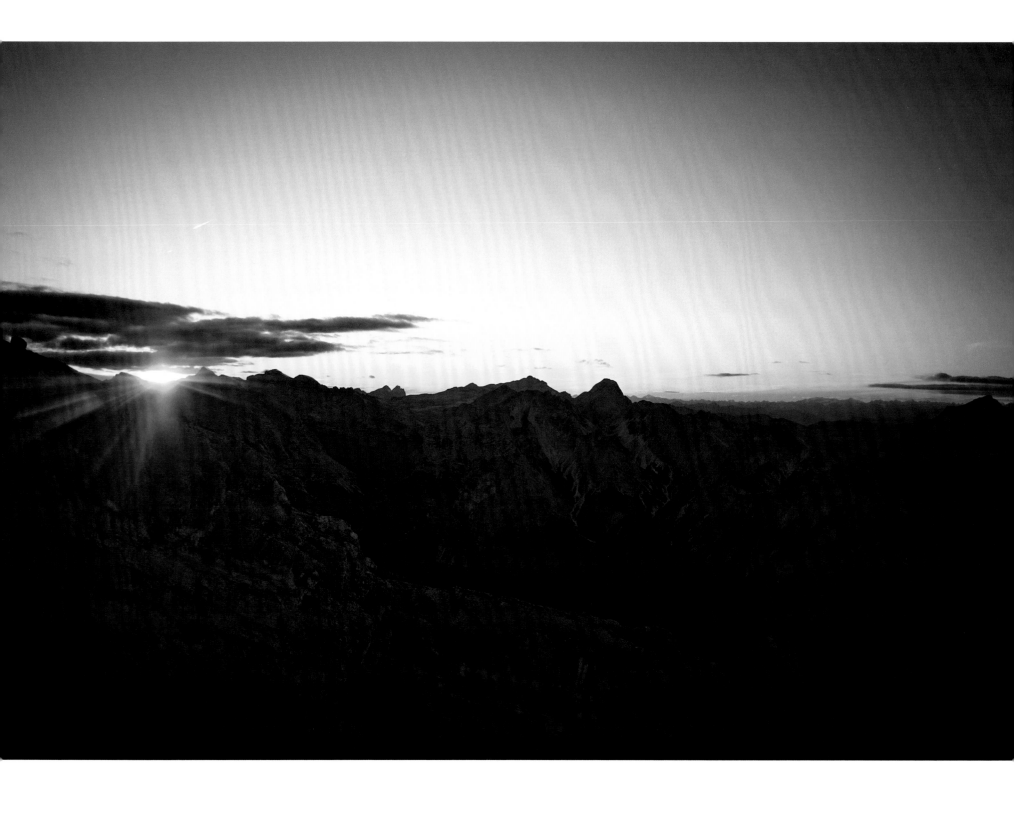

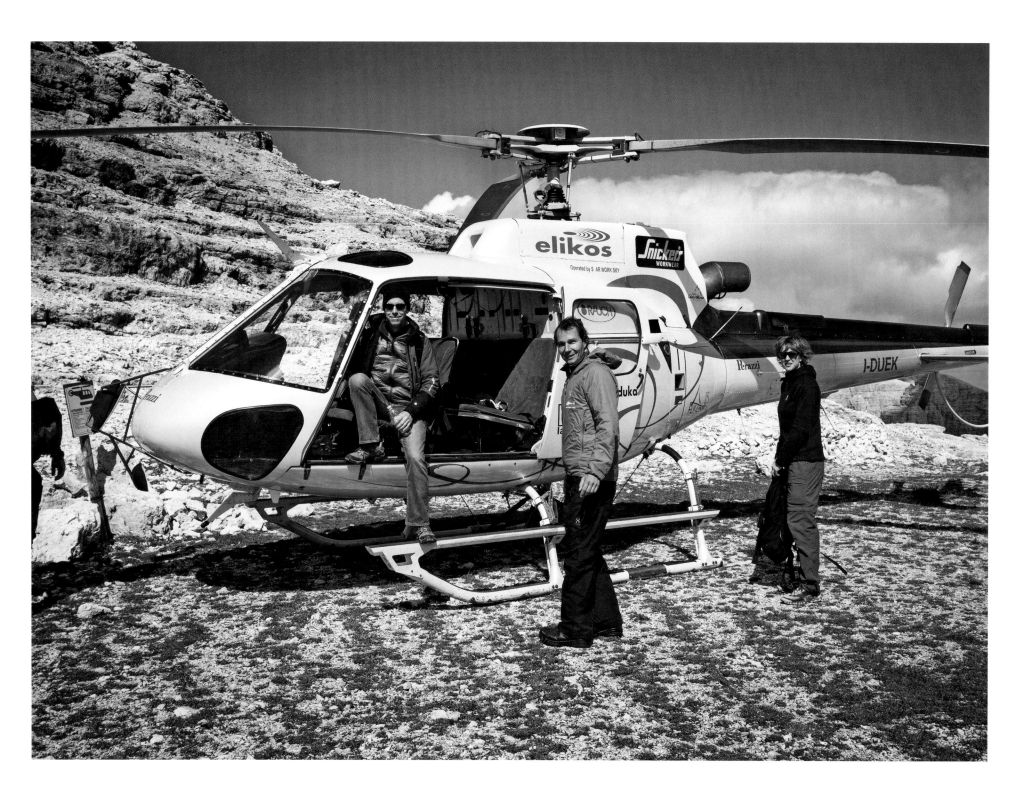

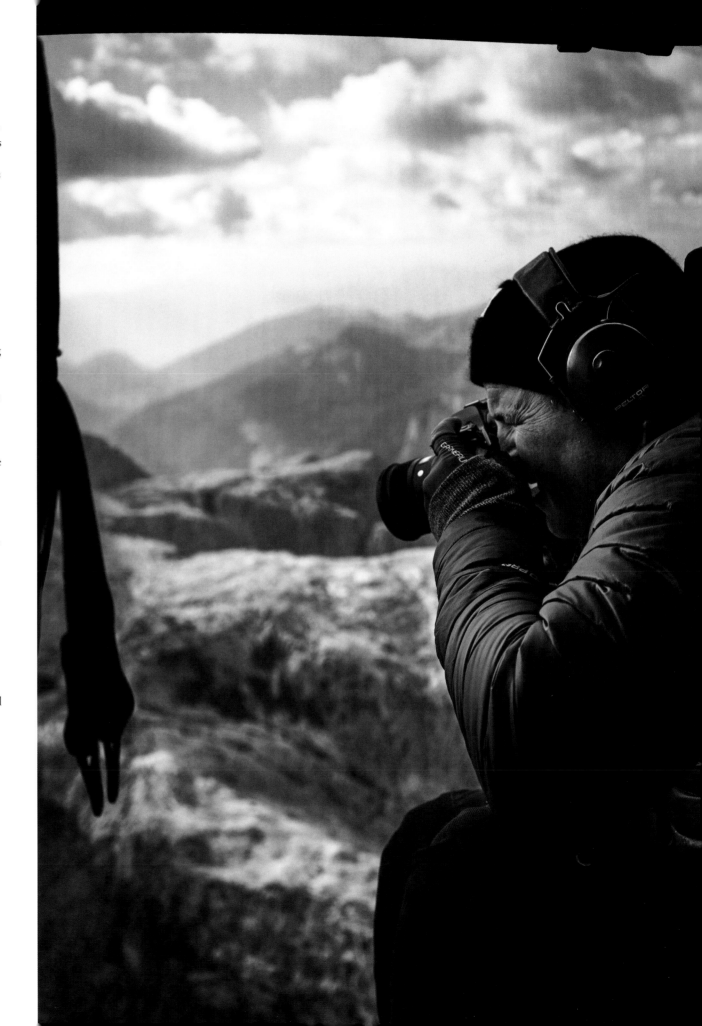

In order to both plan and create this sequence, we needed an accurate model of the incredible landscapes we had selected during the scout. We started by looking online at the various surveys, but these mountains are so rugged and remote, nothing was accurate enough for our use. Even usually reliable sources like Google Earth were very primitive in this area. It was time to create our own.

We commissioned a helicopter and a small team of photographers from Clear Angle Studios to take thousands of photographs from the air. Since we had hundreds of square miles to cover, we had to plan our photography carefully. Photomodeling—the process of creating 3-D computer models from many photos—works best when you have flat, even lighting like an overcast day. And of course, helicopters work best when it's not too windy.

When we did get the right conditions, the process worked perfectly. We would fly to the location and slide open the side door. I would guide the pilot down our chosen canyons at a slow fifteen to twenty-five miles per hour. The two photographers, who were secured to multiple anchor points in the chopper, used lenses of different length and photographed the mountains at every possible angle, taking care to ensure crisp, focused images. With their fast digital cameras, we were photographing thousands of images in just minutes. When a camera would fill up, we would hover in place for a moment to reload, then continue our path.

The only downside was how cold it was in the helicopter with the door open in the high-altitude winds. But we eventually thawed out.

Using those photographs and some sophisticated computer algorithms, we created highly detailed photo-models that we could use both for planning our sequence and as a source for rendering in the final film. By the time we were finished, I had a hard time telling the difference between the real aerial photography and the digital mountains ILM created from these thousands of still images.

RIGHT Dominic Ridley leaning out the side of the helicopter to get a shot of the majestic Italian Dolomites.

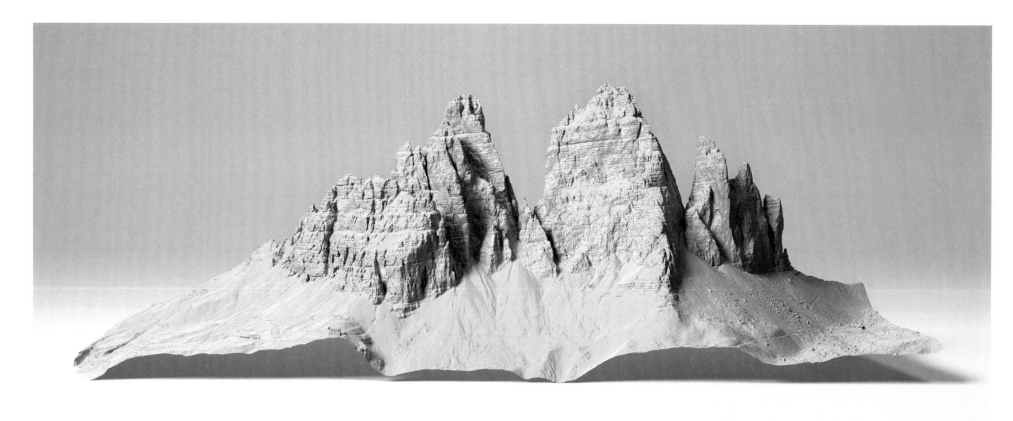
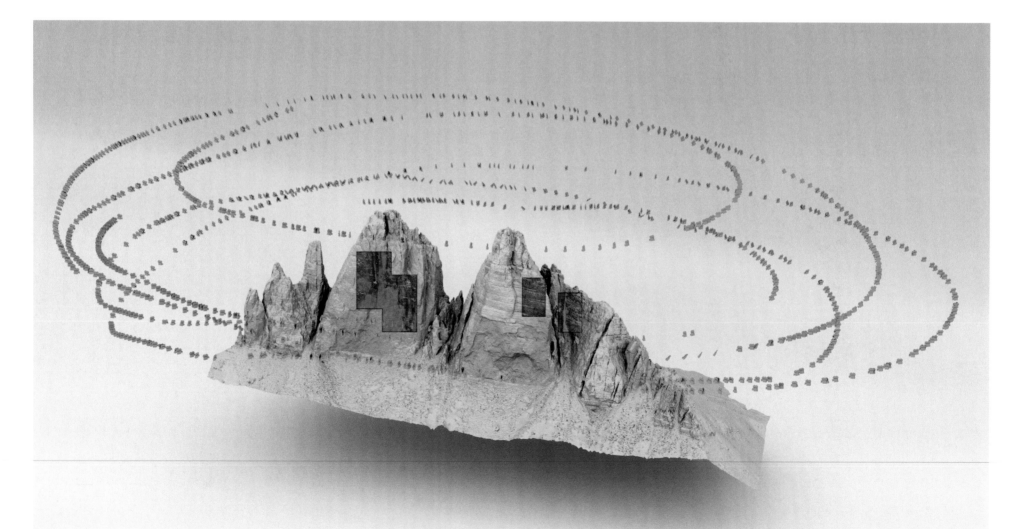

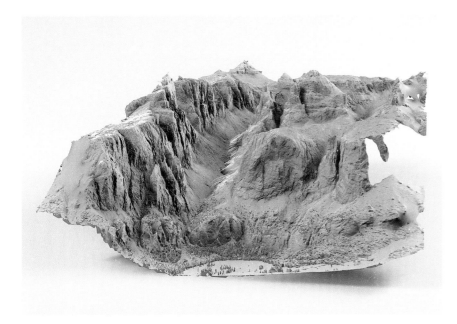

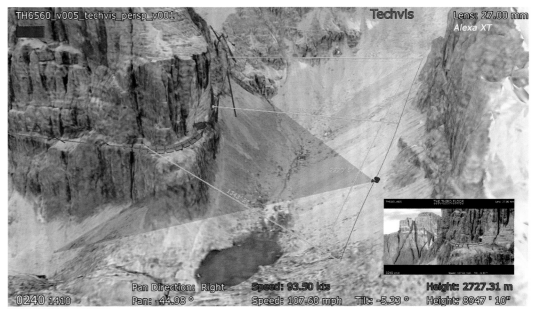

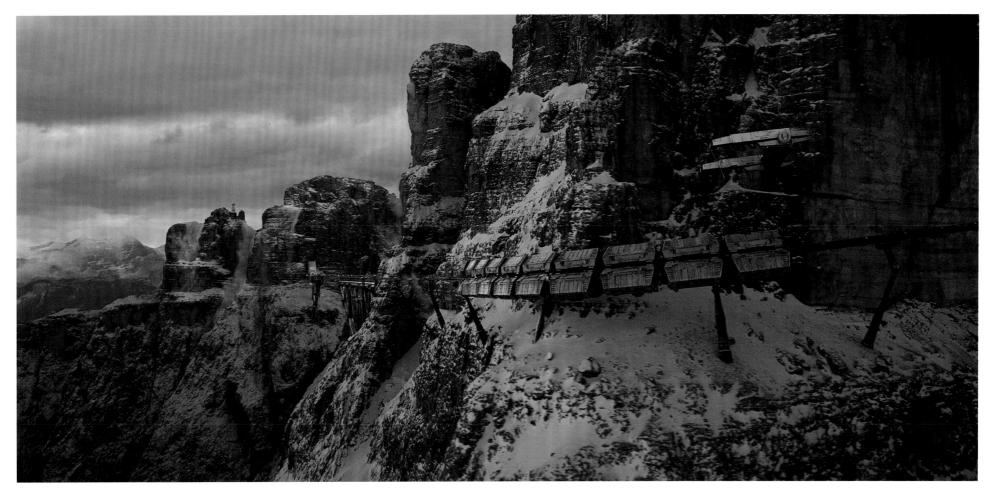

OPPOSITE High-resolution 3-D models of the Tre Cime di Lavaredo range in the Italian Dolomites. On the bottom you can see the path we flew in the helicopter; each of those green dots represents one photo taken and combined together to reconstruct both the precise shape and texture of the mountains.

Top left is a similarly constructed model of a canyon in the Sella Group of mountains, which represented a much larger area to reconstruct. Top right and above are "tech-vis" (technical visualizations) we created when planning out our shots for the sequence. With the readouts on those images, I could direct the helicopter to a certain position, altitude, heading, and speed, and we could capture exactly the angles needed for each shot in the film.

PHOTOGRAPHY:
PRE-SHOOT FROM THE AIR

We had the script, the pre-visualization, and the 3-D geometry to plan our shots. Now it was time to shoot the background photography (also called "plates") for the entire Train Heist sequence. But where do you even start when you have a five-day shoot and twelve minutes of action playing out over hundreds of square miles?

The first thing we needed to do was understand the lay of the land. I love those subway maps that make complicated routing clear, so we tried a similar idea here. We were imagining a long, connected twenty-plus mile line, but in actuality we had selected five separate locations that would be cut continuously during the editing process. Each of those sections got a color—we could call out shots to shoot along the Red Line (climbing up a canyon in the Catinaccio group of mountains) or pick off a down shot along the Violet Line (named after the Violet Towers near that line).

From there, we broke the shots down into several main types. There were the usual angles: for example, pointing the camera forward along the direction of the train line with the camera close, nearly hugging the mountain, or pointing backward toward the imaginary caboose. A dozen generic angles would cover the basics and then we called out all the "special" shots that were specifically choreographed for moments in the sequence.

In all, we started the shoot with a shot list of more than 120 shots and five days to get it all done. I had supervised aerial shoots before, but never anything of this scope. Usually I've had a shot list of five or so setups—this was something else altogether. For advice, I called up ILM veteran John Knoll, VFX supervisor and chief creative officer. He'd never heard of someone trying to shoot that many plates in that short a time. The pressure was on.

I worked with our VFX production team to create a bespoke database I could access on my iPad so I could track which shots we had completed, reference our pre-vis, and be ready to change the plan at a moment's notice due to weather and light. Speaking of weather, we needed the perfect atmosphere to get the look Bradford and I were going for—early morning on an overcast or cloudy day.

We got sun and wind.

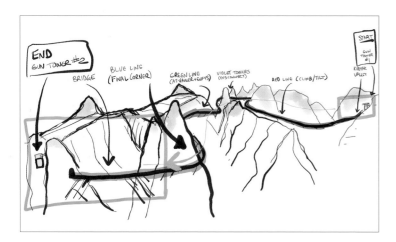

ABOVE Inspired by the color-coding of the New York City subway lines, each section of the train monorail got a color-coded label for clarity, as indicated here on a quick sketch I made for editorial during the assembly of the train sequence.

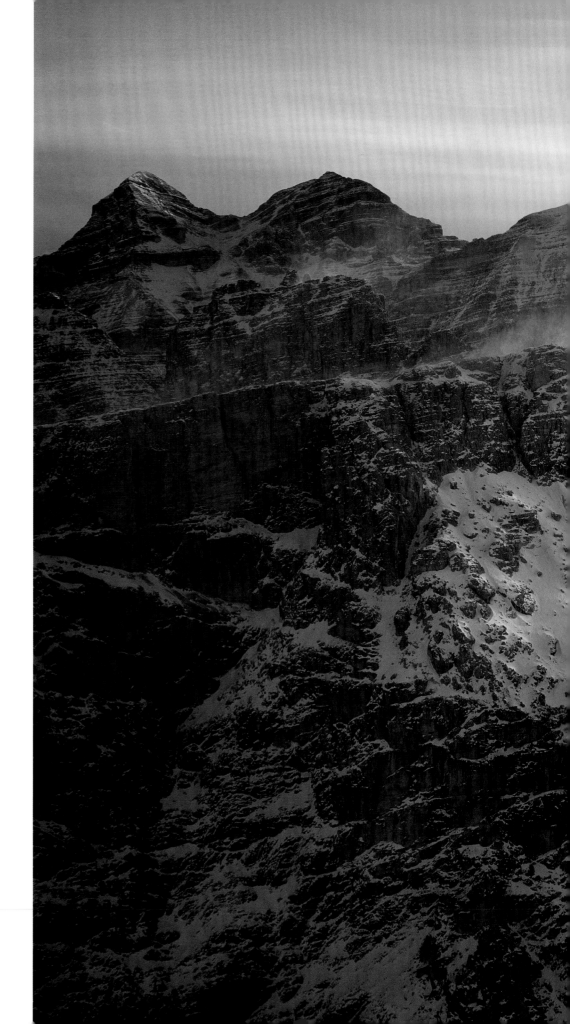

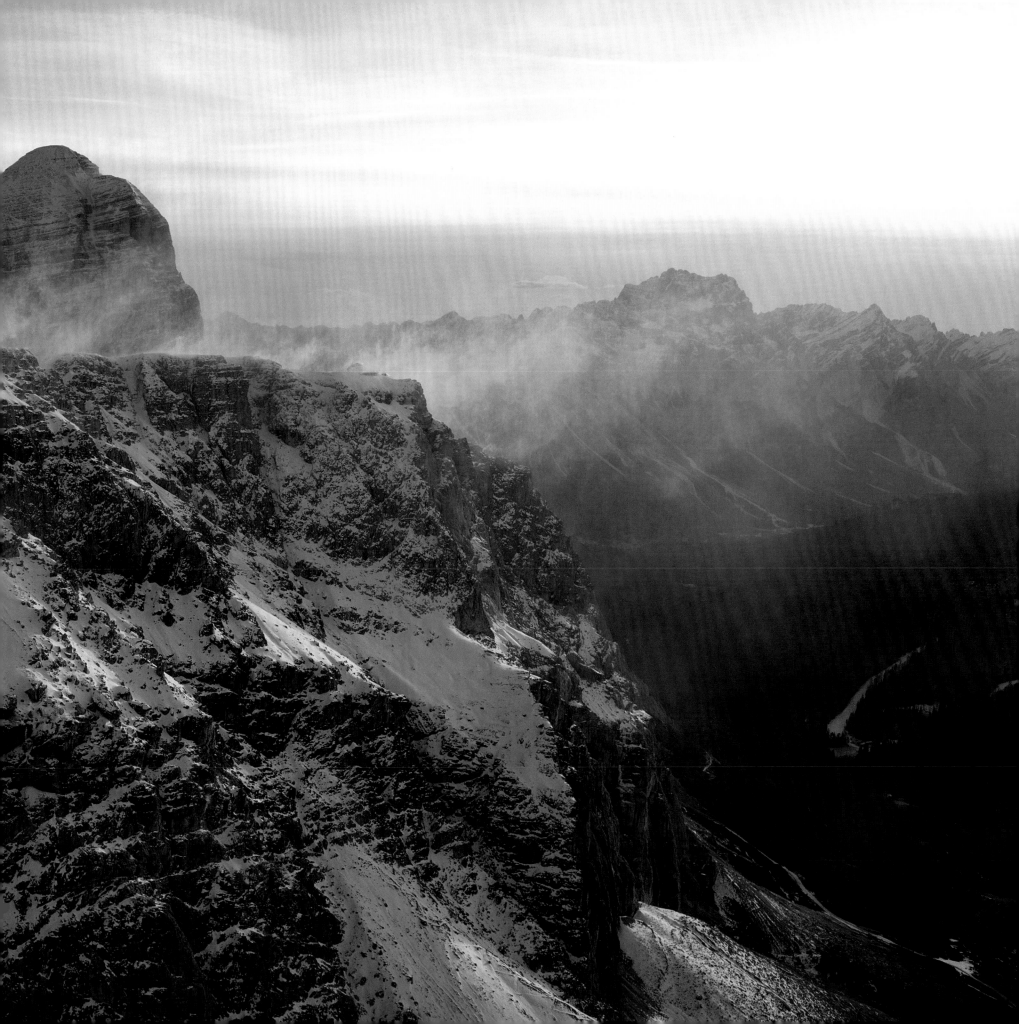

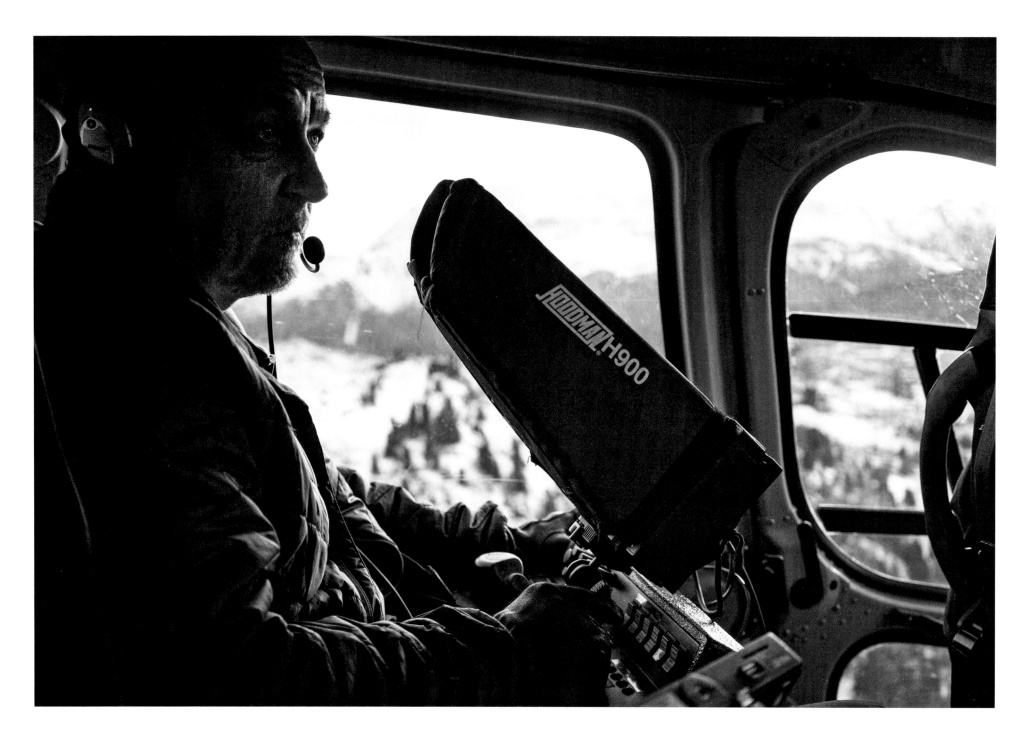

Aerial DP Hans Bjerno operating the Alexa 65 remotely from the back seat of the helicopter with me. Our pilot (not pictured) was Marc Wolff. The first time we took off, I had my head buried in my computer, tracking our location, and making plans for what to shoot next—I had forgotten the g-forces involved in these turns and the effect they might have on my stomach. I looked around and didn't see any convenient bags either . . . deep breaths. At our first landing, an hour later, I enjoyed the steady ground and reminded myself to look out the window more during the hard banks to keep my bearings. It got better with a bit of practice. We had a job to do—there was no time to be sick.

By the time we were a couple of days in, we had developed a pretty great system, working as a team to get a huge amount of footage quickly.

I would identify our shot, give general directions to Marc as to heading, speed, and altitude from our tech-vis, and while we were positioning ourselves, ensure Hans was familiar with the shot by showing him the pre-vis animation. We'd start our approach, roll camera, and Hans, Marc, and I would work together to get a beautiful shot.

It might be easy to forget when you watch the final picture that we were, of course, not shooting any train or action—just the empty background plates of the mountain. Even the bridge would be added later. On a second flyby, I'd suggest the (imaginary) train was going just a bit slower, or faster, or call out beats trying to predict what we would later animate.

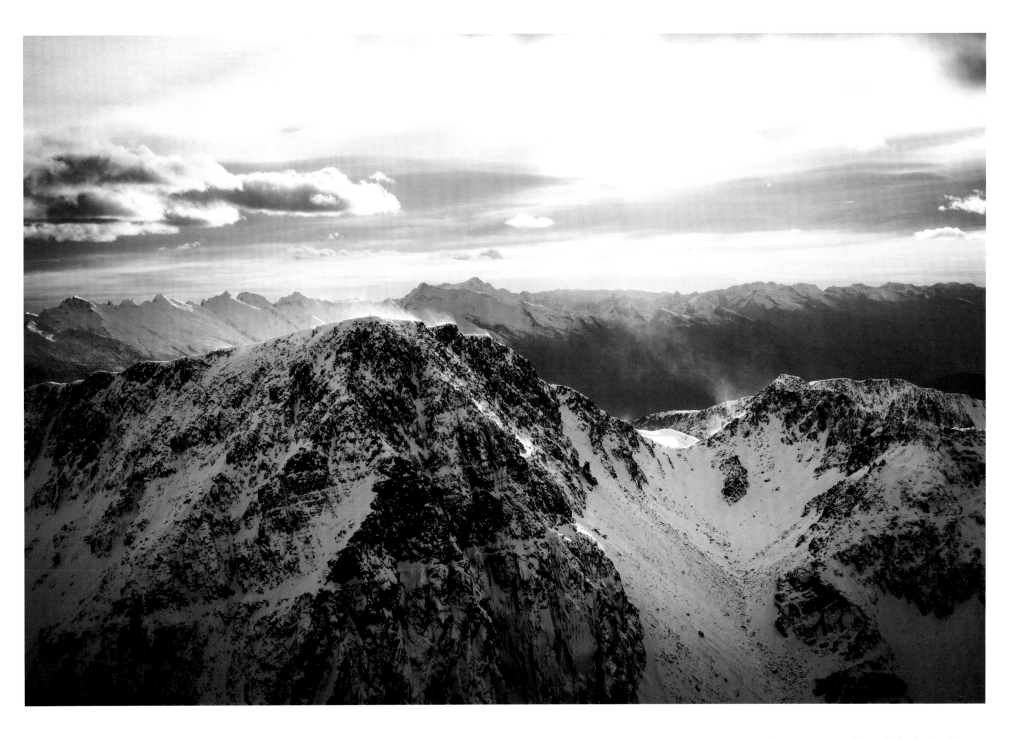

The wind was sometimes strong enough to pull the snow right off the top of the mountains. We were inspired by this and loved these images. You may notice a similar effect added by Industrial Light & Magic to several shots in the final film.

One day, the wind was so strong it really bounced us around. Seat belts were tightened, and I saw even the veteran flyer Hans hold on tight as we shook back and forth in the turbulence. Marc kept us safe, but the camera rig took enough of a beating to strip one of the caterpillar screws in the gyro-stabilized housing. Fortunately, the camera team was able to call in a part overnight, and we only lost a half day of shooting. But every hour adds up, and half a day less time just added to the pressure of getting all the shots in time.

OVERLEAF In order to shoot some of the lower passes safely, we had to land and add markers to the ground for Marc, our pilot, to use as sight lines. With the cones on the ground, the rise and fall of the ground was possible to read from the air, and Marc could make low-altitude passes safely, simulating a camera on a vehicle. Those low passes were for a portion of the sequence where our cast rode kod'yoks to board the train and were cut later to reduce the running time, but shooting these plates was pretty exciting.

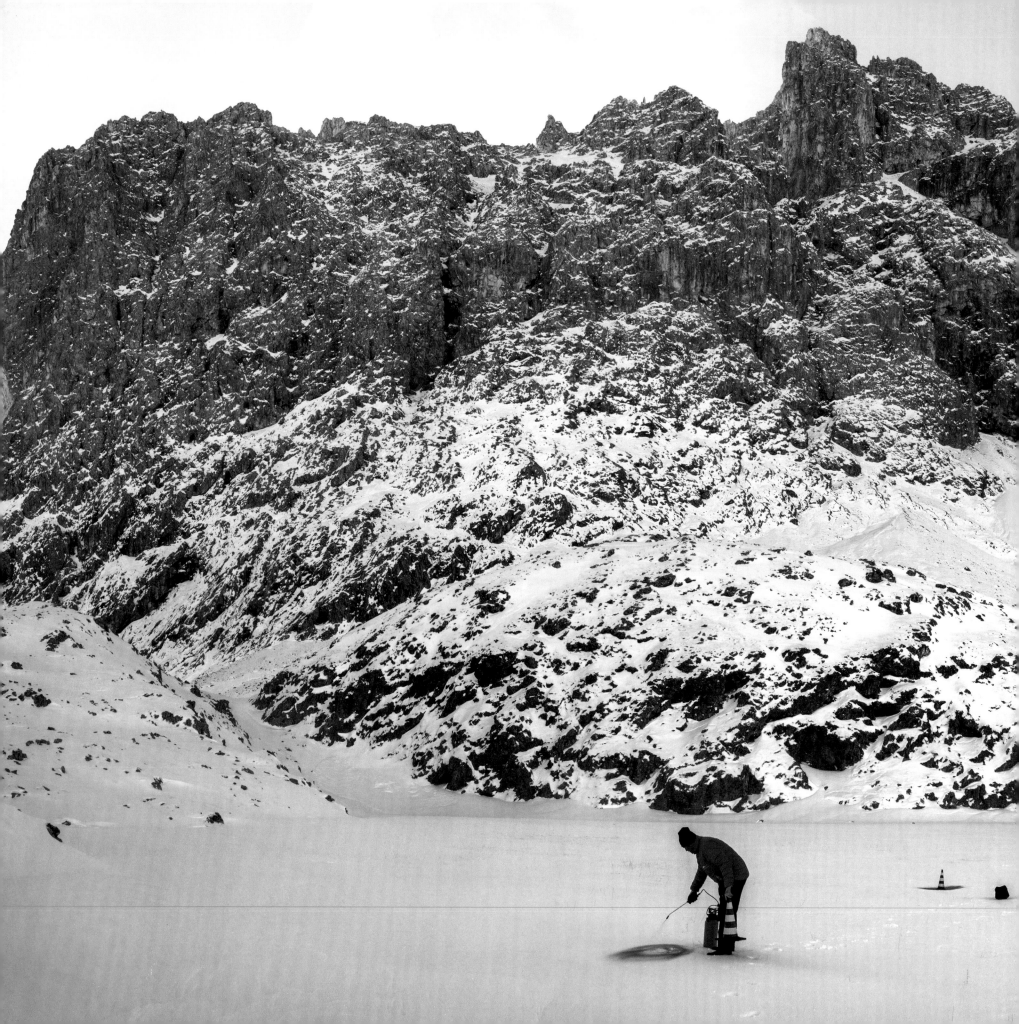

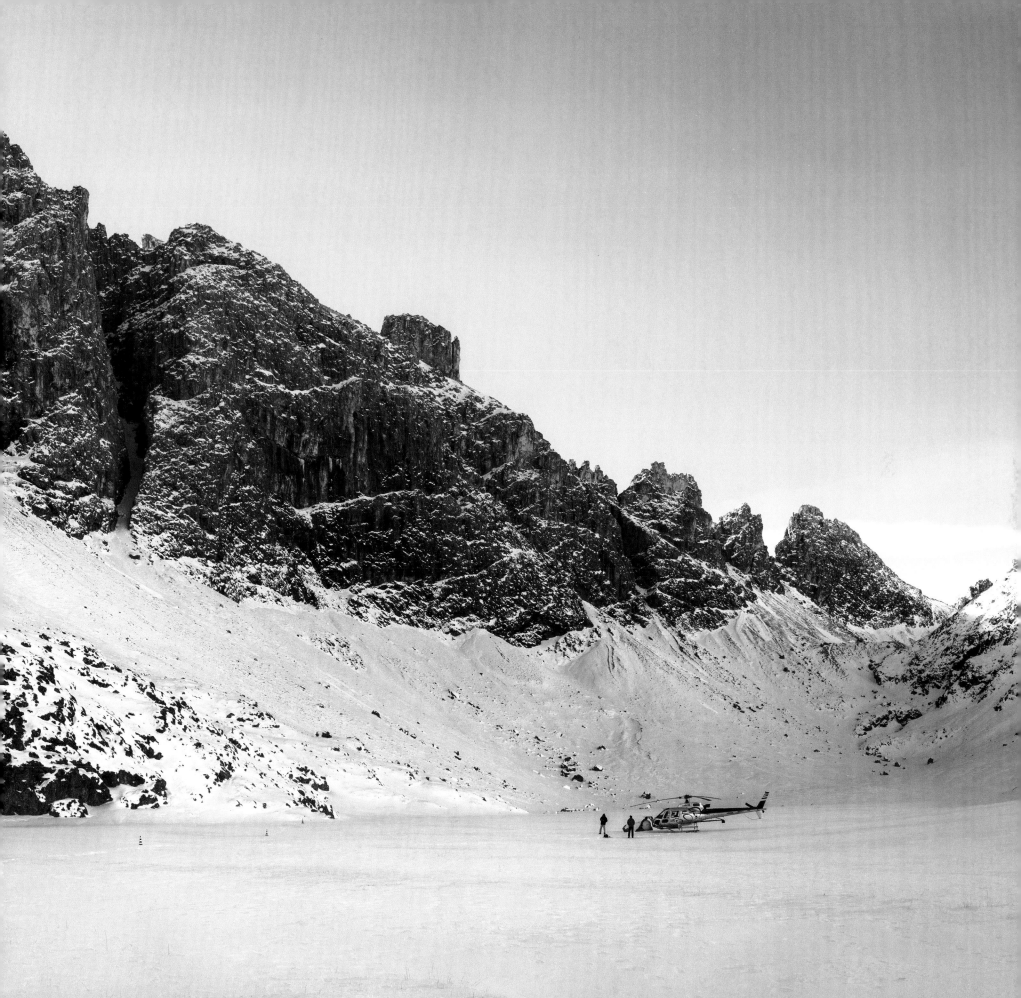

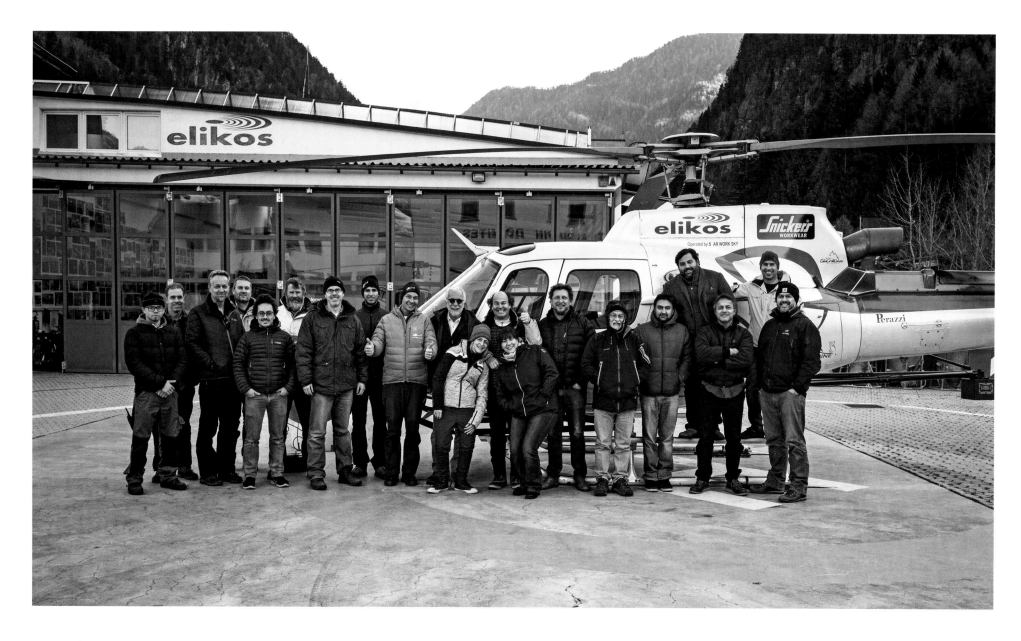

Thanks to the weather and our breakdown due to the wind, the clock was ticking. That last morning, we still owed more than sixty plates, half of the remaining work. I was sweating the deadline.

We made great progress for the whole day, getting dozens of great shots, but even down to the very last hour we weren't sure if we'd finish our list in time. But the clouds came in, gave us just the coverage we needed, and we shot through the remaining fifteen setups in record time. We got some of the most beautiful aerial shots in the film in that last hour as the sun was setting. A perfect ending to a fantastic aerial pre-shoot.

Shooting this week in the Dolomites was incredible, one of the highlights of the film for me. Getting to witness the spectacular scenery firsthand was remarkable. And the care taken to capture these background plates in-camera really shows in the finished film.

ABOVE Our Aerial Unit pre-shoot crew, after a safe and successful shoot.

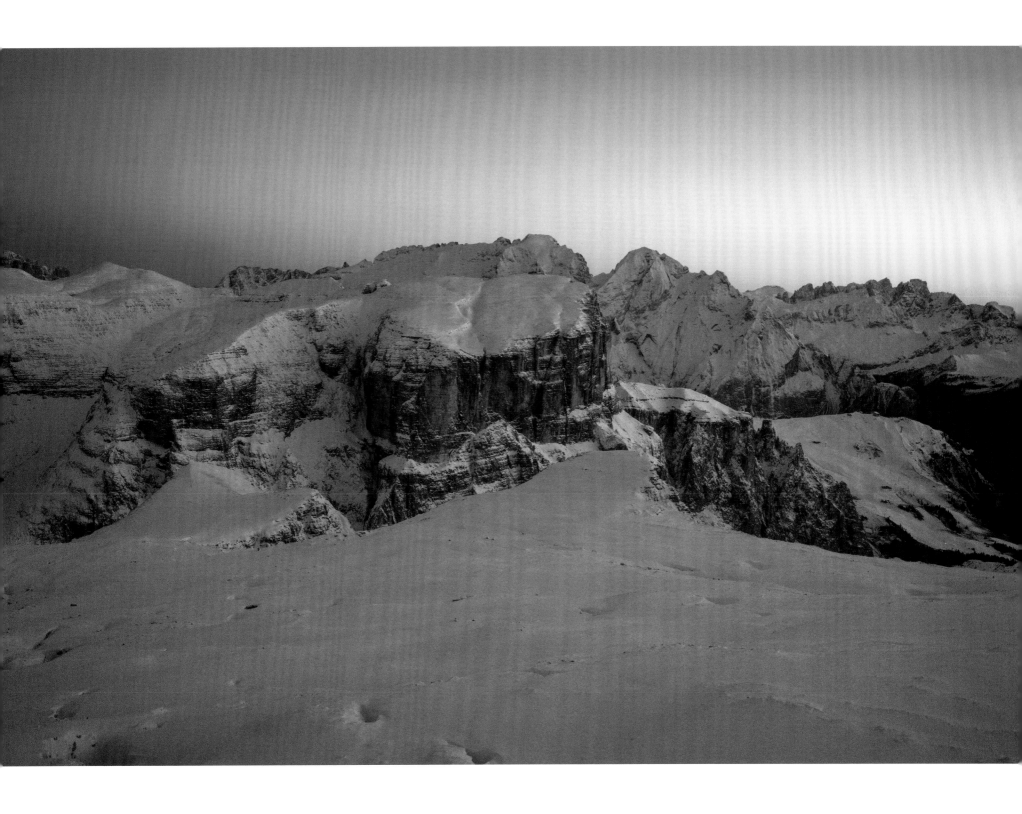

STUNT TESTING

There's nothing better than the real thing, or at least that's what the production set out to prove with the full-speed stunt testing at Dunsfold Aerodrome. We guessed that stunt players might act a little different when on a moving rig at fifty miles per hour crawling along and ducking (imaginary) obstacles. And we learned a lot from what the cameras could, and could not, achieve at those speeds.

In the end, after a lot of testing, we moved most of the principal photography for the production inside on stage. The stunt team, led by second unit director Brad Allen, had captured the reference that we needed to match. Dominic Tuohy and the special effects (SFX) team brought a huge amount of wind on stage, and by being inside we gained the ability to control the lighting and shoot over blue screens to get good extractions of Chewie's fur, so we could cleanly layer the furry character over the digital backgrounds and bring the level of realism the film needed.

Figuring out the magnetic boots for the troopers was a pain in the butt. They needed to traverse the train, and trying to make the physics of it all look believable was probably one of the toughest things for us to execute. We tried many different variations of wire setups, talked about actually using powerful magnets in their shoes, and tried some VFX split comps (shooting multiple passes and combining them together), but none of that worked. We just couldn't get the dynamics to feel right. Finally, when we were almost out of time, Mark Ginther (stunt coordinator) and Lenny Woodcock (head stunt rigger) came through with a custom wire rig that worked great. I felt sorry for the stunt guys in the range trooper suits, because it was definitely not the most comfortable thing to do all day long. Kudos to them for making it work and selling the idea on screen. That, combined with VFX adding CG troopers in a handful of shots really pulled off the illusion.

— Yung Lee, second unit action arranger

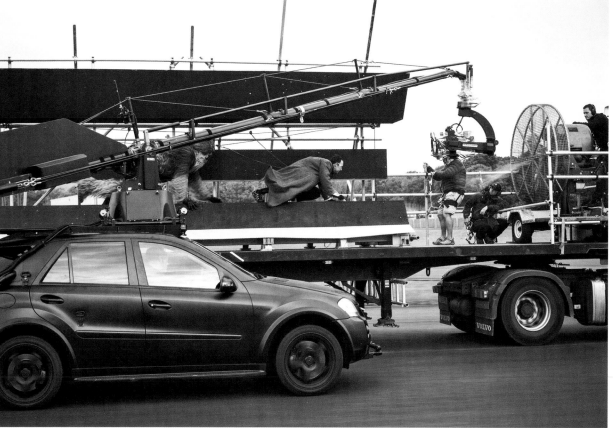

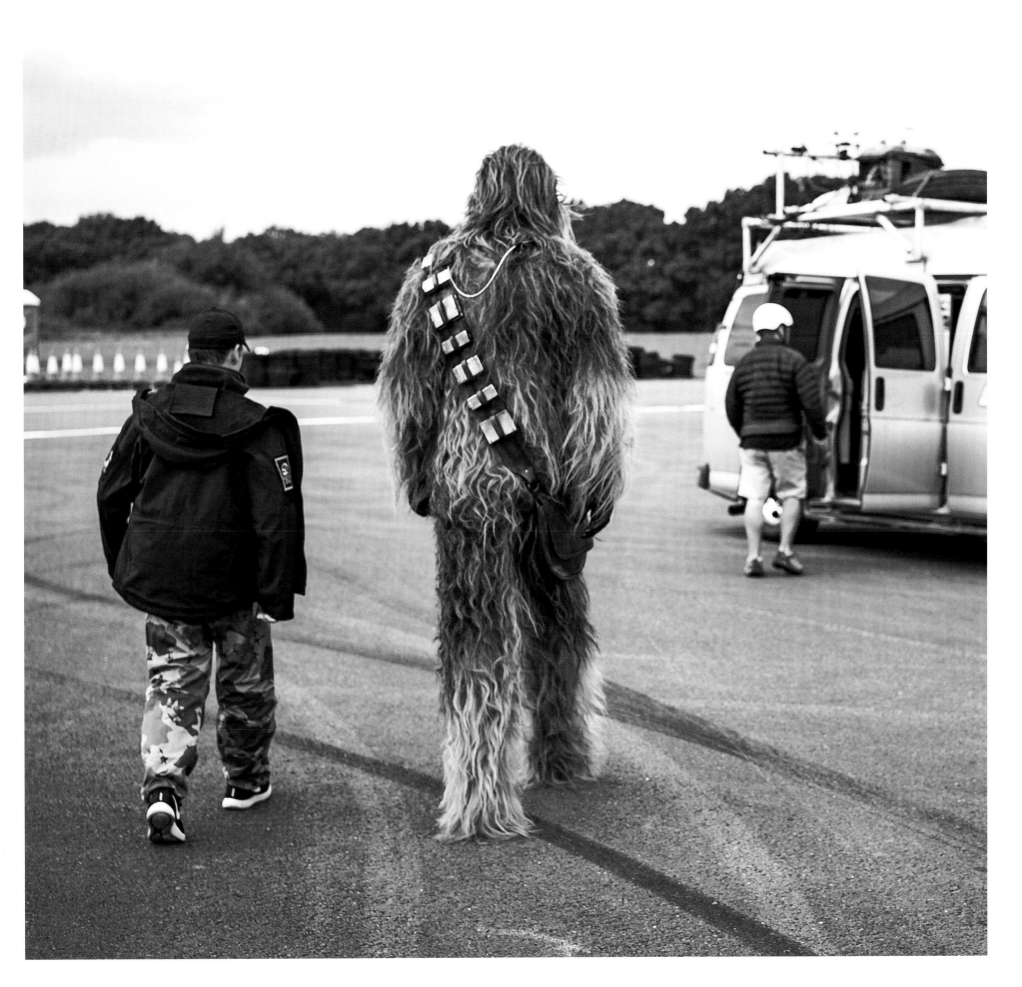

The Canaries

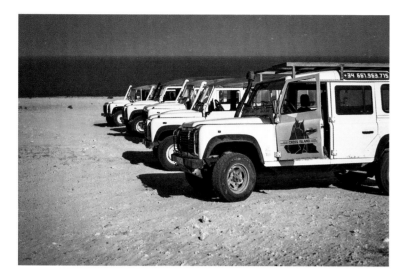

SAVAREEN: THE SHOWDOWN

Location scout Mark Sumner looked around the world for a place where we could find a stark desert that dropped straight into the ocean and was as dynamic as possible. There were a few options on the Skeleton Coast in Namibia, but the logistics were even more challenging there. Once we set foot on Fuerteventura, one of the Canary Islands, we knew it was the perfect spot for the climax of the film.

Naturally, the best location was in a deserted section of a national park. Fortunately, the production was able to work closely with the government to get permission to build the set on the location, and then restore the desert to its natural condition after we departed.

Six off-road Defenders transported our team to numerous locations around Fuerteventura Island to find the perfectly desolate location that dramatically dropped into the sea.

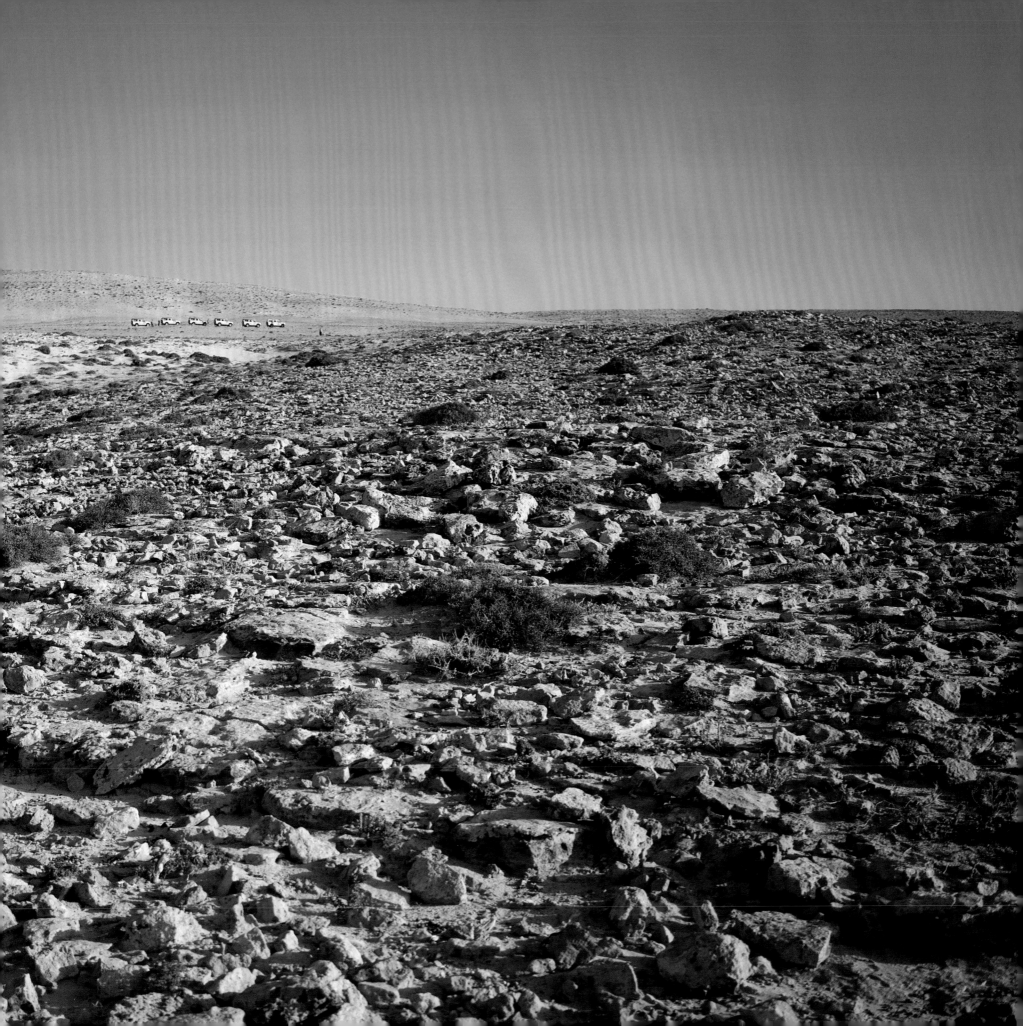

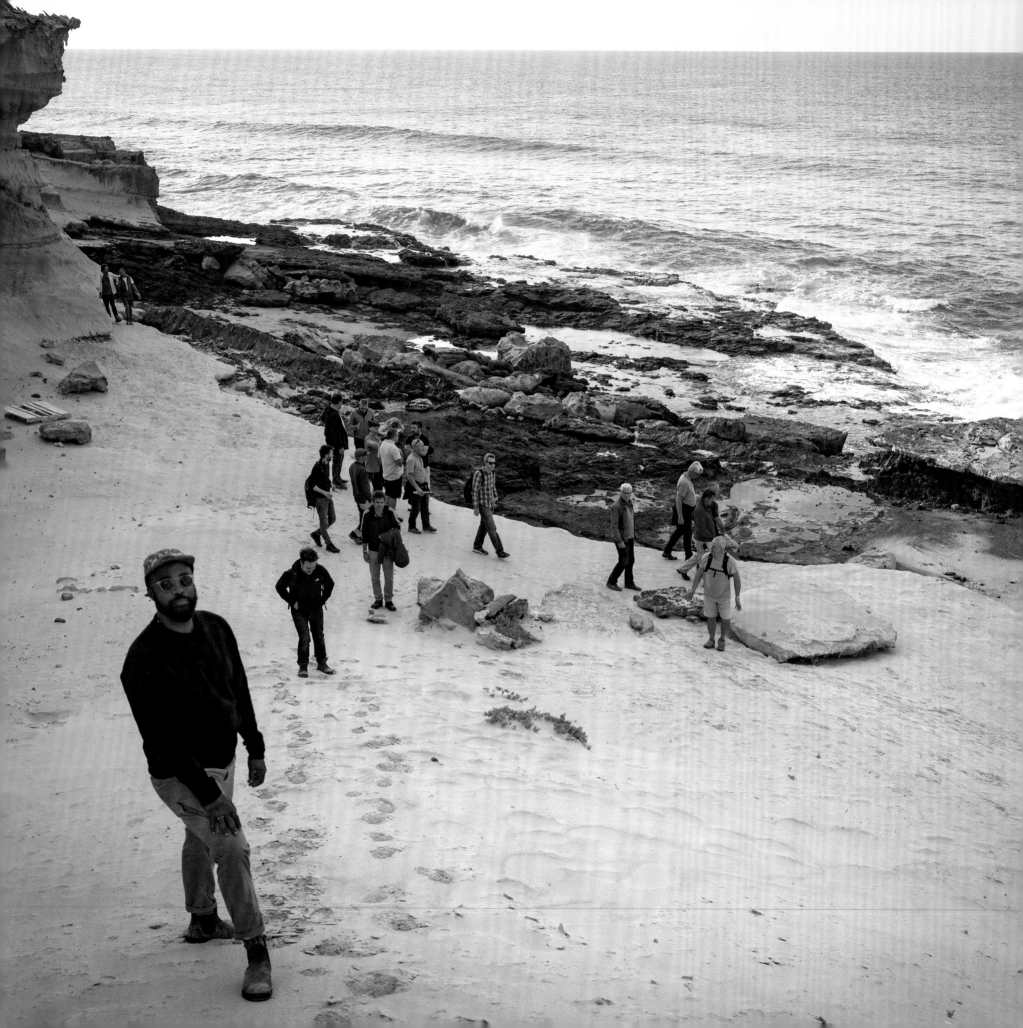

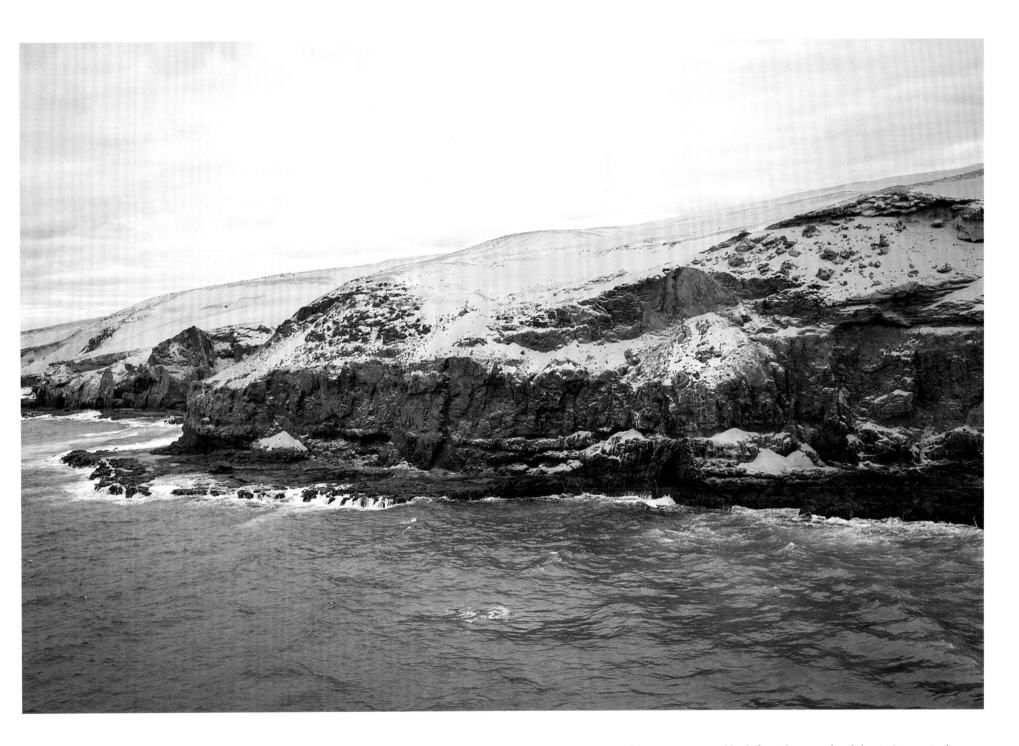

The scout continued both from the ground and the air. I supervised the aerial scout with two goals in mind: looking for the best place to crash land the *Falcon*, and finding the perfect aerial vantage point for the vista from Dryden's ship when he docks in Savareen. We finished the scout with strong options for both.

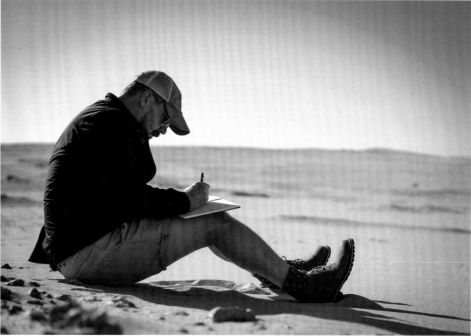

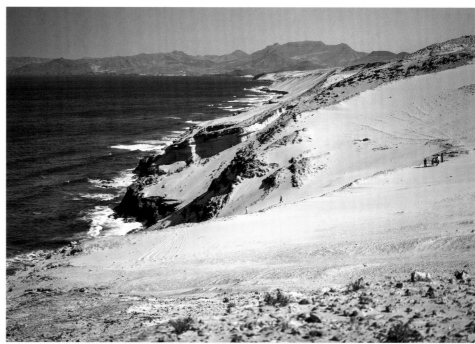

Lee Sandales (upper right) ran the set decorating department and collaborated closely with production designer Neil Lamont (lower left) on every setup, and his work was particularly featured on Savareen. Lee was inspired during this scout to create a backstory for the Savarians in which they live on the water and might harvest a kind of brightly colored shellfish. If you look closely you'll find evidence of a fishing lifestyle hidden among all of the set dec at this site—even down to cloth and other materials being stained by this fabricated shellfish. It's that kind of attention to detail that is felt, more than overtly noticed, but hopefully makes the environment look like a real, lived-in space.

OVERLEAF Bradford Young often scouted ahead of the group. Here, he is pictured at the end of the beach scouting the next inlet for the perfect site for the *Falcon* to crash land. Later, we settled on a landing pad closer to the end of the "main street" section of our set to keep the action of the sequence moving quickly.

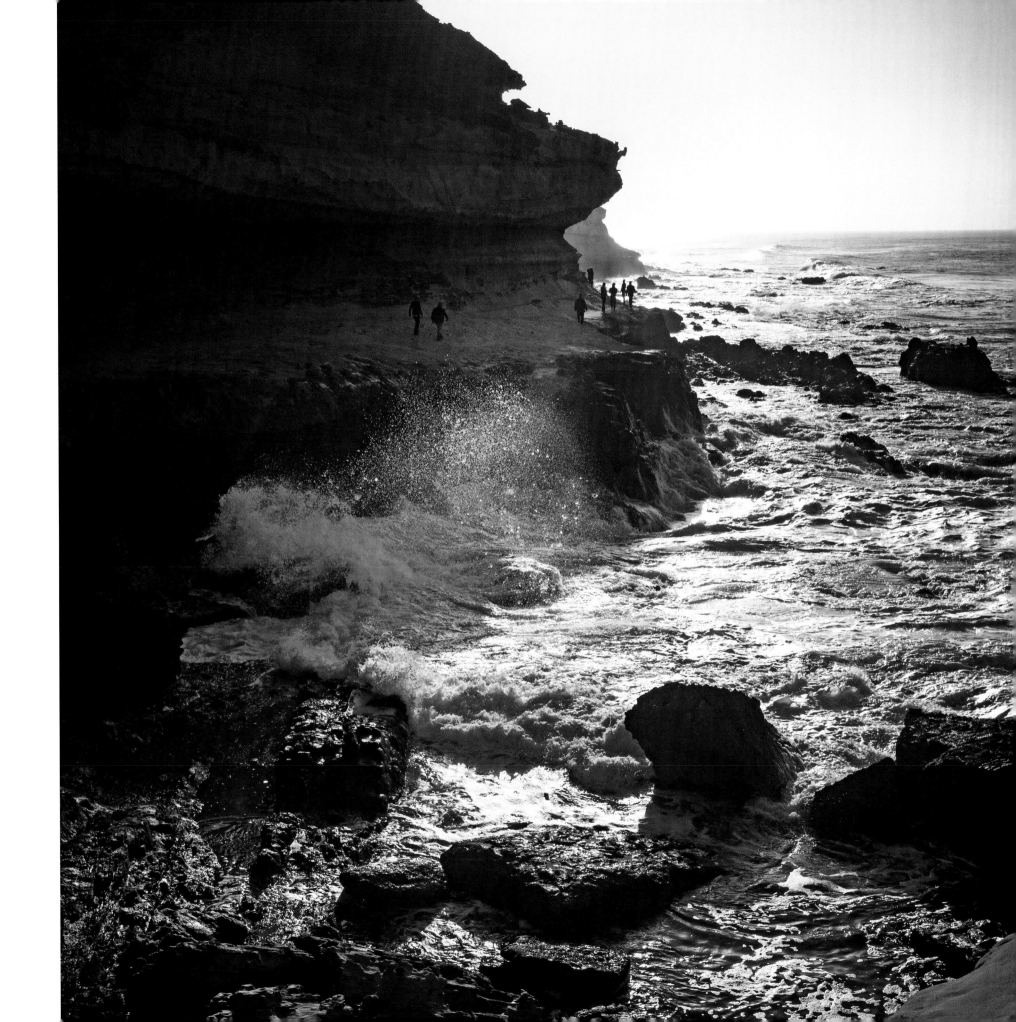

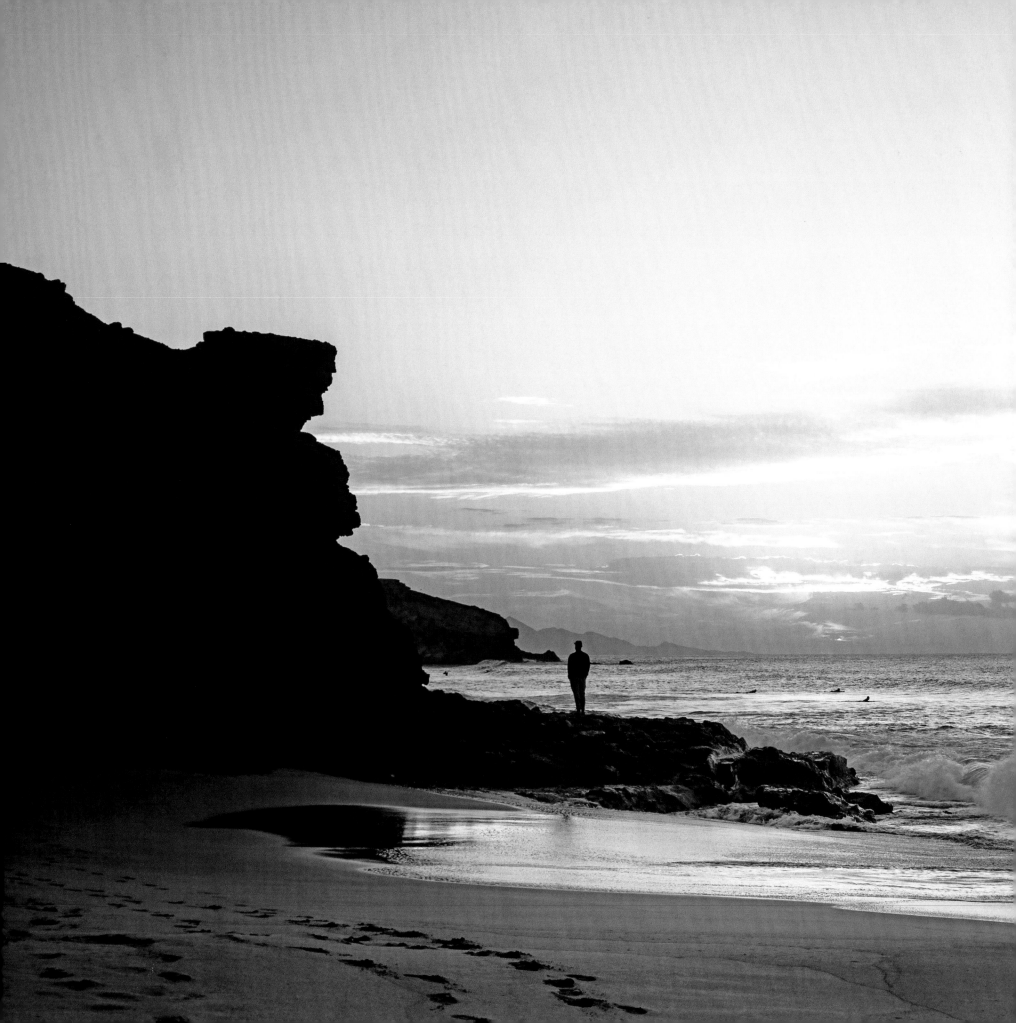

Fawley Power Station

SHOW OPENS

The final location to scout for the film is the first world we visit: Corellia. In *Star Wars* lore, Corellia has been established as the planet on which the *Millennium Falcon* was built, so we were looking for a heavy industrial location. When we learned that the abandoned power plant originally scouted for *The Force Awakens* and *Rogue One* was still available for shooting, it was tough to beat.

Walking through this place you can really feel the history of a working building. The steely smell of oil mixed with dirt reminded me of my grandpa's basement, where he kept his machine shop. A real working place.

The scale was really staggering and a perfect place to stage the opening speeder chase. All we needed was to add our speeders and add some digital TIE fighters under construction, and we were pretty much ready to shoot. Well, as long as we could shoot before they started to tear it down. The shooting schedule actually came down to the price of scrap steel—as the price went up, so did the owner's interest in disassembling the plant for scrap, so we had to move fast.

ABOVE A final frame from the Speeder Chase, with elements shot on location combined with digital extensions created by artists at Industrial Light & Magic. This particular shot was stitched together from several different photographic passes that the second unit choreographed and shot.

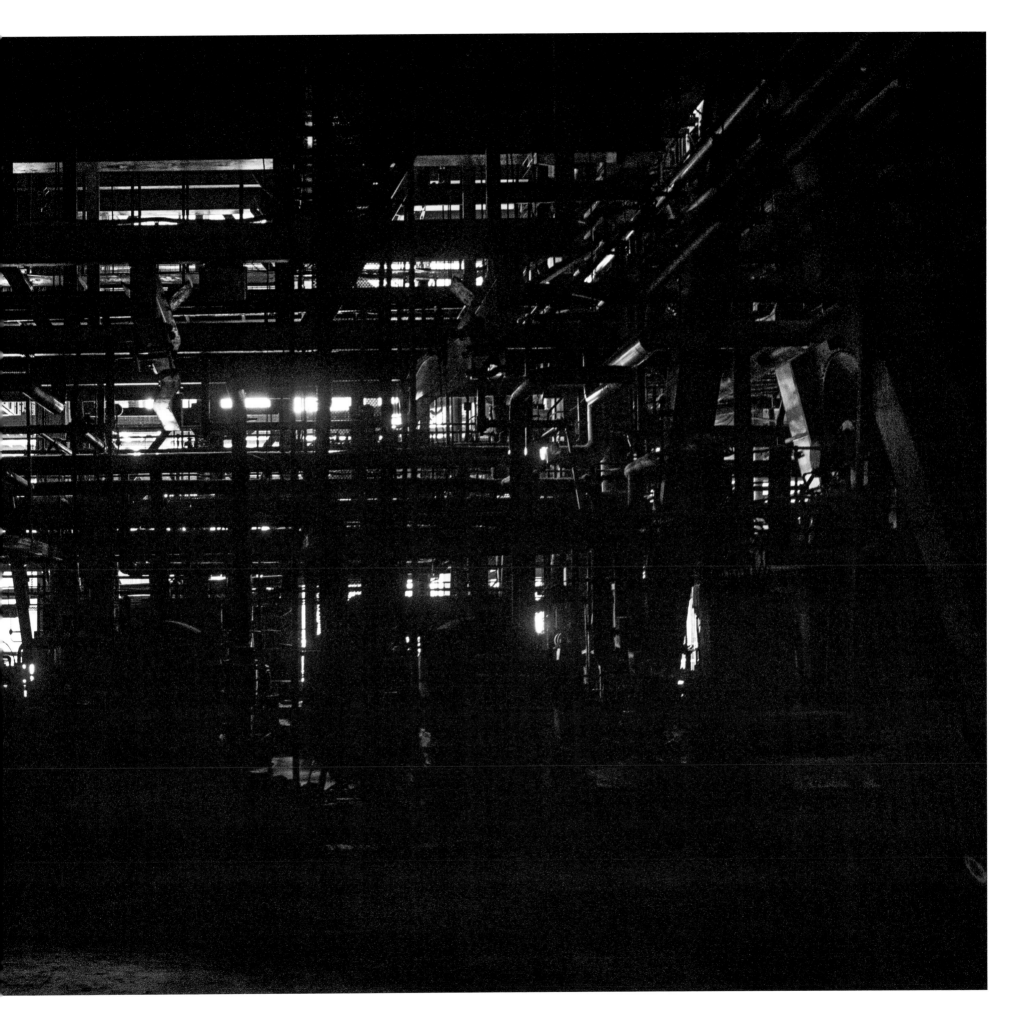

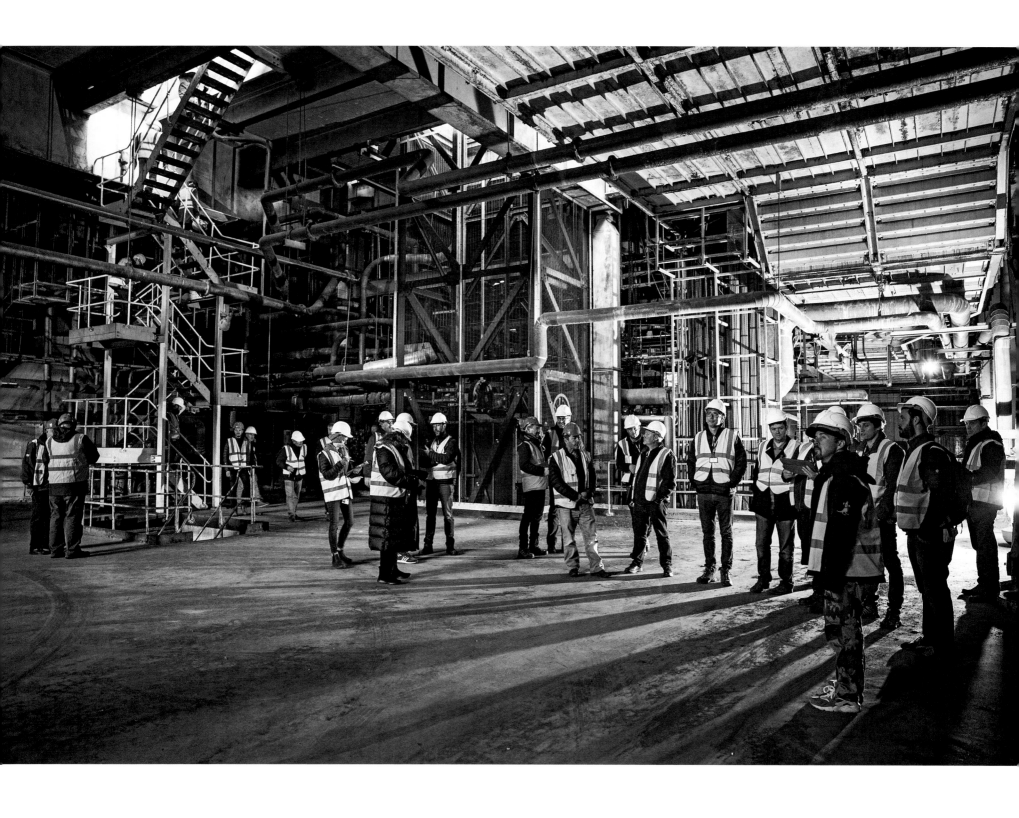

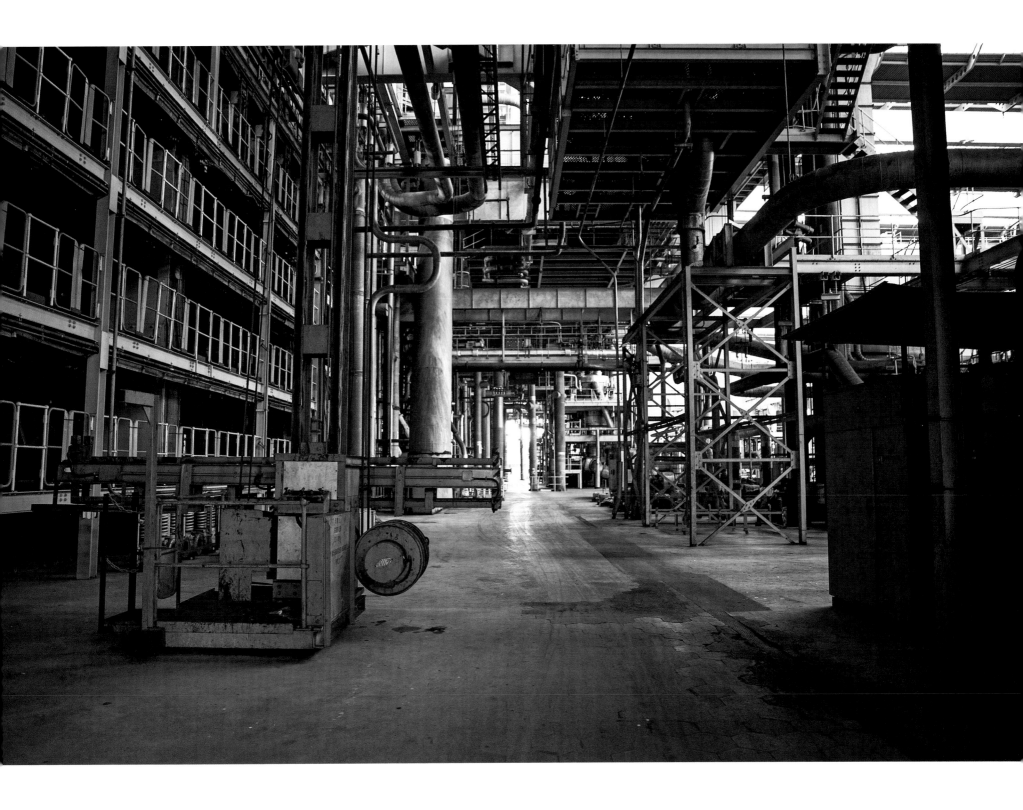

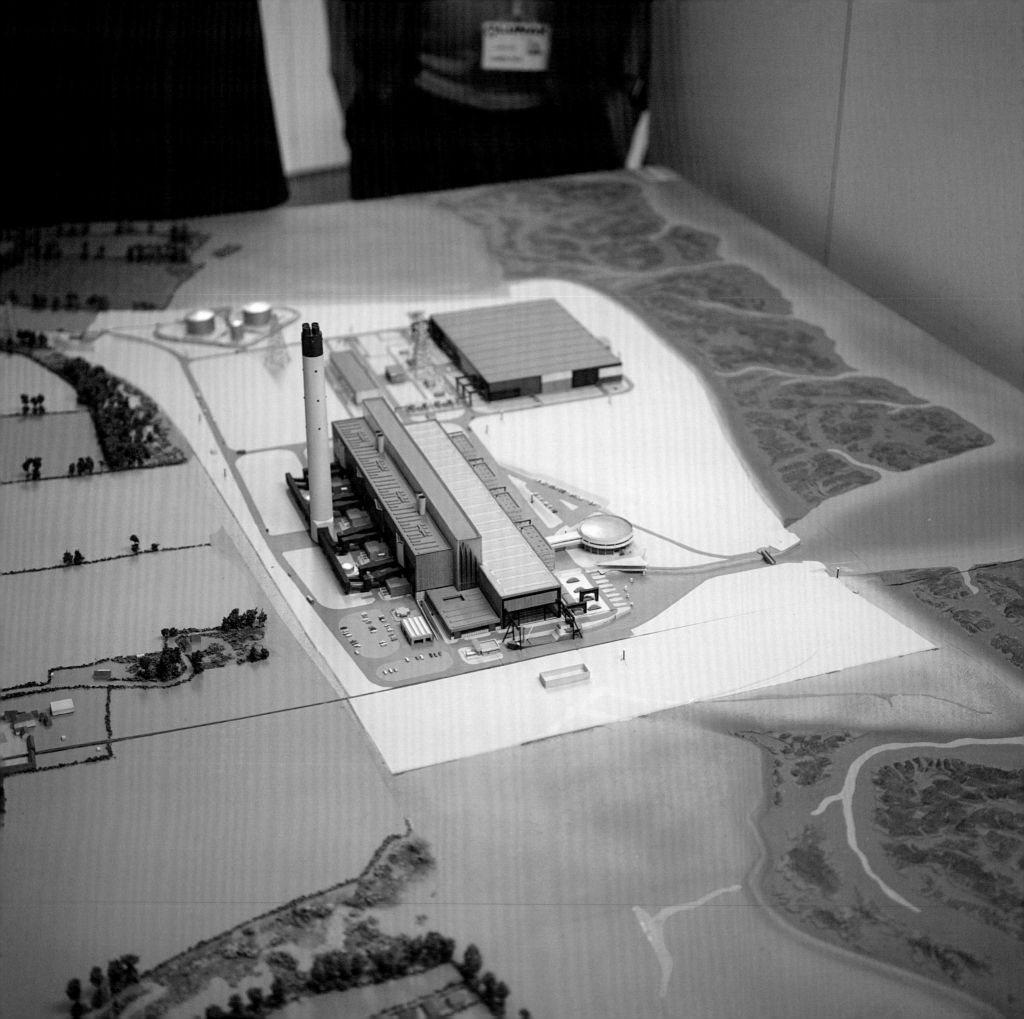

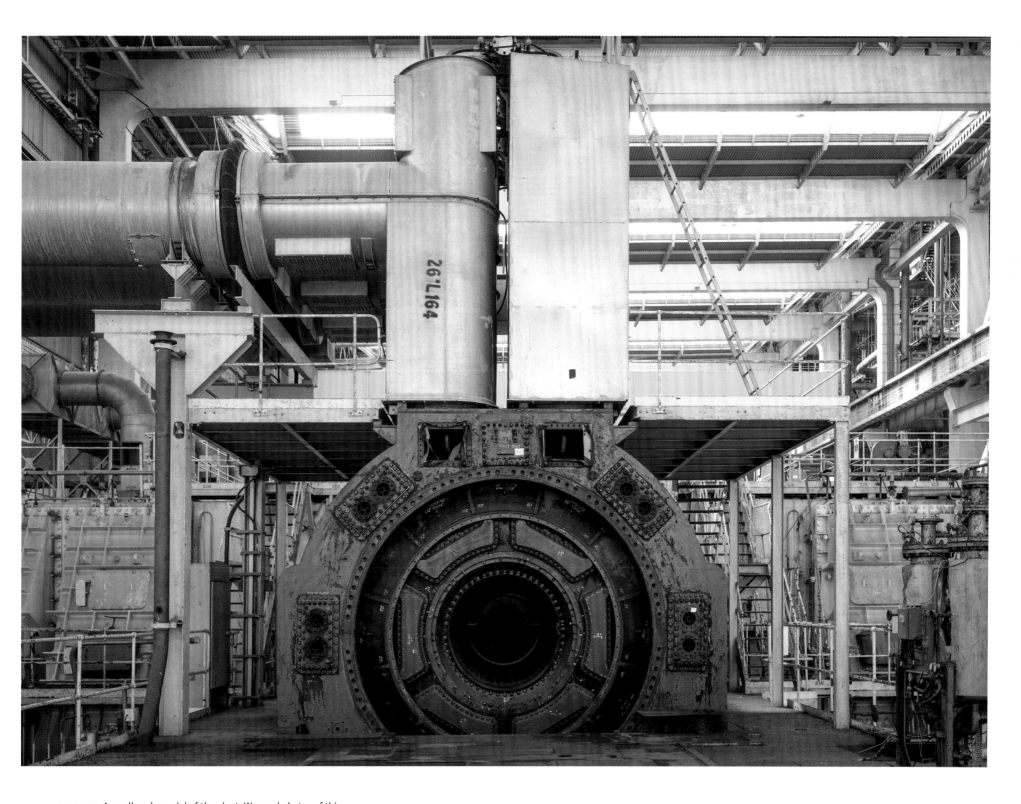

OPPOSITE A small-scale model of the plant. We used photos of this model along with detailed plans to pre-vis some of the aspects of the Speeder Chase sequence. In addition, the stunt team spent many days shooting tests and blocking action on location.

ABOVE One of four half-disassembled generators for the power plant. We were inspired by everything about the design.

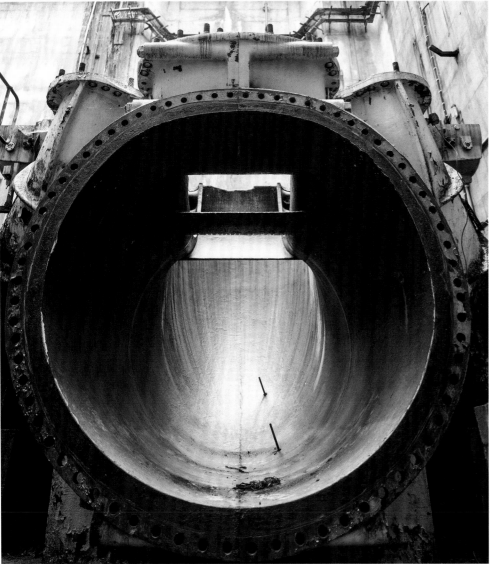

THIS PAGE These giant tubes were used to pull in water to cool the power plant when in operation. Now, with parts cut out, the shapes and colors are spectacular. This tank nearly inspired a whole new sequence where the speeders come crashing down and run through the tubes.

OPPOSITE I'm not particularly afraid of heights, but walking around on some of those upper catwalks had my palms sweating. It's difficult to see from this perspective, but the grates are all about one-inch spaces, so you see down through them. They've been walked on for many years without an incident, but that didn't seem enough to calm the lizard part of my brain that wanted to be back on the ground.

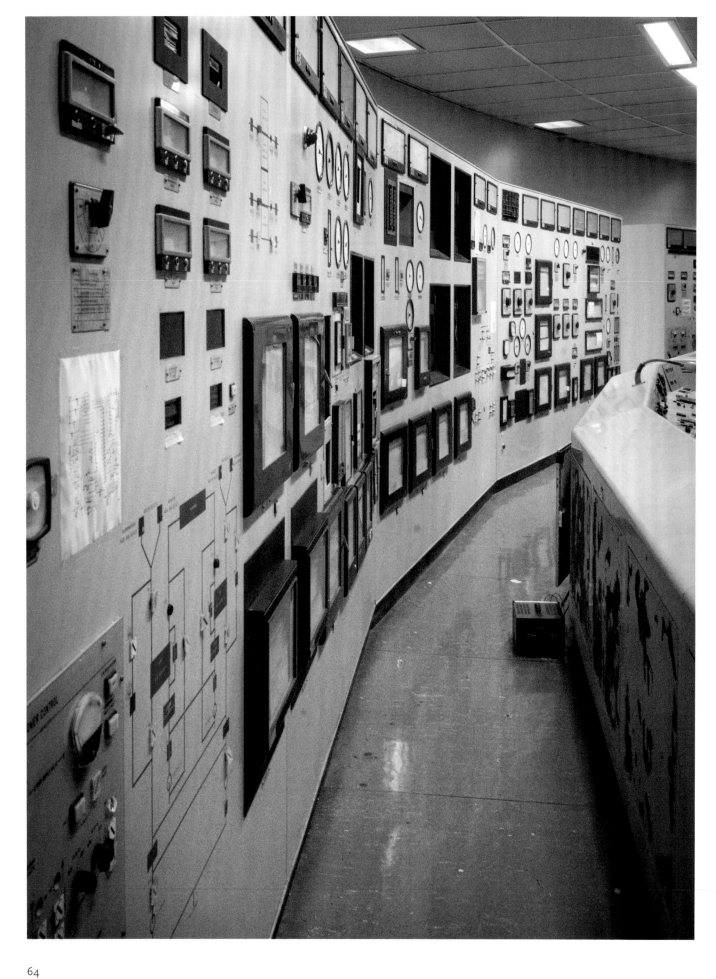

This is the actual control room for the power plant that served as one of the major inspirations for the droid control room on Kessel. I probably took hundreds of pictures in this room—of every switch and dial. There's something about the analog design of rooms from this era that is really inspiring.

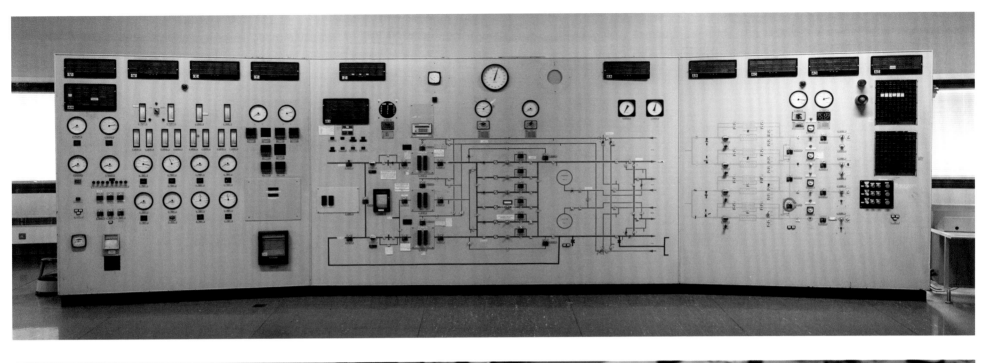

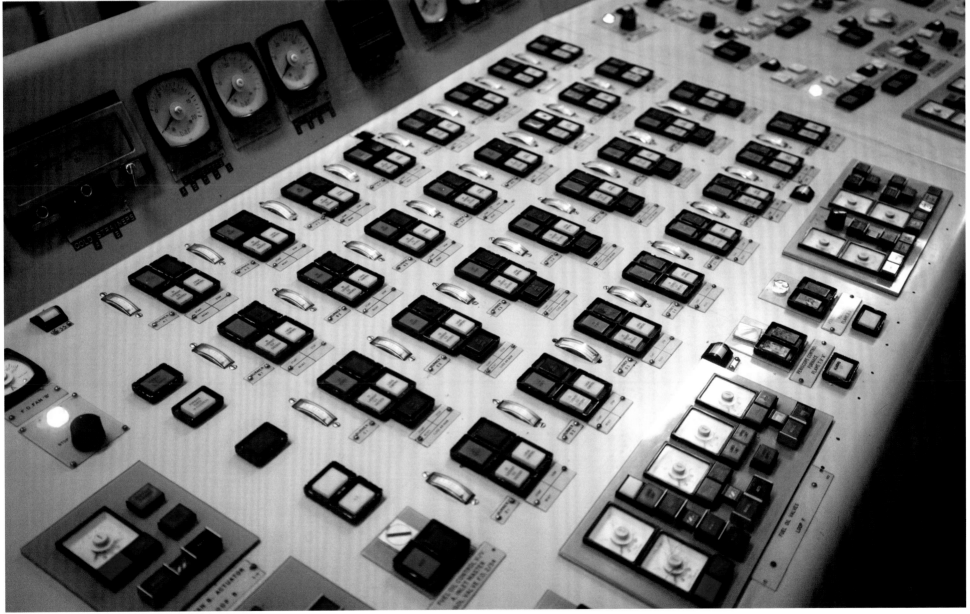

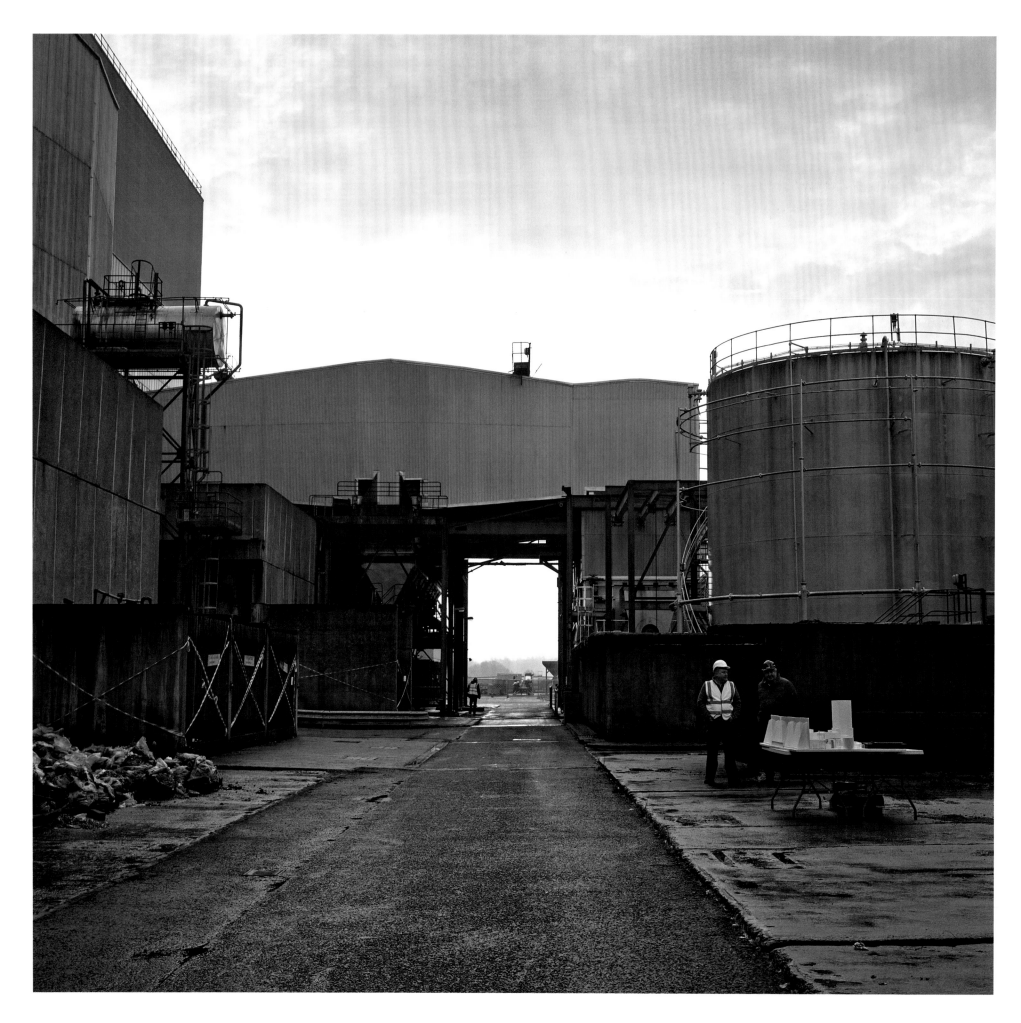

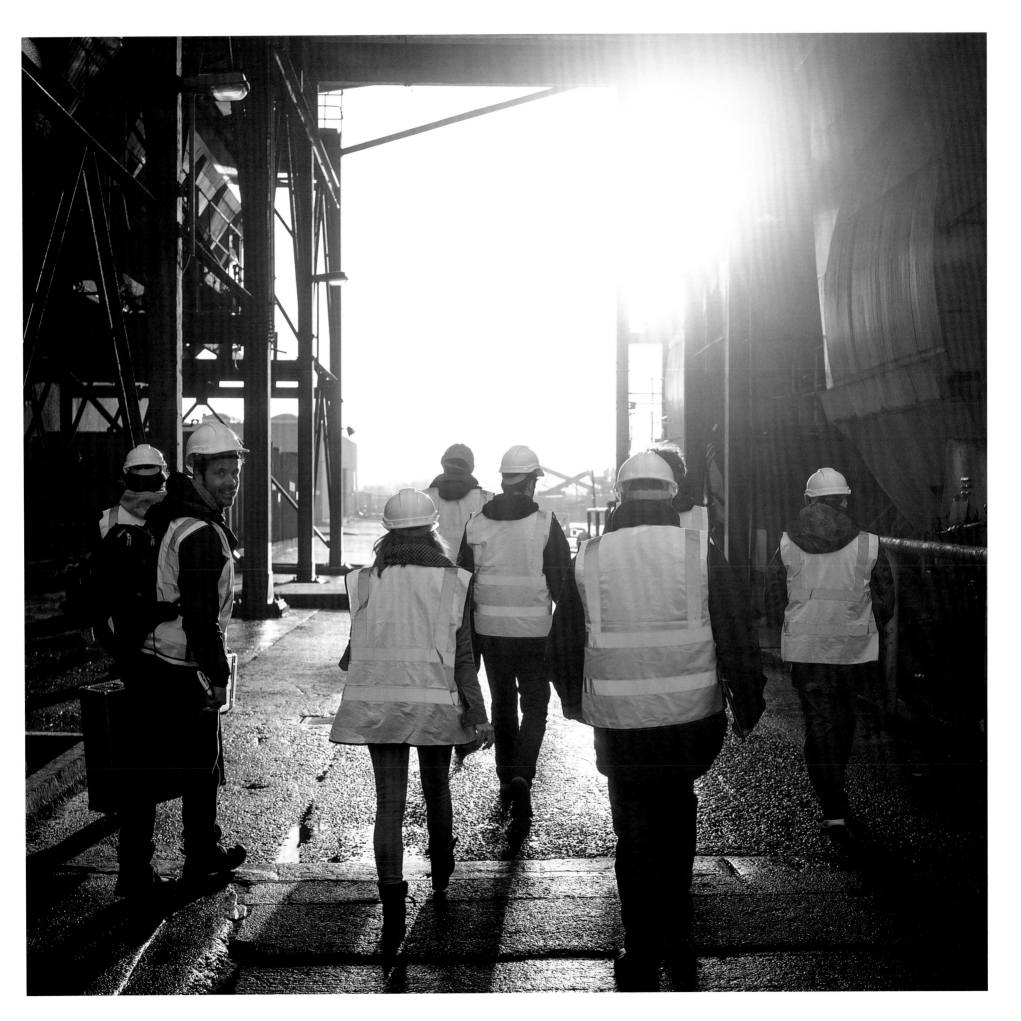

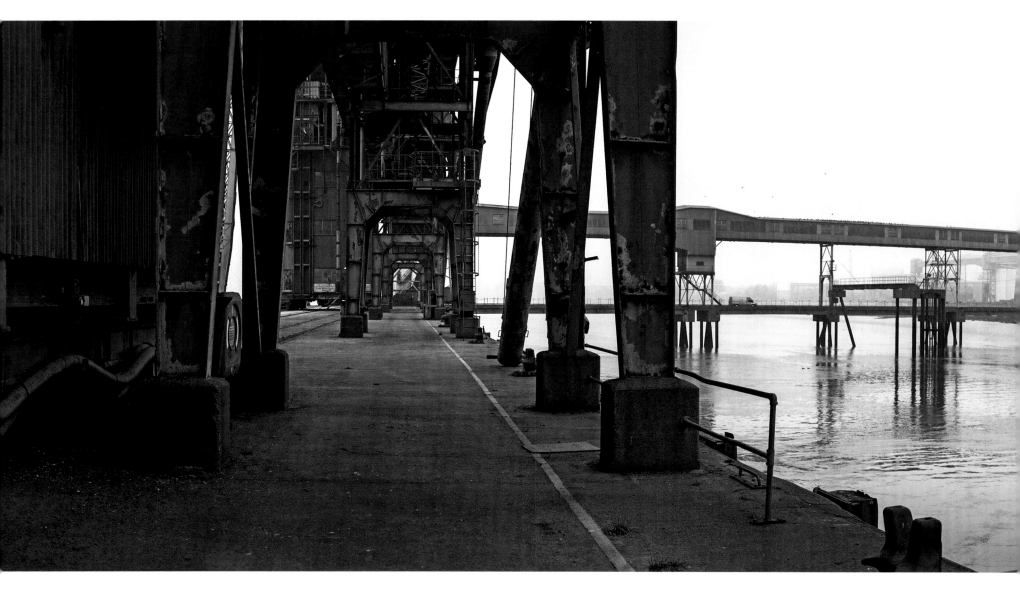

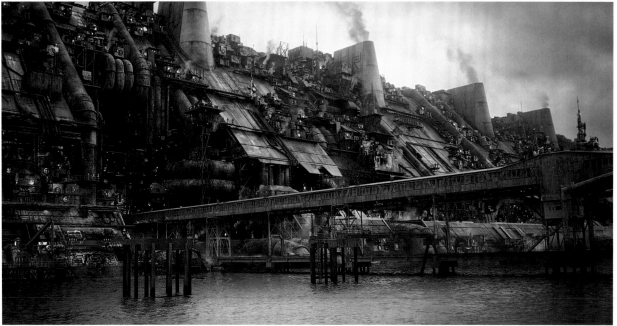

To complete Corellia, we needed to give Han and Qi'ra an escape. This location, Tilbury, ninety minutes outside Central London, is actually used as an active dock for unloading grain. We scheduled our shoot late one night between shipments to take advantage of the amazing structure and drivable docks. Because the schedule dictated that these shots needed to be complete before we had the finished speeders, all the speeders in this part of the sequence were completed digitally. It was great to have this environment as a starting point for our 3-D environment, and you'll see the look of this location carried through on the bridges throughout the sequence as Han and Qi'ra race toward the Coronet Spaceport.

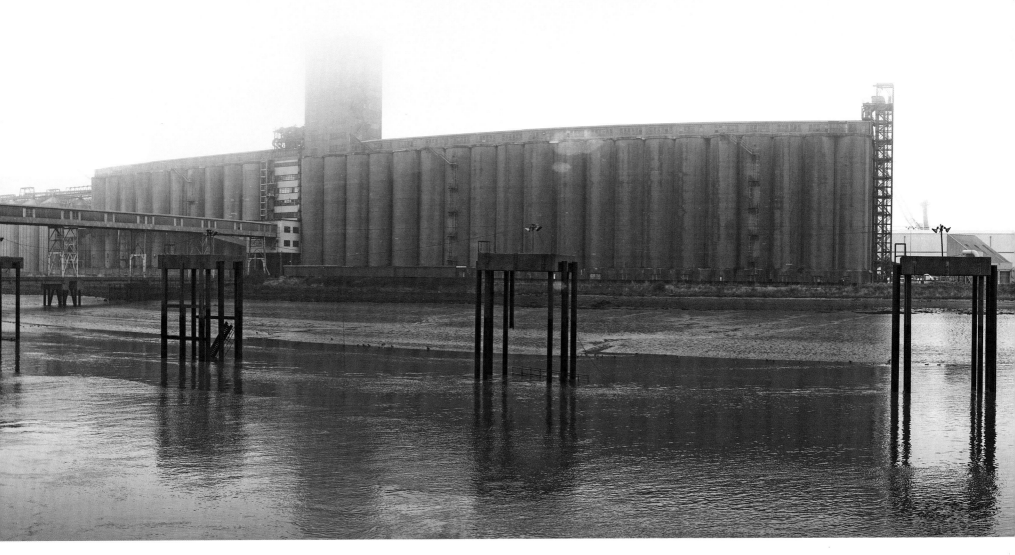

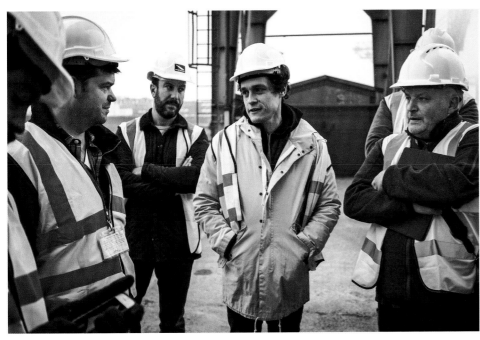

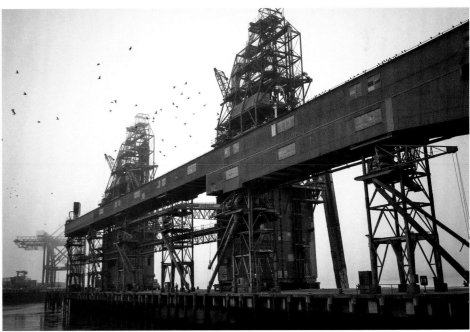

Pinewood

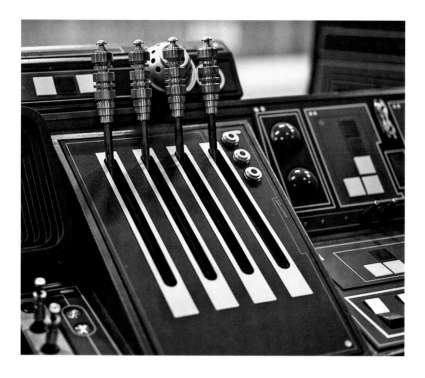

FINAL PREP AT THE STUDIOS

In addition to scouting remote locations, a lot of planning and building was happening every day back at our home base, the historic Pinewood Studios. Time was literally ticking away; less than three weeks remained on the prep calendar. The release date had been chosen, so every day counted. All the sets needed to be completed and every detail finalized before the cameras could roll.

THIS SPREAD Lando's *Falcon* is based on the original ship interior but with a massive facelift to reflect his fastidious character. The photo on the right reflects the cockpit during the early days of construction before most of Lando's upgrades had been completed. The finished hyperdrive levers are pictured above.

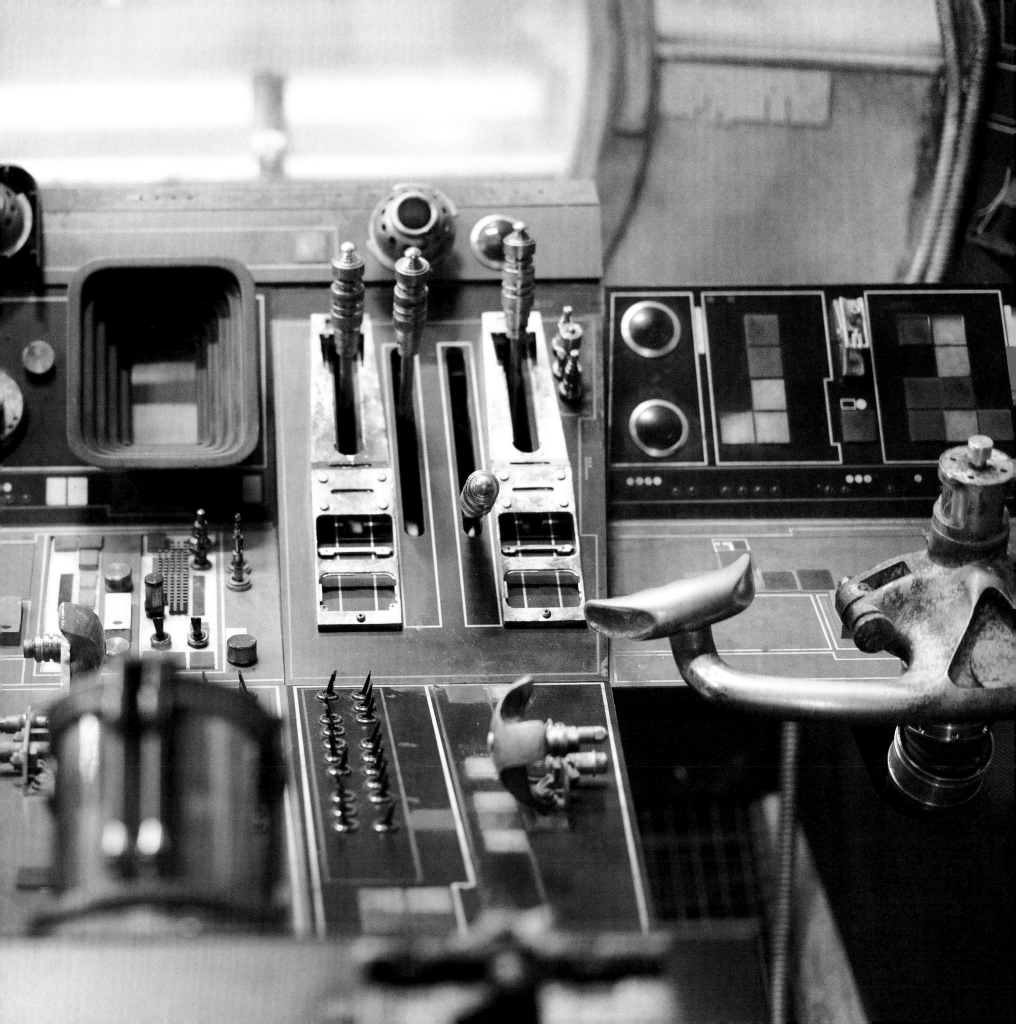

ABOVE Inspecting a Corellian "gak band" inspired by the details around the rim of the *Millennium Falcon*. If you look carefully, this detail is found throughout Corellia, both in the practical and digital sets. This was one of those designs that was basically perfect on the first viewing. Once everyone saw it, we found uses for the "gak band" everywhere.

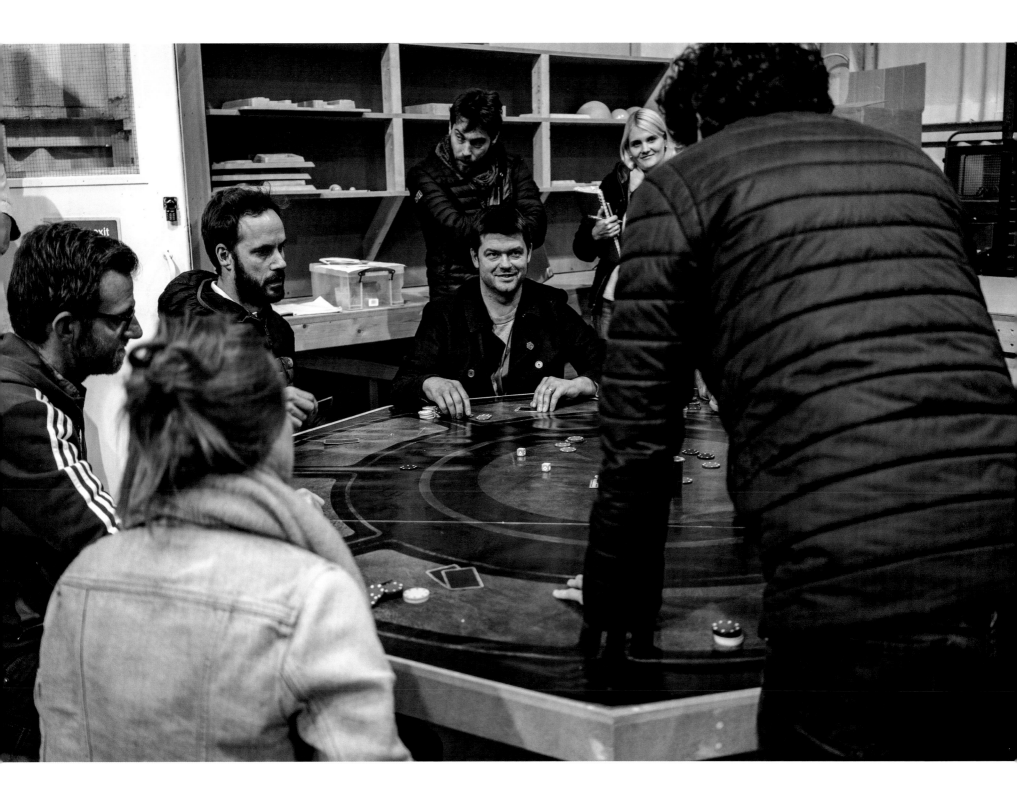

ABOVE Testing several different sizes of tables for the famous game of sabacc between Han and Lando. There was a lot of discussion about getting the right size to allow enough room for the puppeteers and the alien characters while keeping the principals as close as possible. Here, Chris Miller sits in for Han, Phil Lord for Lando.

OPPOSITE This was our first test for the in-camera technique we refined on this film. You are seeing several projectors creating an image on a screen like you would see in a movie theater—the difference here was that we were using very bright, high-contrast laser projectors and synchronizing them with the Alexa 65 camera so that when they were photographed from inside the cockpit (upper left), it looked just like the ship was flying over the mountains. We tested LED walls as well, but Bradford and I preferred the projectors for his lighting style, as they were higher quality for photographing directly.

ABOVE I caught Bradford's first step inside the cockpit of the *Millennium Falcon*. His face tells the story of how we all felt that day.

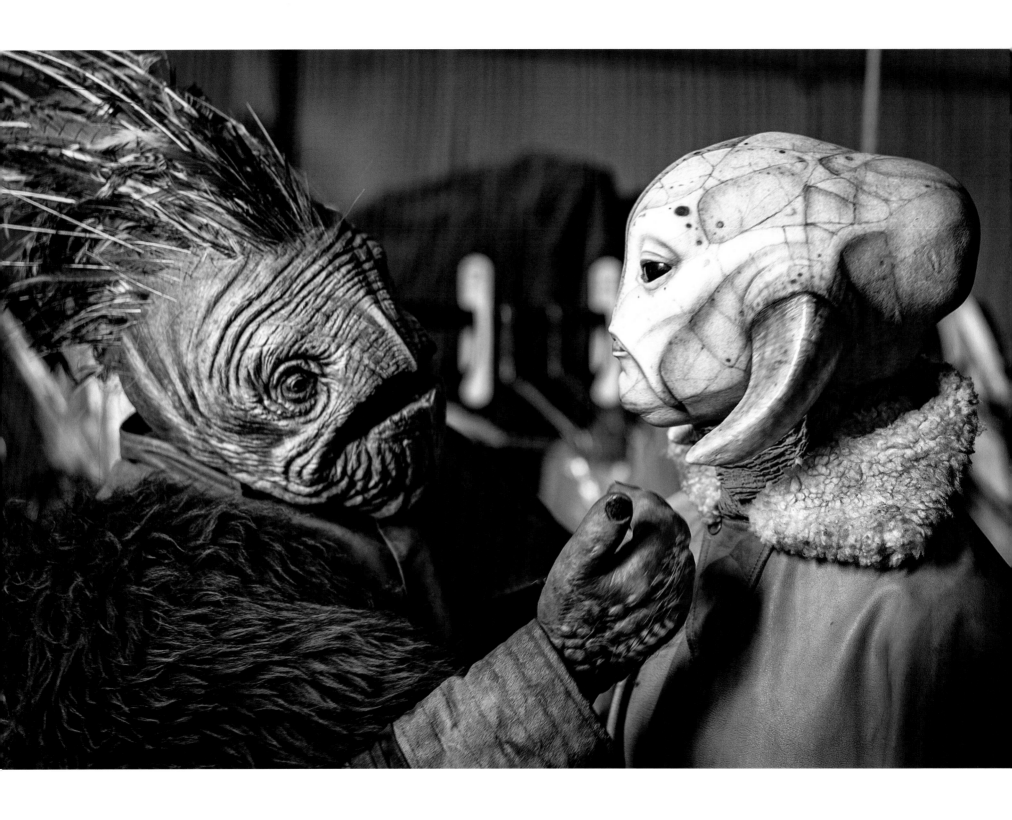

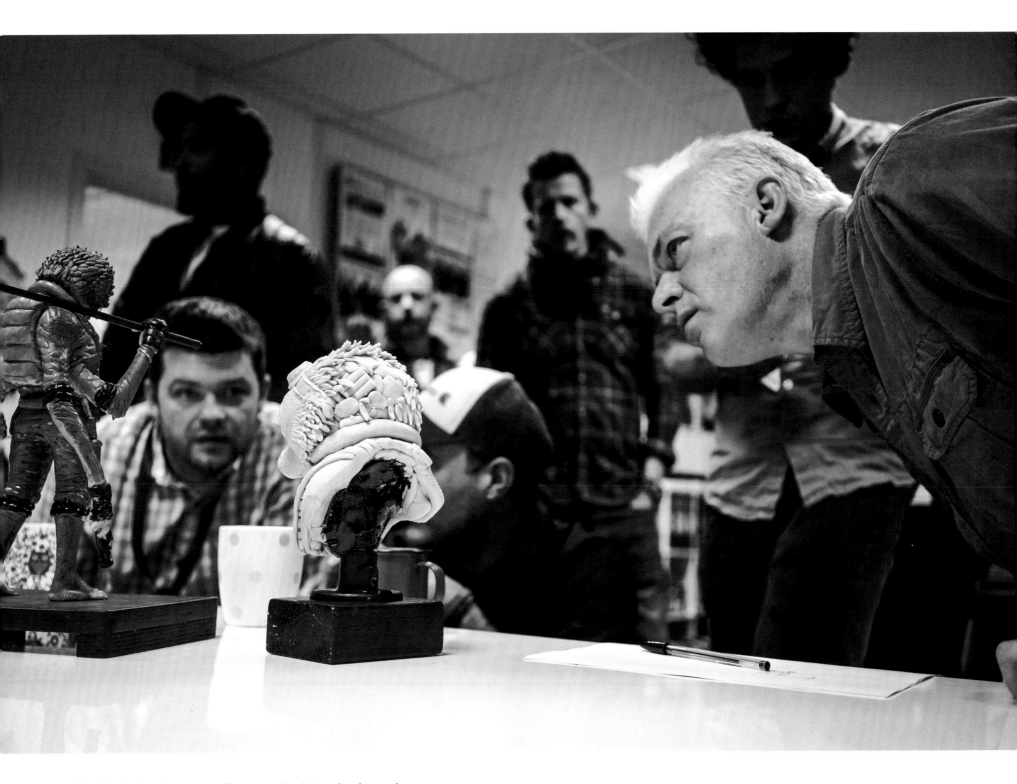

Neal Scanlan led the creature effects team that designed and created nearly all of the creatures in the film. Rio Durant was one of the most challenging characters to design because we were looking for an endearing character that would be instantly likeable but who also felt like he fit within a ragtag group of mercenaries. Pictured above are a few of the favorite maquette studies the talented creature effects (CFX) team sculpted.

The art department was busy constructing the Spaceport set on the 007 soundstage, the largest stage in Europe. Neil Lamont had designed it to leverage nearly every square foot of the stage, and it was completed up to thirty feet tall. As one of the first featured sets in the film, it's designed to make a strong first impression. Visual effects topped up the set in a number of shots, but most of what you see was achieved in camera.

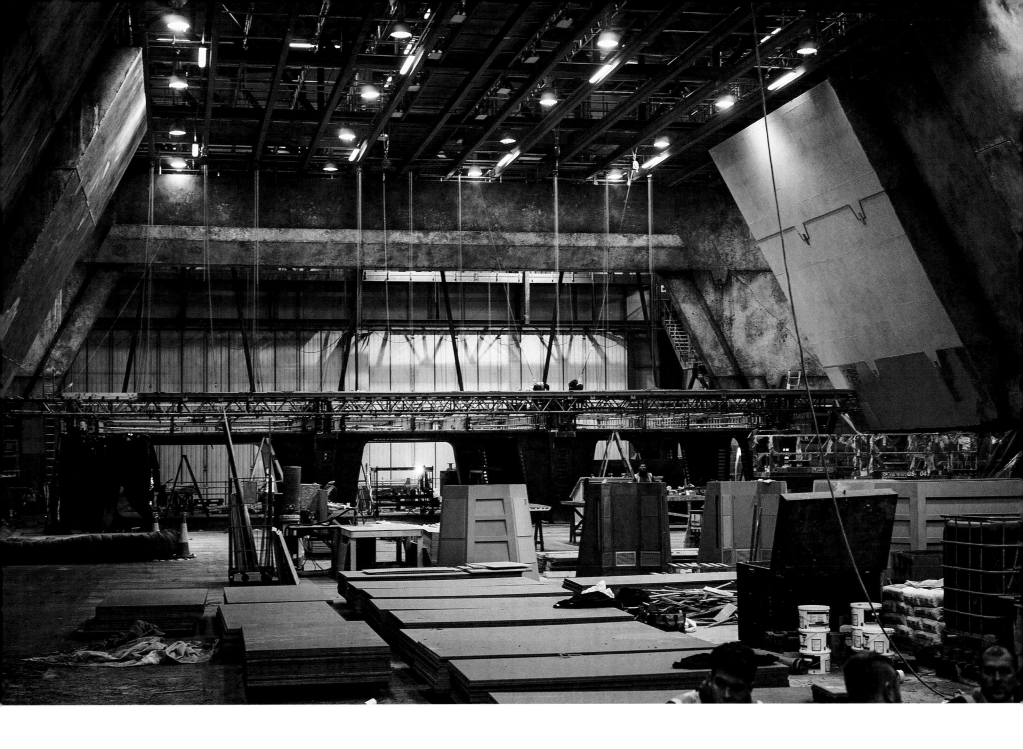

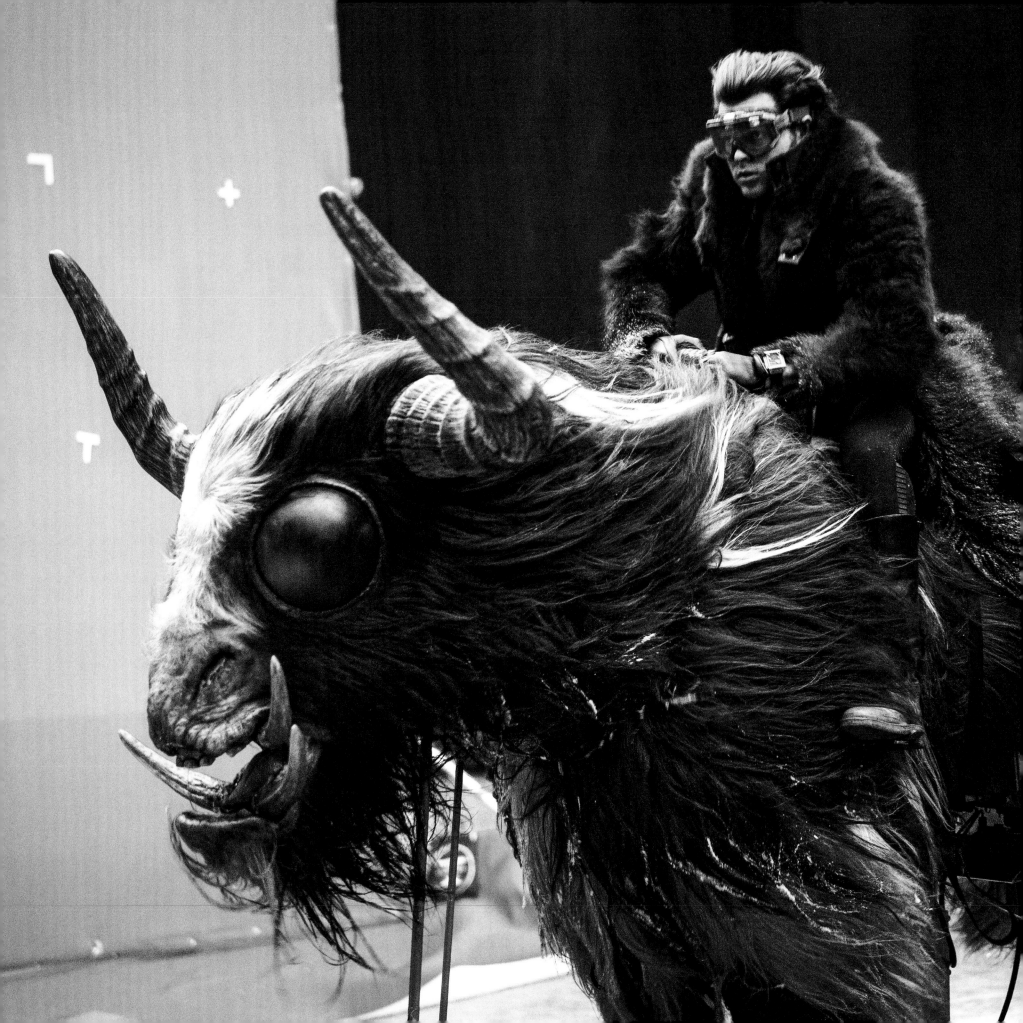

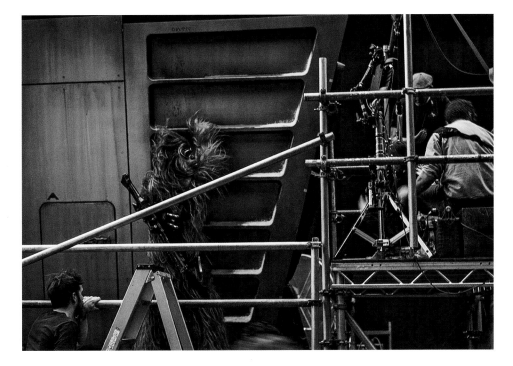
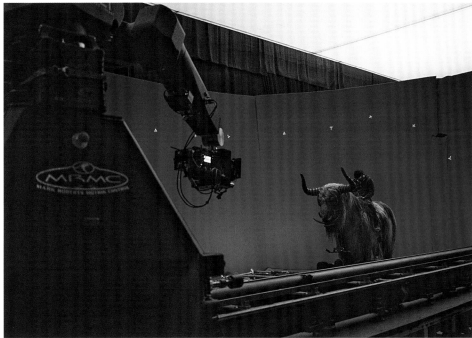
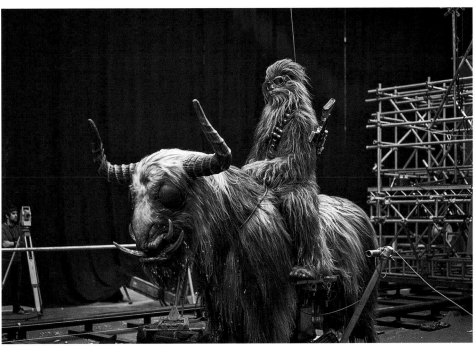
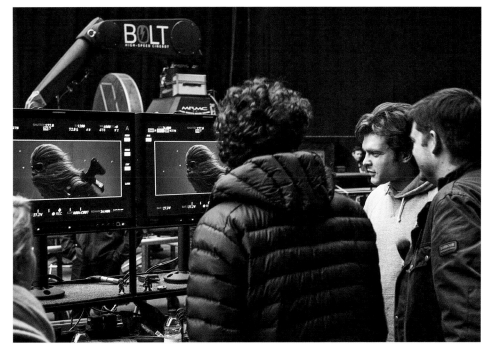

In the original script for the Train Heist sequence, our ragtag team boards the train from a herd of buffalo-like kod'yoks in the style of a classic Western. Later, the scene needed to be cut to reduce the running time of the sequence.

To shoot the elements for this sequence, the visual effects department needed to plan out the shots over the background plates I had shot in the Dolomites. Once we had our chosen angles and had measured the exact camera moves the helicopter performed, we then translated that movement onto the motors moving the kod'yoks and the high-speed motion-control camera (upper right). Because everything was carefully synchronized, we would see a real-time preview of Han, Chewie, or Beckett layered over the digital train and the background photography right on the side of set, so we could ensure we had a performance that matched the scene perfectly.

We built the setup to be flexible, so we could try various performances—that was especially important since this was Alden Ehrenreich and Woody Harrelson's (Beckett) first scene as their characters. With wind, flying snow, and a fully articulated neck and head brought to life by the talented puppeteers in the creature effects department, we were ready to shoot.

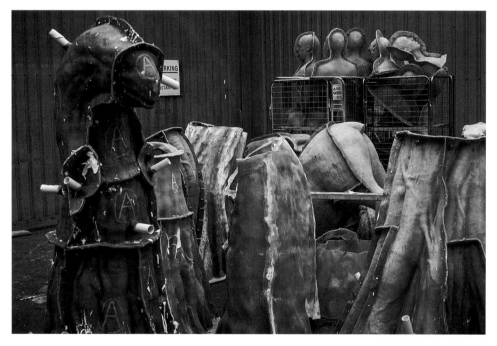

Just looking at Six Eyes without his skin (upper left) gives you an idea of the kind of complexity that goes into a character like that. The CFX team continued to push the boundaries of what is possible to achieve practically on set during this film. New, smaller motors and more sophisticated onboard electronics improved the level of performance possible to puppet in real-time.

In fact, Six Eyes was so well designed they even let me have a try being the remote puppeteer. The first actor was inside the suit and controlled the gross movements of the character. Ingeniously, there were multiple sensors inside the head that would detect the head movement and automatically adjust the gaze direction and trigger eye blinks. The remote puppeteer had a joystick to override either one, or all, of the eyes to be able to layer on a specific look on top of the preprogrammed movement. After all the work they had put in preparing the character, getting a good performance on set was easy enough that even I could do it!

OPPOSITE L3-37, played by Phoebe Waller-Bridge, was a great interdepartmental collaboration. The costume department took the lead on design (with assistance from CFX), and we all closely collaborated on what could be achieved practically and where VFX would take over.

In this early test, you can see the designers working with Phoebe to ensure the costume prototype was a fit and allowed her the appropriate range of motion. Special care was taken with hip and knee joints to allow her the flexibility she needed to be able to climb into the copilot's seat of the *Falcon*.

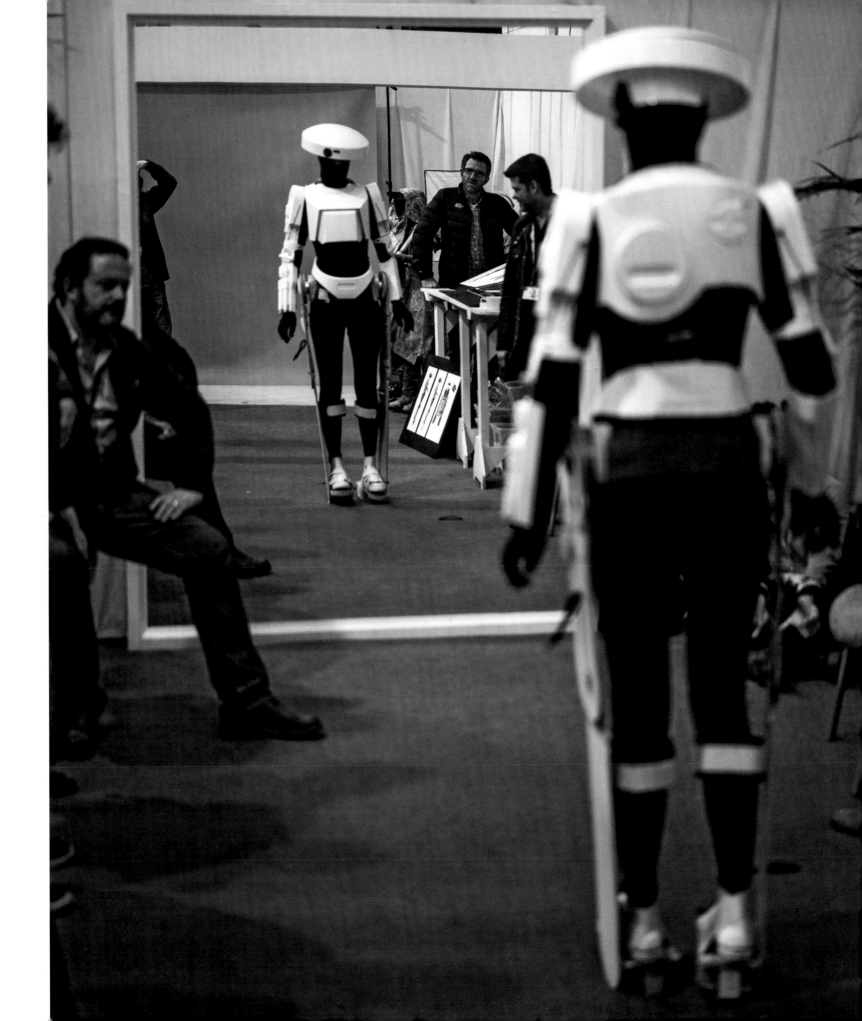

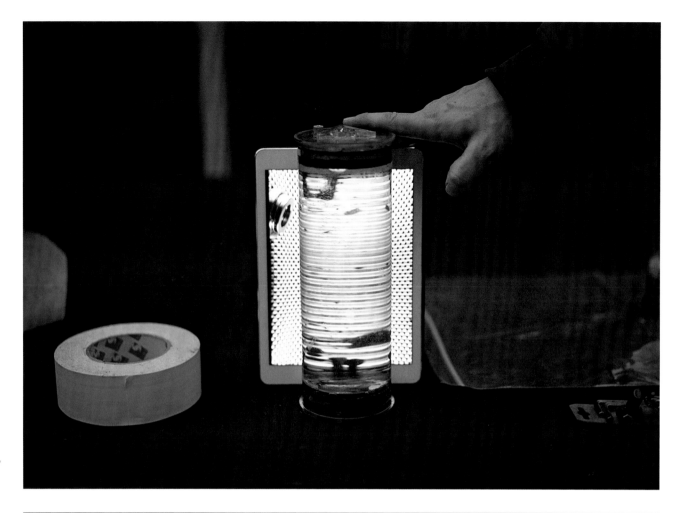

I remember a long, long time ago when we first started talking about how we could potentially make the coaxium practically. We started off talking about first trying to get a projected image onto the prop, but due to the nature of the prop design we had our limitations. After a lot of research, we found the substance we were going to use, which was all based on ferrofluid. What is so fantastic is that ferrofluid actually is used to fuel spaceships. The more we explored it we learned how versatile a substance it was and how organic and different and almost alive it appeared when you influenced it with magnets. We had the idea of trying to puppeteer it with magnets, which we explored, and it worked to a great degree, but it was going to be almost impossible to hide a puppeteer around this little prop with all the action in the scenes.

Rob's idea to loop footage of the animated ferrofluid on an iPad allowed us to shoot it independently then play it back in real time. I think that was the turning point where we realized that we could have complete control over the performance of the ferrofluid and the actor could look directly at it and everything could be controlled remotely from the iPad. If we wanted to change to a different performance or color, it was all remote-controlled by the playback team on set.

We tested three or four different curvatures and densities of plexiglass to go over the iPad to make the curvature read. We started off without any lens at all, but it was almost too perfect. By shooting through this lens, it was almost like you were looking into a fish bowl—it was the perfect solution."

— Jamie Wilkinson, prop master

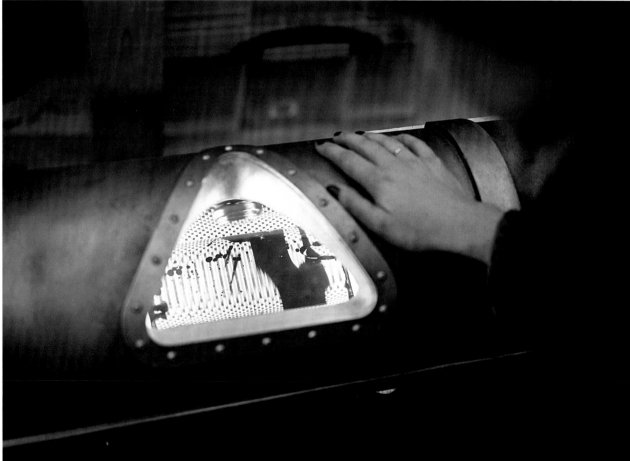

PRODUCTION

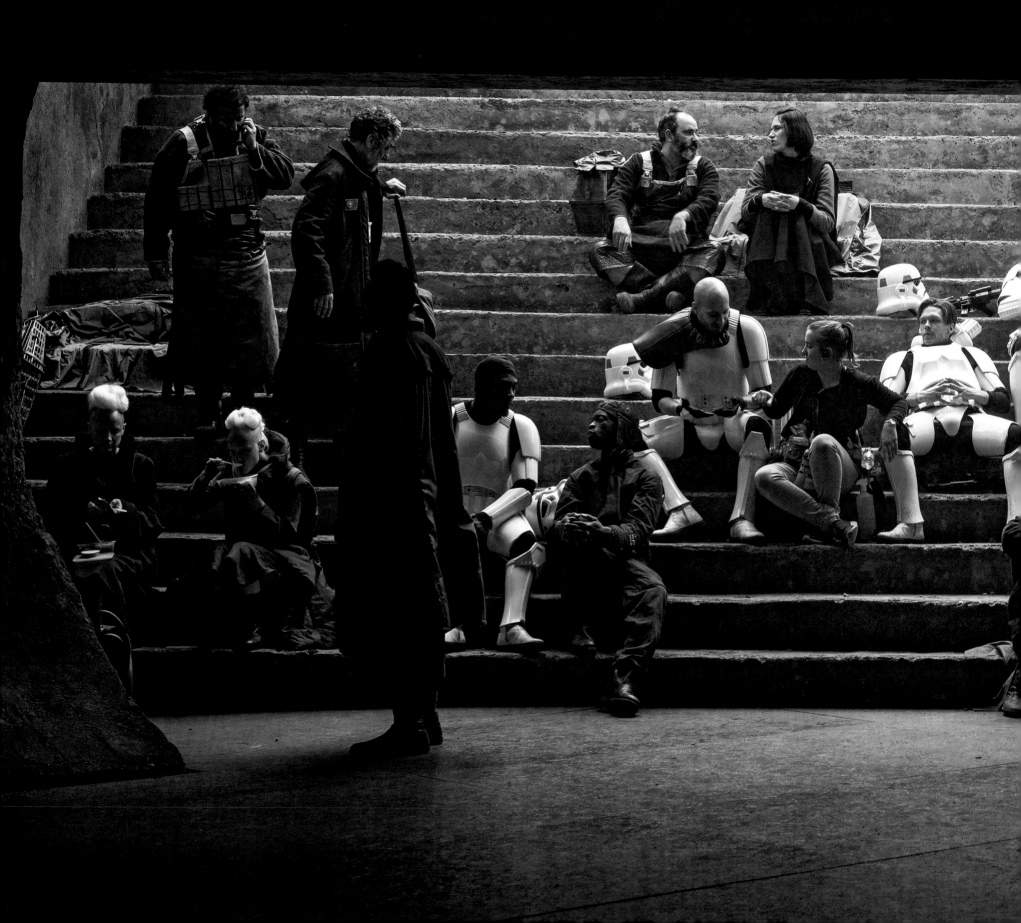

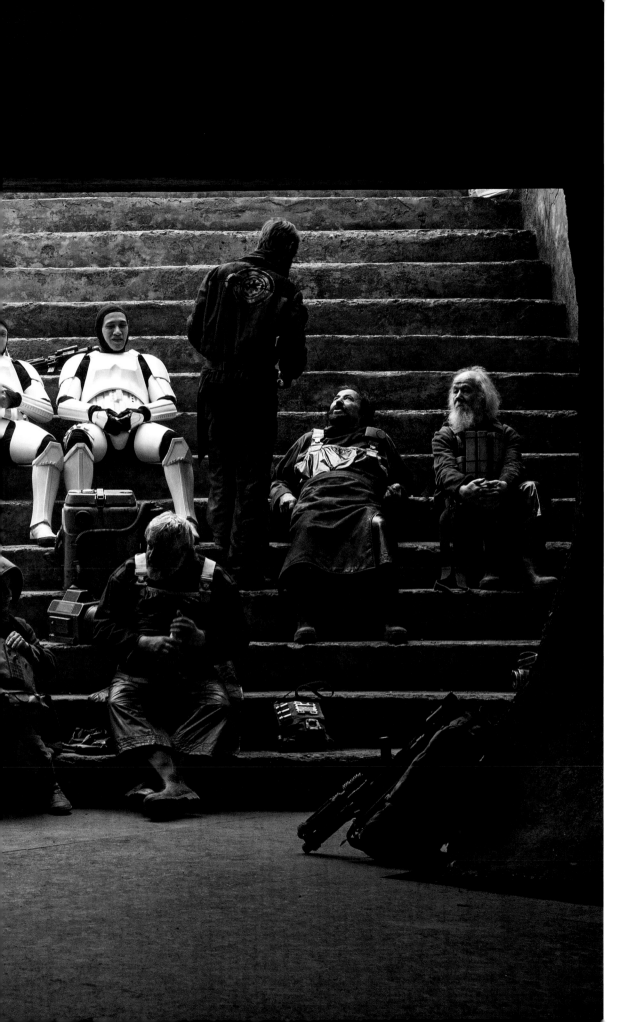

The Shoot

There's nothing like that first call sheet, the first time you hear "Action" on the set of a *Star Wars* film. Nerves, anticipation, and, of course, a lot of pressure for everything to come together perfectly. We started our shoot on the Spaceport on the 007 Stage at Pinewood Studios, with hundreds of extras, stormtroopers, creatures, huge camera cranes, and all the complexities you'd expect for a scene of that size.

I remember those opening days. I was planning a big "stitch shot" with a remote-controlled camera on wires hanging high above the set. Because we didn't have enough extras to fill the entire Spaceport, the plan was to make the move twice, once with the extras on the far side of the security fence, and another with them on the close side. I worked with the camera team to come up with a way to create a semi-repeatable move we could work with in visual effects, and even got to make a few moves myself to show Bradford. He liked one of them and we lined it up to shoot. I realized I was on a set where everyone was really looking to plus, or improve, every step of the making of the film, and the traditional boundaries between departments that you can sometimes run into were gone, replaced by a sincere spirit of collaboration that would pay off over and over again through the production of the film.

Meanwhile, pre-vis is still underway for the most complicated sequences, sets are being designed and built just in time for the production to move in. After shooting for ten hours on set, we'd have production meetings or visual effects reviews each night to ensure we'd be ready for the next few days.

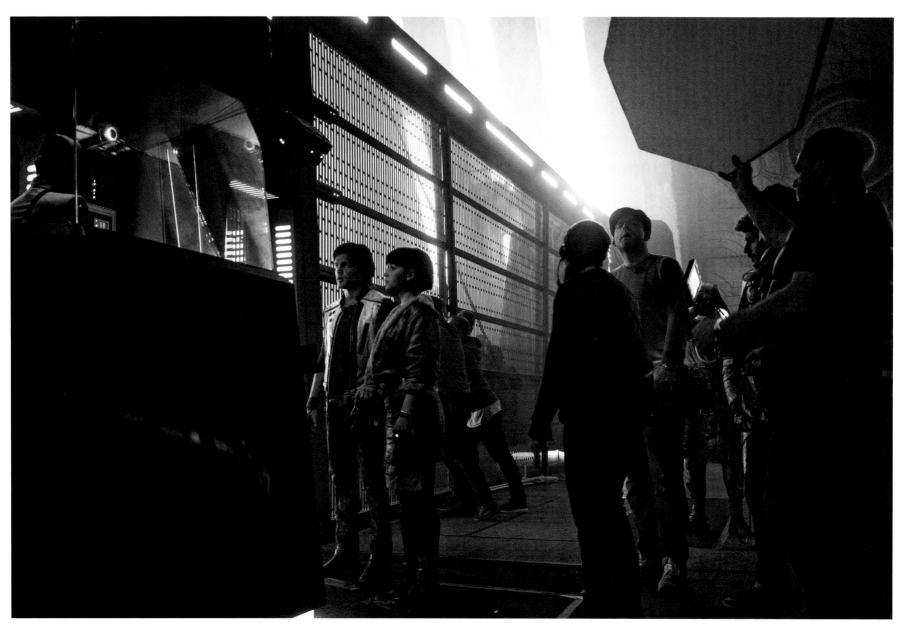

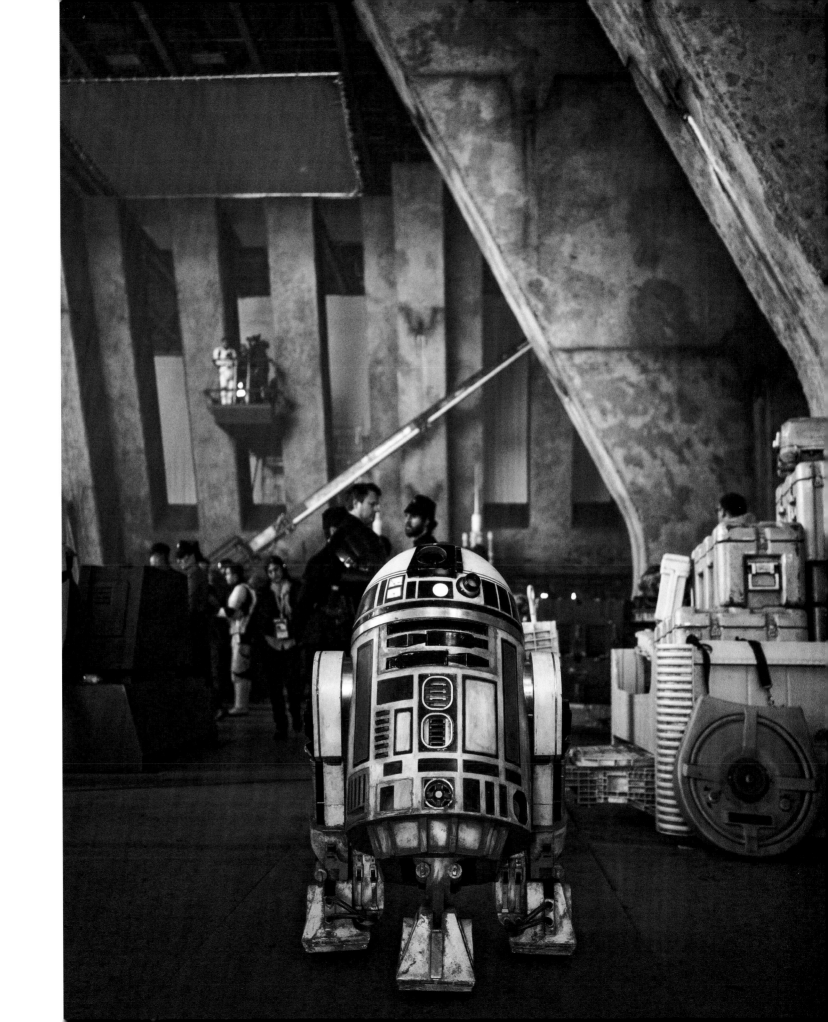

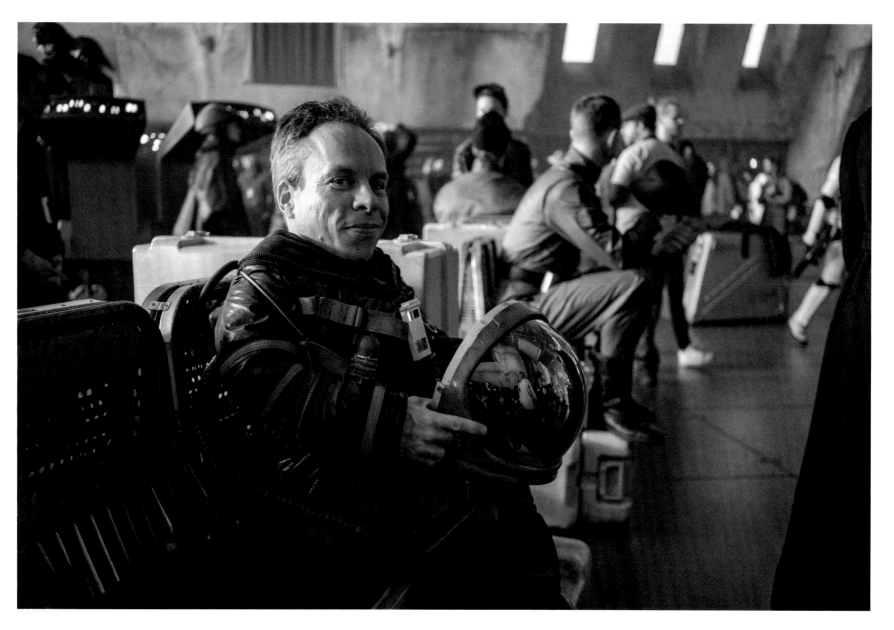

ABOVE Veteran *Star Wars* character actor Warwick Davis played a huge number of roles on the film. In this early sequence, he plays a spaceman riding on a cart and walking through several scenes. Without this photo, you might not know it was him in the costume.

LEFT My family. We moved to London for more than a year for this production and had a great experience in Europe together. When AD Toby Hefferman was looking for background players, I recruited my family to play in the scene. They got a taste of life as an extra and worked hard for these ten days, filling in lines and generally being roughed up by stormtroopers. It was a lot of fun for me to have them on set and for them to see what what I do during a full day's shoot. They have stories to tell from those days and are visible in one shot in the film if you know where to look!

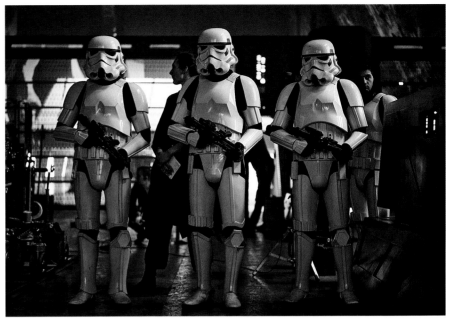
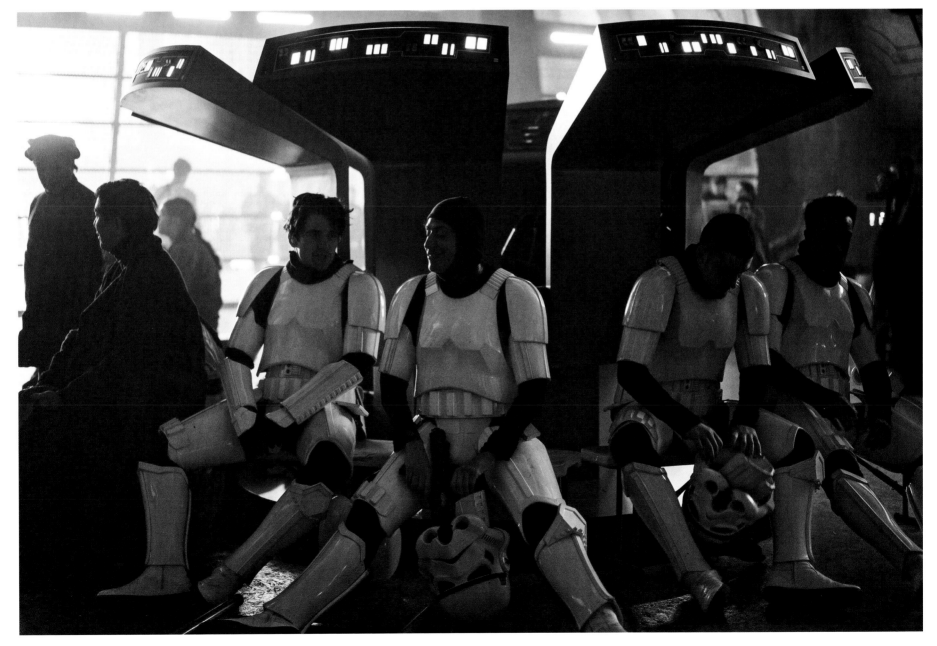

SYLVAINE DUFAUX
First Camera Operator

Sylvaine was integral to the look of the picture and developed a reputation both as a talented camera operator and a brilliant DP when Bradford was occupied with other sets. I interviewed her as we were finishing up the film.

ROB Behind the camera, you interact with just about every other department. How do you approach all those relationships?

SYLVAINE I think it is part of being on a film set. You get in a relationship with everyone and then it's that collaboration you have with the boom, make-up, every other department. Sometimes I will see the makeup artists wondering if they are allowed to look through the lens and it gives me pleasure to say, "go for it." We are all working for the same thing so there are no borders. For me it is really important to get everyone involved. Everyone is more conscious and more careful. It's the fun of it.

ROB On this film the visual effects were really welcomed. You, Bradford, and Perry Evans (gaffer) were happy for VFX to contribute with rear-projection, LED panels and really collaborate in using them heavily to light scenes. It felt like there were no lines.

SYLVAINE Especially on a film where you know there will be a lot of VFX. Let's work together because it would be nonsense not to. It is also interesting in the *Star Wars* universe because there is a lot of in-camera work that we do but there is still some layer of visual effects to apply after. And I think that one thing I really appreciated was the relationship that you, Rob, had with Bradford. We bring the feeling of Bradford's photography, and my camera, and the lighting, and we can implant the VFX on top of it. It will be quite seamless in the end.

ROB What was it like for you being able to use some of those rear projection technologies in the cockpit? Did it really change your job instead of shooting on a blue screen?

SYLVAINE It has changed our job completely. It changes our relationship with the actors, and the body language of the actors has changed the camera movement and the way we all feel. I love it. I think this new technology is opening a door and it's very interesting what's possible now. You see what the audience will see. It's so different than being in front of a green screen.

ROB Ron Howard is very specific about what he is looking for from the camera. I've been so amazed with how consistent you and Bradford's style has been while also getting all the shots he needs for the storytelling.

SYLVAINE Ron has all the knowledge and experience of all those films behind him, and he's a true filmmaker. He is curious about the challenge of something new. He has, in a way, welcomed a new language. He would come up with what he wanted, and then we'd work to decide how we can give him what he wants with the language that we had established. It was a double challenge on the camera and that, for me, was even more exciting.

OPPOSITE Sylvaine operating in the Corellian Spaceport surrounded by droids and space travelers.

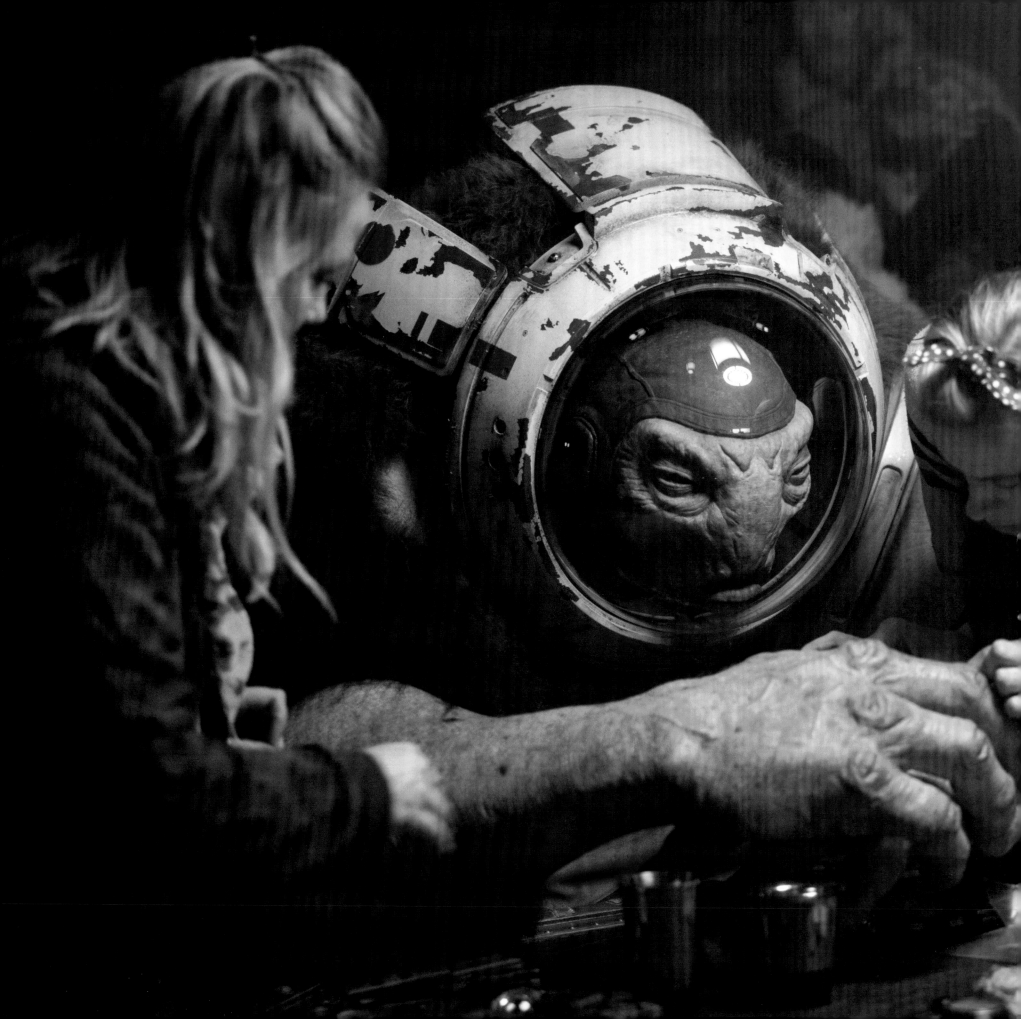

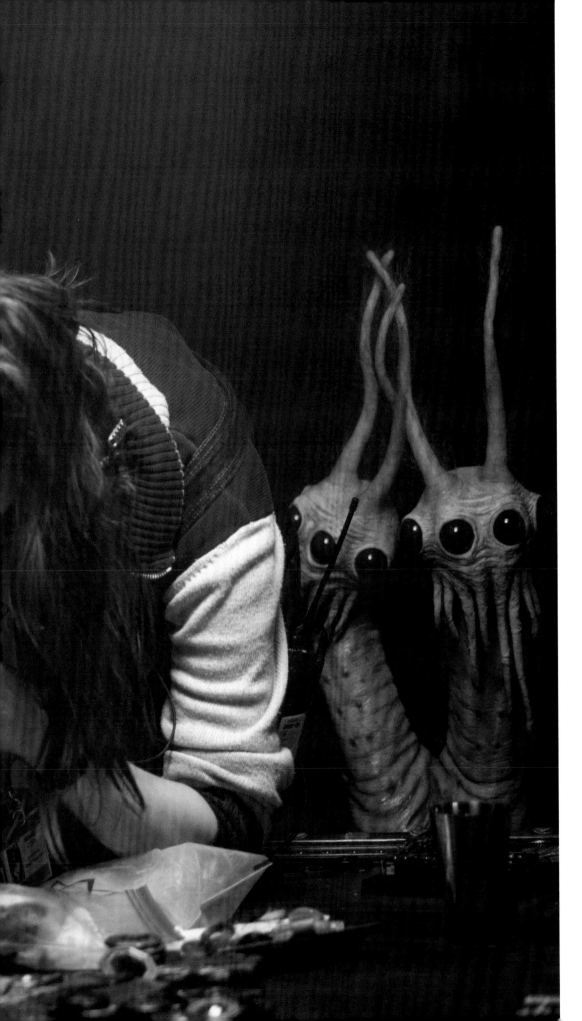

Sabacc

THE BIG GAME

The Lodge was a tour de force for nearly every department on the show. Art department and set dec created a 360-degree environment that was completely believable from the moment you stepped inside. Creature effects packed the room with aliens and hid puppeteers in every possible nook and cranny—you really had to watch where you stepped because there was probably a puppeteer squeezed in there.

The sequence also introduces two important characters who would quickly become favorites: Lando Calrissian and L3-37, played by Donald Glover and Phoebe Waller-Bridge, respectively. In addition to painting out rods behind some of the creatures, the main visual effects effort was focused on ensuring we could execute L3 perfectly. The job was complicated by the scenes packed with extras, who all had to be painted in behind Phoebe's every move for every frame.

The cast had rehearsed the game and actually knew how to play sabacc, so it was particularly funny if someone got a wrong card—they'd add up the score and flag any errors for us while shooting the scene!

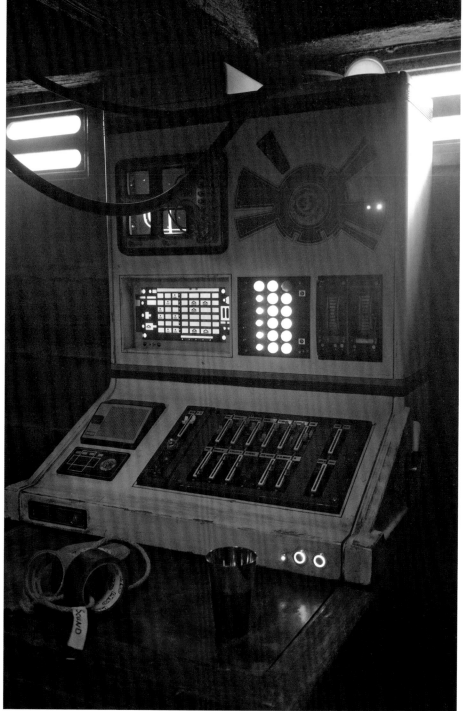

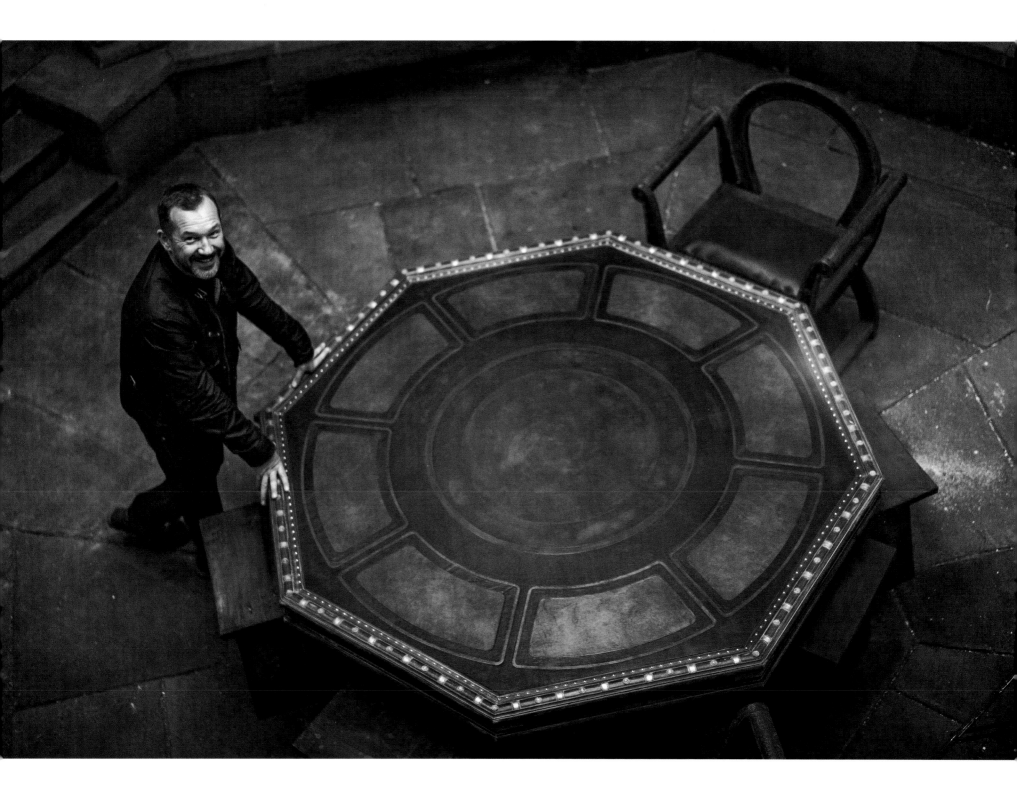

I caught Lee Sandales inspecting his table before the rest of the set dressing had been brought into the Lodge. The set was so immersive it really felt like you were in a lodge up in the mountains. Once Lee's team brought in the rest of the set dec, it was packed with details. I particularly enjoyed the hanging kod'yok head and the bar area with all of the *Star Wars* drink-making gear and a variety of serving equipment. All of the details really add up to complete the illusion.

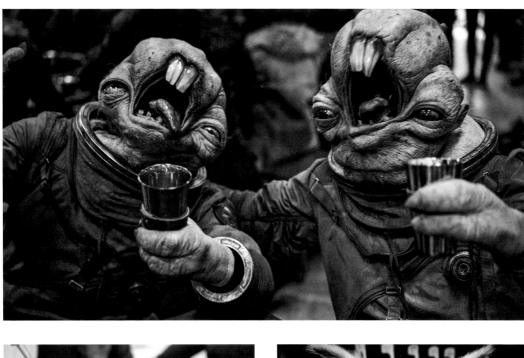

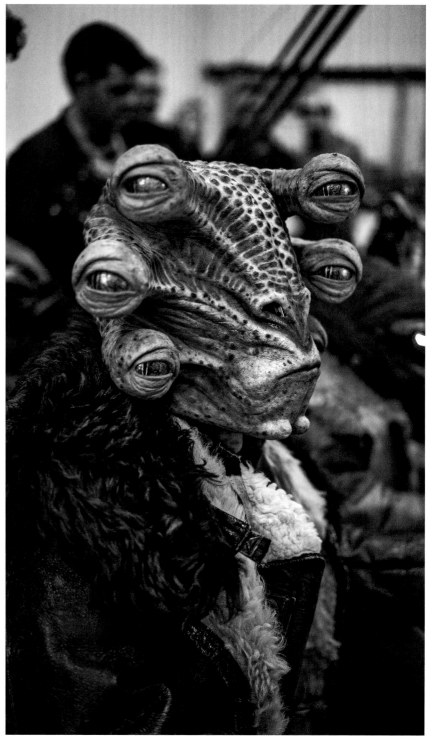

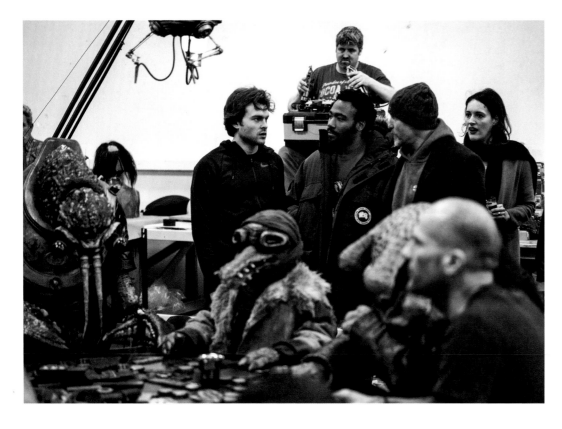

The cast was all together for the first time and took a visit to the creature shop just as they were rehearsing the sabacc scene. I'm not sure if they were told in advance what they were walking into, but the scene was pretty lively with puppeteers under every limb and a pole-arm swinging around the room to fly a drink droid from character to character. From their faces, I could tell they were as excited as I was to be walking into a *Star Wars* movie with aliens as costars.

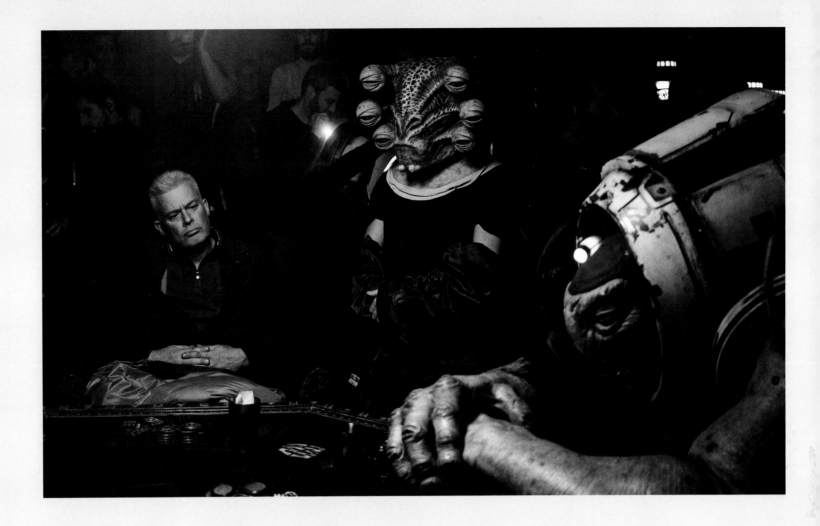

NEAL SCANLAN
Creature Effects Supervisor

ROB One of the characters I really liked in the card game was Six Eyes. His puppetry is super sophisticated but surprisingly easy to control. Do you want to describe some of the cool things that went into that character?

NEAL Sometimes the design can really help you. Six Eyes is a great character in that it has these eyes on rods, and from a performance perspective you can think of each eye individually or as a group. So, if you have six eyes you can use one eye to look one way and another eye to look another way. Or, you can use two eyes to look over your shoulder. Some really fun possibilities for performance.

One of the things we've always felt was that practical animatronic heads need some kind of onboard intelligence or some natural life that wasn't just an arbitrary program. We wanted it connected to the performer inside. With Six Eyes we used accelerometers and gyros to sense where the performer's head was looking. The all-around eye and eye-rod movement reacted as the performer's head started to move left, so the eyes would all go left and look with him. As he moved right, there

would be a built-in hesitation then a look to the right. So even when the second puppeteer who actually controlled the eyes wasn't putting in any performance, you could actually watch this character and believe he was in a conscious frame of mind. Then, we can layer on top of that the second puppeteer, who has the ability to perform the mouth for dialogue and blink or move the eyes independently, and you get a very fascinating performance to your character.

ROB In terms of the mix of practical and digital—how do you find the right mix of what to achieve in-camera and what we would add in post?

NEAL It's the *Star Wars* methodology that you at least try to do everything practically. I think that's because there's a sense that there is something about the world of *Star Wars* that feels very real to us at all times. It is a world that is tangible to us and fantastical to us that it's outside of our own perception of our own world. It starts from that—not so much that it's a particular technique being better than the other, it's just the demands of this particular story and this wonderful franchise.

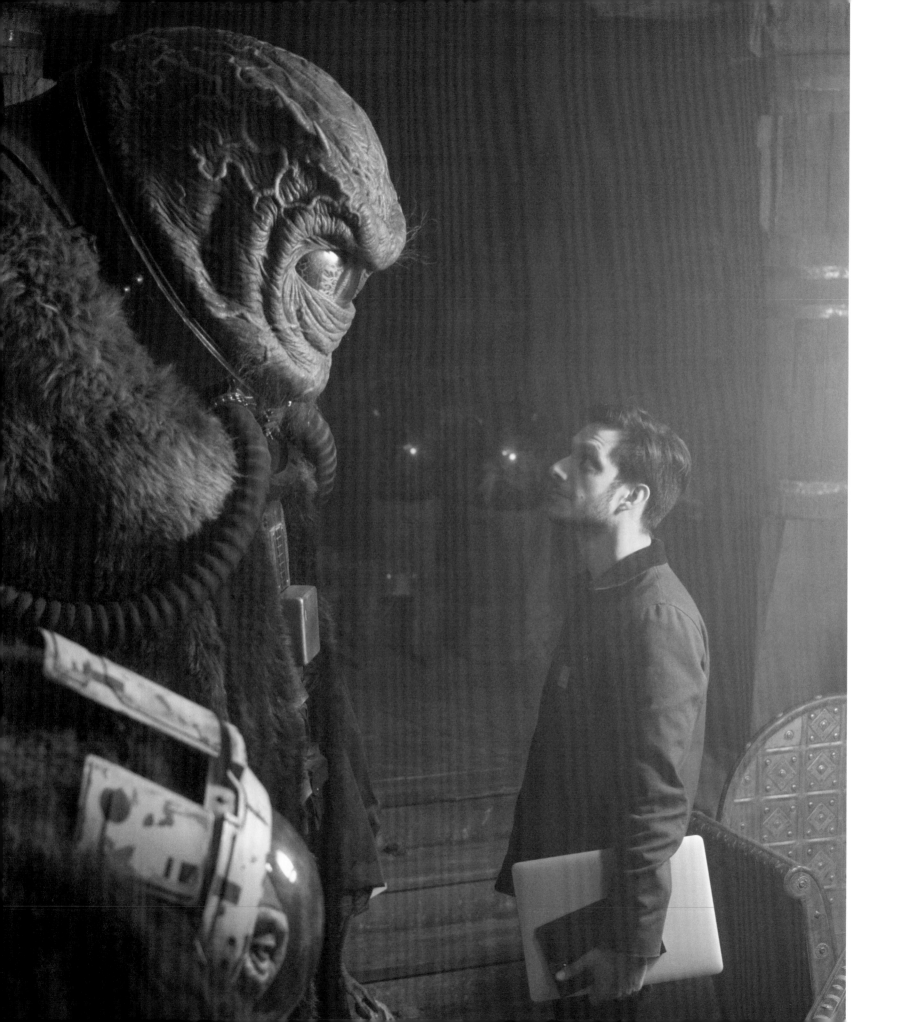

T.J. FALLS
Visual Effects Producer

VFX producer T.J. Falls managed the on-set VFX team on Solo *from the first days of prep, through principal photography, all the way to the last day of the last pickup in London. I sat down with him to talk about managing the team.*

ROB What is the key to making a successful on-set VFX department?

T.J. To be as effective as possible, the visual effects department has to seamlessly integrate with all other departments working on the film. We're one of the first departments to start on the show and one of the last to finish. The choices made early on often ripple through the production until the very end. Our VFX team spends as much time working with other departments on how to make things practical as we do planning for our digital effects during the post-production process. We work closely with the Art Department, CFX, SFX, Hair, Make-up, Props, and others to figure out precisely what will be built or practically shot on camera versus what we will augment, replace, or extend with visual effects. Determining the precise handoffs where creatures or sets transition from a tangible physical object on set to a CG object can make a huge impact on the believability of the shot, let alone the time and cost it takes to get it done.

For instance, preparing for the sabacc game, VFX and CFX worked hand in hand to ensure the design of the creatures would need only minimal digital touch-ups for rod removal, puppeteer paint-outs, and other small enhancements.

ROB What is one moment on this film where you had to pinch yourself because it felt like you had the best job in the world?

T.J. I found myself standing in front of the *Millennium Falcon*, Kathleen Kennedy on one side of me, Ron Howard on the other, and we're watching Chewbacca fly through hyperspace and we just look at each other and start laughing. The whole thing was just surreal, and it was one of those moments where we all realized we were doing something special.

OPPOSITE VFX coordinator Ben Aghdami is momentarily mesmerized by Big Eye on the set of the sabacc game.

TOP RIGHT T.J. Falls on set in the Kessel Mines.

RIGHT VFX production assistant Maddison Gannon loads some new pre-vis for Rob and Ron to review on set.

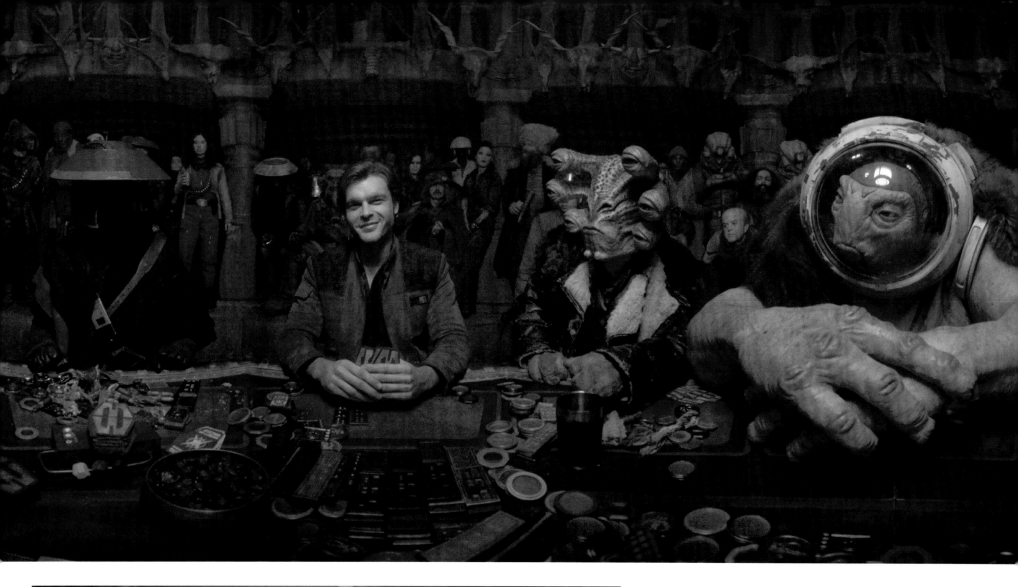

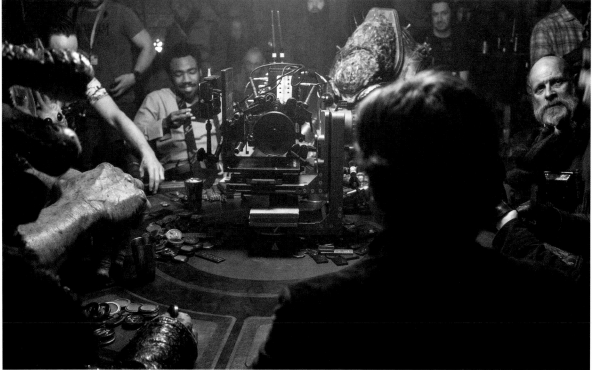

In addition to shooting the film version of the sabacc game, Jackson George, who works in Disney's marketing department as senior VP of Creative Film Services, had an idea to create an immersive experience in the amazing 360-degree set. After a few quick calls to discuss the creative concept, Jackson and I set out to make it a reality.

Due to the low lighting levels, existing 360-degree cameras weren't viable for the scene. To be true to Bradford's cinematography, we used an Alexa camera and shot the 360-degree scene in six different passes, one tile at a time. I worked with the grips to create a quick nodal camera rig, and Alden Ehrenreich (Han Solo) and Donald Glover (Lando Calrissian) were gracious enough to come in on a Saturday after a busy week of shooting to pick up one extra version of the scene.

In the end, we stitched the separate passes into one seamless 360 that puts the entire production value of the Lodge on display for users in virtual reality or watching on any 360-degree player.

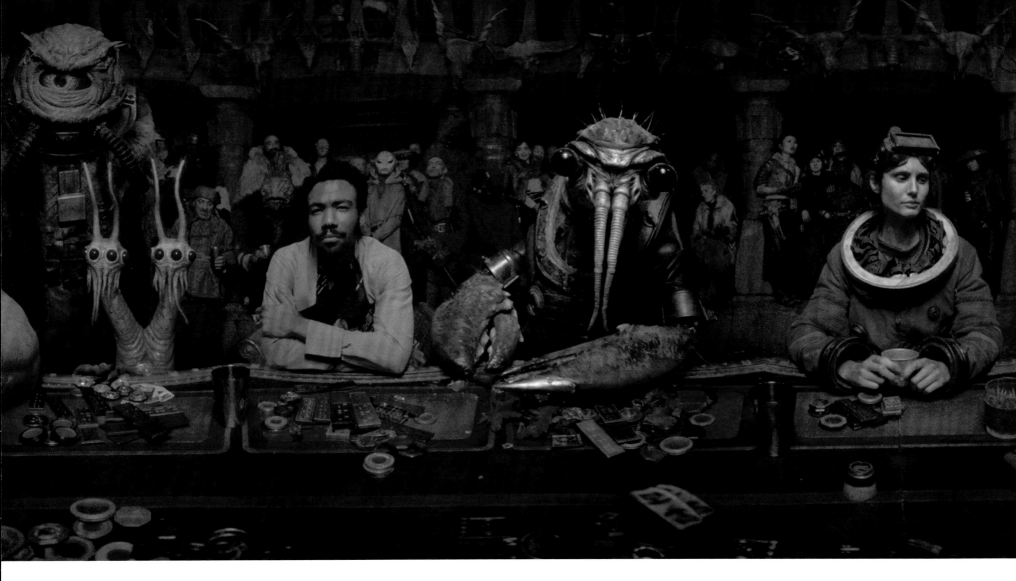

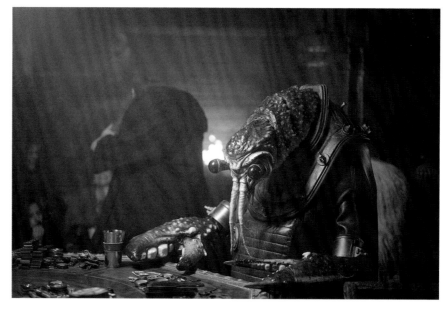
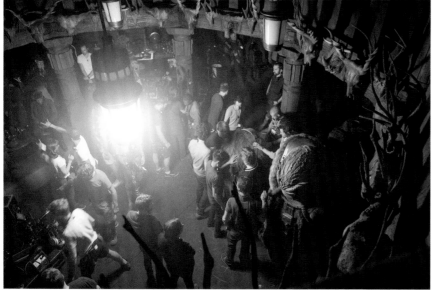

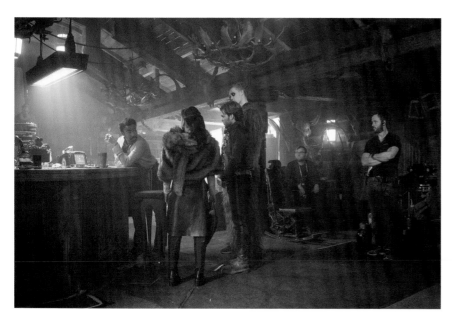

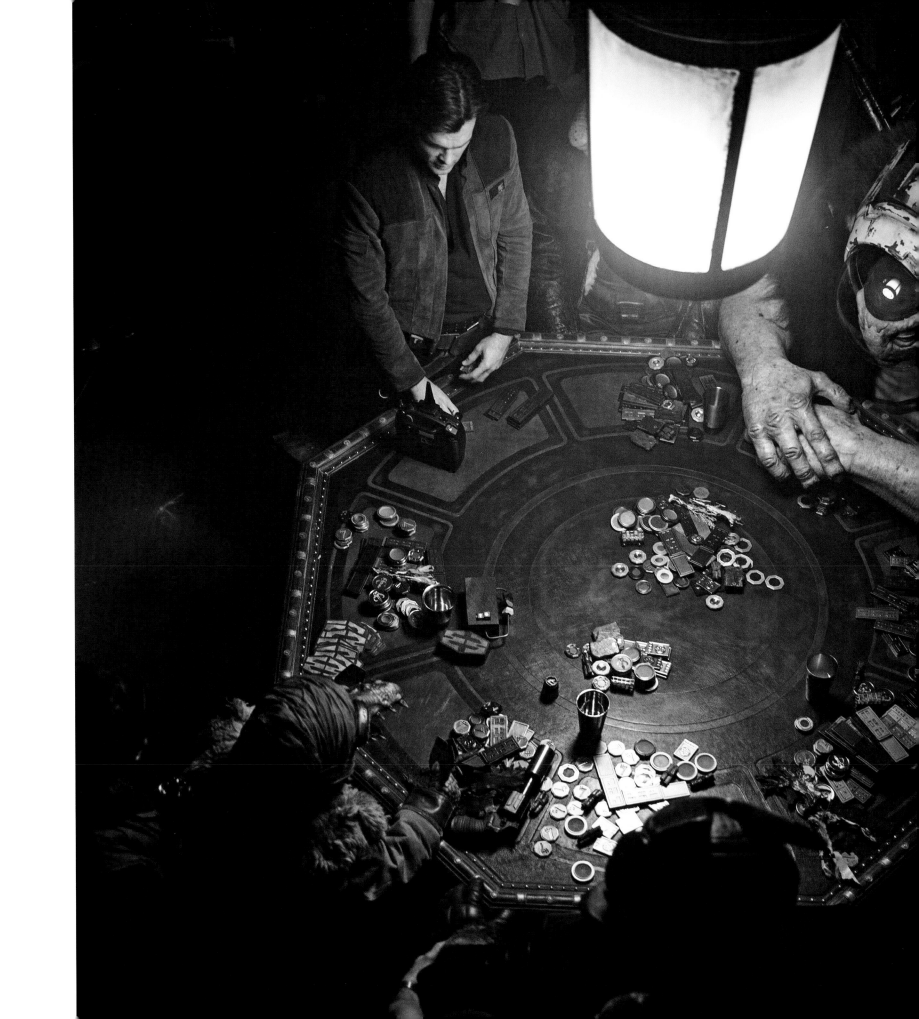

The Train Heist

30 TONS, 60 MPH

Shooting this action sequence called for a great deal of care. Working at height on a rig that could tilt more than ninety degrees at a moment's notice and weighed thirty tons required respect. It could take several hours to make a shot given all the logistics and safety issues to care for, so we had to be strategic to make each day work.

We also wanted the action to look as though it was shot on top of a moving train. We started the research for this sequence by looking at classic Westerns where the trains were real. We collected more than sixty minutes of footage from movies ranging from Buster Keaton's *The General* to *Indiana Jones and the Last Crusade*. Matching the look of those real trains imposed some limitations on where we could put the camera. We had to avoid the trap of the sequence feeling like it was shot on a stage.

For certain shots, we could add support structures like the one pictured to the right. It allowed a working area for the camera department to get certain angles on the cast and we excused the slight cheat, thinking if we were shooting this on a real moving train we likely would have built a similar platform.

I watched the pre-vis and thought to myself, "this has never been done before and this is what Star Wars films are all about."

The rig itself weighed more than thirty tons and had the ability to go from low mode to high mode in less than ten minutes. It could also tilt ninety degrees on one axis in under three seconds with an additional fifteen degrees of movement from side to side. The pre-shoot at Dunsfold runway with stuntmen and Chewbacca on top of two-by-twenty-foot containers helped us pick the perfect wind speed for the best look: forty miles per hour.

And, of course, it had all four of our main actors riding the rig with a forty-mile-per-hour wind effect!"

— Dominic Tuohy, special effects supervisor

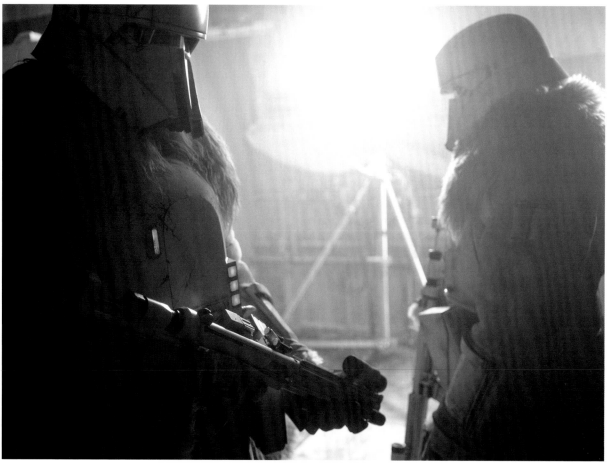

RIGHT Final looks at the costume designs for both the range troopers and (opposite) Enfys Nest.

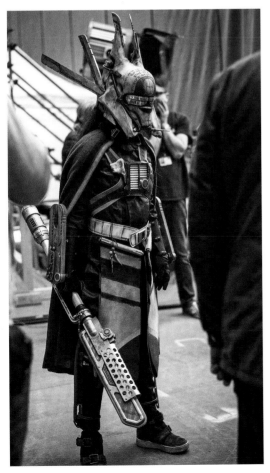
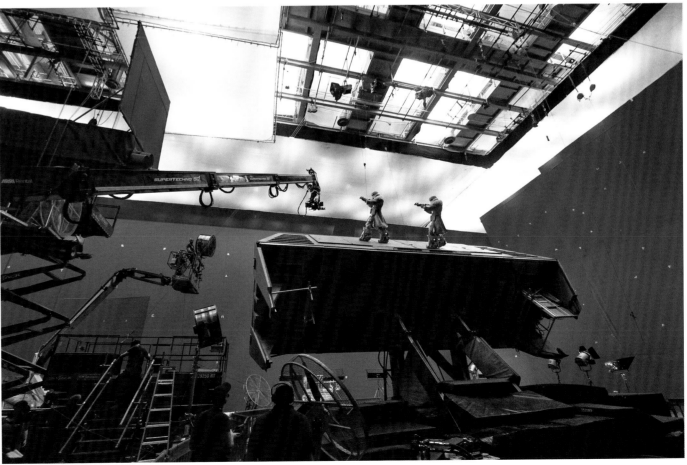

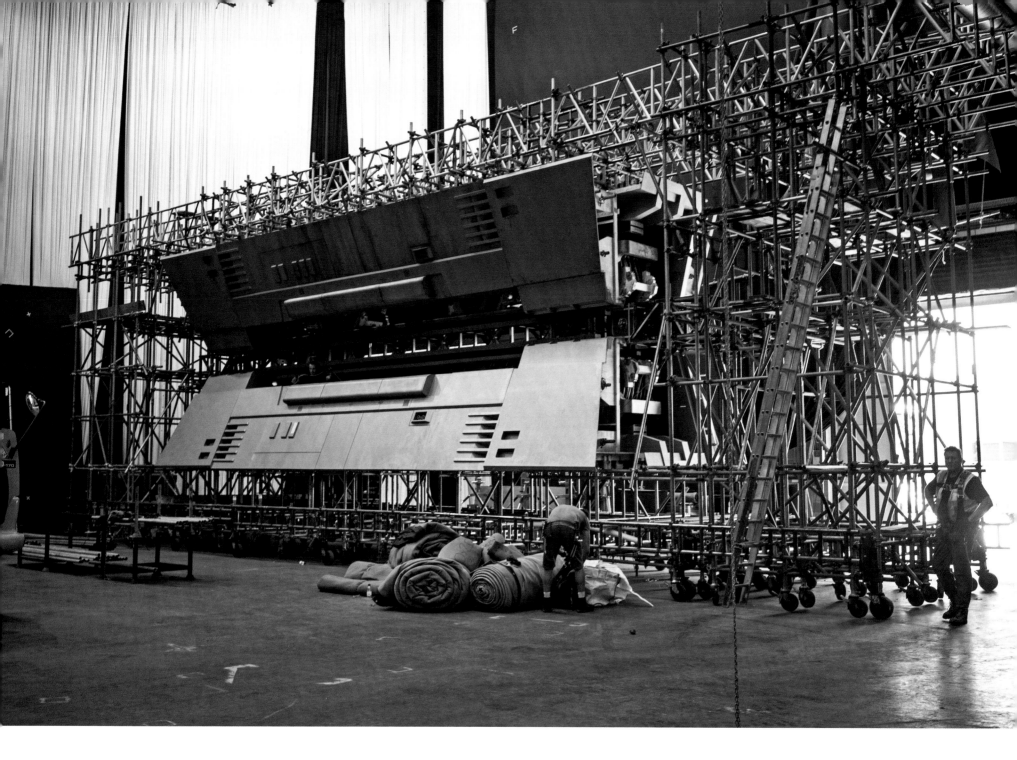

The "crawl rig" is pictured above. This set is built to cover the part of the train where the top and the bottom train cars meet right around the track. It was used for the scene where Han cuts himself loose from the top train car in order to safely crawl to the front hitch. Even though it's only in a handful of shots in the final film, we were fortunate to benefit from the craftsmanship the art department provided in these detailed sets.

In the end, Ron Howard requested that the train be even more frosted and worn than the original photography, so the artists at Industrial Light & Magic, led by VFX supervisor Julian Foddy, did an additional layer of paint and texture to add to the cold atmosphere Ron was looking for. In the final result, it is hard to tell the difference between the practical and the digital components.

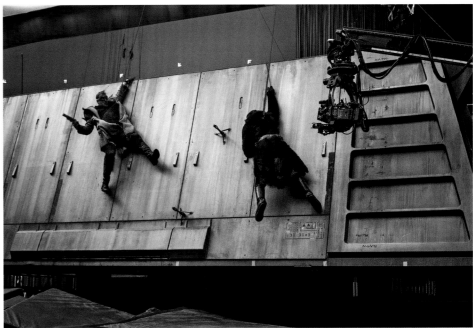

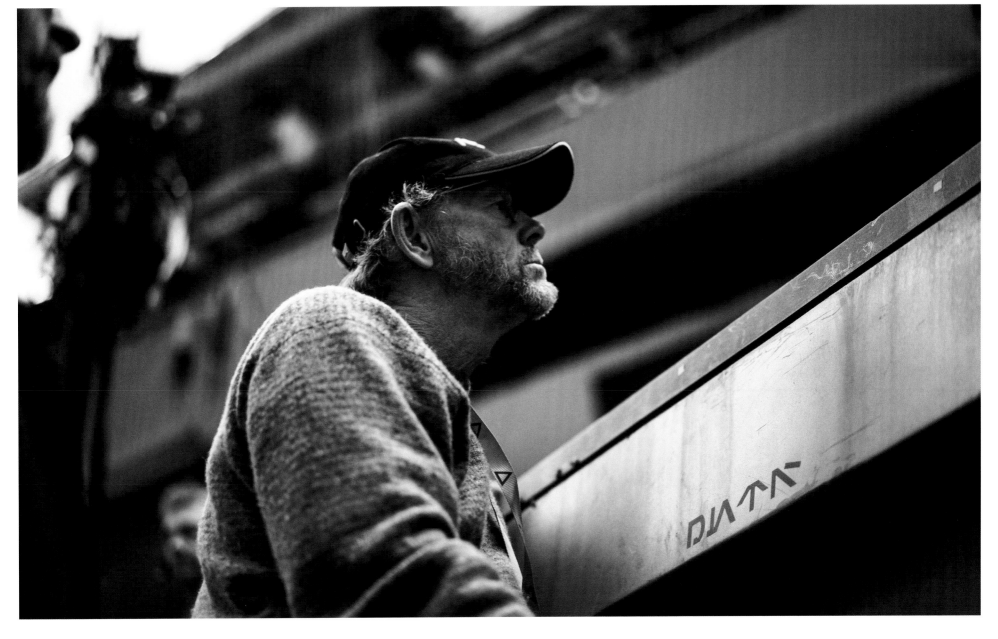

Mimban Battle

GOING TO WAR . . .

I remember the first day on the Mimban battlefield on the huge 007 Stage at Pinewood Studios. The set was large, with impressive craters and obstacles almost dark gray and incredibly smoky. Just the place for a battle.

The camera follows Solo and Beckett running through the battlefield with phosphorus rockets flying over their heads, flames and explosions and sparks and dirt flying everywhere, each explosion silhouetting them for a brief second.

It was then I thought to myself, "I have a cool job."

— Dominic Tuohy, special effects supervisor

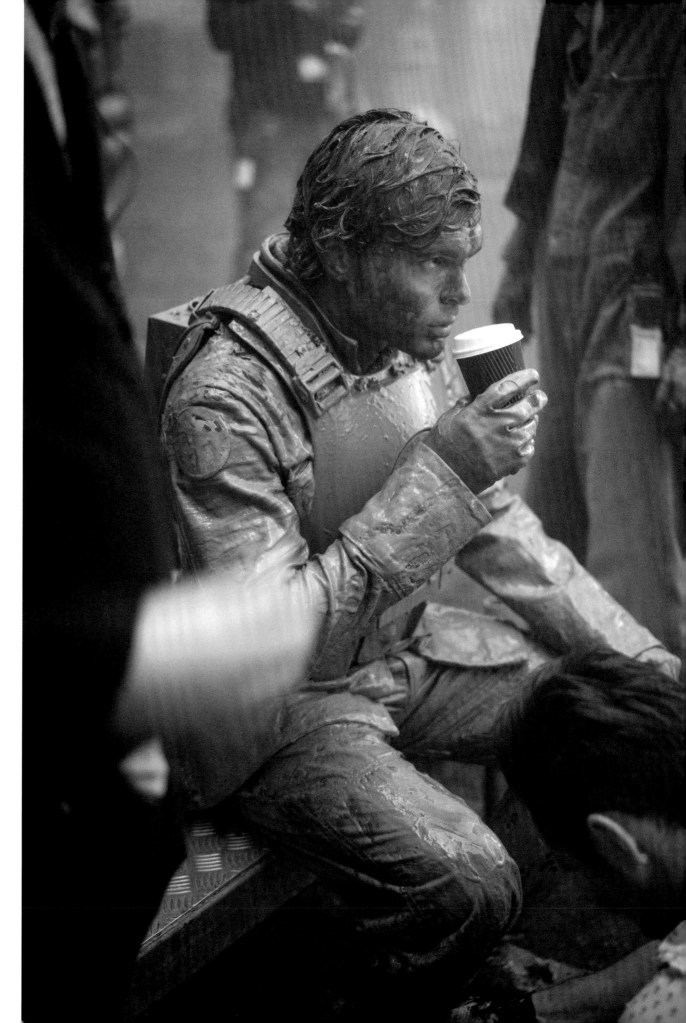

BRADFORD YOUNG
Director of Photography

On the side of the Corellian Spaceport shoot, Bradford sat down for an interview conducted by my youngest daughter, Allison, for a school project. The assignment? Interview a photographer. She got to interview one of the world's best: an Academy Award Nominated DP on the set of a Star Wars *film.*

You can see from his work that Bradford is a world-class photographer, but you may not know he's a great role model as well. When Bradford and I first met on the film, touring the Lucasfilm Archives together, I told him he's the kind of person I wanted to make sure my family got to spend time with, and we were lucky that we did.

Allison's report:

I interviewed Oscar-nominee Bradford Young. It all started at Howard University in Washington, DC. For Bradford's first two years he did not major in anything. He was not sure what he wanted to do with his life. He knew he wanted to be in the arts, but he was not sure really what yet. Then he met a few friends and they were already into photography. That was definitely a push in the right direction. After eight years of school, Bradford managed to come out with two degrees: MFA (master of fine arts) and a BA (bachelor of art).

Bradford's jobs after school were just building blocks for what he does today. He started with things in the community. Some things were weddings, birthday parties, etc. Then he started to get more professional jobs, like doing portrait pictures for people. That is always how it starts.

Now in Bradford's job as a cinematographer, he has many responsibilities. Some are making sure that the camera is in the right spot and doing what it is supposed to do. Others are making sure that the lighting and the performance is right. He has to listen and make sure that everything looks right. That is a big job for one man.

Bradford has some help from his friends as well. His favorite part of his job is being with his friends every day. If he can do what he loves, great. If he can do what he loves with his best friends around him, perfect. Bradford loves people. He loves being able to help people, talk with people, and hang with people. It's a very good thing that he is as friendly as he is.

Stories are the things that inspired Bradford to get into cinematography. He would read stories and see what he is reading—some call it the mind's eye. When he realized that you could put stories with what he sees in his head, he knew for sure that that is what he wanted to do.

I had lots of fun interviewing Bradford, and I hope that you learned lots about what his life is like. He is always busy, but he is always having lots of fun. I always love seeing people that love their jobs as much as Bradford does.

OPPOSITE Bradford Young with his son on the set of Mimban, fully atmosphered for shooting.

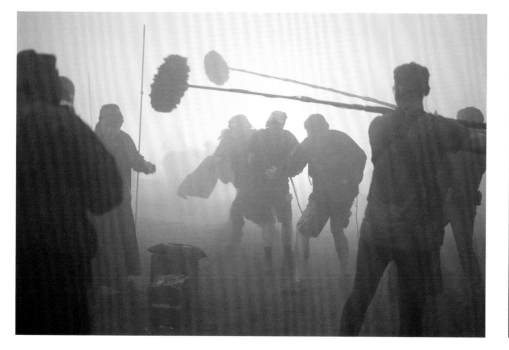
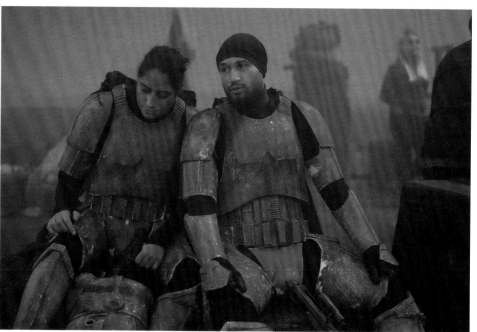
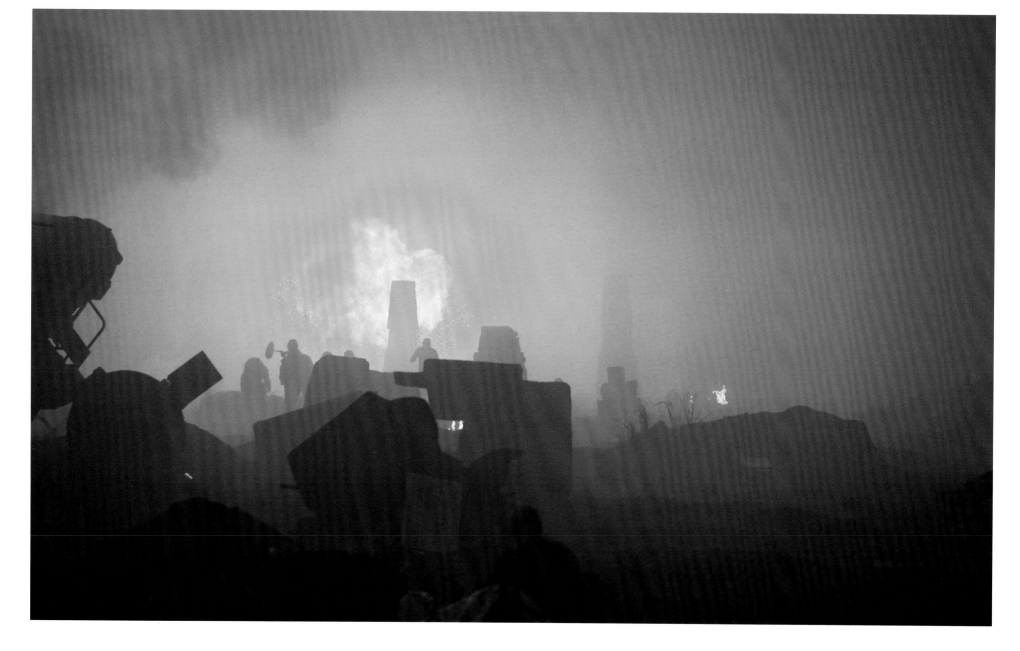

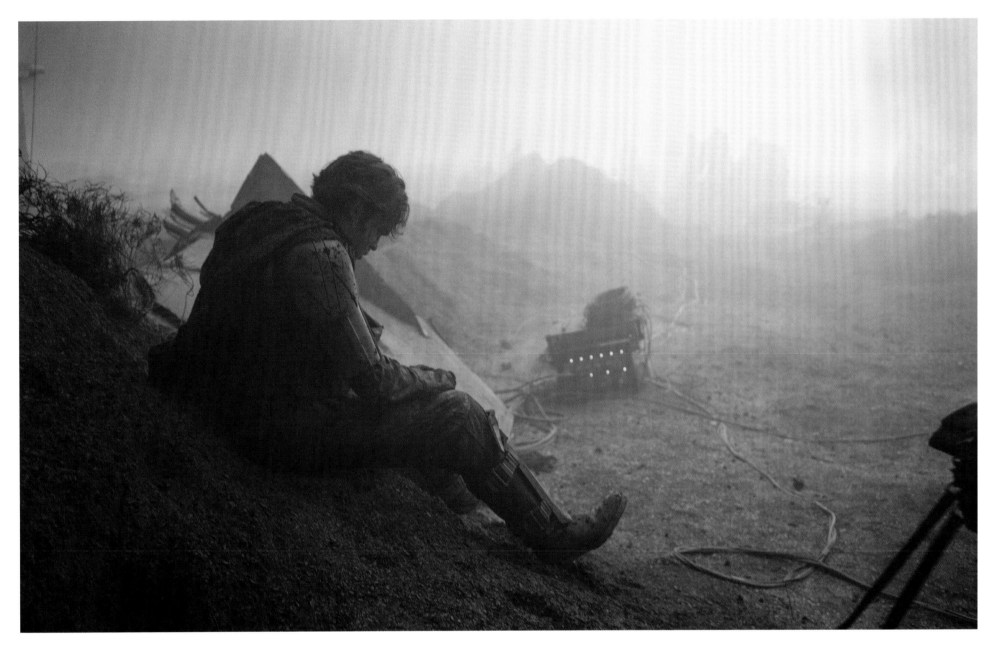

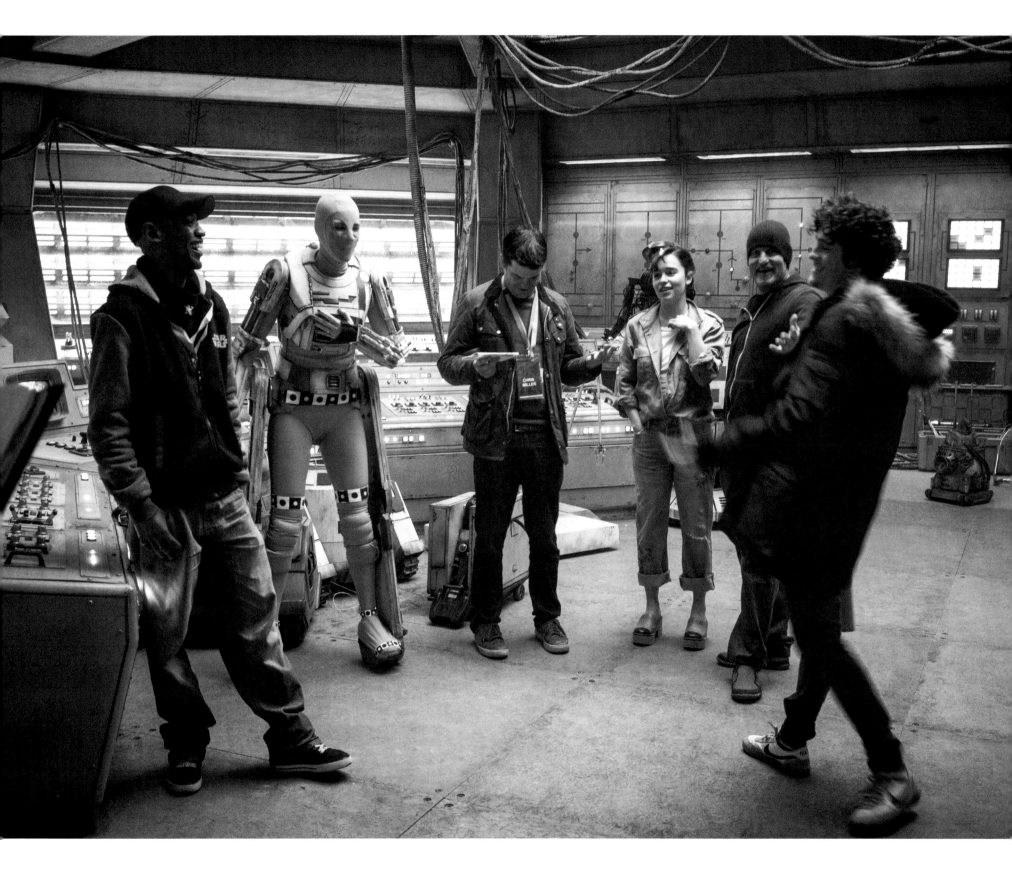

The droid control room on Kessel was another 360-degree set, inspired by the control room we photographed at the Fawley Power station.

RIGHT SFX supervisor Dominic Tuohy wires the walls to explode and shower sparks on demand.

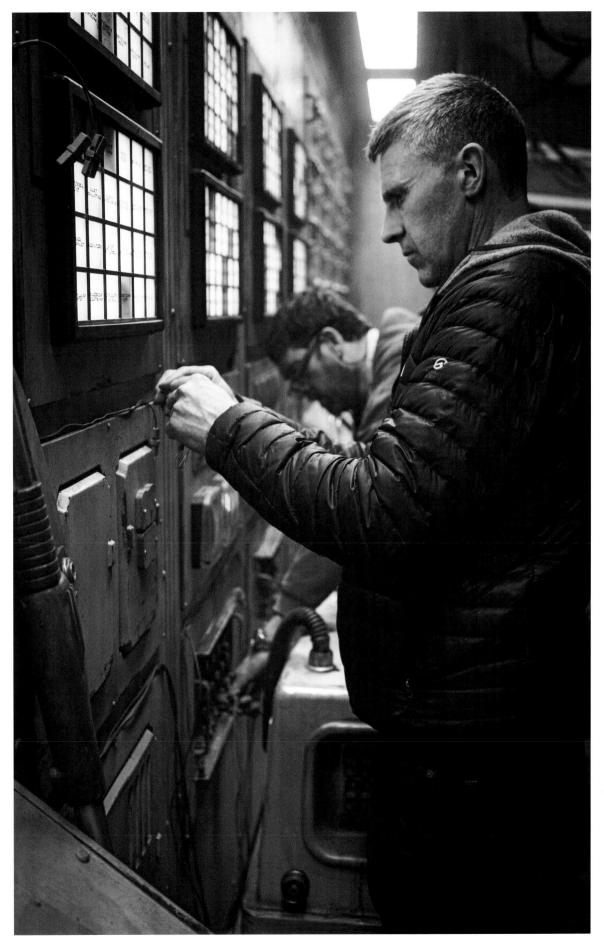

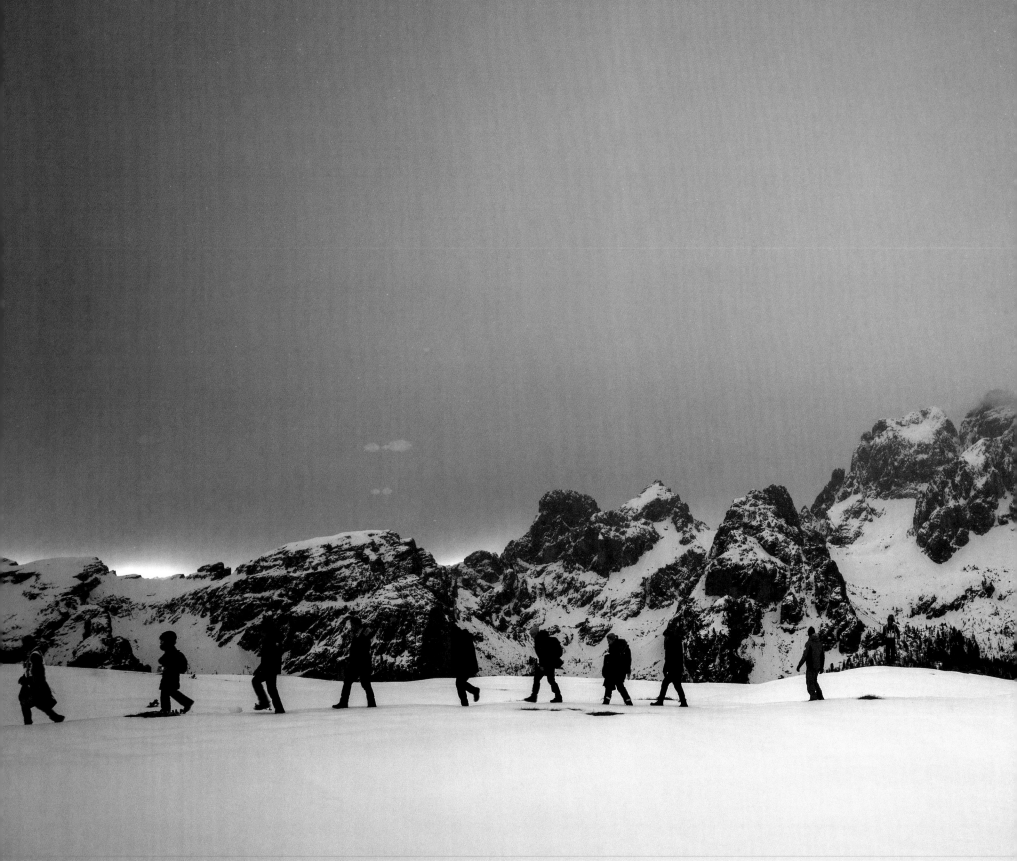

Vandor

ON LOCATION

There's nothing like a great location, especially somewhere as special as the Dolomites. We arrived in a blizzard and that was just the beginning of the challenges the weather would throw at us, but the crew was up for it and we got some of the most spectacular footage in the movie during our few days on location.

Chris Miller had wanted to be sure we had a little snow, but not so much that Vandor would ever be confused with Hoth. Of course, trying to get "spotty snow" in the Dolomites is like asking for a "small earthquake" in California—you never know exactly what you're going to get. We were very fortunate to arrive to fresh snow, but enough melted during our shoot to get the perfect look. A new *Star Wars* planet was born.

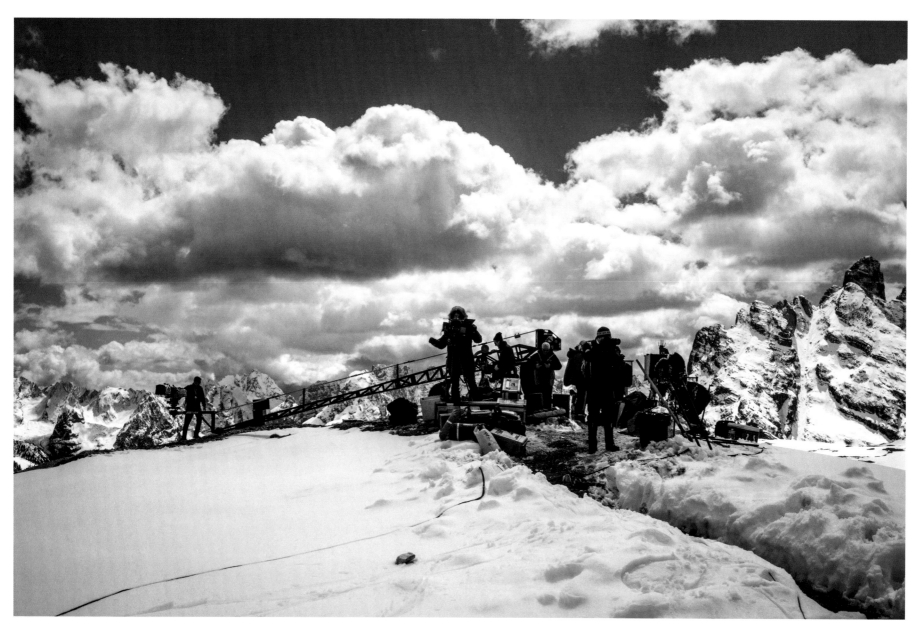

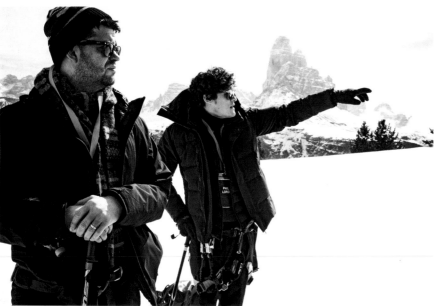

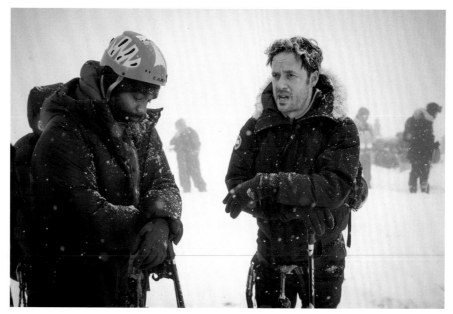

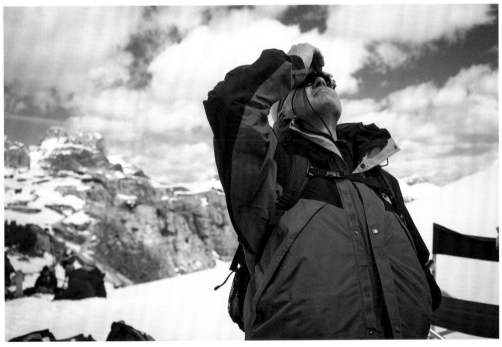

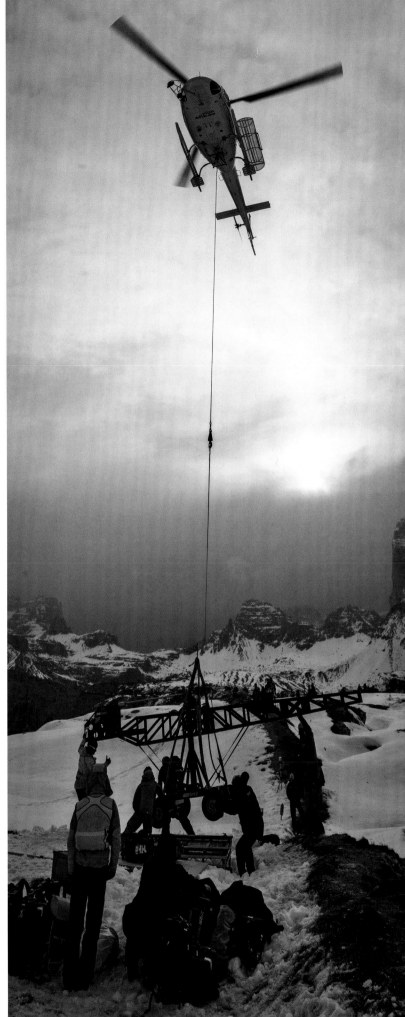

The logistics were remarkable. Access to the location was via two different vehicles, the last a 4WD truck. Paths were dug for the crew to be able to hike out to set and back to the forward base. Helicopters flew up the gear that couldn't be brought on trucks due to the size.

And of course, the weather. It was a blizzard one hour and sunny the next. We were constantly looking for the shadow from the clouds that would let us shoot the scenes we needed to make the day.

But any time we were tempted to get frustrated, we could just look around at the incredible views in every direction and smile. Truly a perfect setting for a *Star Wars* film.

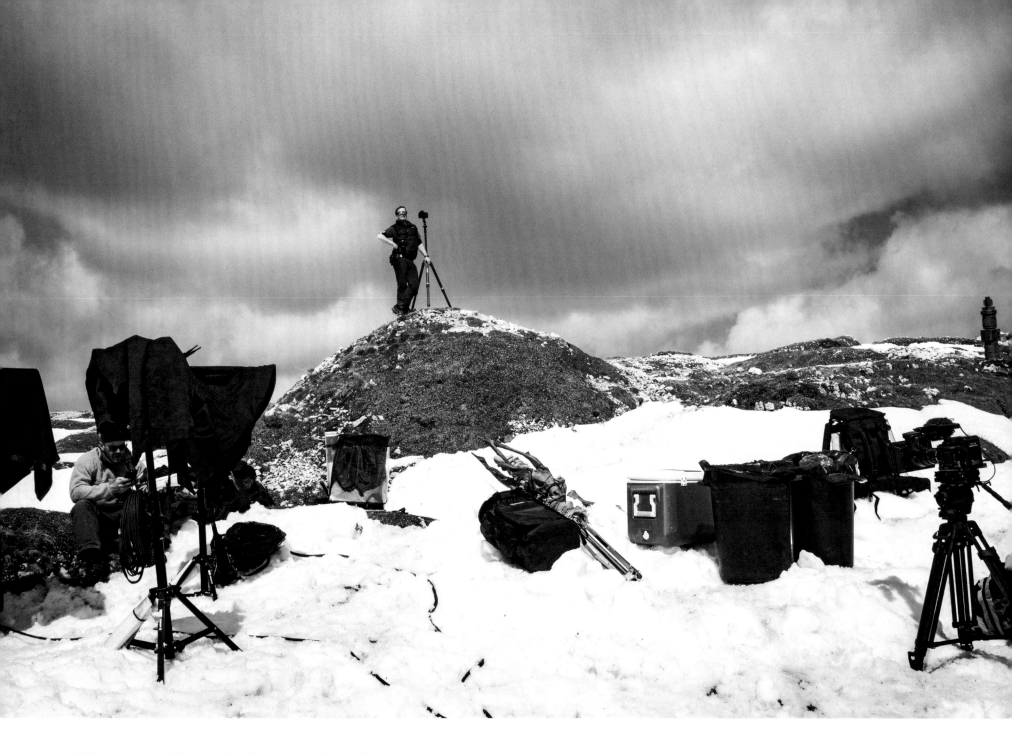

VFX data wrangler Ed Price standing by to snap another set of spherical high dynamic range images on his camera as soon as the lighting changes again. We used those photos both for knowing how to light our visual effects and to drive lighting on set to match the exact color temperature of the real-world light.

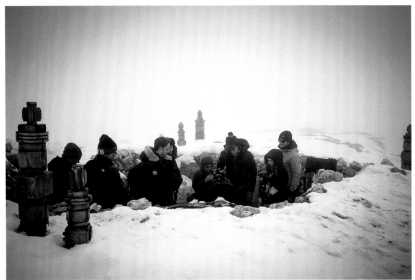

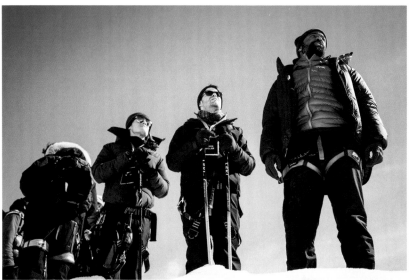

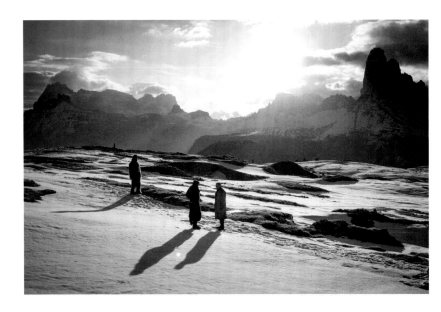

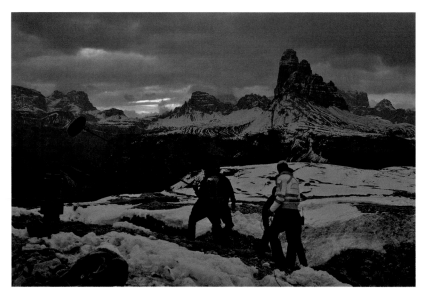

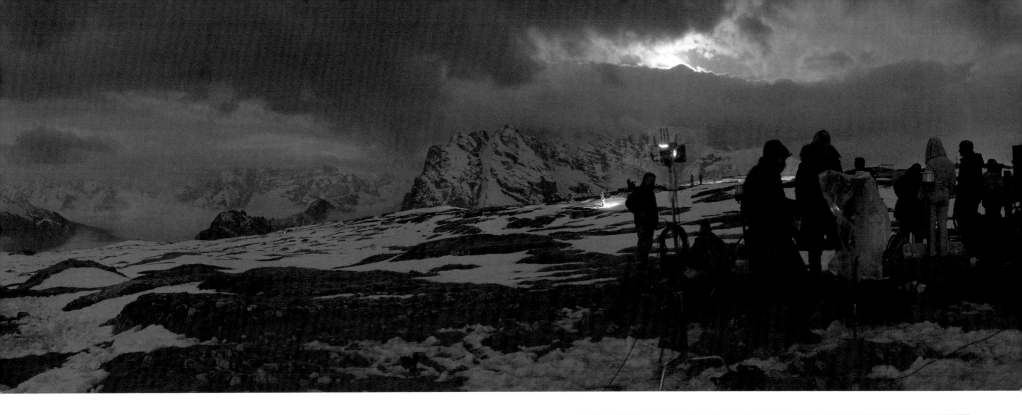

Location work is unpredictable, but when it comes together, it really is magic.

On the final shooting day in the Dolomites, we still had several complicated and important scenes to cover. The only plan we could think of, hatched over pizza in the nearby town the night before, was to wake at two A.M. and shoot the pre-dawn shots setting up the campfire, shoot the walking scenes at sunrise, and then hopefully get the scene between Han, Beckett, and Chewie after if the weather held.

It came together perfectly. The crew was up early to be at the top of the mountain for a three-thirty A.M. call, and everyone was on the top of their game. We split the A and B camera teams so we could be shooting multiple scenes at the same time. The actors were incredibly well rehearsed and nailed the performances right away—and the beats of the day played out even better than our most optimistic scenario. The weather not only cooperated, but gave us amazing clouds and just the right amount of sun to play for the scene.

We left Italy with all of the shots in the can. One of the best days of the entire shoot.

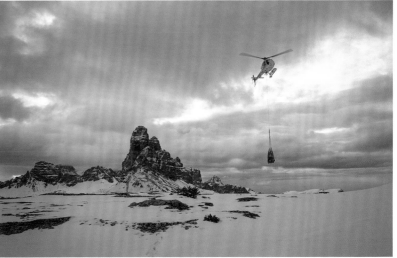

BOTTOM RIGHT The crew during a warmer moment on Vandor. Photograph by script supervisor Sheila Waldron.

Speeder Chase

The speeders were created using bespoke four-wheel-drive vehicles with 525-brake horsepower. At the push of a button they could be switched to front or rear wheel drive only. On top of that, these were driven by world-class stunt drivers: one, a British World Rally Champion; the other, a famous driver who formerly portrayed "The Stig" on Top Gear. The machines drove at high speed around the location with lots of obstacles, SFX elements, sparks, steam, and explosions.

For the shots where we needed the actors to drive in the car on location, SFX rigged a "pod" to the front of the speeder so the stunt driver could drive from a hidden position. Alden Ehrenreich and Emilia Clarke got quite a ride!

The design of Correlia was influenced by the Fawley power station itself, lightly dressed by the art department, and later significantly extended by VFX.

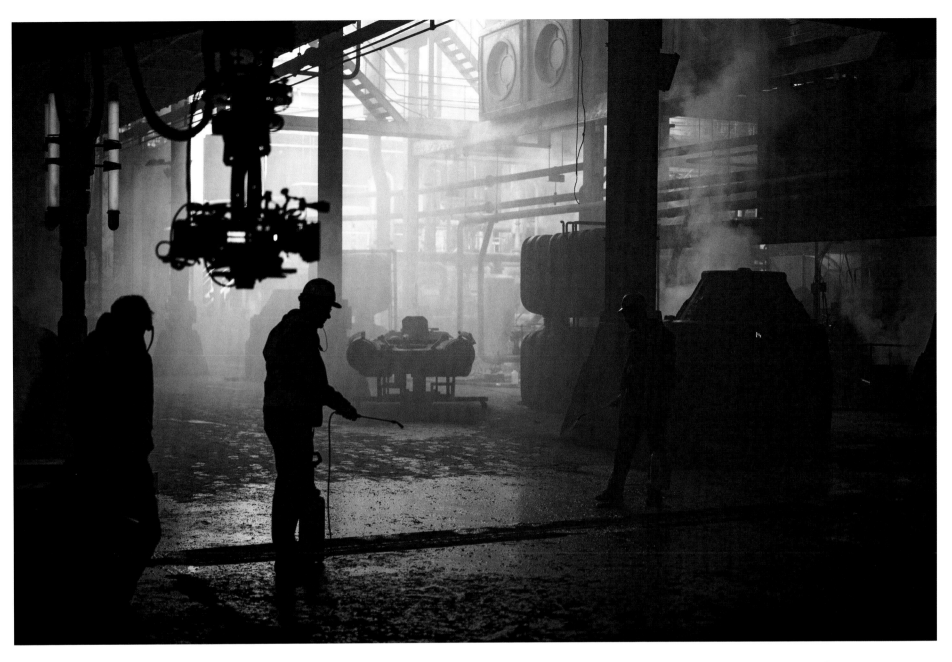

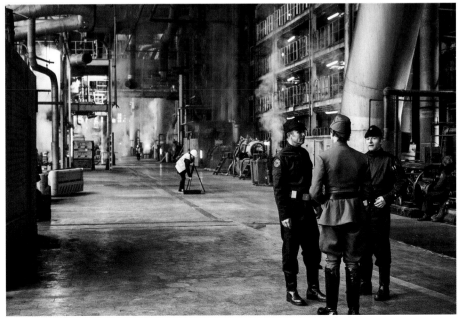

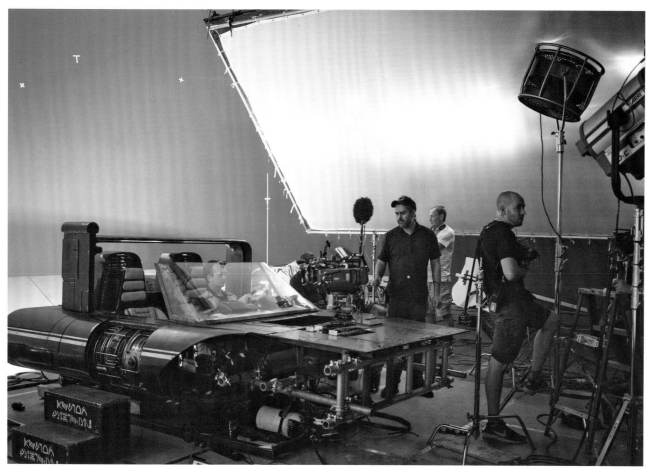

For safety and logistical reasons we couldn't shake and tilt the Speeder with our actors inside to the full extent we needed for the shot, so we split the pre-vis animations in half, putting half of the motion on the speeder and the other half onto the motion-control camera. Once combined, when you looked through the camera while it was moving, it created the illusion of the full-speed action while keeping the actors safe. Next, we set up LED screens around the set to light with plates that we already shot on location, and we worked with ILM to craft a precise color calibration for the content shown on the LED screens, adding a level of interactive realism we never would have attained otherwise. The planning and multi-departmental integration of this scene created a harmonious balance that came together so nicely and allowed me to appreciate the care and skill of all those involved.

—T.J. Falls, visual effects producer

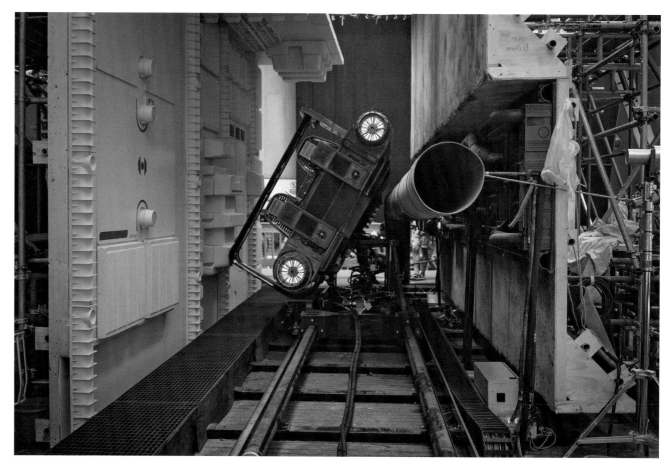

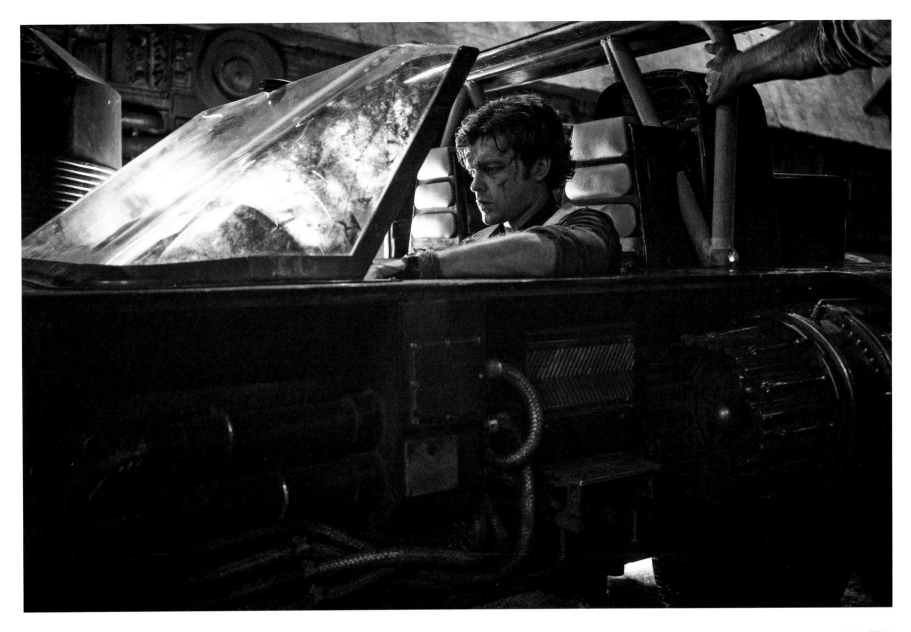

The next trick was to use "poor man's process" to shoot additional dialogue that wasn't feasible to capture on location over the roar of the engines. Poor man's process is often done with grips turning lights against a blue screen backing, but the results are rarely convincing. We brought in LED walls and fed the giant screens with moving footage the VFX unit had shot on location to represent the background movement and light the scene.

For the most active shots, VFX once again collaborated with the SFX team. Dominic Tuohy remembers, "A bespoke motion base was used with carefully matched movement data from the stunt action we had already shot. With this data fed back through our computer system and combined with the VFX file, the vehicle's movement was extremely realistic."

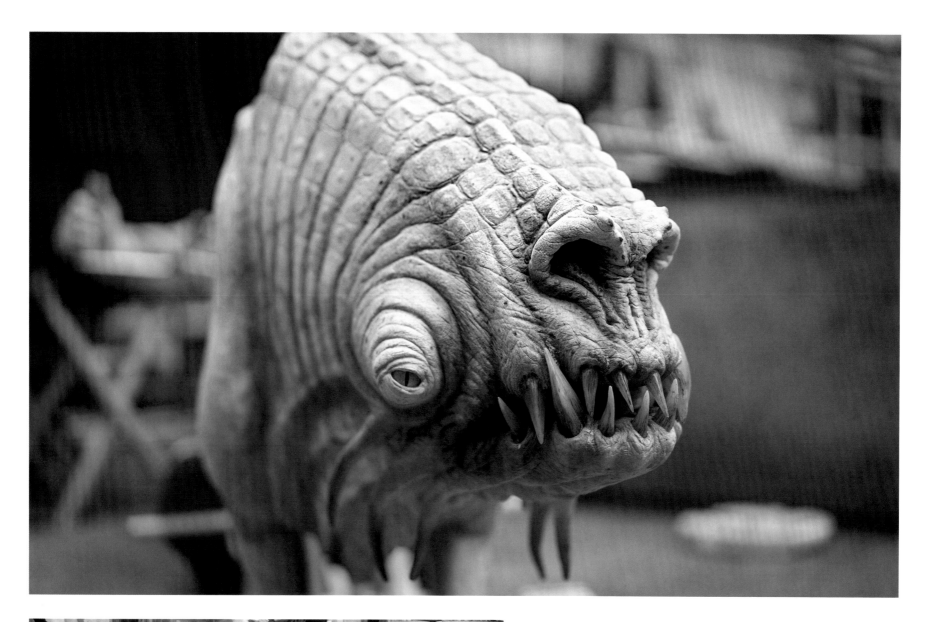

Moloch's Corellian hounds were always a favorite on set because they were created with a combination of techniques. First, we had the dogs in their suits. That version didn't have any facial movement, and the jaw hung loose a bit to give some motion. In post, we animated those faces to make them feel alive, painted out the real dog tail, and painted on their feet to finish them off—but much of what you see is the real dog.

For the close-up shots where you see the dog performing, we switched to a puppet on set. The detail that was in those faces really worked, and once you got the slime and all the motion working together, it was pretty convincing.

Taking a real animal and suiting it up is a slightly crazy approach—I think there is something primal about seeing that. We are so familiar with dogs and dog movement, but it's not a dog. I think that has an eerie mix to it.

— Neal Scanlan, creature effects supervisor

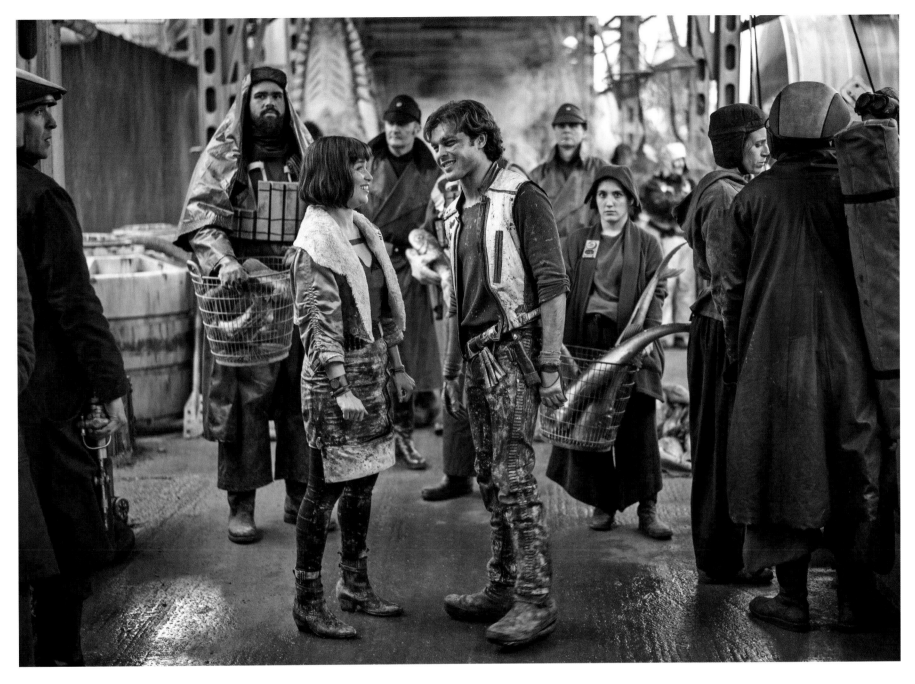

The *Falcon*

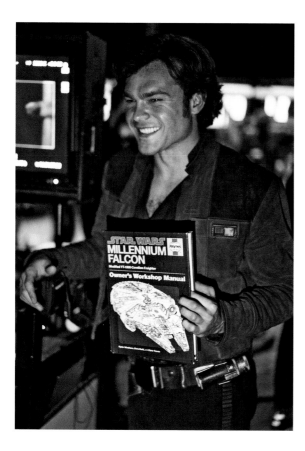

As the senior digital asset manager for Solo, one aspect of my job is providing reference to those on set, so they know the look of what they're trying to achieve.

One early morning I was required to go down to the Millennium Falcon set to provide the on-set art director with concept art. With a lack of coffee in my system, I was quite tired when I arrived on set. As I looked round for the art director, I could hear someone singing at the top of their voice. In typical British fashion I thought to myself, "It's seven-thirty A.M., mate, calm down." Naturally my face also conveyed this message.

As I looked up the ramp entrance of the Falcon, with a look of disgust, I saw it was none other than Lando Calrissian himself looking straight back at me, belting out the song lyrics. My face suddenly changed from distaste to shock to joy, as I realized I was getting my own personal Childish Gambino gig. Thank you, Donald . . . and sorry for the look!"

—Kyle Wetton

ABOVE Alden brings his *Millennium Falcon Owner's Workshop Manual* to set to talk about button sequences for a take-off scene coming up next.

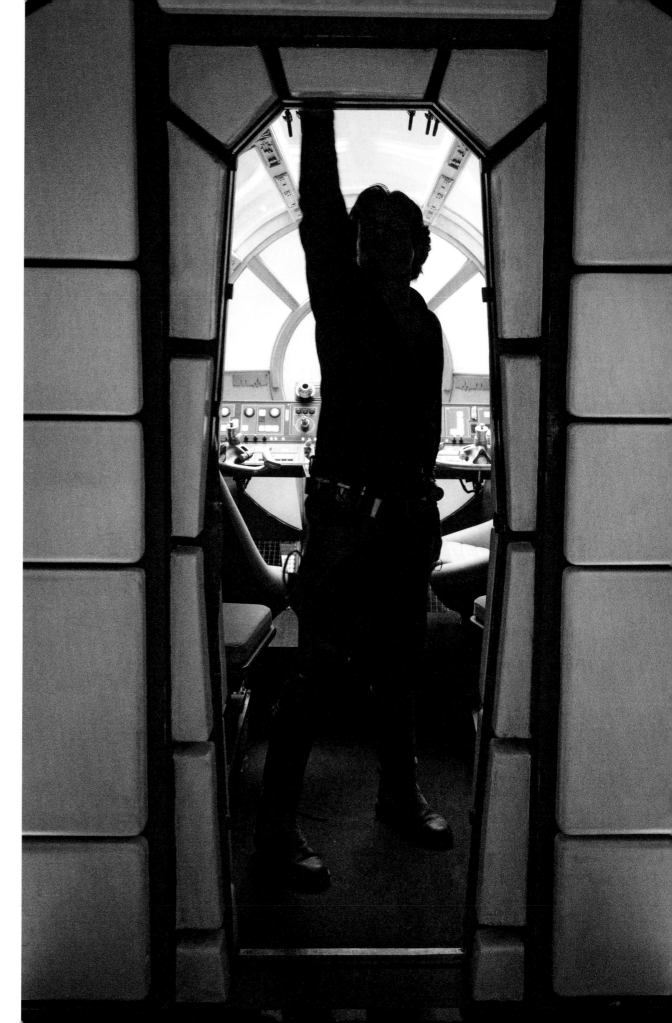

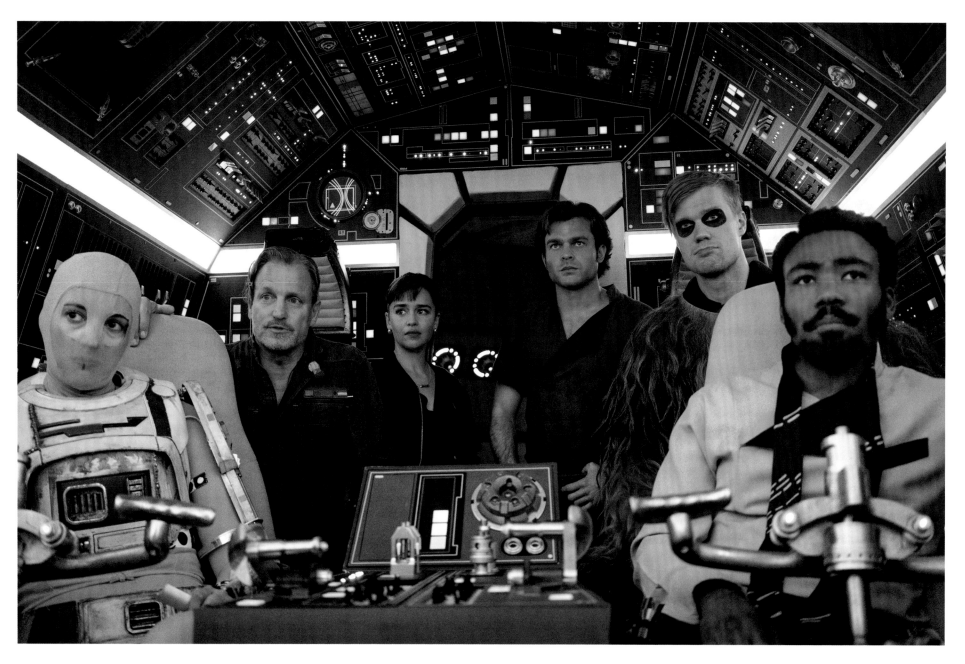

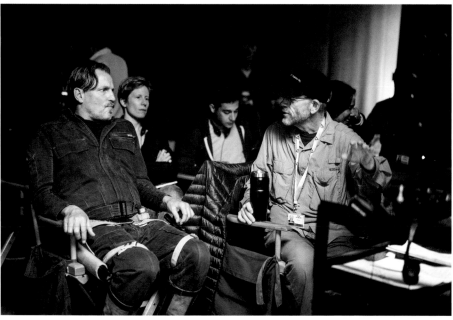

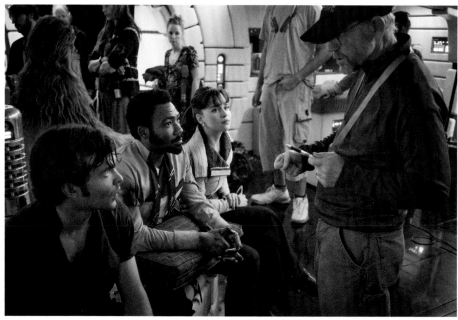

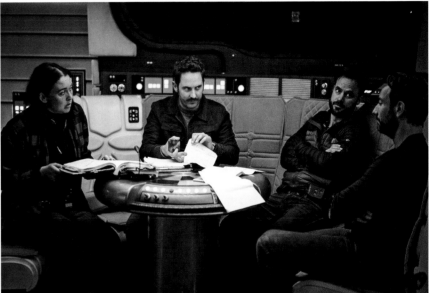

Solo has a lot more scenes in the *Millennium Falcon* that any other *Star Wars* movie. Getting to prepare for these scenes with the media for the projection walls, and then watching Ron Howard block the action to make each moment unique from one moment to the next, was an incredible learning experience.

Over the development of the film, I was involved in helping to design and plan the action sequences and present the work to Ron Howard for his direction. During production, if Ron had requested a tweak to the script, Jon Kasdan would sometimes reference our pre-vis and include it in the new pages for the next day. It was a really great feeling to be watching the scenes play out on the monitor that we had invested so much effort into planning for almost a full year. And, if a small detail was wrong, or the look needed to be tighter to camera for a beat, often Ron would ask me to run up to the cockpit and pass along a note to the actors. I'd be talking with Alden and Joonas, but when I'd get back to the monitors and see the shots, I'd realize I had been passing along notes to Han Solo and Chewbacca.

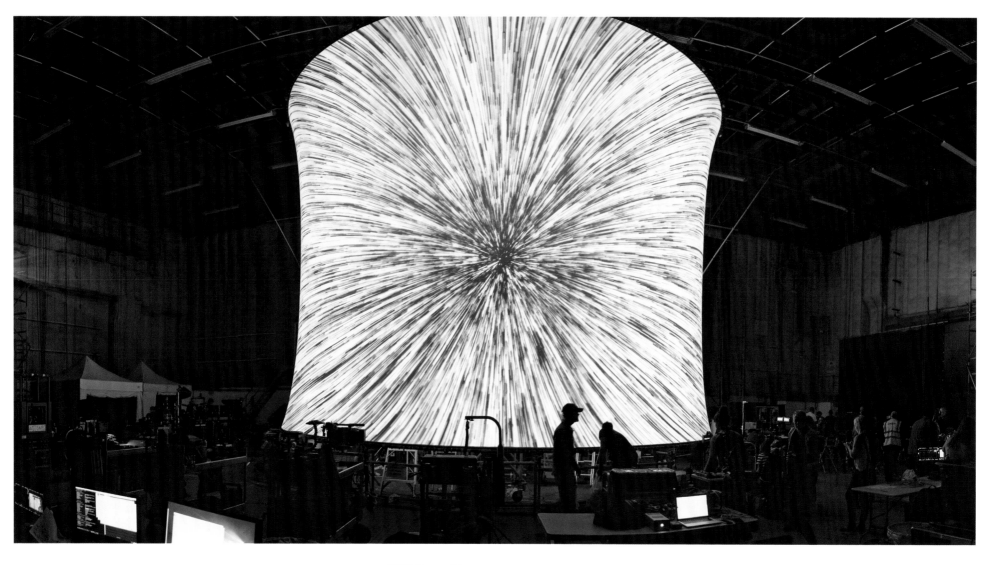

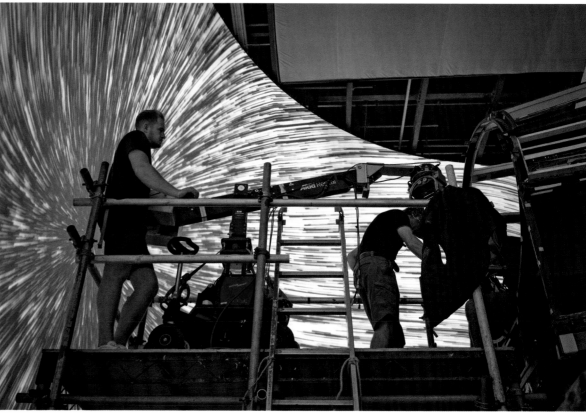

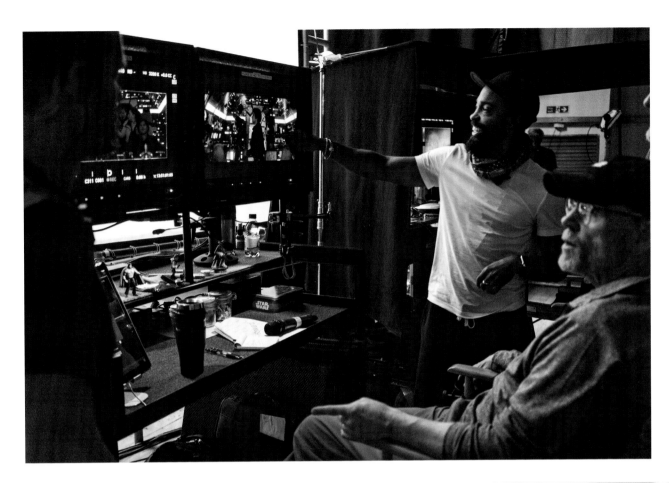

On the first day we had the full cast in the cockpit, we were rehearsing the scene where the team is traveling to Kessel. When Donald and Phoebe pushed levers to take the *Falcon* into hyperspace, I gave the cue to Phil Galler, our projection operator, and he triggered the ILM animation that wrapped around the screens and took our cast into hyperspace. They freaked out! Between the cockpit, the motion from SFX, and the wraparound screen, they really were in *Star Wars*.

Not only did the wraparound screens help our cast feel immersed, they provided our camera department a world outside the cockpit that they could light with, and photograph directly. It was incredibly satisfying to see all of the hard work come together and see the Kessel Run come to life in front of our eyes.

TOP As fun as it was to come to work every day and shoot in the cockpit, it was physically demanding. Cramped quarters, being bounced around by powerful hydraulics to simulate the turbulence, not to mention the intense action of reacting to things like the Space Monster eyeball that appears out of nowhere added up to give the cast some seriously sore muscles.

RIGHT My first camera test of the screens while they were still only partially calibrated. I was so happy with the light levels and the exposures we were getting I took this photo and then ran this image back to Bradford on the other set we were shooting. We both knew that our planning was going to pay off.

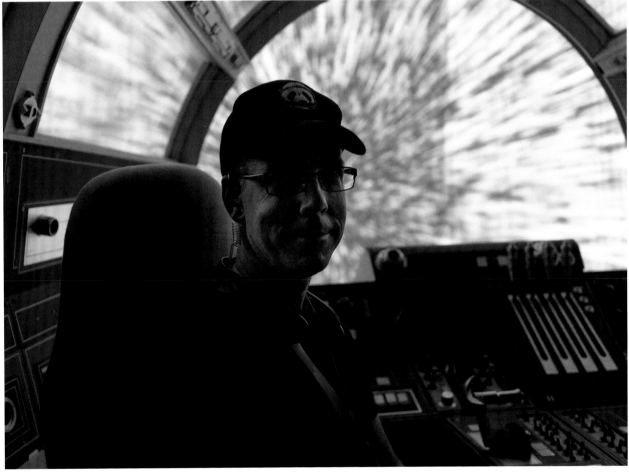

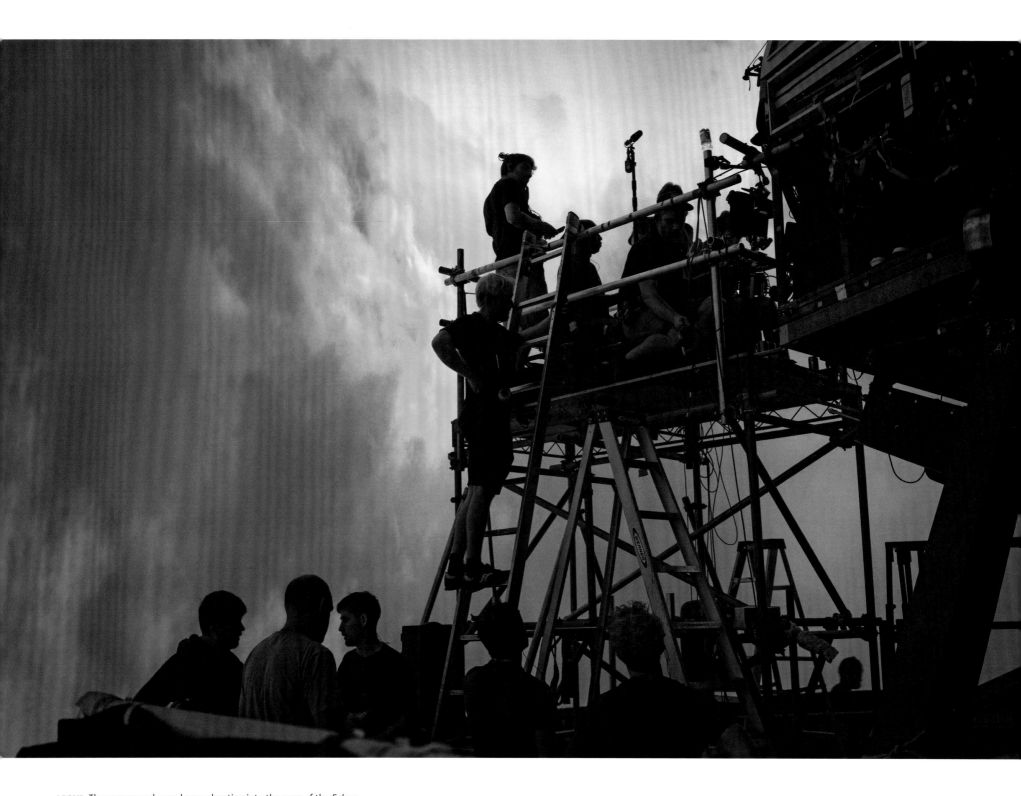

ABOVE The camera and sound crew shooting into the nose of the *Falcon*, surrounded by clouds from the planet of Kessel for takeoff—Han's first time flying the *Falcon*.

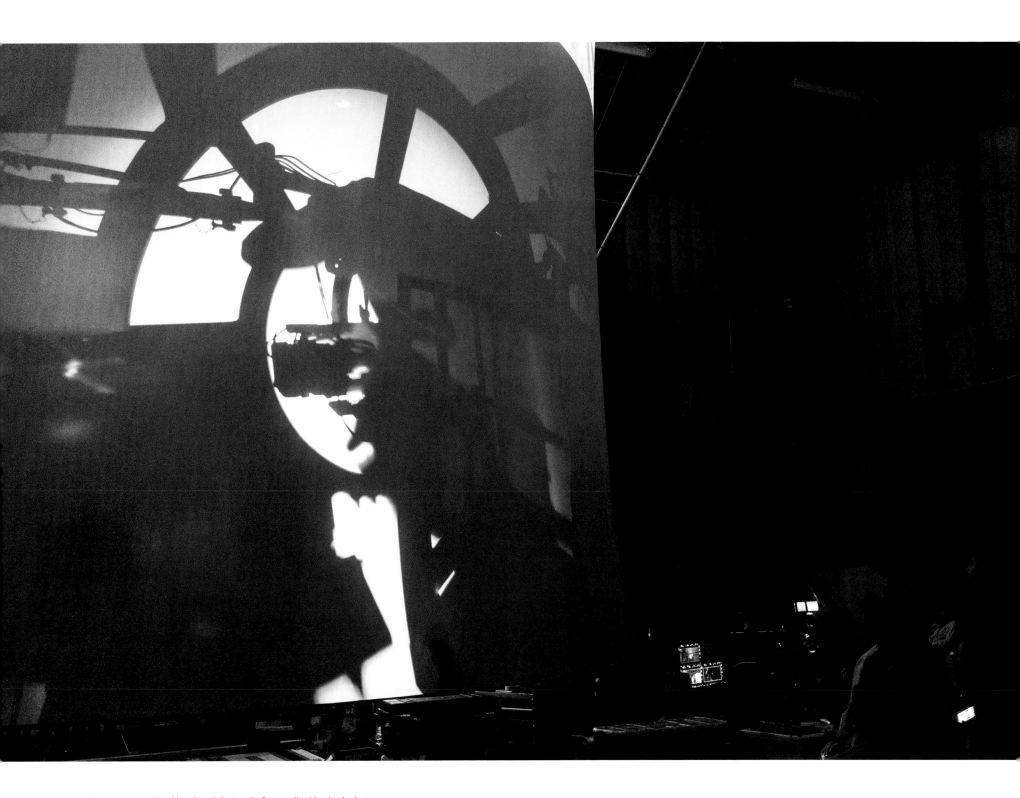

ABOVE I was at our VFX table when Sylvaine Dufaux walked by, looked at me, and pointed to the shadow the camera was casting on our projection screen with a smile. I love this abstract image; it really encapsulates the moving parts taking place behind the scenes to shoot the Kessel Run.

JAMES CLYNE
Lucasfilm Design Supervisor

I think one of my favorite designs for the film would have to be the *Millennium Falcon*. What a challenge. I shake in my boots just thinking about the responsibility to get this right. Time will tell. The history behind this iconic ship is unequalled. And, although it was my job to see the design through from inception to final ILM digital asset, it really took a village of talented artists and designers to make it all happen.

All we knew initially from the script was that the ship was under Lando's ownership and that it had an escape pod. Where we went from there was all up to us. After many design iterations with my art crew, we jumped into building ¹/₇₂ scale physical models to show the team for early buyoff. A bulk of the inspiration came from the early designers of the original films, Ralph McQuarrie and Joe Johnston. But I wanted to also do something a little sleeker, more refined than the "piece of junk" that we all know and love. Final detailing and proportion came from my collaboration with ILM model makers. At that point every little nut and bolt (does the *Falcon* even have those?) had to be built for final shots. And that was just designing the intact *Falcon* . . . We also designed all the many stages of damage it endured along the famous Kessel Run. Returning, at the end, almost to the *Falcon* we know and love in Episode IV.

One of the hardest designs to crack was, of all things, the Corellian trooper speeder bikes. It's one of the most basic shapes of any vehicle I've designed for the *Star Wars* universe. Most people won't know that they almost didn't make the final cut, but they're in and look great. The art team did hundreds of little sketches trying to crack the exact right shape. Was it a two-person speeder, or a single-person motorcycle-like speeder? We went back and forth on it. The directors really wanted something simple and iconic, and we were just giving them stuff that was too complex.

One of our producers, Simon Emmanuel, was advocating for a speeder bike while I kept pushing the two-person car. After much discussion, it was decided it should be a speeder bike, not more of a car look. I was kinda bummed, but in the end I admit it was the right choice. Simon had it right. Honestly, that's the real joy of filmmaking: working as a collaborator with other creative people, solving problems.

As a postscript, the "basic" final design came from a sketch I did on my iPhone, with my index finger, on a plane back to the UK. You never know where inspiration will strike!

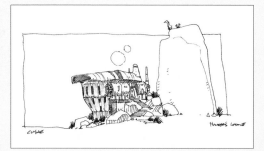

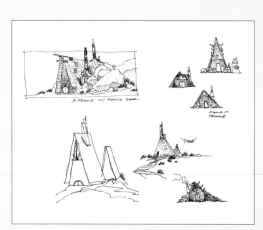

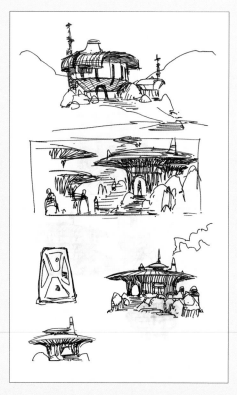

OPPOSITE James Clyne standing by for his return flight from a scouting trip to the Italian Dolomites.

Savareen

ART DEPARTMENT BUILDS, AND BUILDS . . .

One of the biggest things in the film really was the Savareen set we built in Fuerteventura. It took a long time to find that location. From the beginning we pretty much knew we were going to a deserted kind of cowboy town, like you'd find on the West Coast. The film's final journey up to the saloon and the church at the top of the hill is the kind of thing you'd see in a Western. When that whole set was decided on and we were trying to budget it and get permission to build there with the help of the Fuerteventura government, we never thought we would quite get there. It really was phenomenal that it came together. We put a lot of production value on the screen—it isn't every movie where you get a set this large in-camera. Of course, we work with visual effects to finish it off when we point toward the refinery, the Falcon, or Dryden's ship, but we were really proud that most of what you see is achieved practically on location.

—Neil Lamont, production designer

ABOVE Neil Lamont climbs the coaxium refinery set on the first day of the shoot. Everyone was blown away by the attention to detail.

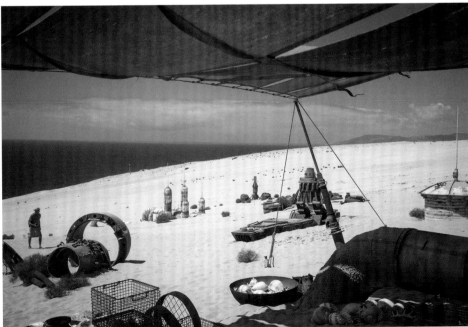
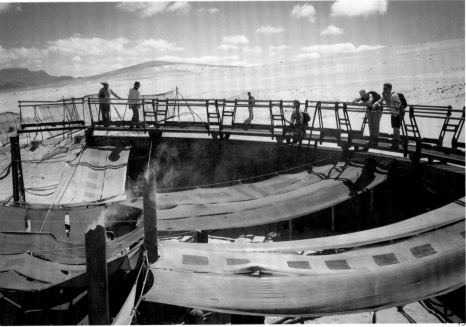

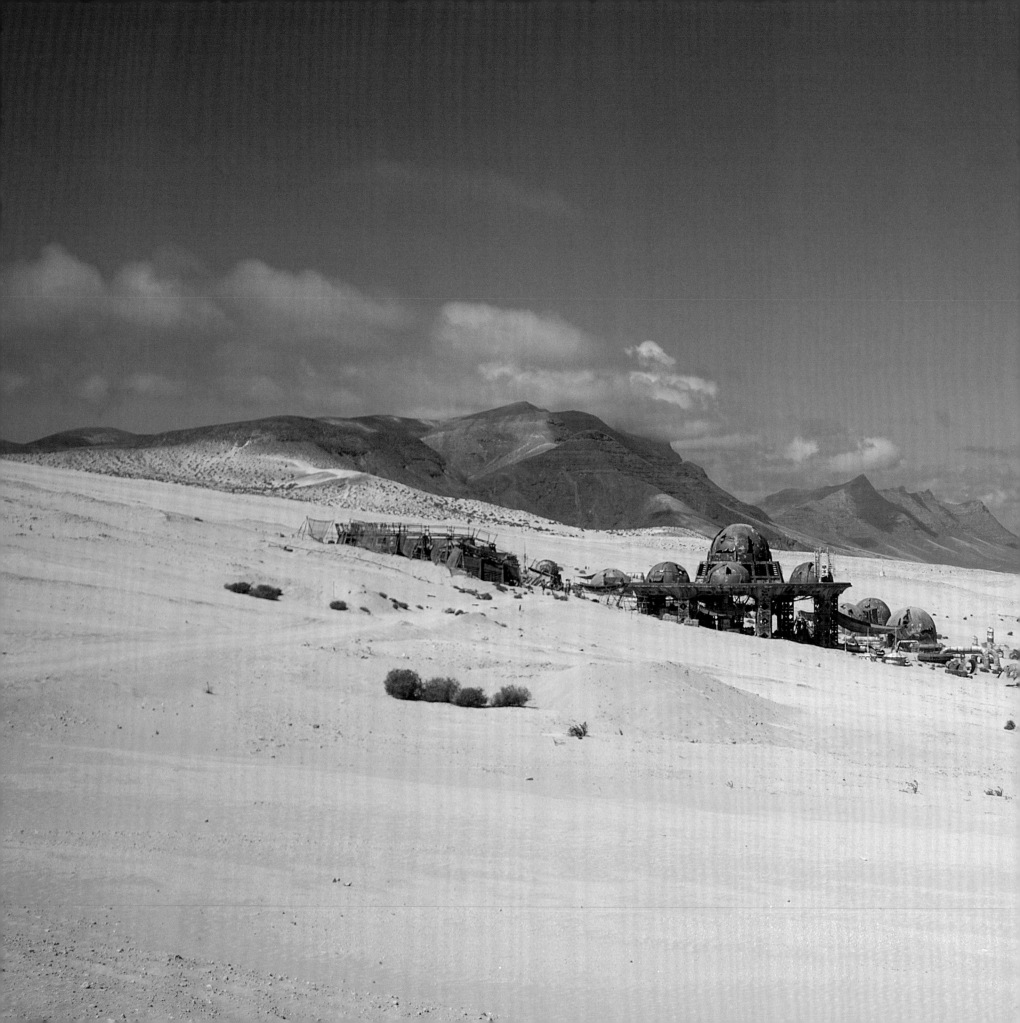

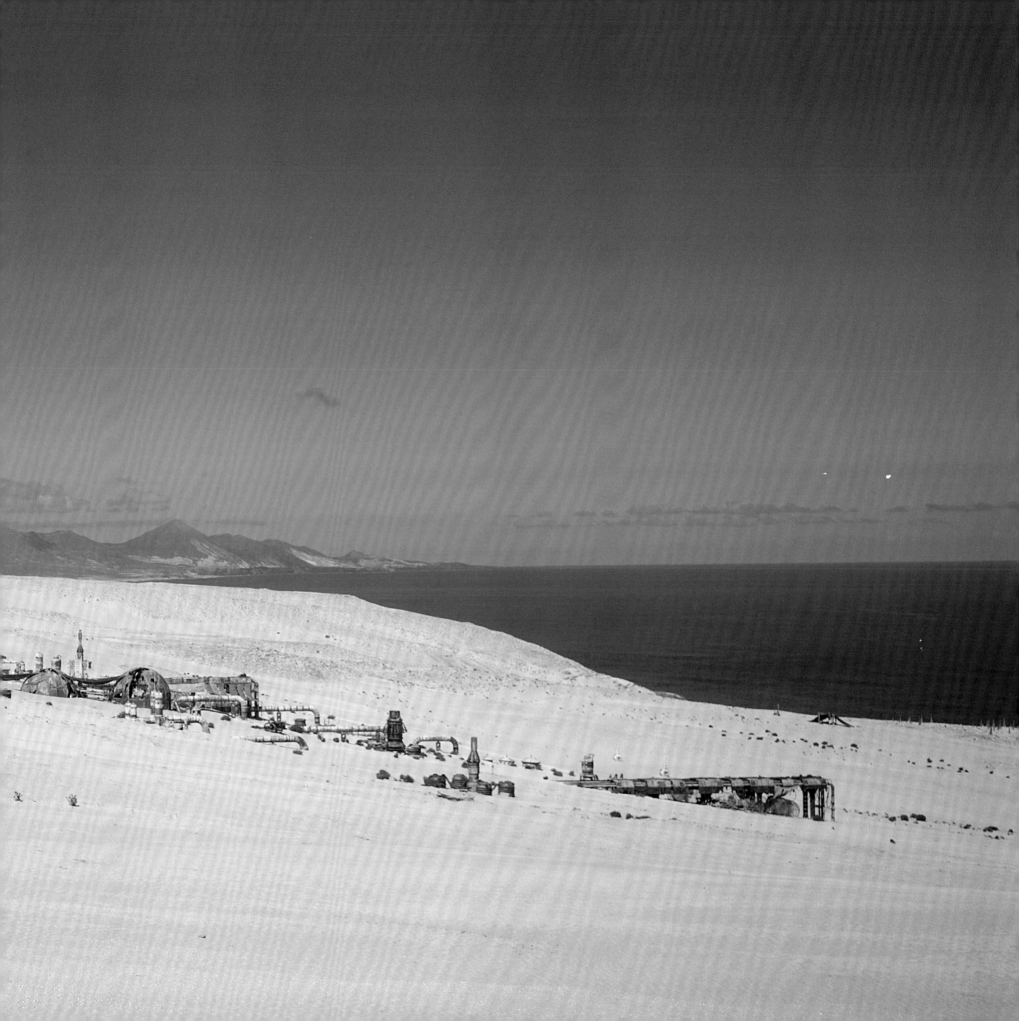

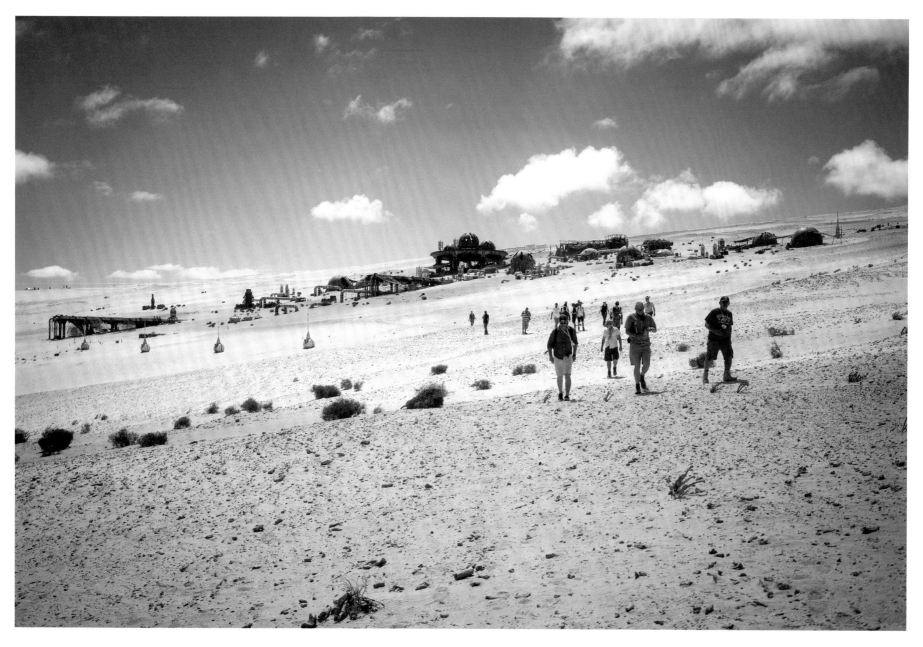

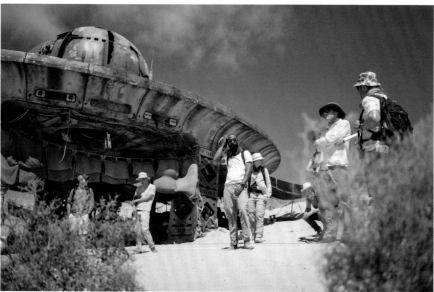

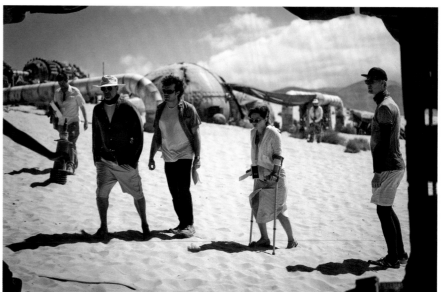

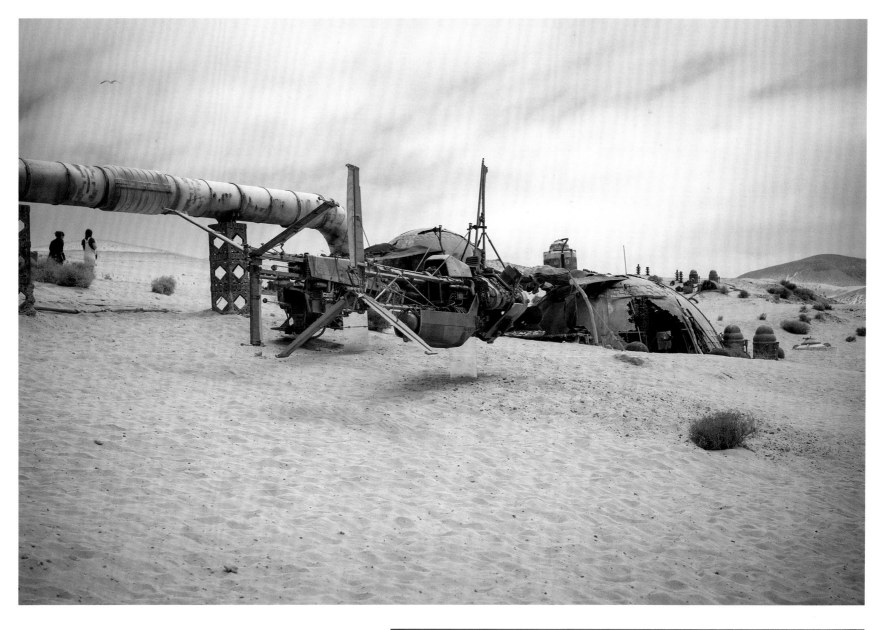

ABOVE Early on, Neil and I discussed whether some of our favorite "old school" techniques could find a spot in this film. The art department designed these swoop bikes to be supported by a single steel support, and we also brought along some mirrors just in case we could use the same technique first used for Luke's speeder on Tatooine in the first *Star Wars* film.

In a number of shots, artists painted out the supports frame by frame digitally. But, if you know exactly where to look in the final film, you'll see some shots where the bikes are floating, not with digital trickery, but old-fashioned smoke and mirrors.

RIGHT Moisture vaporators across the landscape were built practically and filled out the already expansive set.

OPPOSITE, BOTTOM RIGHT In spite of Emilia traveling to Fuerteventura with a leg injury from the previous week, she toughed it out for the shoot. She had to work harder than anyone else on set shooting in the steep sand with those crutches between takes.

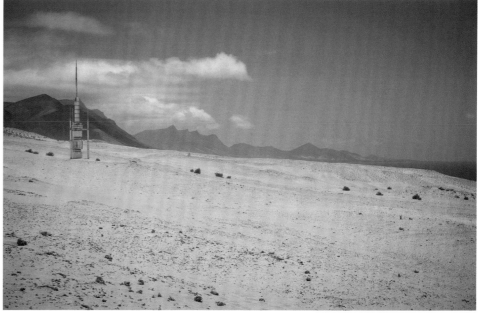

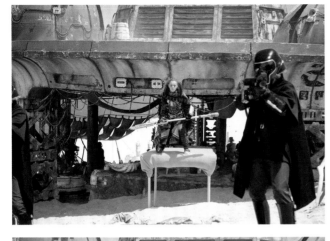

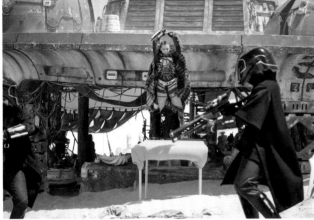

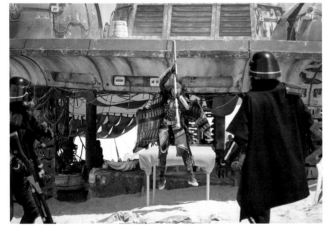

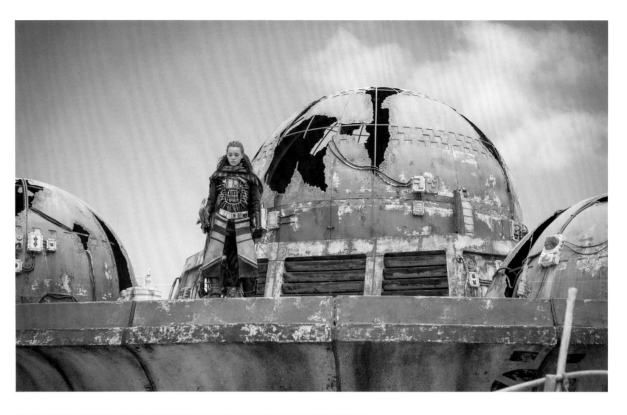

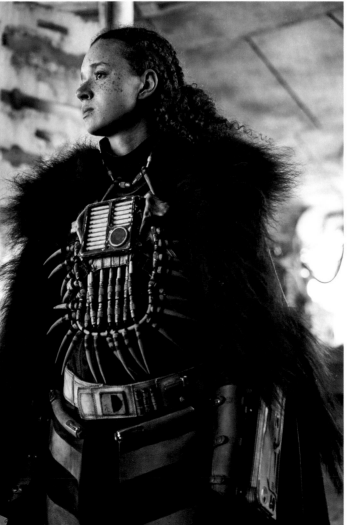

I am a costume designer, but I came into the business as a concept artist, so I still hold that kind of position. I don't think there are many costume designers that do that. Sometimes it feels like I'm doing two jobs at the same time. I'll do some concept drawings and talk about it with Dave Crossman, co-costume designer. We have a strong, almost symbiotic partnership; we always talk about everything I draw before we show it to anyone else. I got really lucky because I think we have almost identical taste. We can walk into a room and there's a costume up and we almost always have the same notes. It's great to have someone to look at across the room if you're feeling a little unsure and they say, "right?" And you think, "yeah, I thought so."

— Glyn Dillon, co-costume designer

In this film we've had the most costumes and the most variety to deal with of all the Star Wars films so far. Perhaps my favorite were the Savarians, because we were able to weave a Native American style of look—a cultural look with headdresses and very strong colors—into the designs. From a costuming perspective, this was the biggest Star Wars film ever.

— David Crossman, co-costume designer

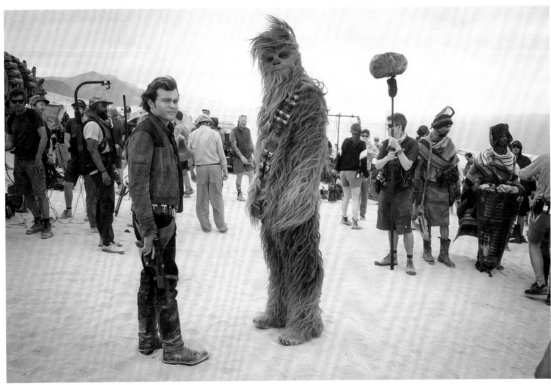
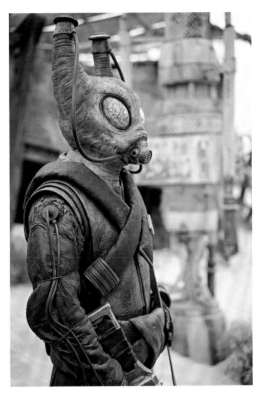
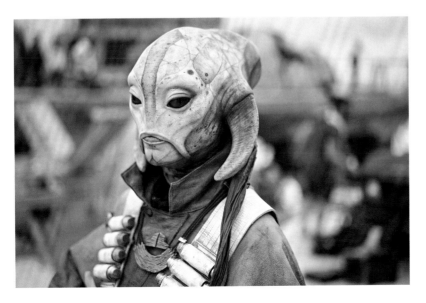
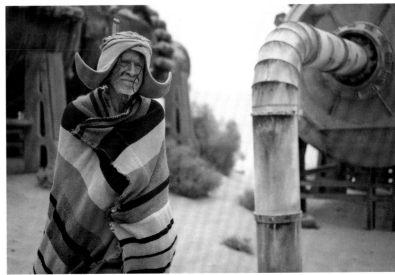

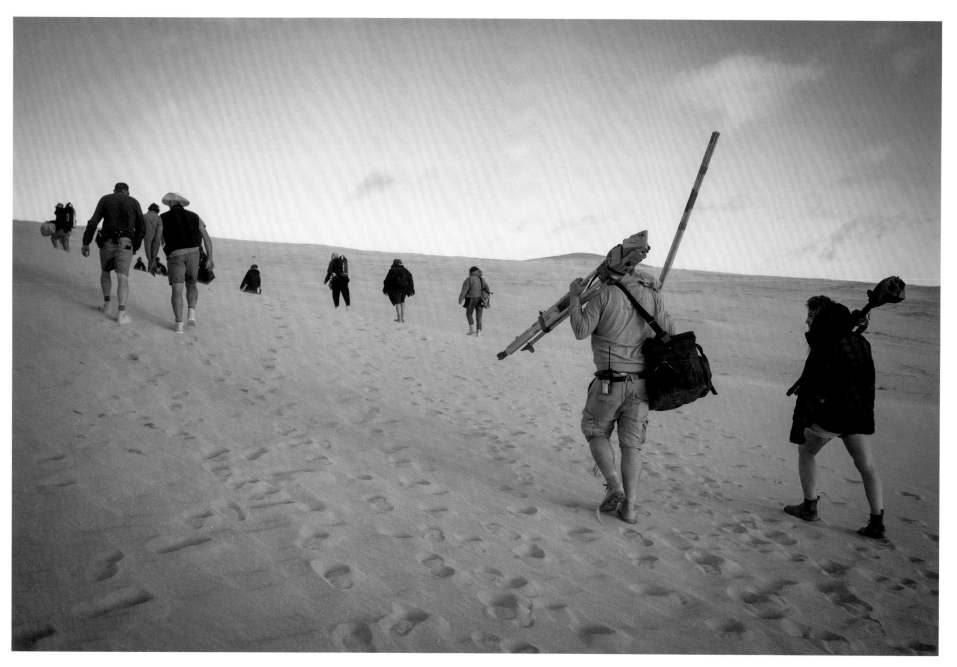

The sand blowing through the air in Fuerteventura could destroy a laptop in a couple of minutes, not to mention getting in everyone's eyes. In spite of the brutal conditions, the crew had great attitudes throughout the long days that started and ended with the cold desert air but were super-hot when the sun would come out from behind the clouds. In all, it was a strikingly desolate place to shoot the climactic scenes for the film.

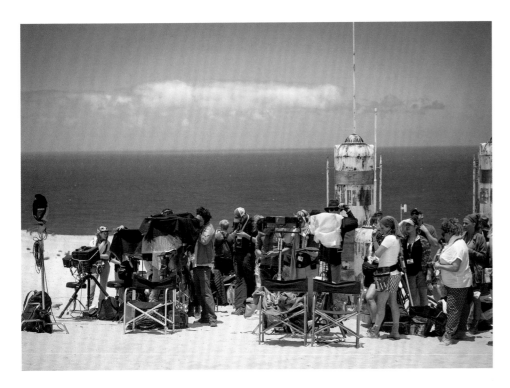
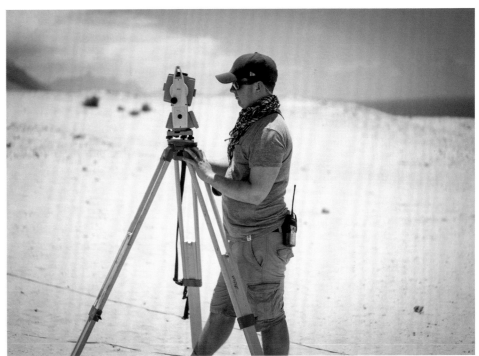

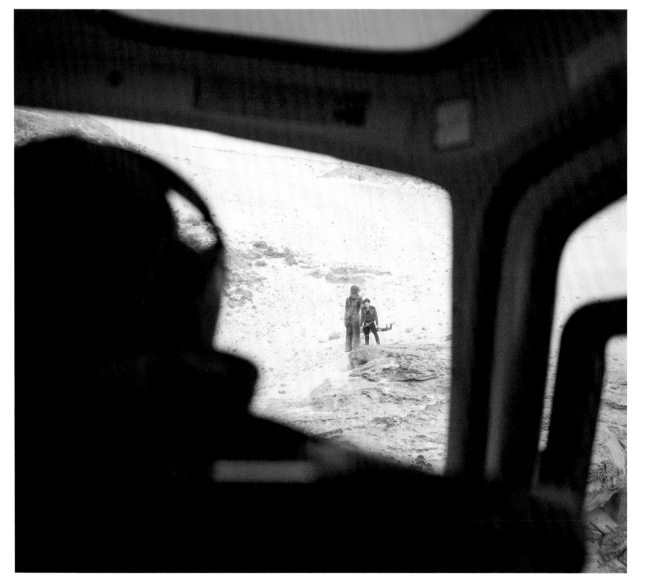

I was asked to supervise the aerial photography in Fuerteventura as well, which was another highlight for me. We had some very important shots on our list, including Han and Qi'ra's goodbye scene, which I had planned out in pre-vis and got to fly for real.

But perhaps my favorite shot was flying low and fast over the Savarian town to get various options for the *Falcon*'s crash landing, coming in hot to land at the coaxium refinery. Just telling the pilot we're acting as the *Millennium Falcon* got everyone in the right mood. Those hard banks were some of the strongest g-forces I felt during this shoot—fortunately I remembered to keep my head up and my bearings about me this time! We were really cooking as we flew low and fast over the town, then out over the water, trying a number of different angles early one morning before the rest of the crew had been called.

In the end, we got exactly the action we were looking for—the huge set the art department had built paid off. And then the artists at Industrial Light & Magic took over and made a digital extension for the very end of the shot, supplementing the photography with a digitally re-projected set and landing pad—of course, adding a beautifully animated and rendered damaged *Falcon*. A memorable shot from beginning to end for me.

OPPOSITE, TOP After an early scout, these are the rough boards I drew on the plane to pitch the landing concept. A variation on this is the one we ended up settling on for the film. I'm not a great draftsman, but it's super fun to try to draw some of these beats to communicate the ideas for the film. And the more I drew the *Falcon*, the more recognizable it became!

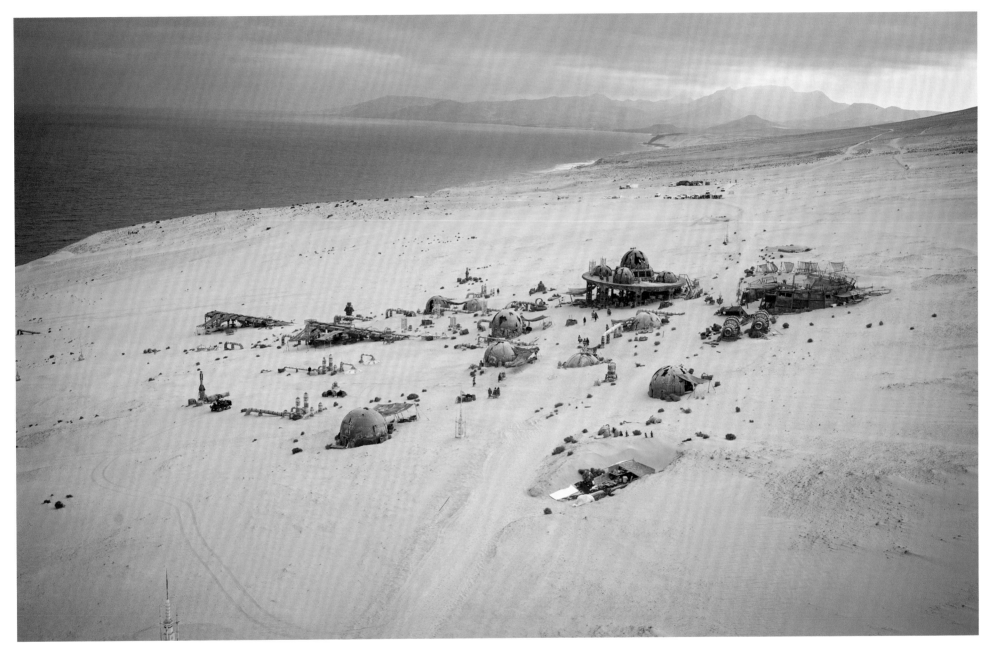

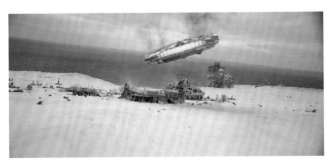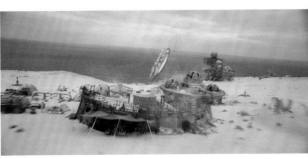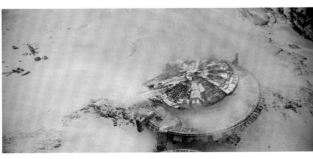

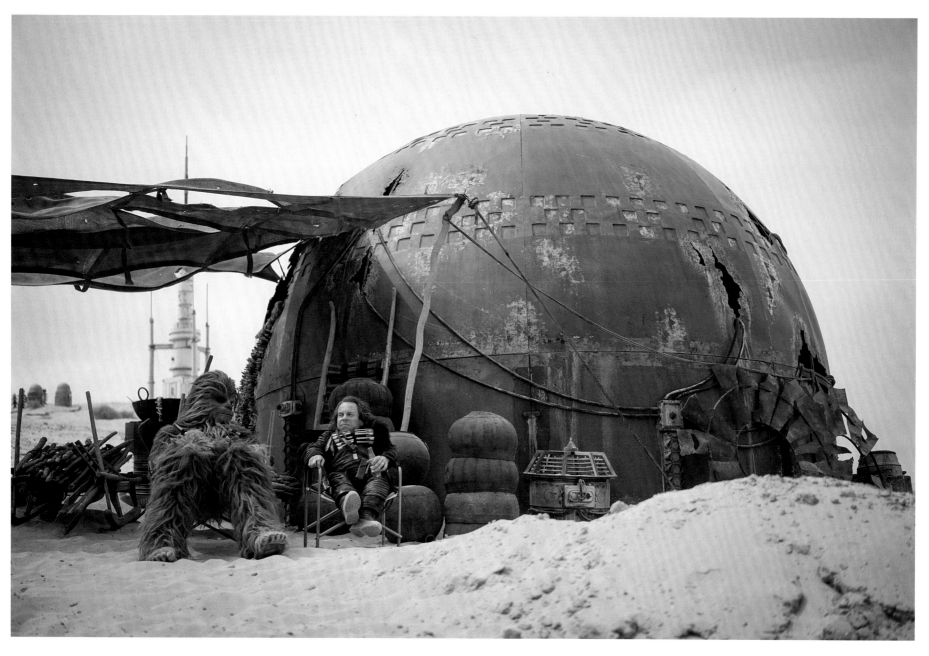

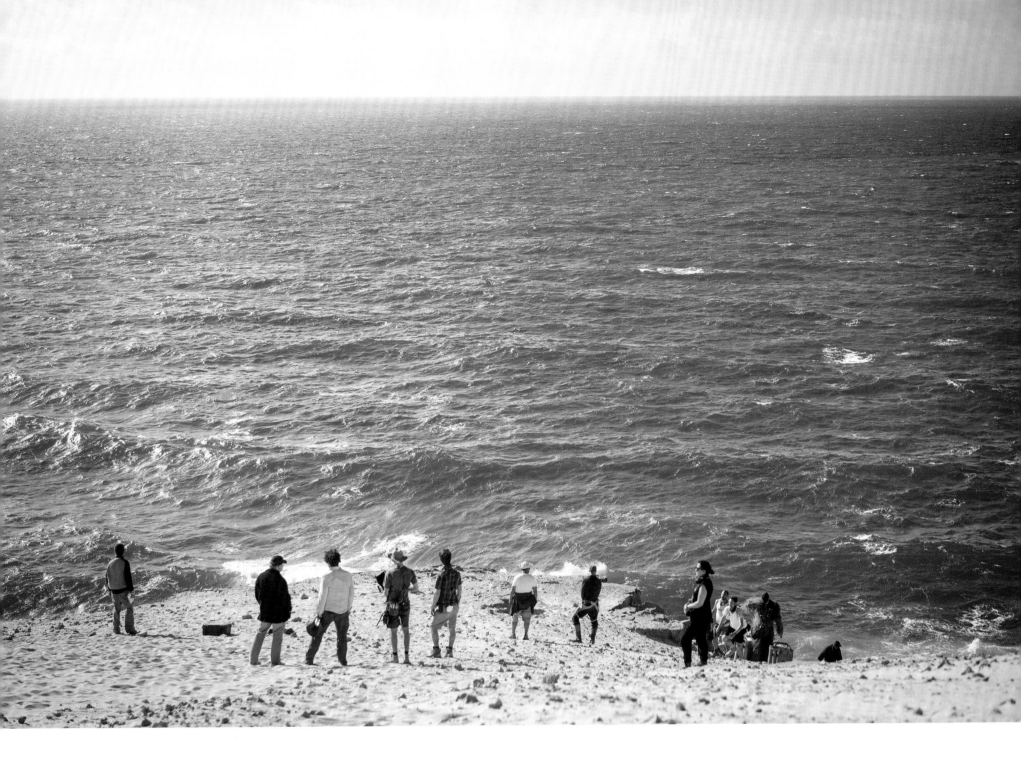

OPPOSITE, TOP Joonas Suotamo (Chewbacca) and Warwick Davis resting between takes on Savareen

OPPOSITE, BOTTOM LEFT The camera department brought this tracked Technocrane to access the steep slopes of the set. Covered with a tarp, it looked suspiciously like a sandcrawler.

OPPOSITE, BOTTOM RIGHT Executive producer and president of Lucasfilm Kathleen Kennedy talks with Sylvaine Dufaux on location in Fuerteventura.

ABOVE Blocking out the Han and Beckett showdown from on top of the hill looking down.

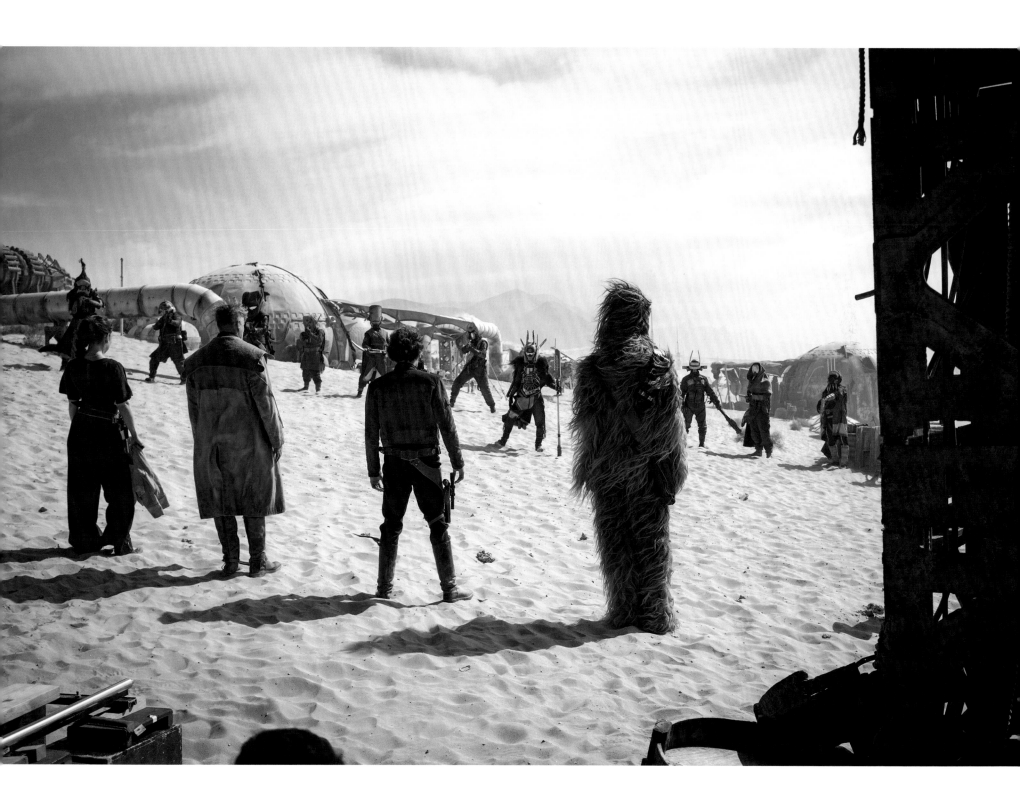

ABOVE Alden standing by between takes, ready to take another
tough walk up the hill on camera to approach Emilia.

Kessel

THE DROID REBELLION

One of the most complicated scenes of the film to shoot was the action scene on Kessel: the droids and slaves break free from their shackles and, in the chaos, our team makes their escape with the coaxium. The set was large enough to show up on Google Maps. There were effects in every direction with weapons, huge explosions, atmosphere, and as many cameras as Bradford could setup at once—all going for every take. We had hundreds of extras on set every day, and at least as many crew. It took a team of thirty just to feed everyone. This was a scene that really benefited from Ron Howard's steady directorial hand.

The sequence was started with Brad Allen, action designer/second unit director, and the action stunt team who blocked out the hugely detailed choreography. When Ron had additional ideas and simplifications, splinter unit director John Swartz took an afternoon with an iPhone on the set to block out options for coverage. Ron made additional notes and coverage changes as we were shooting and doled out shots to both the second unit team, who handled all the major stunts, and splinter unit, who handled more of the acting moments over the next few days to clean up all shots for this complicated beat.

The end result is a thrilling escape that leads our heroes directly into the unknowns of the Kessel Run; unknown both to the characters in the film and to the visual effects department as our ideas for the sequence evolved even into post-production.

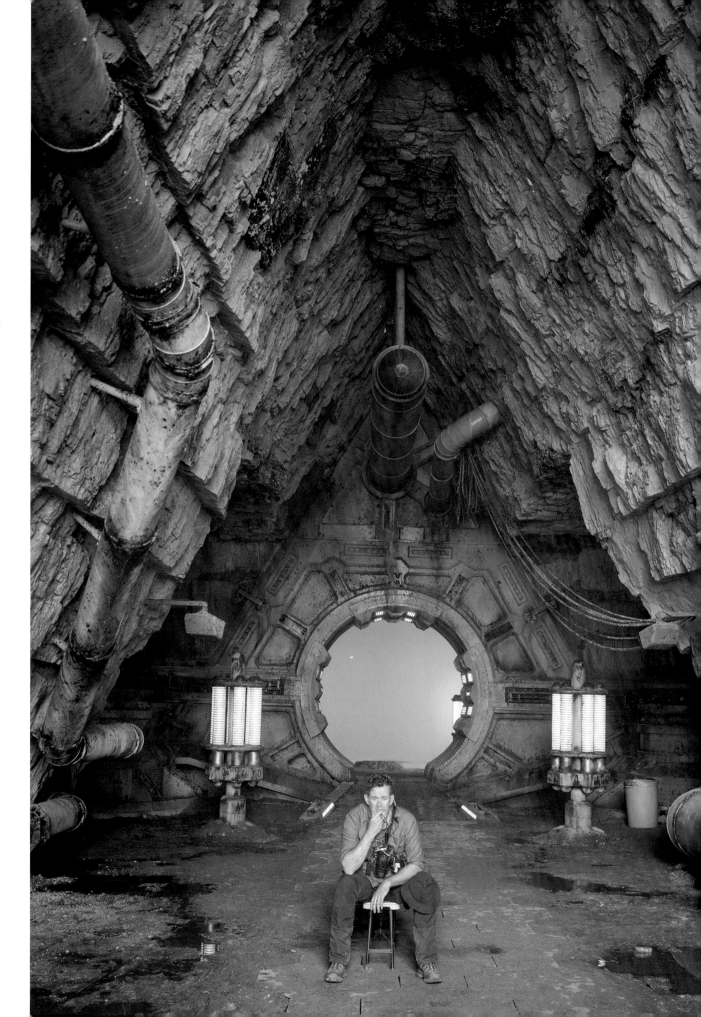

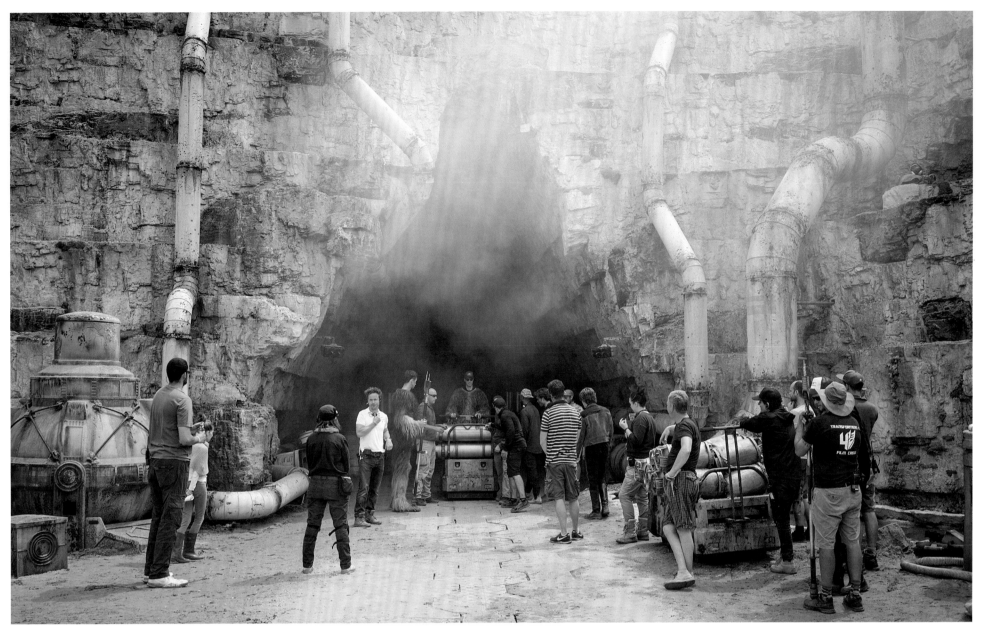

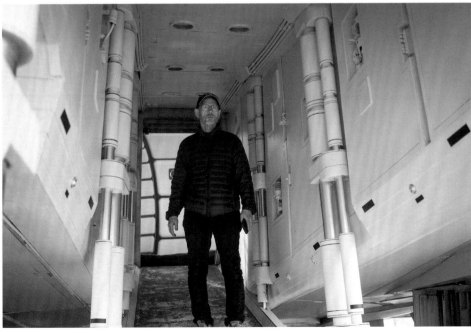

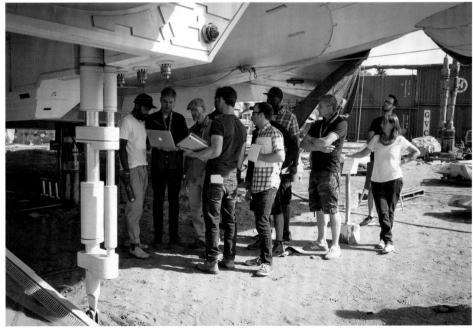

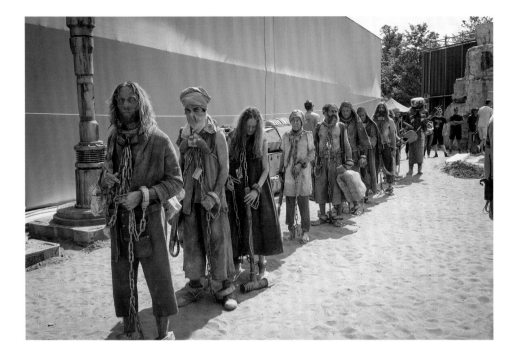
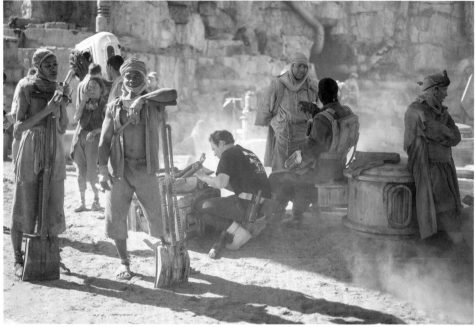

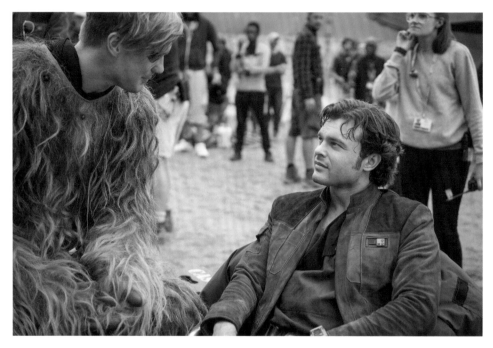

From a VFX perspective, we had to be ready for everything. Even though the set constructed by the art department was huge, it still rarely filled the frame with Bradford's wide lenses and cameras tucked into every corner. Nearly every shot had set extensions, lots of digital blaster fire to add, and of course all of this integrated into the atmospheric environment created by Dominic Tuohy's on-set SFX team.

One of the biggest tricks with shooting outdoors is the variable weather. Bradford was looking for overcast days, which is usually a good bet in London, but a lot of the time it was sunny. Bradford and his team flew in giant shades hanging from cranes to allow us to shoot in the middle of the day when the sun was otherwise too powerful. We'd use practical smoke to try and hide the parts of the background that were too bright. Sometimes, Ron would lean over to me and ask, "can you fix that?" and I figured we probably could. As it turned out, the VFX artists on this sequence really delivered in both extending the backgrounds, blaster fire, and explosions—and all the other little details that bring Kessel to life.

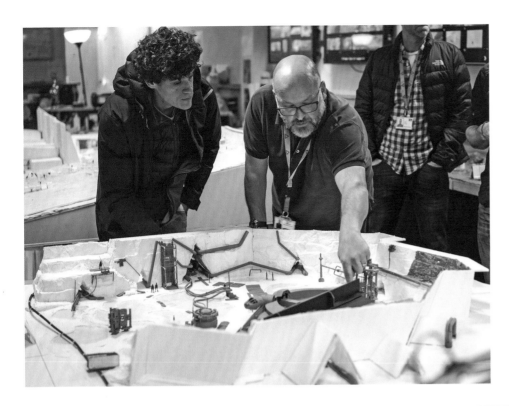

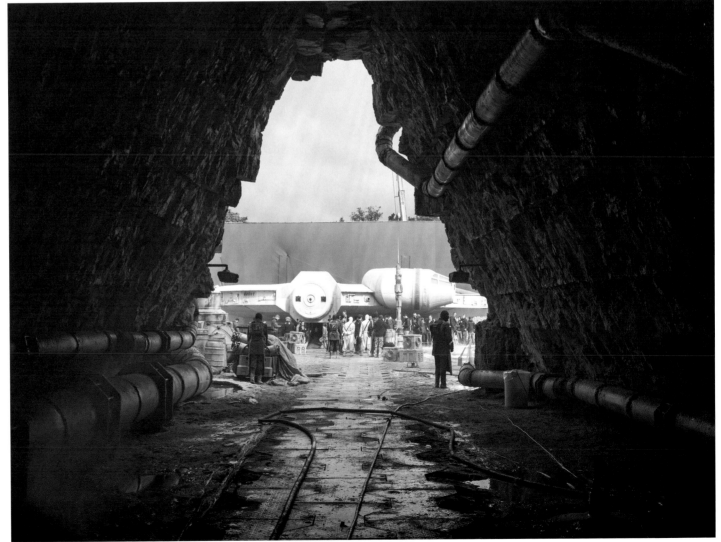

TOP LEFT Executive Producer Phil Lord inspects an early foam core model of the Kessel Landing Pad.

TOP RIGHT The view out the "triangle tunnel" on the foam core model, and below it (right) is the same view on the set. Just like the plan, only we moved the *Falcon* a little to the right after seeing it all lined up (which took two giant cranes!).

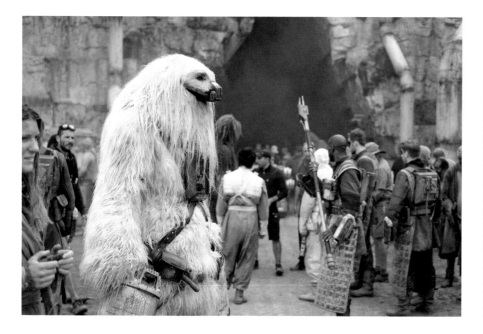

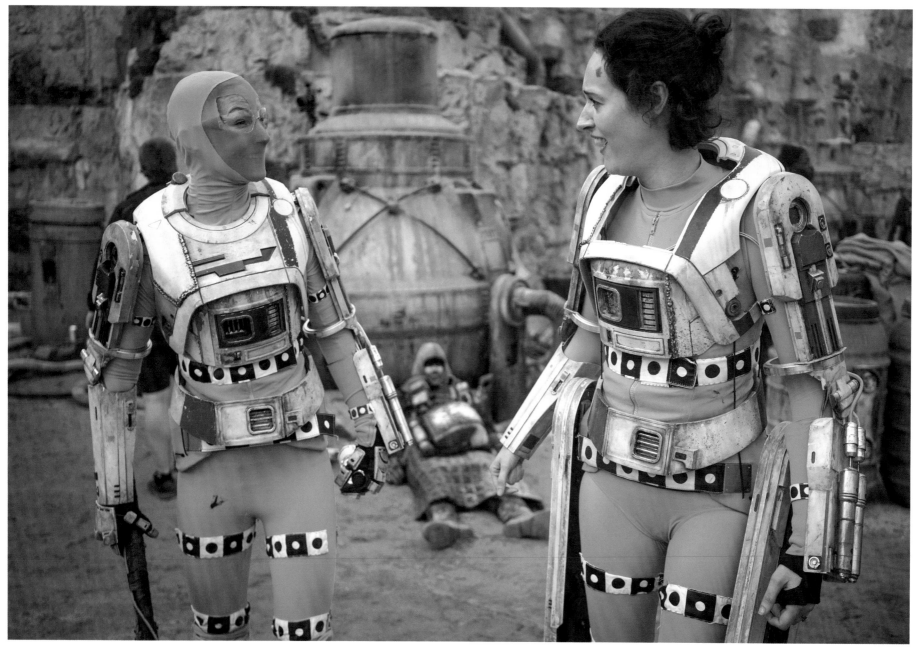

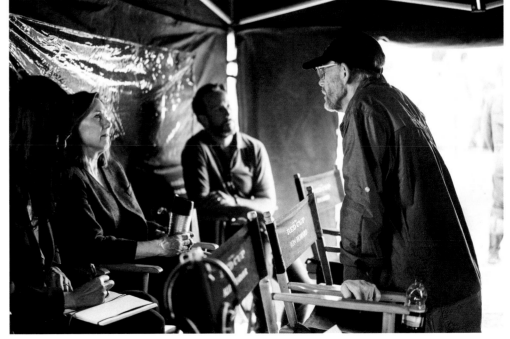

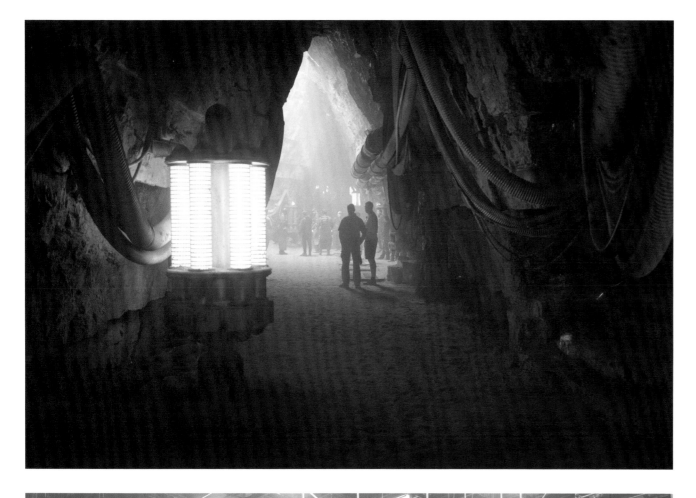

My job as supervising art director is to manage and realize the vision of the production designer, Neil Lamont. We have worked together for more than twenty years now, off and on, on various projects including Star Wars, which has become a huge portion of our work. My role as supervisor is to build a team to deliver Neil's vision and make sure we manage that team and make sure to deliver to the high standard that is expected of us and that we expect of ourselves.

The concept art is the very first step in the whole process, and on a Star Wars show that team is made up of artists from Industrial Light & Magic and artists that Neil brings in. That's the germ of the designs, where they start, and they get developed on into practical, physical sets and into the 3-D digital world as well.

That early design stage of the process tends to be more on Neil's side of things, and then I take it and translate that into construction drawings, and those get passed onto either our construction team or equally onto the visual effects department to build.

Having a good relationship with visual effects is really key to making sure the overall look is unified and carried throughout. There are so many variables within filmmaking, and having good, open lines of communication and good relationships with all departments is important, but particularly with visual effects it is such an important part of the process.

I'd like to think we functioned very well on this film and managed it well.

— Al Bullock, supervising art director

BOTTOM LEFT The exterior of the Kessel tunnels are seen here in this photo of an early morning crew meeting. The tunnel is supported externally, in places structurally hung from the stage to create the quintessential triangle caves in a design first pitched by James Clyne and taken all the way to the practical set by Neil and Al's teams.

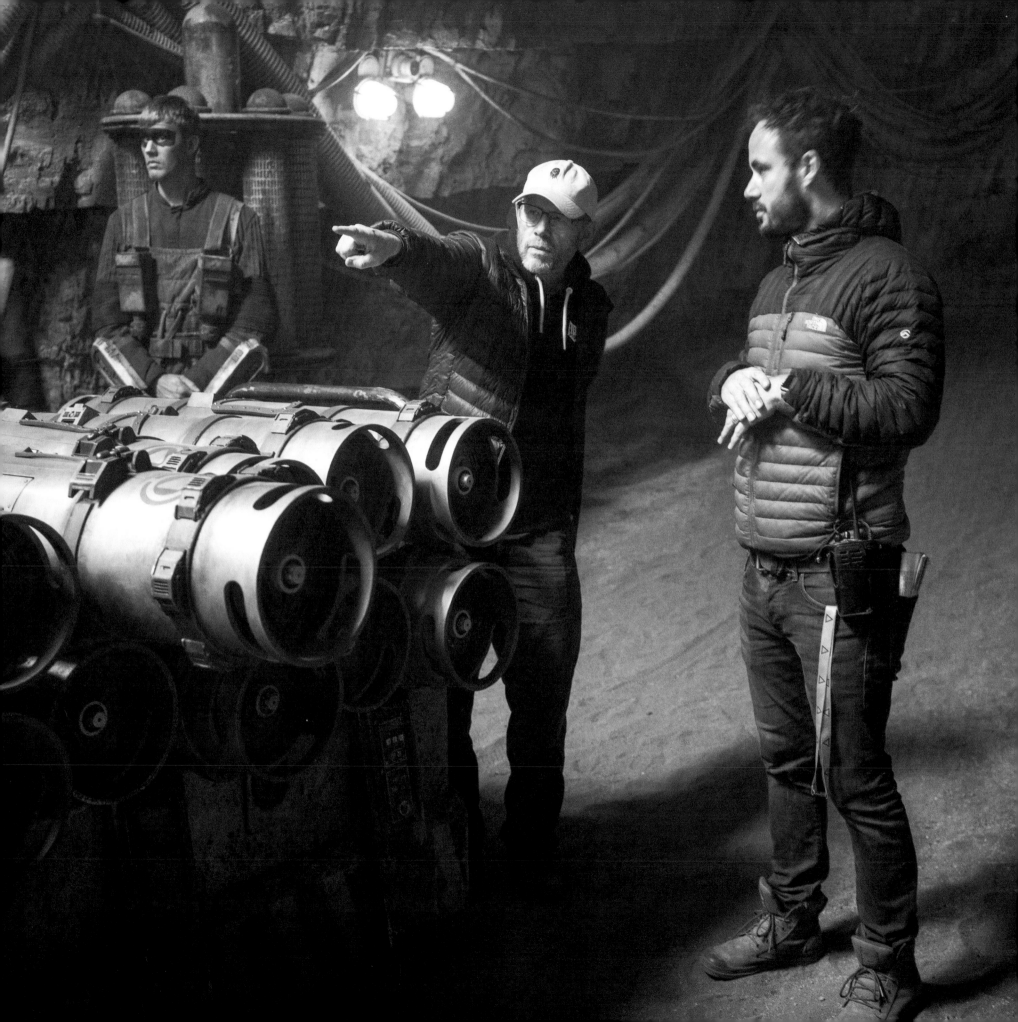

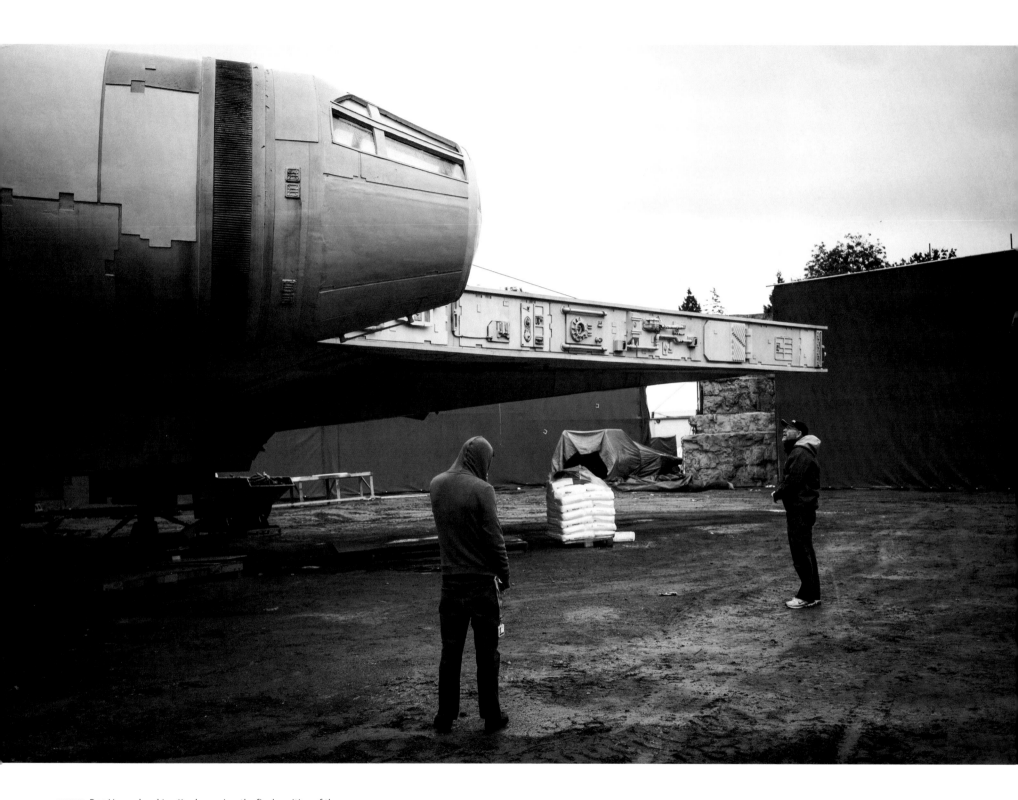

ABOVE Ron Howard and Jon Kasdan review the final position of the
Falcon for the scene where we first reveal Lando's *Falcon* in the film.

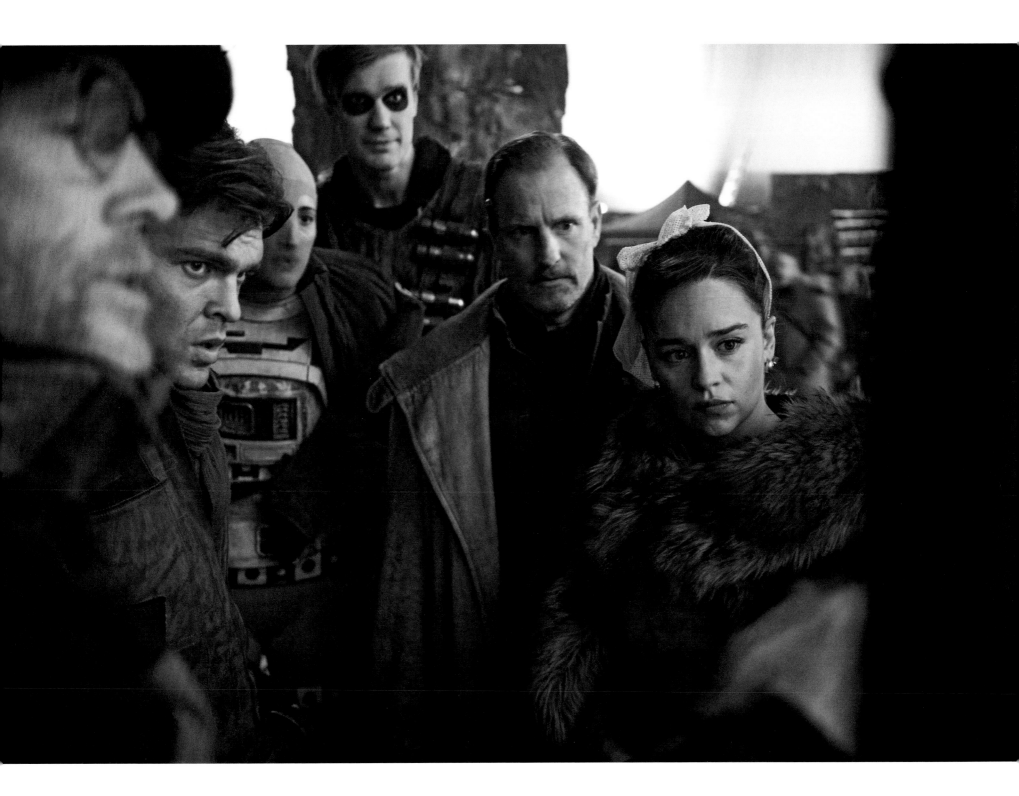

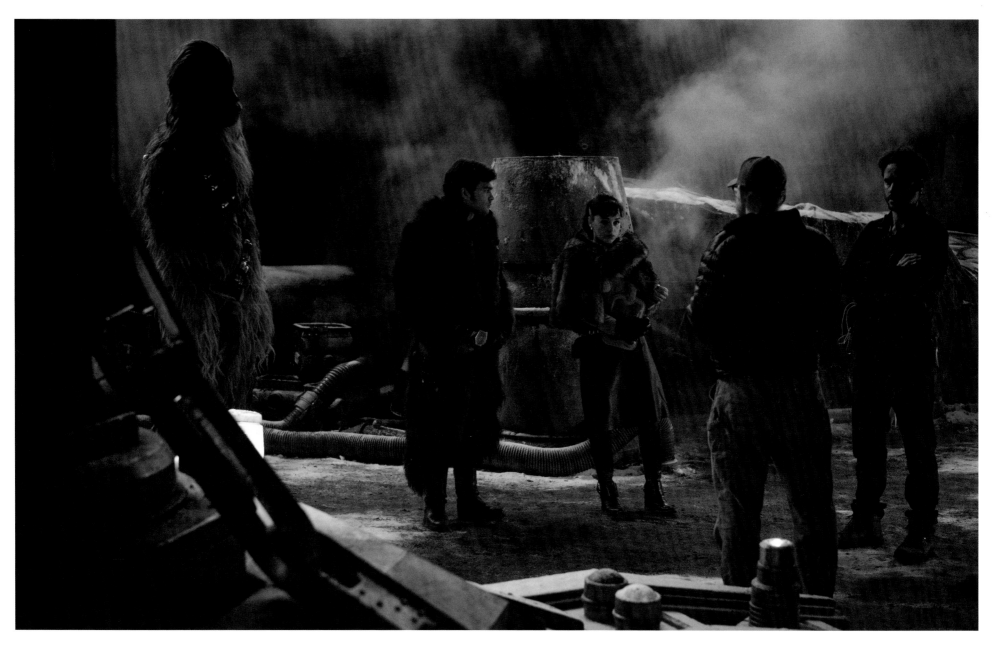

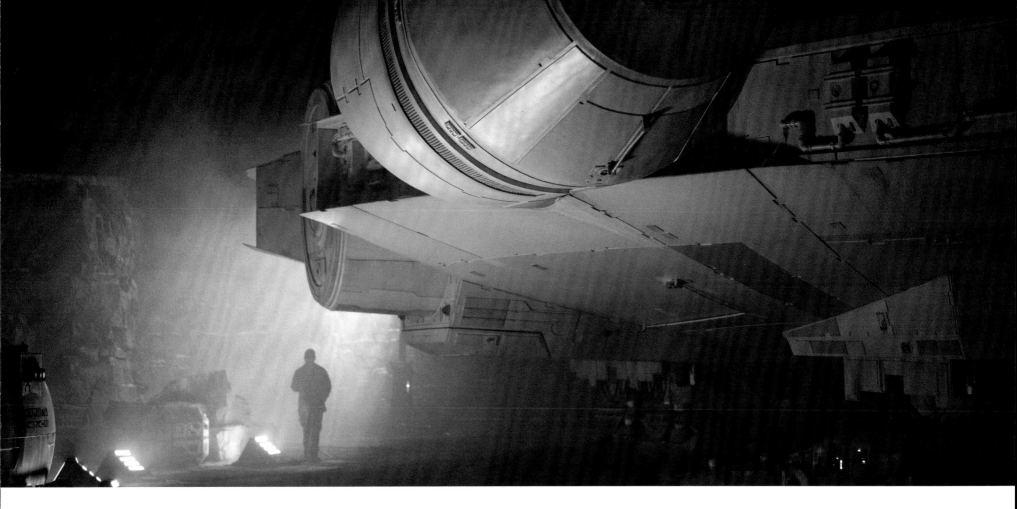

Night shoots tend to be hard for everyone involved, especially around two or three in the morning when the night is wearing long and it's usually pretty cold. This night was an exception. Phoebe was nearing the end of her shoot, and this was one of the last nights with the full cast together. In between takes, SFX set up a makeshift "campfire" for the cast to stand around. Donald was telling jokes and generally cracking everyone up. Getting the shots seemed smooth, the set was looking great, and everyone was in top form.

My extra job for the night, in addition to enjoying the vibe, was to work with the drone team to get the overhead *Falcon* shot to reveal Lando's *Falcon* for the first real hero shot in the film. After we'd wrapped all the other coverage, I remember Ron asking me if I was comfortable shooting these drone shots without him, and I was happy to. The machine could fly for a few minutes at a time, so we got the drone in about the right position, called action for our cast, and got a few variations on our shot at the end of the night, right before sunrise.

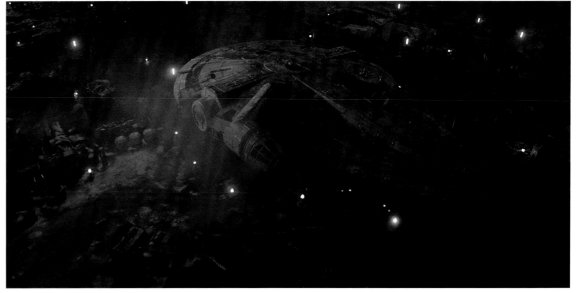

Characters Evolve

DRYDEN VOS

The character of Crimson Dawn capo-regime Dryden Vos, and the scenes aboard his luxury star yacht, were among the most hotly debated and rewritten elements of the movie. He was a major character in every draft of the script, though originally conceived as second in command to a senior crime figure.

As we progressed through several drafts, both with Chris Miller and Phil Lord and then with Ron, Dryden evolved. His elder boss was eliminated, and he became the senior crime figure in the movie, answering only to the mysterious head of the entire Crimson Dawn crime syndicate. He became a threat to Han's relationship with Qi'ra, and grew more clearly antagonistic with each draft. We used Robert Prosky's character Leo in Micheal Mann's Thief as an inspiration— an antagonist who presents himself as benign, even charming, but is deadly and ruthless.

Paul is a brilliant actor and an absolute pleasure to work with. While most actors would return to their dressing room or trailer between setups, Paul would hang out with us at the monitor, talk about movies and life, and tell stories. He brought humor and enor-mous charisma to Dryden, and his input immediately found its way into the pages we were constantly rewriting.

We ended up shooting all of the scenes on Dryden's yacht twice and we were able to learn and improve the scenes the second time around, even making changes to the set. We were writing up to the very last moment, as you can see from this picture of me. They end up being among the most fun in the movie.

— Jon Kasdan, cowriter

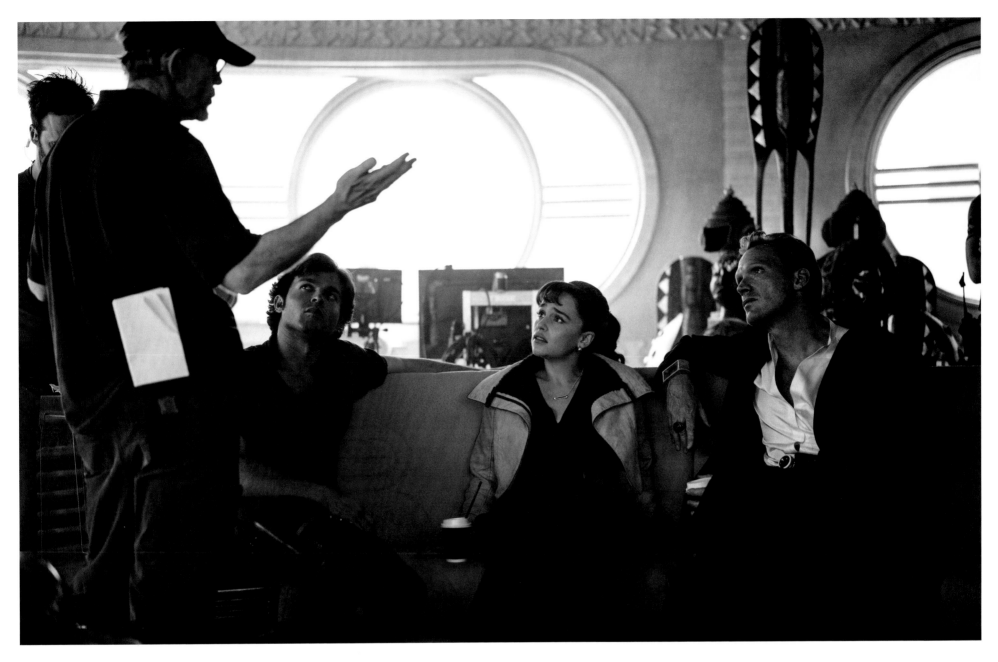

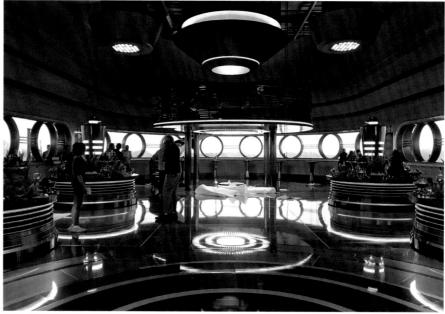

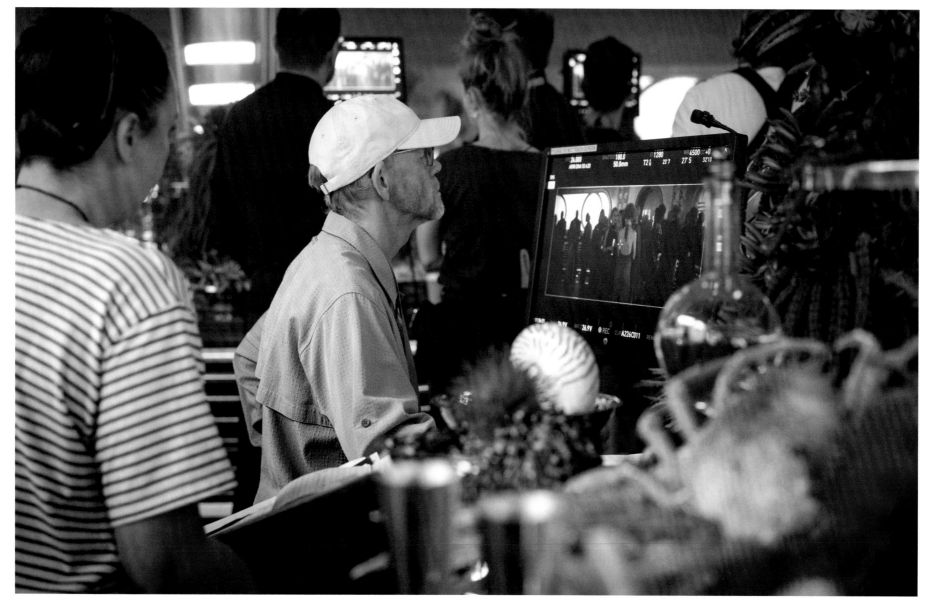

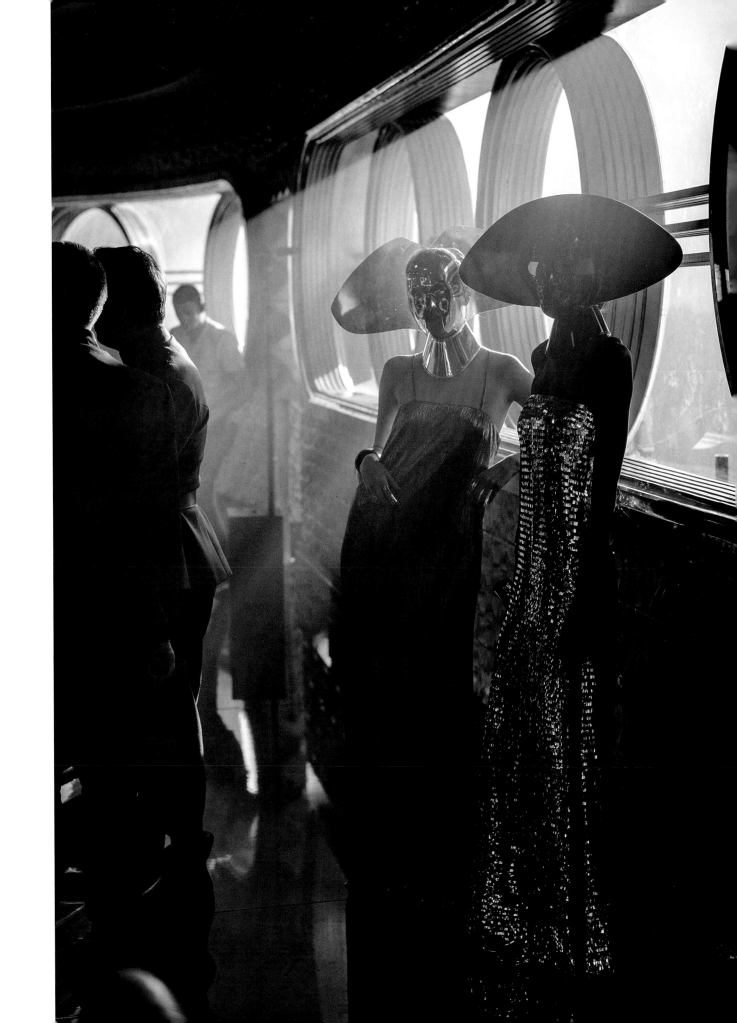

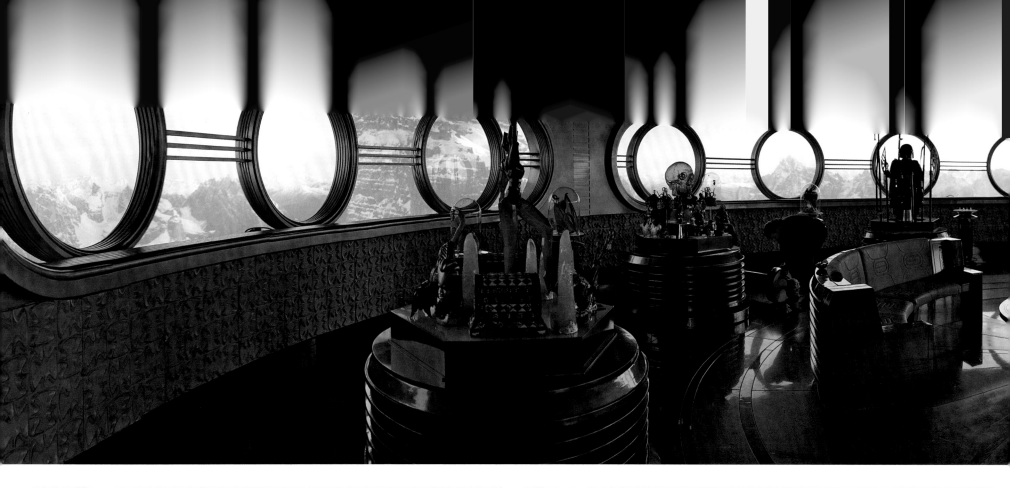

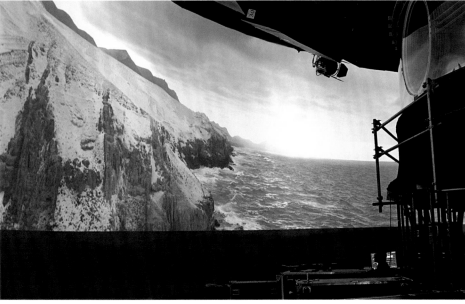

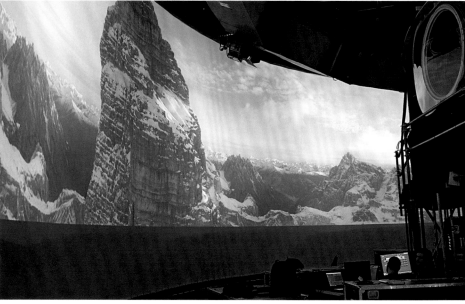

We used projection to create the vista outside Dryden's office. The imagery was created from moving footage I had shot from helicopter shoots both in Italy and Fuerteventura that was stitched together by the artists at Industrial Light & Magic and projected here with eleven laser projectors.

The completed illusion looked very convincing by eye and was carefully calibrated to provide exactly the right light for the camera, even taking into account the slight tinting effect the plexiglass windows would have otherwise added. The view out the window could be changed instantly from Vandor to Savareen, with just the flip of a switch. When we were in the mountains of Vandor, we had wind blowing the snow off peaks and even flying Vandorian seahawks. On Savareen, crashing waves and flying seagulls helped complete the illusion of a live environment.

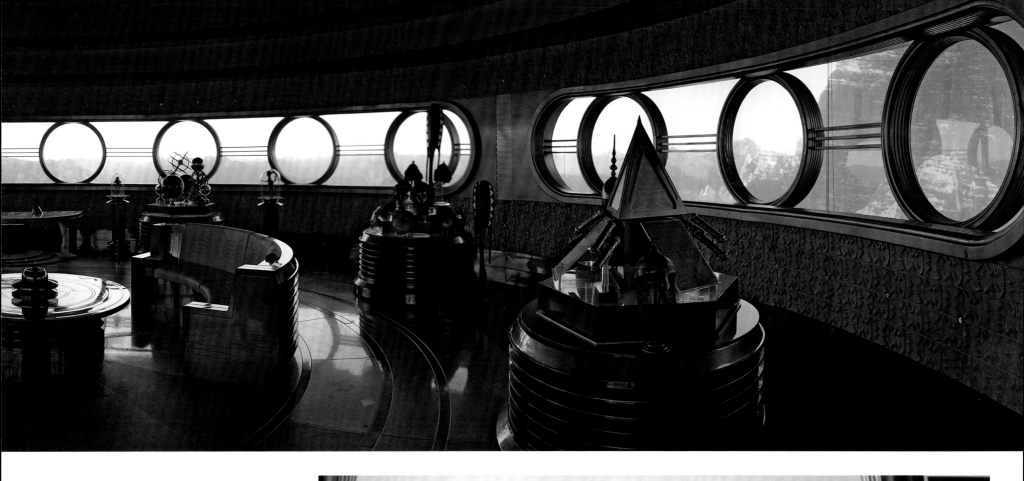

Spending time on a Star Wars *set is always exciting and a bit surreal. You are overwhelmed by the amount of talent and artistry that goes into the creature design, set building, and professionalism of the filmmaking army. But my favorite moment, one I will never forget, is standing in Dryden's ship. You look out the window and see Vandor so perfectly projected that you feel like you are on another planet. And then in walks Chewbacca. Not Joonas Suotamo dressed as Chewbacca. No. For me in that moment, it was Chewbacca.*

My inner eight-year-old was high-fiving my outer thirty-nine-year-old. It was magical!

—Matt Shumway, animation supervisor, ILM

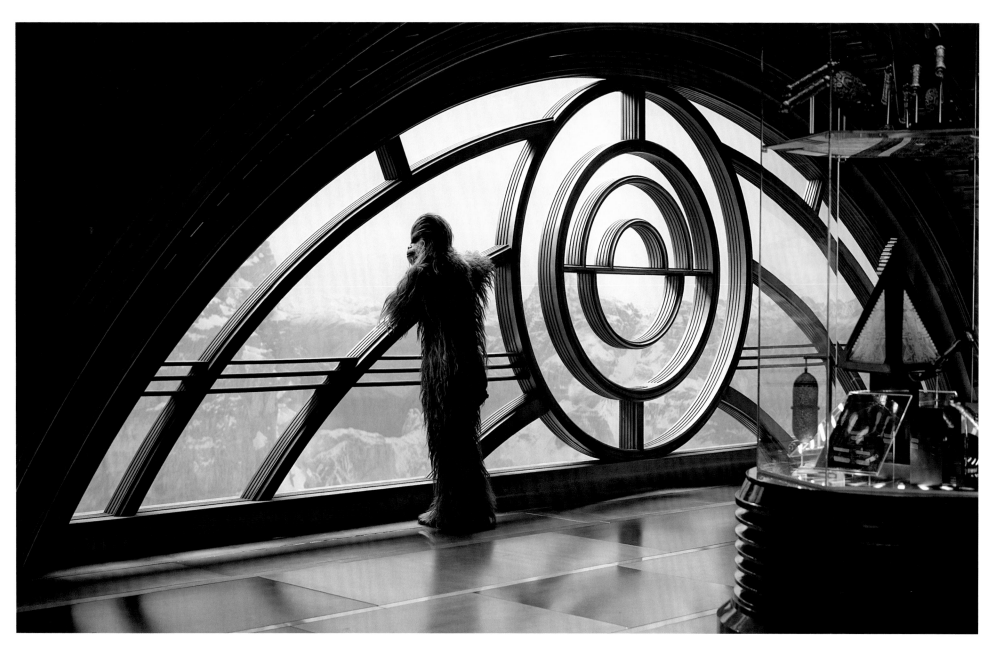

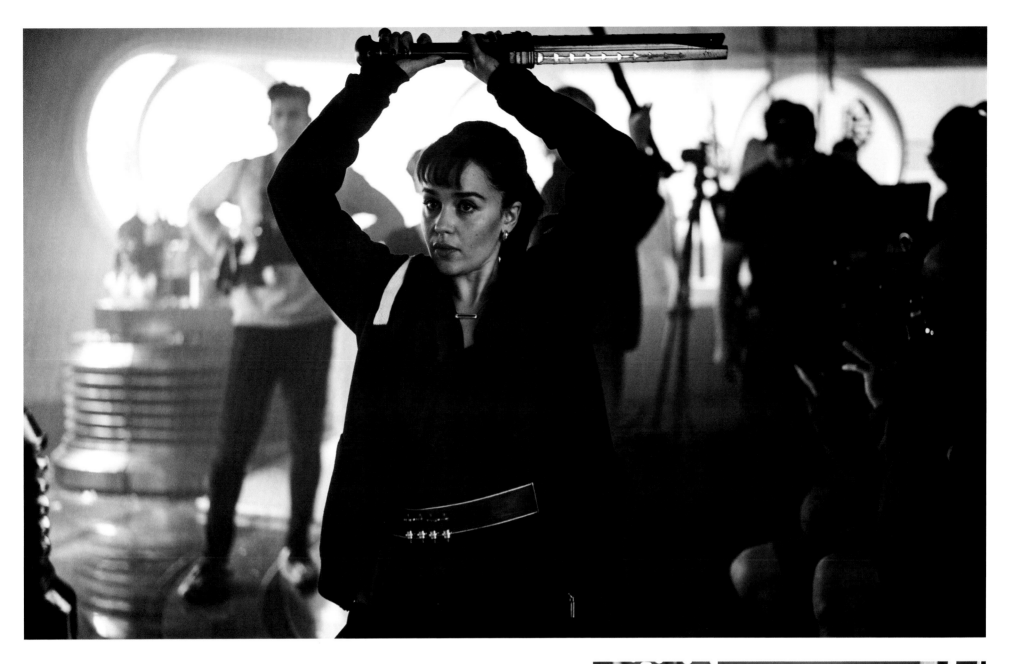

Fight scenes take time. They take a lot of training and camera setups, especially when you want to see your actors doing all the action. In our case, we were pressed for time, so Ron had the second unit shoot the fight scene all the way through with the stunt players in for every shot. Then, editorial made a quick cut of the scene, and we chose just the shots we needed for the cast to re-create. For the shots where the cast couldn't duplicate the stunt, we used "face pastes"—the actors performed the stunts at half speed a few times until we matched close enough to the reference stunt performance. Then, the visual effects team at ILM "pasted" the faces of our cast on top of the stunt players. The final result is a seamless mix even though we shot the faces on a completely different day than the bodies!

Later, Ron told me he thought it would take forever to shoot the "face paste" shots because we'd need such a good match. Fortunately, our camera department was quick to line up the shots and the lighting, and the cast was game to do take after take. We'd play back the results against the reference select and I'd guess (by eye) if we had enough to make it work. In the end, I think most people will be tricked and see our cast performing all of the complicated stunts, even though ILM swapped out all the faces throughout the scene.

RIGHT Ron Howard directs the action, crammed into the elevator on the raised set next to Kathleen Kennedy.

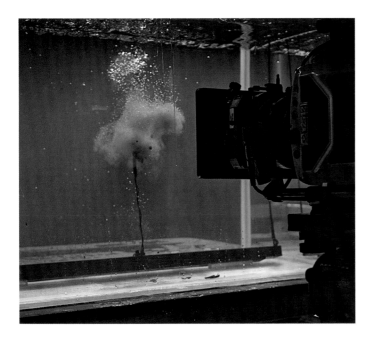

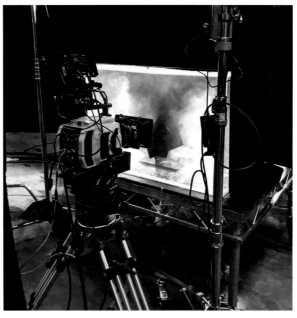

Star Wars has had incredible explosions since the destruction of the Death Star in the very first film. I wanted to find something unique for the coaxium explosion at the end of the Train Heist sequence. In researching various options, I found some high-speed reference of underwater explosions and that really inspired us for this two-stage blast. I wanted to shoot it practically to get those unexpected results, but, unfortunately, with a small charge the entire explosion lasted only 1/100th of a second!

We researched our camera options and found a Phantom camera that could shoot at 25,000 frames per second. This remarkable camera didn't have particularly high resolution or color range, but it had exactly the frame rate we needed. It would give us several seconds of explosion elements from this near-instantaneous event.

Another trick when shooting at these high frame rates is the lighting. To see anything at all with such a short exposure, you need a lot of light. We rented lights custom built for lighting at high frame rates. They would charge up with a large capacitor, and right before we'd call action, we'd flip the switch. The lights put out 99k [watts] worth of light each for ten seconds at a time, sort of like a really long flash. It was so bright we had to shield our eyes for each take.

We 3-D printed the precise shape of the mountain range, placed it underwater in an aquarium, lined up the camera to match the angle from the aerial plates, and then mounted the charge. Three, two, one, pop. The explosion was barely audible and looked small in real life, but on camera at 25,000 frames per second, with the mountain for scale, it looked exactly like I was hoping. And we got those unexpected shapes I was hoping for, too.

We needed the right charge to simulate the coaxium exploding on the mountain range. I knew we could do better than a firecracker, so we made a bespoke pyrotechnics charge and placed it strategically on a 3-D print out of the mountain range that VFX had captured on location in the Dolomites. We filmed this at 25,000 frames per second, and looking back at the footage, the images, color, and texture of the gases from the charge expanding and imploding on themselves was truly something special. The interaction with the 3-D printout really gave it scale.

— Dominic Tuohy, special effects supervisor

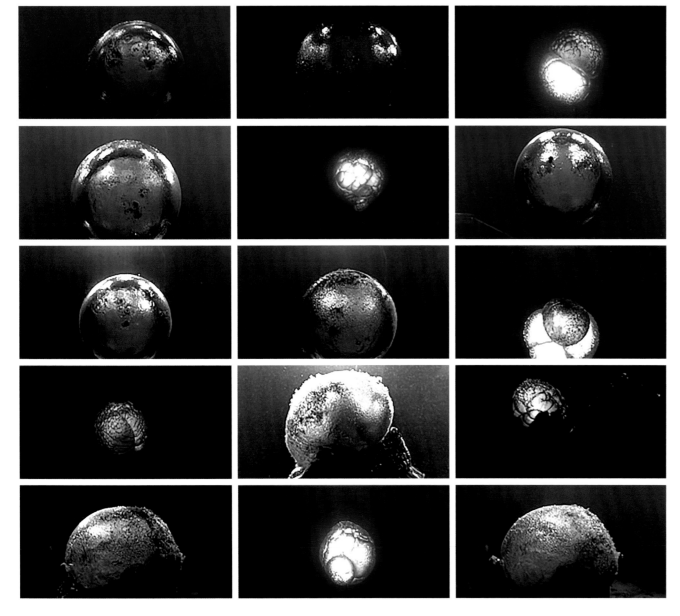

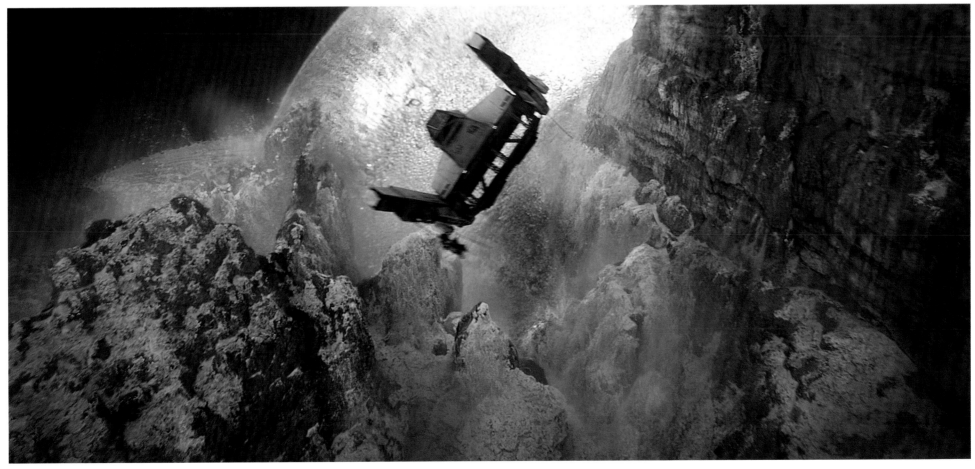

LADY PROXIMA

Another character that had quite an evolution over the course of the show was Lady Proxima. The design was led by the creature FX department with hundreds of drawings and designs. When Ron Howard joined the film, he wanted to revise the character to allow for more freedom of movement. He wanted Proxima to be able to get right up to Han and threaten him as directly as possible.

The CFX team built a polearm-based rig to support the character, which required a sizeable team of puppeteers to move around the set. One person controlled the height, another the left-to-right motion. Two puppeteers swam around in the water with long rods attached to

Proxima's hands to control her gestures. There were hundreds of tiny servos actuating her facial expressions and even controlling her secondary arms. Unfortunately, in the challenging wet environment, the arms died early in the first day, so they were replaced digitally to give them the performance we needed.

In addition to painting out all of the many puppeteers and all the associated rigging, the artists at ILM also adjusted Proxima's lips, eyes, and brow to sync her animation for the final performance. It really was a case where combining both practical and digital brought the character to life in a fresh way.

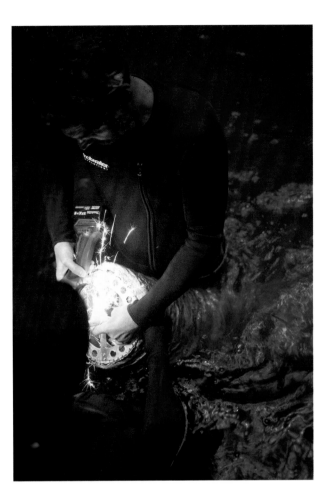

My daughters (pictured right, on the left and center) had a chance to play as extras for several weeks during the shoot. I asked Abigail, my oldest, to share one of her funny experiences from the set:

"So there I was, cramped and sweaty in the other-worldly set of Lady Proxima. We were all slouching around, sitting in mucky puddles and yawning. Every-one's attention was on the only exciting thing that was happening: Alden rehearsing in the center pool.

"Next to me a boy only a little older than I was whispered to us all, 'You know what I hate about Holly-wood? None of this is real. That guy down there,' he said gesturing to Alden, 'That's not even the real actor. That's the stand-in.' He spoke confidently and boldly and I looked over at Alden before speaking up.

"'No. That's Alden.'

"He turned to me with faux sympathy, as if I was a child still believing in the tooth fairy, and sighed. 'That's just not the way it works over here,' he said.

"Then it happened. Alden walked passed our grimy little corner to go talk to the directors and he paused when he saw me. 'Hey, Abby!' He grinned and kept walking.

"'Hey, Alden,' I said, smiling widely as the cocky boy looked down at his feet. Victory."

ABOVE Alden got the cast playing "the movie game" between takes on set. The game goes back and forth with no repeats. The first person names a film and then the next person names an actor in that film. The next person has to name another film that actor was in, and play continues until someone is stuck. Woody had been in so many movies, he'd always pull it back to some obscure film he was in that no one else knew for the win!

ABOVE Bradford Young talks with Kathleen Kennedy on the side of the Kessel Tunnel set. Kathy was a huge supporter of the look of Bradford's photography throughout the production.

RIO DURANT

Rio's performance was truly a group effort. On set, he was performed by Katy Kartwheel. The brilliant Jon Favreau provided the voice in post, and our animation team brought it all together by adding their own talents to the mix. We even got our amazing director, Ron Howard, to provide us some hilarious facial acting! It was so wonderful to see everyone's collective brilliance bring Rio to life.

— Matt Shumway, animation supervisor, ILM

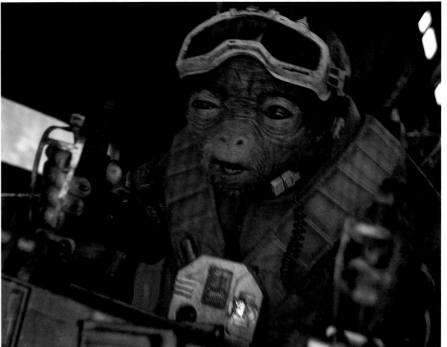
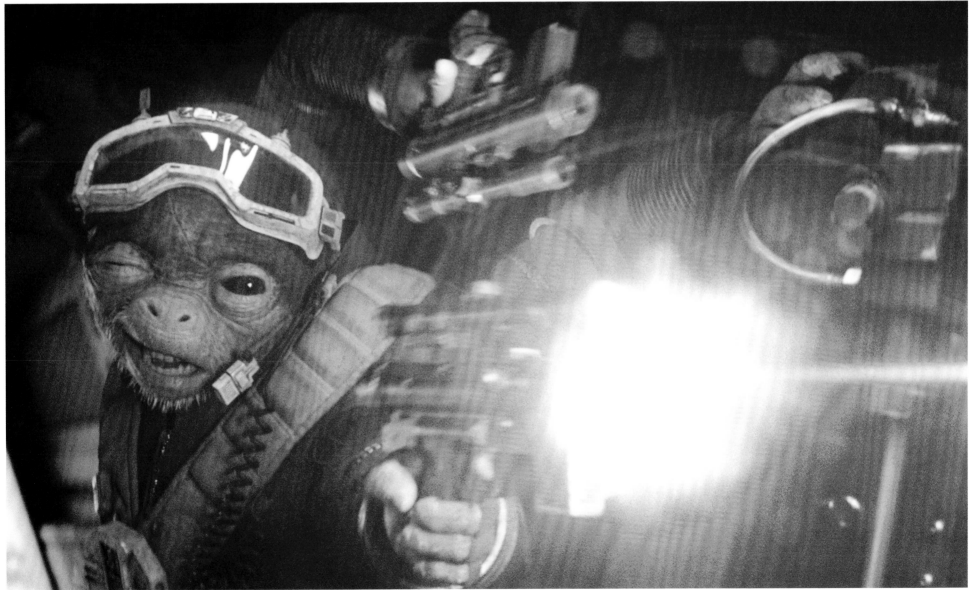

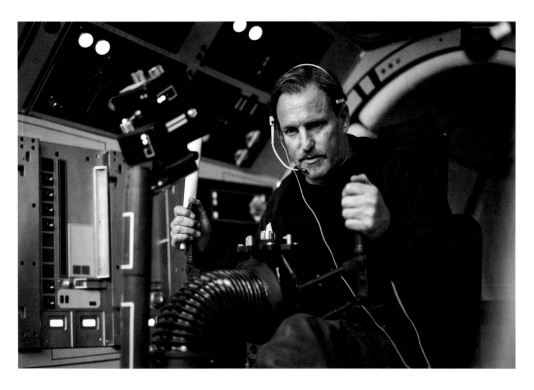

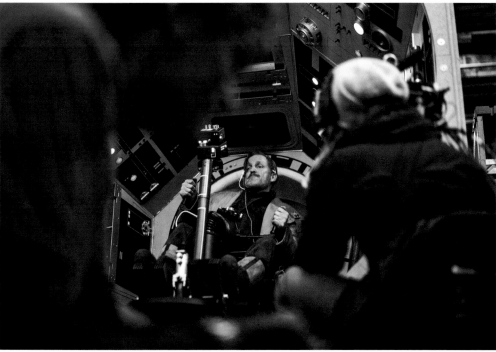

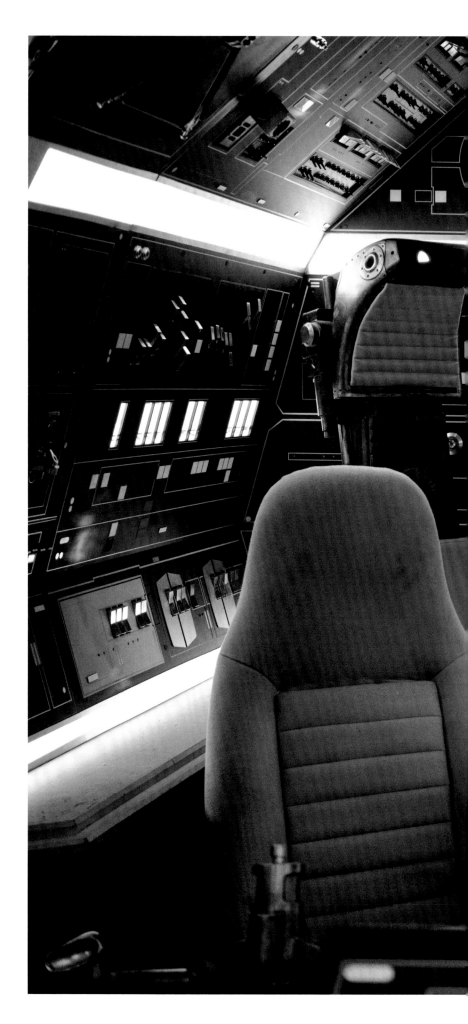

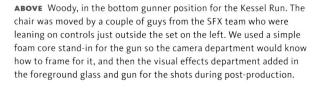
ABOVE Woody, in the bottom gunner position for the Kessel Run. The chair was moved by a couple of guys from the SFX team who were leaning on controls just outside the set on the left. We used a simple foam core stand-in for the gun so the camera department would know how to frame for it, and then the visual effects department added in the foreground glass and gun for the shots during post-production.

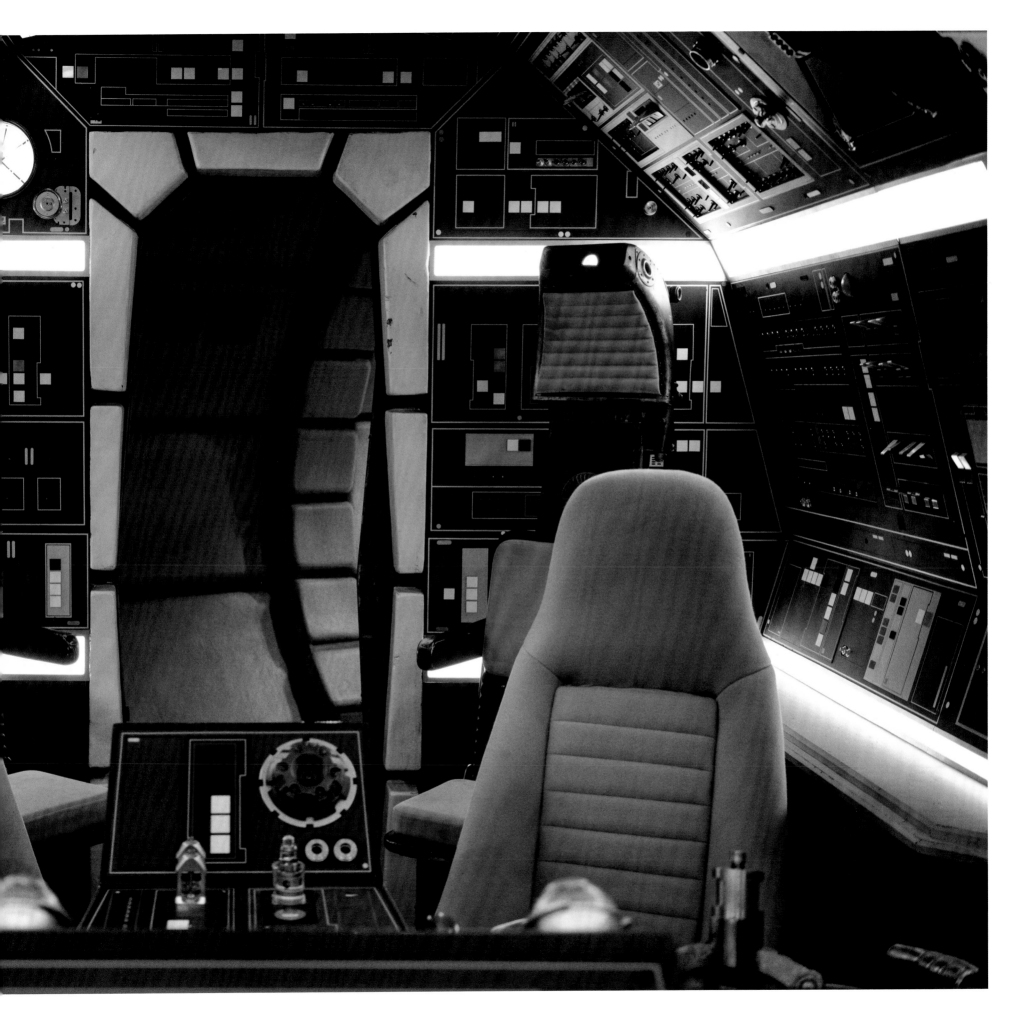

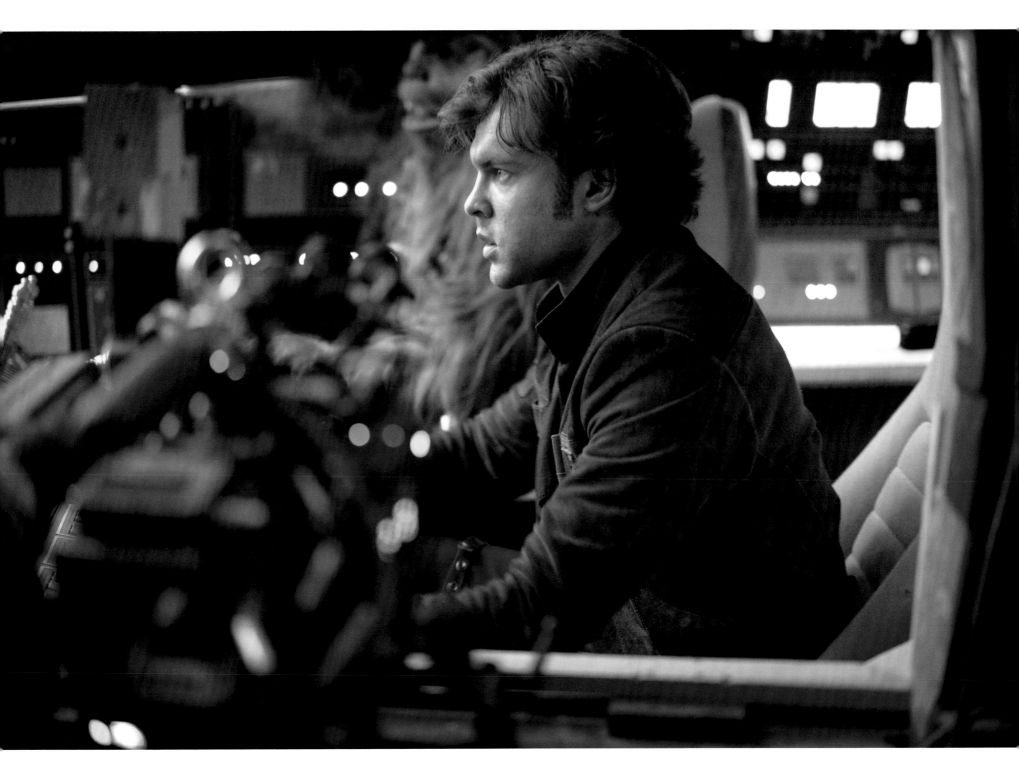

Shooting the Kessel Run. The lighting here is provided by the on-set LEDs displaying content from Industrial Light & Magic and pre-vis from another VFX house, The Third Floor. Ron preferred to shoot the whole scene in continuity from beginning to end, triggering different cues as needed. We could either play the entire fifteen minutes on a run, or work on a small section of the scene over and over at his direction. In all, there were more than 120 cues to trigger scene changes and specific lighting effects all the way through the sequence. For the actors, it meant they could focus on the acting, including looping back and trying another take while the cameras stayed running—the images on the LED screens would simply guide them along, providing them context and eyelines.

ABOVE After a long shoot, Alden begins to breathe a bit easier
as we all realize principal photography is drawing to a close.

Bringing It All Together

We moved from London to Burbank and set up in the post-production offices on the famed Disney Studio Lot; the same place where Ron Howard acted many years before. Post is focused time. Everything is shot, and the editorial process is well underway. Ron Howard and Pietro Scalia had been cutting each day as we were shooting. All the pre-vis footage had been cut in, but there were a lot of holes in the film that VFX would fill. There was still a lot of work to do.

Because of the short post-production schedule, there was a lot of pressure. Pietro and Ron worked to lock down sequences early so that the visual effects artists could start in earnest on the hardest aspects of the VFX work. We had pretty good rough cuts for the Train Heist and Kessel Run, but big action sequences with many all-CG shots still needed to evolve and tighten throughout the post-production process to ensure we're telling the story as clearly as possible.

This was where Ron's process really started to pay off for us as a group. Even though there was a lot of pressure to work quickly, it was a safe space to pitch ideas and work to plus the film shot by shot. Ron made the final decisions but also trusted his team to do to excellent work—which is great because the team working on this film loved to do just that.

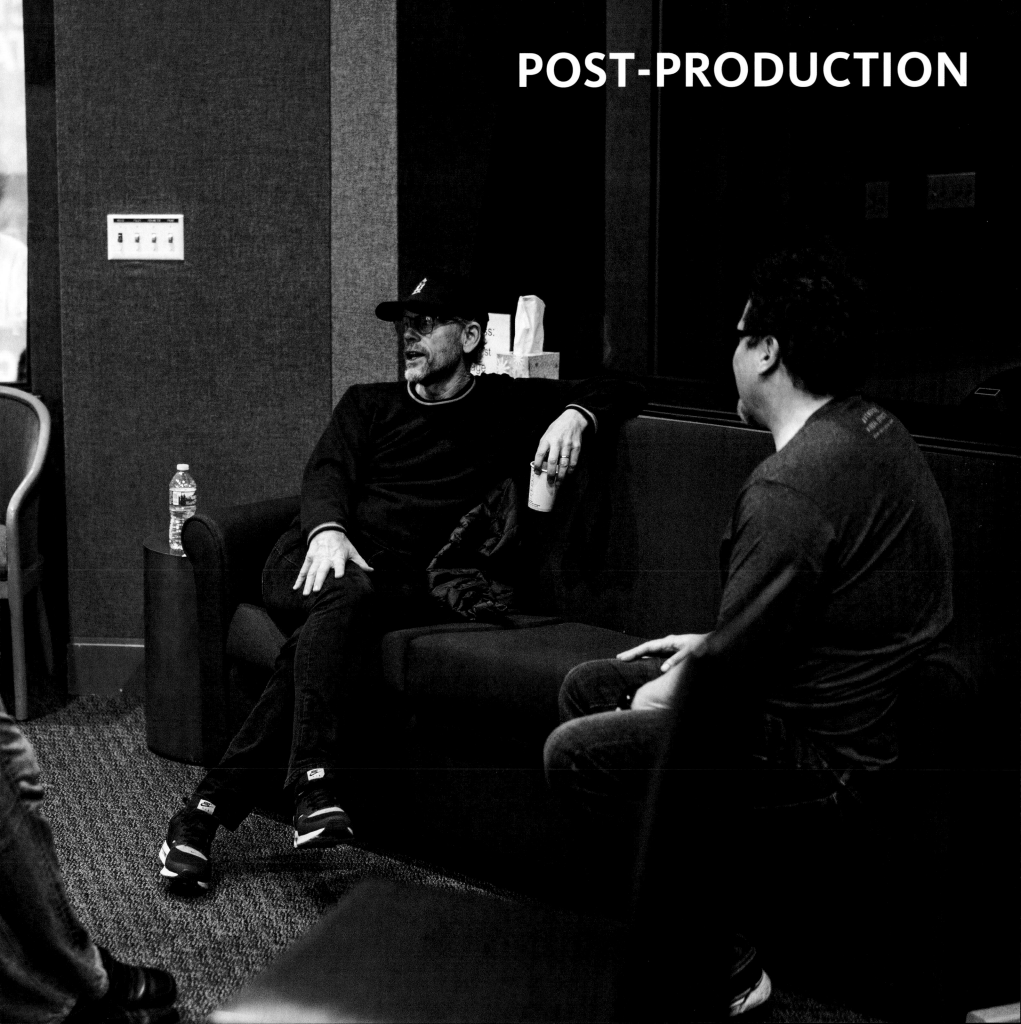

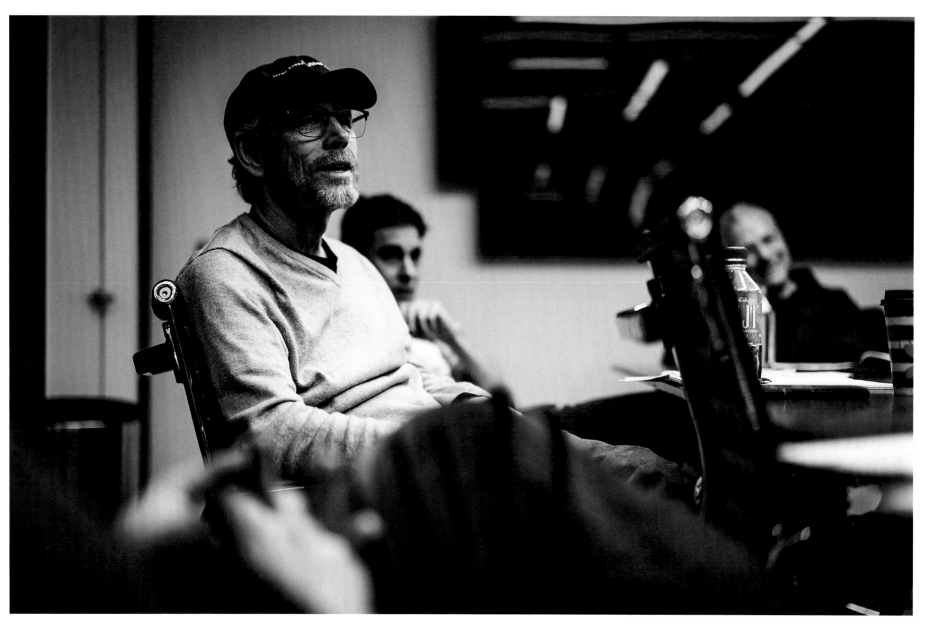

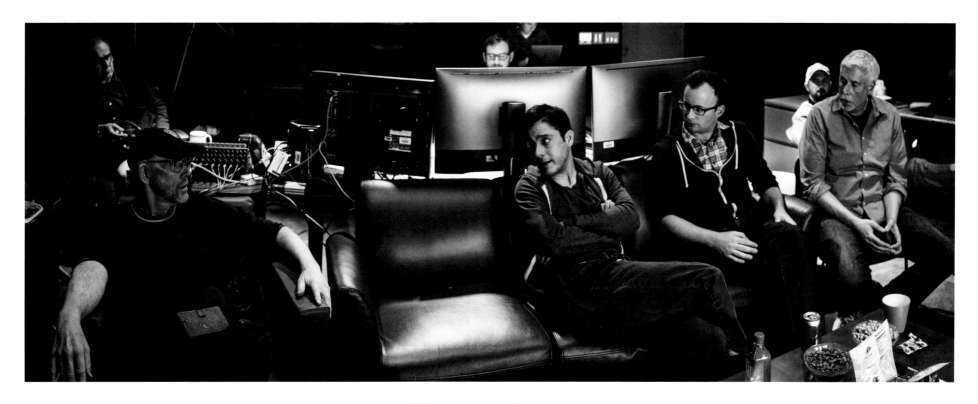

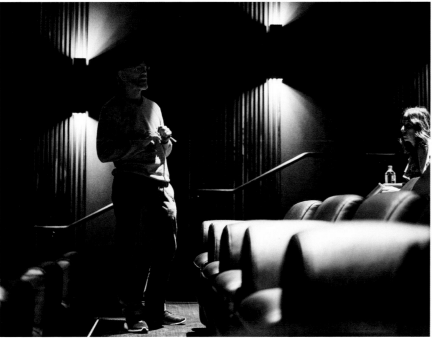

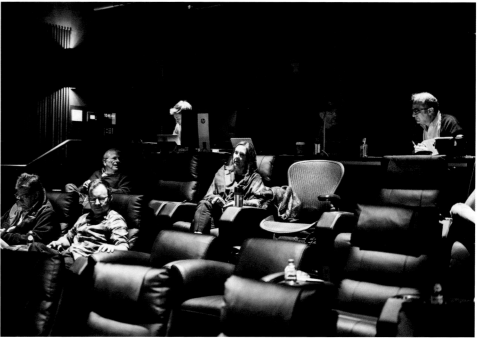

Ron Howard continued to lead a collaborative process through post-production. In the top photo, Ron gathers Pietro, additional editor Chris Rouse, Jon Kasden, VFX editor Phil Eldridge, VFX Producer Dan Carbo and me to review a work-in-progress edit of the train heist sequence. Chris had been helping Pietro cut the sequence and would have a new edit for us to review every week or two. These reviews were fun, each person chiming in with ideas—and sometimes practical constraints like, "if we change that shot it means VFX will have to redo Enfy's nest in another 20 shots, are we sure we like the idea that much?" Everyone was pushing for the same thing however, how strong can we make these sequences.

When it would feel like we had made a marked improvement over a previous version, Ron would schedule a screening to watch part or all of the movie together and Kathy Kennedy, Jon Swartz, Larry Kasden, producers Simon Emmanuel and Allison Shearmur, and others would give additional thoughts.

The process was iterative, with Ron taking in all the feedback and working closely with editorial and VFX to improve the sequences day by day. The story was getting clearer and the shot design was getting stronger each week.

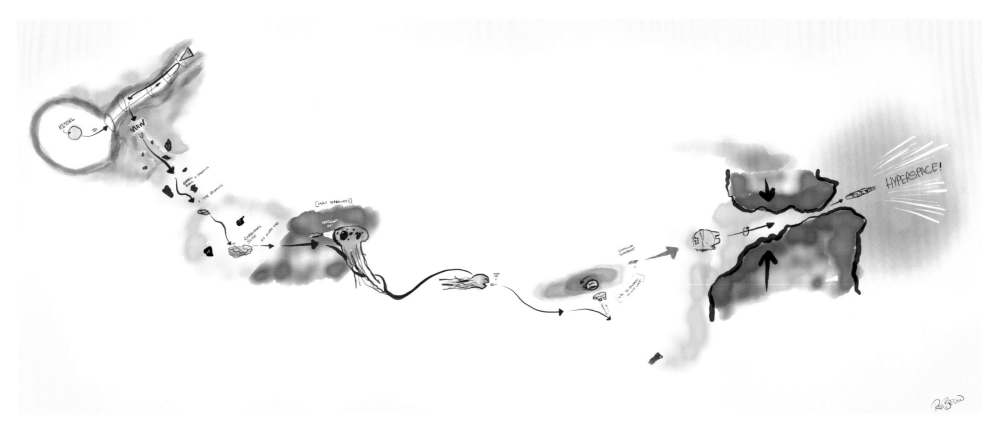

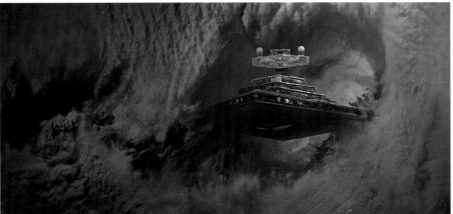

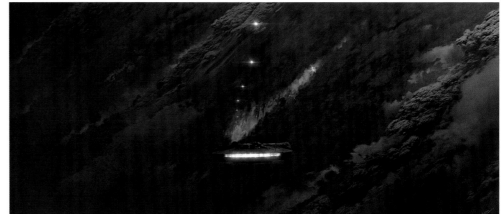

THE KESSEL RUN

When Ron joined the project, he made a few significant changes to the Kessel Run. We reviewed all the pre-vis and ideas from the older scripts, and Ron fell in love with the idea of a huge space monster—it really resonated with him. To save running time in the film, he decided to cut a sequence where we flew through the inside of a giant carbonberg, and instead sent us off to make the pinnacle of the sequence pivot around a giant creature.

This was quite a curveball for such a complex sequence, so we jumped on it. James Clyne led the team to design the creature itself, and I worked with our pre-vis team to work out the story beats and how we might make the final elements of the Kessel Run come to life with a new creature in the mix.

Additional editor Chris Rouse also taught me a lot about the quick cuts we needed for this big action sequence. One specific thing we talked

about a lot was how to guide the eye of the audience between cuts so it plays smoothly and is easy to understand, even with really short shots. By keeping the action in roughly the same part of the screen between the shots and composing each shot to guide the eye to the next important beat, even a very short eight-frame shot (one-third of a second) could communicate an important story element. Chris is a real expert and was so fun to work with on the development of this sequence.

Once we had our heads around the important beats, I drew out this map (above) between takes on set. We used it as a guide while shooting to ensure we had all the turns in the right spots for the entire length of the sequence.

This drawing also ended up on Chris Rouse's wall during post and helped everyone track the geography of the main story elements.

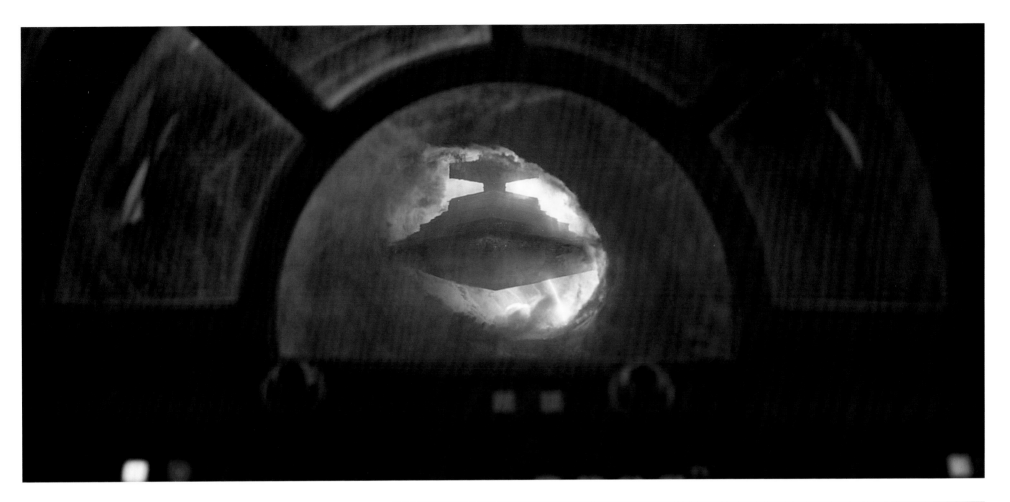

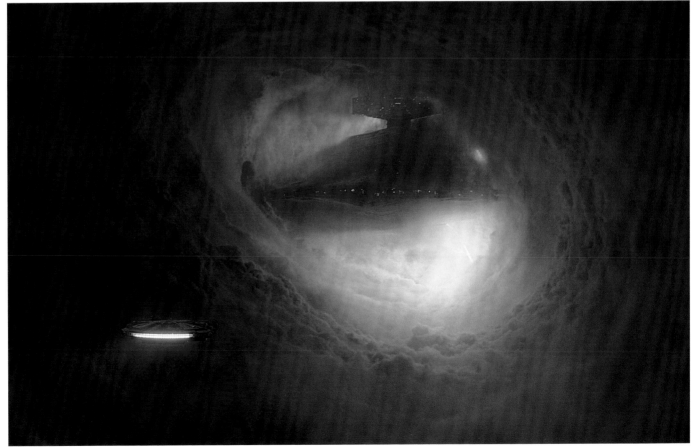

One of my favorite shots in the film was this reveal of the Star Destroyer in the Kessel Run exit. I remember pitching this in an early visual effects review, and everyone liked the idea, but there were a number of cuts where it just didn't fit in the movie. Fortunately, the final cut of the movie had a great place for this strong visual moment.

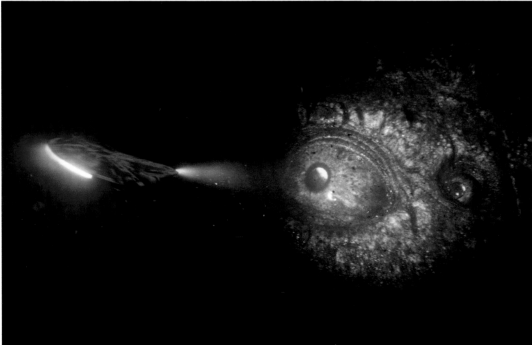

The Kessel Run. From the earliest stages, Larry and I knew we wanted, or rather, felt we were obligated to include the Kessel Run in this movie. It's one of those classic references from the original Star Wars that so effectively and economically conveys the richness and fullness of George's galaxy. You weren't told what the Kessel Run was, or how the Millennium Falcon did it in less than twelve parsecs, but it sounded rad, and it told you Han was a braggart, which was all it needed to do . . . in 1977.

Forty-odd years later, it's a different story. First of all, a parsec is, as any self-respecting Star Wars nerd knows, a unit of distance, not a measure of speed. So when Han says, "A fast ship? You've never heard of the Millennium Falcon? It's the ship that made the Kessel Run in less than twelve parsecs," it's exactly like saying, "a fast car? You've never heard of my Ferrari? It's the car that drove from LA to Vegas in 250 miles." Doesn't quite make sense. Adding to that the pitch-perfect way Harrison delivered the line, it became a legendary piece of Star Wars lore. How could it possibly be as exciting, or as cool, as it sounded when Han said it?

From our first conversations, we knew we wanted to give the sequence a swashbuckling pirate flavor. We also saw it as our only opportunity to add some fantastical sci-fi elements to this more grounded (at least for Star Wars) crime movie. This led pretty naturally to the idea of "sailing through a hurricane," a convention of pirate stories that speaks to that primal struggle between man and nature, or, in this case, man and cosmos. From there, we latched onto the concept of the Maelstrom, our "hurricane in deep space," as the solution to several problems. We could have a clear visual, comprehensible "safe route" through a treacherous environment that Han could then deviate from, flying off into uncharted mysteries, a place where rules don't apply and we could throw anything at him. This basic construction stuck from the very first draft to the finished film because it felt true to Han's character—he is the captain who would sail into a hurricane.

The sequence continued to evolve through post-production as we began to identify which elements were working and which weren't, requiring Rob and his team to be extra flexible and patient under incredible time pressure. In fact, the mission to actually complete the Kessel Run sequence by our release date is a story at least as exciting and nail-biting as the sequence itself.

But, for me, the biggest surprise came in the actual shooting of the sequence. The cockpit scenes in Solo were filmed with enormous screens outside the windshield, on which the actors could see the environment the Falcon was flying through, making it pretty much the coolest flight simulator ever constructed. The cockpit itself is not very big, and we often had five cast members, including one very large Wookiee, crammed into this tiny space. Instead of breaking the sequence up into bite-size pieces, Ron preferred to run through huge sections, which often meant eight- or nine-minute takes. This had an effect on the actors, all crammed into that sweaty little box for days on end. They were living the Kessel Run, and it was exhausting. It also gave the sequence a kind of reality and soulfulness I never imagined it would have. Their performances, humor, dedication, sense of joy, exhaustion, and camaraderie are what drive the story. That, combined with the stunning, groundbreaking visual experience ILM created, results in what I believe is a truly unique action sequence in movies—one that fulfills the promise of the Kessel Run and, hopefully, means we'll never have to do it again.

—Jon Kasdan, cowriter

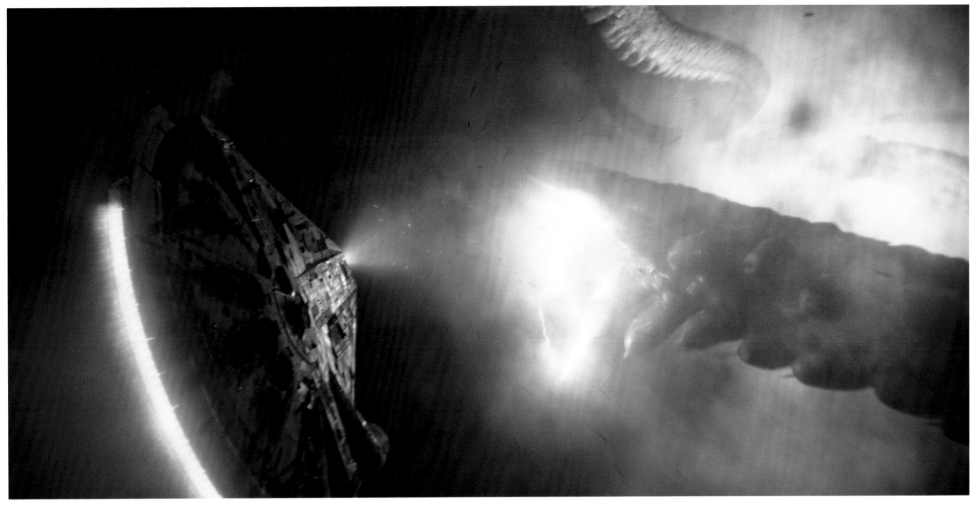

One of my favorite opportunities to collaborate with the VFX team and other departments was in designing the fabled Kessel Run. This was a big one. Everyone involved was challenged to dream this sequence up nearly from scratch. We had guidance from the script, such as the carbonbergs floating and crashing through space, but nearly everything else had to be created out of thin air.

One of the early breakthroughs was applying a methodology that required us to stick to believable worlds. For instance, a look that felt more like a thunderstorm or hurricane helped us suspend our disbelief more than a giant nebula in space. Everyone knows what it's like to be caught in a storm on a commercial airliner—it's scary stuff. We wanted to evoke that same tone here.

From there, the VFX team layered in other suggestions of black rain and hail to add to the effect. Seeing comped-in rain streaming across the Falcon's cockpit glass added a sense of dread for our heroes.

— James Clyne, Lucasfilm design supervisor

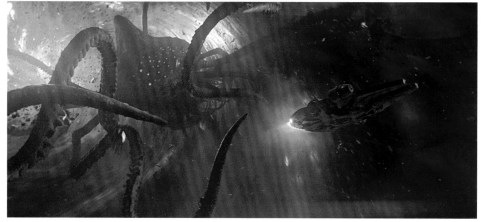

Every once in a while, when working on a film with such talented artists, a sequence-defining image lands in your inbox like a gift. In the case of the Gravity Well sequence, James Clyne gave us a particularly important gift that helped clarify a complicated story beat and really sold us on the whole concept (pictured here, top). Thank goodness he painted it. The graphic, simple look of the Gravity Well told a complete story of how it would interact with our Space Monster. There's nothing better to inspire the team and get everyone on the same page than a touchpoint like this.

Of course, as we developed the physics simulations, the rendering techniques, the effect animation, the character simulations, and all the other details that really sold the sequence, the look evolved. The two images above are what we see in the final film. I frequently referred back to James's painting to remind myself of what we were targeting: clear storytelling.

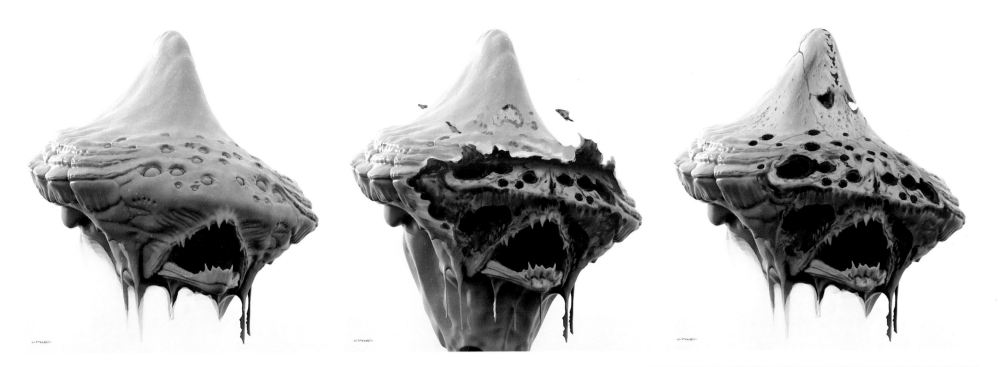

When it came to ripping the face off the Space Monster, we had an eager ILM team who couldn't wait to build and texture the bone, muscle, fatty tissue, tendons, and everything that we'd need to make the tearing flesh look realistic. As it was taking shape, we realized that it wouldn't be hard for this effect to tip over the line and go too far. One of our production coordinators, Mary Austin, didn't quite have the stomach for seeing all the in-progress face-ripping work during dailies and would audibly groan when the shots came on screen. I joked with the team that when Mary couldn't take it anymore, we'd know that we nailed it—she'd be our barometer. We wanted to give the audience a brief shock to underscore the power of the Gravity Well and be a bit of a gross-out. As we were nearing the end, I looked over and Mary was peeking out between her fingers and trying to take notes at the same time. Nailed it!

— Pat Tubach, visual effects supervisor, ILM

TOP Ron wanted a graphic moment at the end of the Space Monster sequence to appreciate the force of the Gravity Well and to witness the monster's demise. This art, inspired by *Raiders of the Lost Ark*, was referenced by the artists at ILM who created the simulations to tear the flesh and muscles from the Space Monster's face.

Visual effects editor Phil Eldridge (pictured opposite, bottom left) was responsible for making sure the VFX teams had all the specific count and lineup information to make the shots work for editorial. In addition to the traditional duties of a VFX editor, he also helped with early editing work in partnership with Pietro Scalia and Chris Rouse on the heavy VFX sequences.

The editing rooms down at Disney were abuzz with activity. Ron would be bouncing between working with Pietro on the cut, working with Chris on the Train Heist and Kessel Run sequences, and joining us in our daily visual effects reviews.

Often, I'd get pulled into a room to look at a new cut and we'd have some problem to solve. How can we sell that Han is looking at the Imperial Enlistment set in a single shot? What if we paint out the dice in a few shots at the opening of the film so Han can put them on right after the title card? Fortunately, visual effects open up a lot of good creative options in post, and we were always driving the story forward with these new ideas.

Of course, we had to balance that against the time remaining. Our compressed schedule required us to finish more than a hundred shots each week, or twenty shots every single day. When a new idea would come up, Ron and Pietro would often look at me to ask if we could fit it in. Everyone was aware of the responsibility to deliver this movie on the date, and fortunately ILM had the artistry and firepower to make it all possible.

BETH D'AMATO
Paint Supervisor, ILM

Going into this film I knew it was going to be fun. I mean, it's exciting enough just to work on a film that centers around characters we've all known and loved since the 70s, but there was a great surprise professionally, too.

I was invited to attend a screening in which various members of ILM's supervising and key creative teams were asked to take notes and provide feedback on the film.

After twenty-plus years at ILM I understand how rare it is to get the opportunity to provide feedback that could potentially change the film you're working on. And as a female supervisor in the industry it's even more rare. You get somewhat used to being outnumbered. I even went into this feedback session expecting to have to work hard to be heard, but that wasn't the case at all.

It was truly a collaborative experience. Ron Howard and Lawrence Kasdan asked for input and then discussed those ideas with me openly and creatively. We talked for hours. Professionally speaking, it was the most rewarding and satisfying day of my career. It's going to be so fun to go the theater and see firsthand how we shaped the final outcome.

Additional Photography

A QUICK RETURN TO PINEWOOD

When Ron Howard joined the picture, he had only a few days of prep to get up to speed on a remarkably complicated picture. His experience and abilities enabled him to prep and shoot efficiently under the pressure of the grueling principal photography schedule.

After the first cut had been assembled and screened for the producers, the Lucasfilm Story Group, and ILM creative teams, Ron put together the plan for a few strategic changes he wanted to address. Some of those items required additional photography, so we headed back to Pinewood Studios for two weeks of shooting.

We revisited a handful of sets, sometimes Ron only needed a shot or two to complete his vision of the edit. In this process, I was able to be helpful by leading the pre-vis teams to provide Ron with moving visualizations of the more complicated shots.

And of course, because time was short, every night after a day of shooting we would gather for a meeting with Ron and the ILM VFX teams to review the latest work. We'd give notes and approve (or "final") shots for the film from London. Every day spent on set was a day closer to release, so we had to move fast.

LEFT Here, we were discussing the shots we needed to complete Han's boarding of the AT-Hauler during the train heist sequence with Sylvaine.

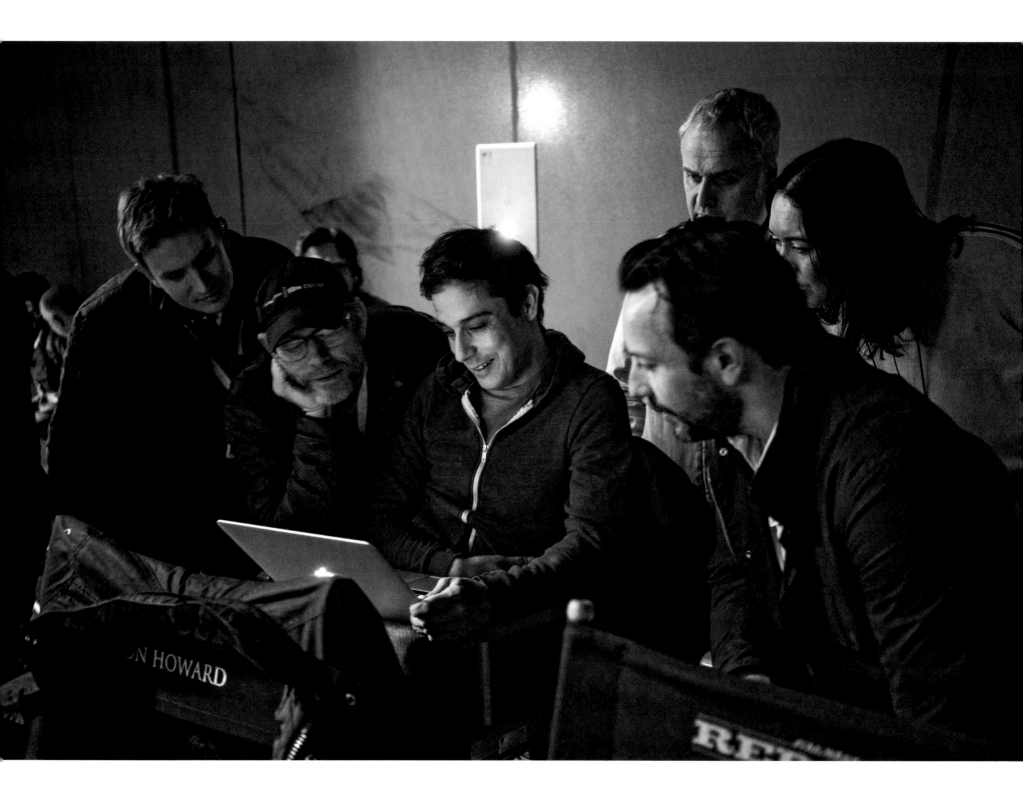

ABOVE Jon Kasdan playing back the Kessel Run sequence on set with work-in-progress animation and editorial work for preparing the day's shoot.

ABOVE Getting the team back together: the production team meeting to kick off the pickups.

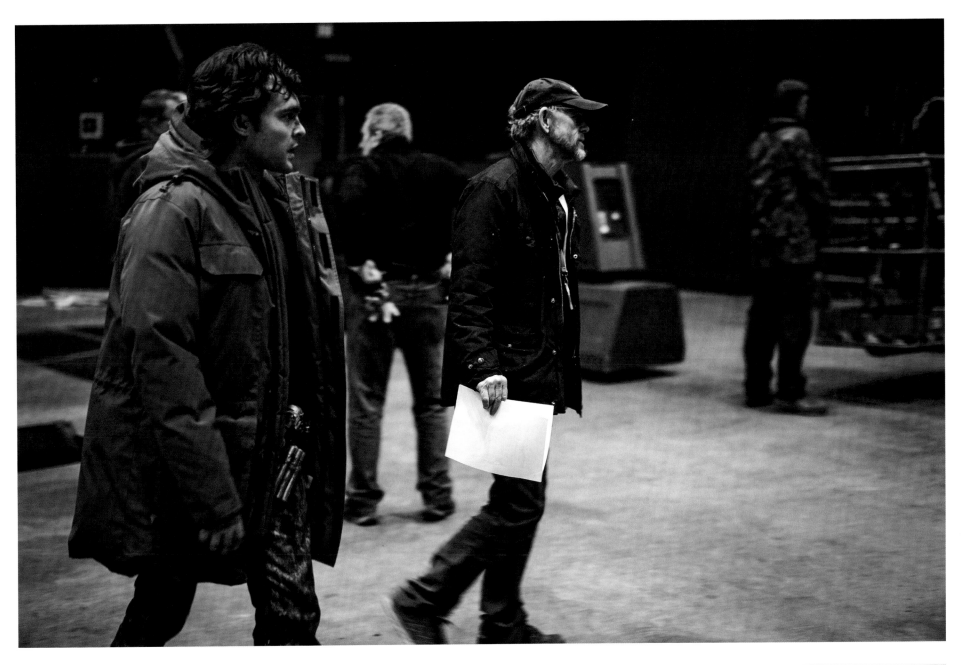

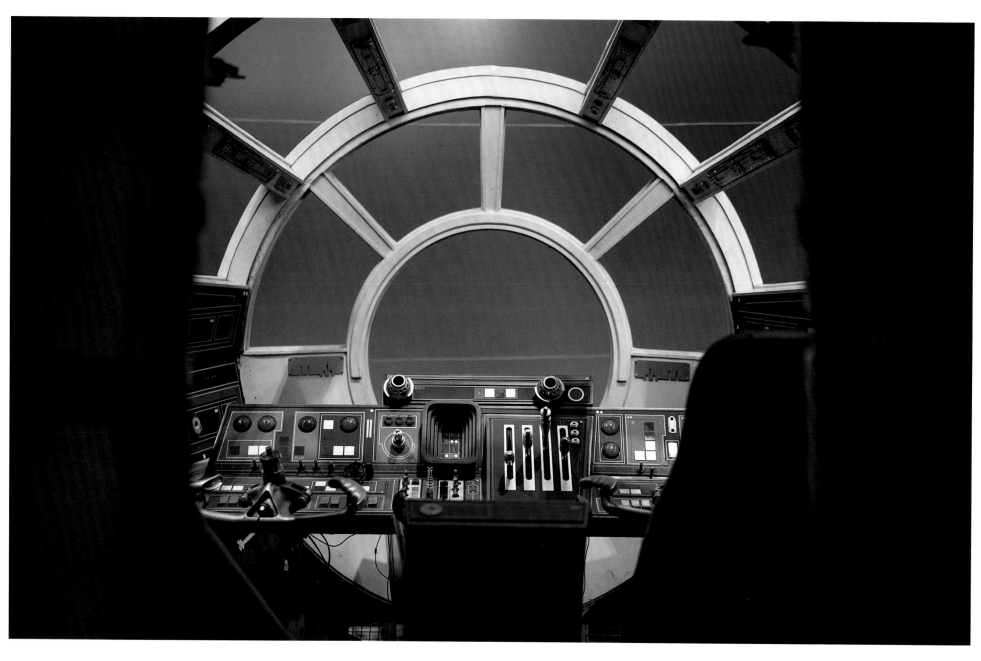

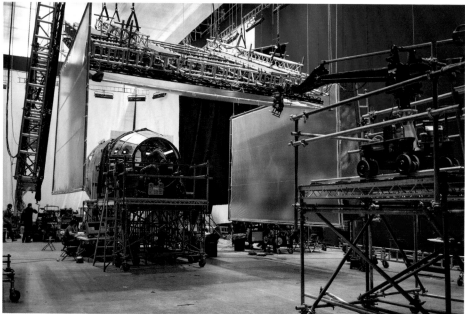

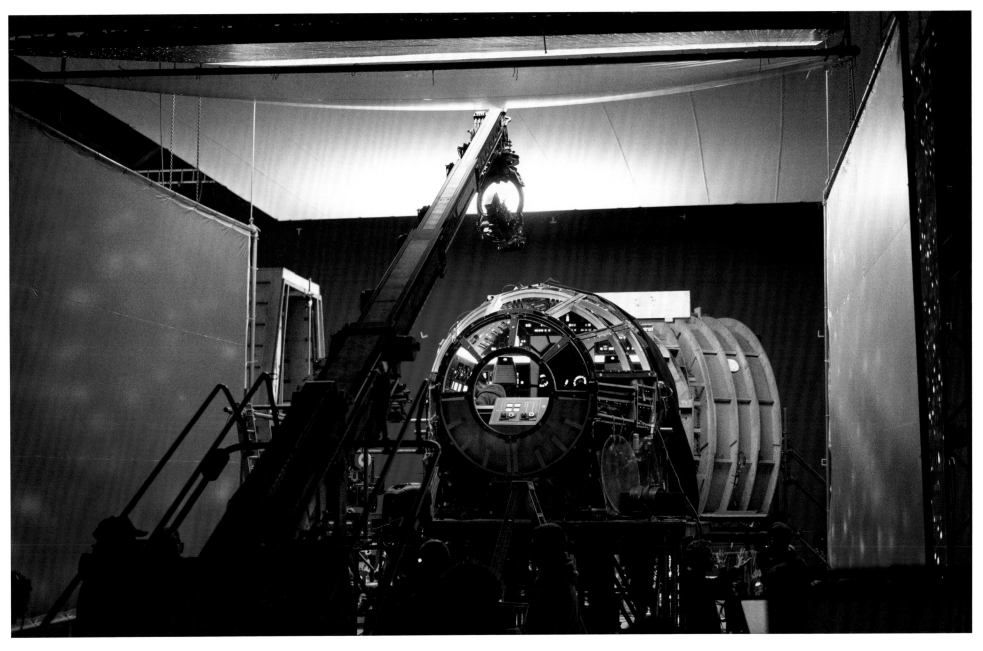

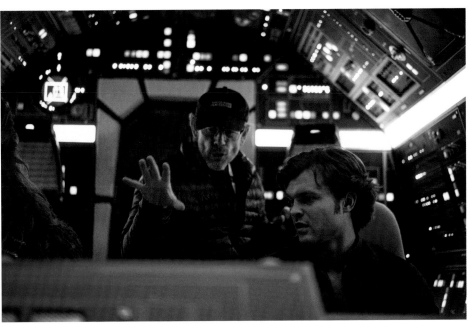

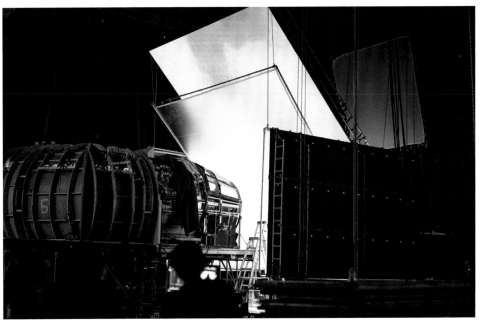

On the final day of shooting, we invited the production crew to get a sneak peek at the trailer that marketing and the visual effects team had been working hard to complete. For most, this was their first look at complete shots from the film, and the crew was really excited with how the look was coming together. The first trailer aired just a few days later, premiering during the Super Bowl in the United States and then around the world.

ALLISON SHEARMUR
Producer

Alli might have been small in stature, but she was a force of nature and a bundle of unbridled energy. She loved movies almost as much as she loved people. She also loved the process of making movies and the collaboration that develops around the art of filmmaking. Alli had a wonderful way of making sure that each and every person on the film felt valued and, most of all, heard. She was always the first person in the makeup trailer checking on the cast and making sure everyone was happy and felt taken care of.

She was also great with story. She had a system I've always envied where everything was color coded so that each and every change could be viewed quickly and then scrutinized with every department head. Her attention to detail was unparalleled, and her ability to zero in on even the smallest detail was so valuable.

She was also a great friend. Making movies, especially in the role of producer, occupies a vast amount of time, and you're often away from family and friends. Alli always made being away a pleasure. She loved art, clothes, and just exploring fun places, so any weekend we had off she was putting together plans.

Alli loved her family too, and on Solo she was able to have them with her throughout the shoot. Both of her children, Immogen and Anthony, went to school in London, and having them close by made the work that much more fulfilling.

Early in the process of the film, Alli was diagnosed with cancer. Most people might have stopped their lives at that point, but Alli did not want to be defined by the disease. She wanted to be defined by her love of life, her family, her work and her friends. She never stopped working on Star Wars throughout her illness and, in fact, attended a visual effects review only a day before she tragically passed away. Solo is dedicated in loving memory to her devotion to movies and storytelling and the joy she brought to so many.

— Kathleen Kennedy, producer & president of Lucasfilm

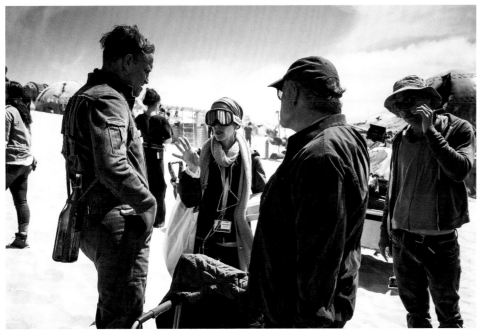

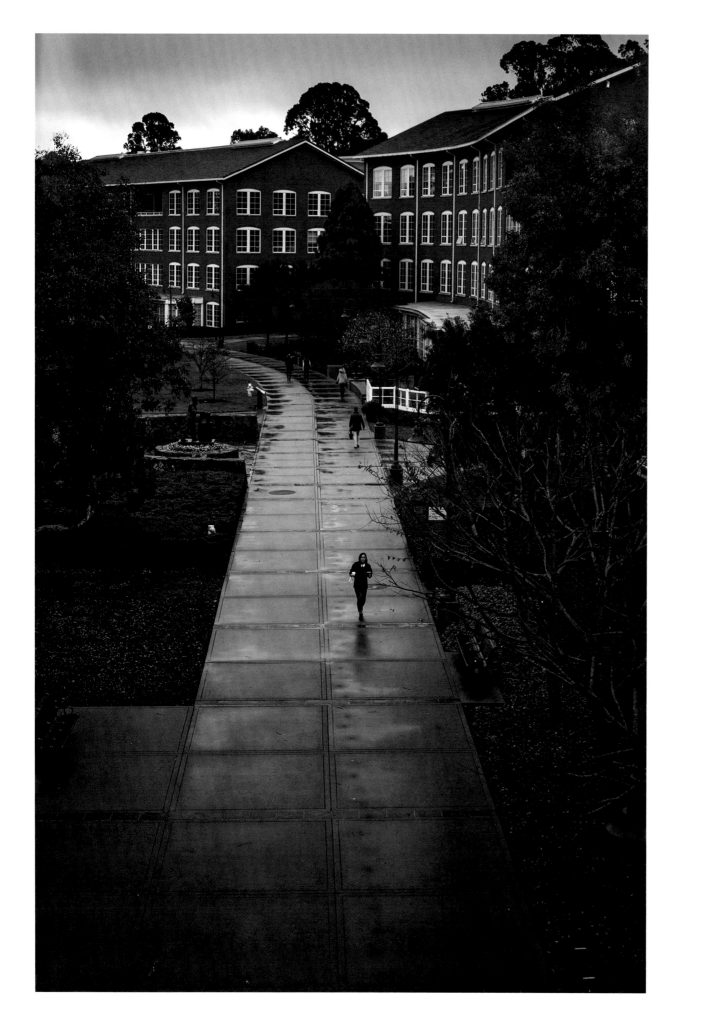

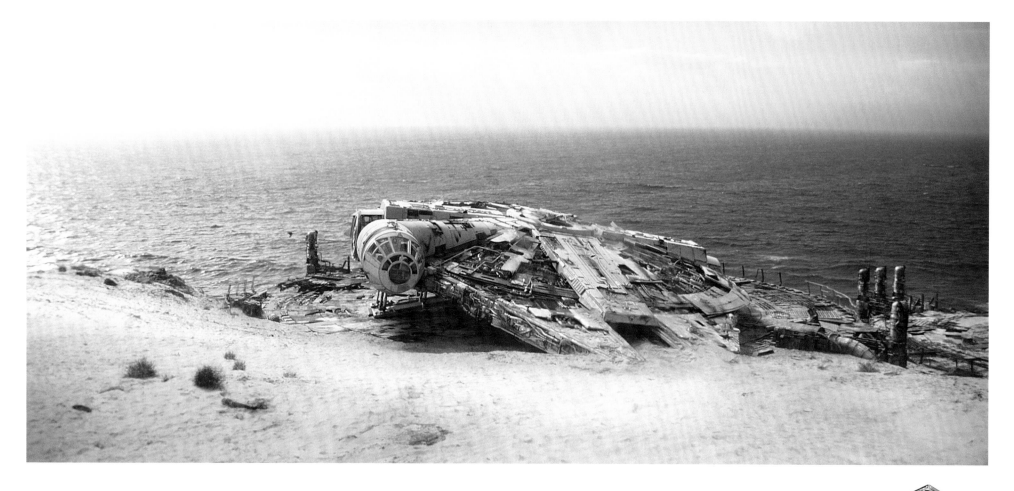

It's great how ILM gives you so much creative freedom. I was compositing a static shot of the Millennium Falcon that needed a little life. I decided to introduce a flying bird that lands close to the Falcon. Nobody asked for it, but we showed it to Ron and he loved that detail. So that little bird ended up being a small part of my Star Wars story!

— Jaume Creus, senior compositor, ILM

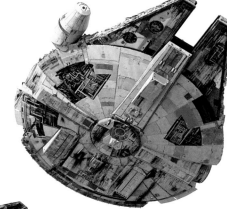

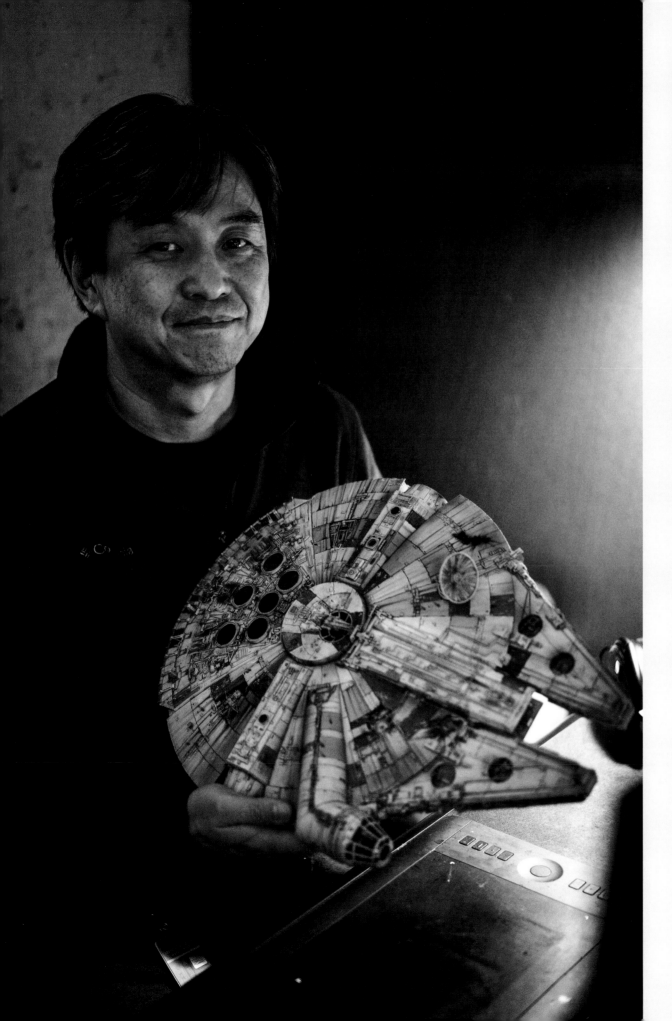

MASA NARITA

Senior Modeler, ILM

This movie is about Han Solo's legend, but it is also a story about the *Millennium Falcon*.

When I first heard that I could model the new "old" *Millennium Falcon* as the lead modeler for the film, I thought I was extraordinarily fortunate. Ever since I first saw *A New Hope* in theaters when I was a junior high school student in Japan, my dream has always been to work on *Star Wars*. However, at the time it was unheard of for someone from Japan to work in the Hollywood movie industry, so I had to abandon my dream, and I ended up working for a Japanese brokerage firm as an IT researcher. Twenty years later, I decided to go after my dreams; I quit my job, attended CG school, and finally, after working several years in the industry, I achieved my dream of working on *Star Wars*!

My biggest challenge building the *Millennium Falcon* was figuring out how to transform Lando's *Falcon* into Han's *Falcon*. I first had to design the interior greeble and all the important multilayered details for Lando's *Falcon*. The finished *Falcon* ended up having more than six million polygons and more than 21,000 parts.

Then I got started on the various damaged *Falcon*s we needed for the film. There are eight steps of damage staging to fully transform Lando's *Falcon* into the final Han *Falcon* seen at the end of the film. Making the transition to damaged parts and managing the visibility of those damaged parts was complex, but I believe that all of the hard work paid off. I am very proud of what I did to contribute to this film. Not only that, my biggest decision—at the age of forty six—to quit my job and work in the visual effects industry finally paid off!

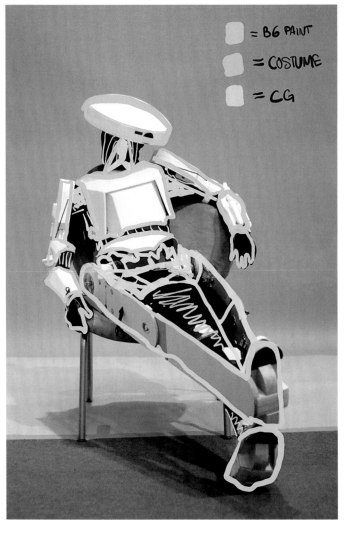

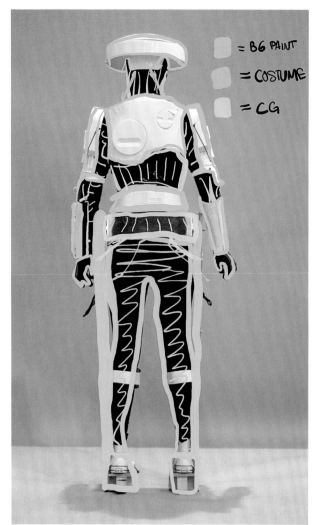

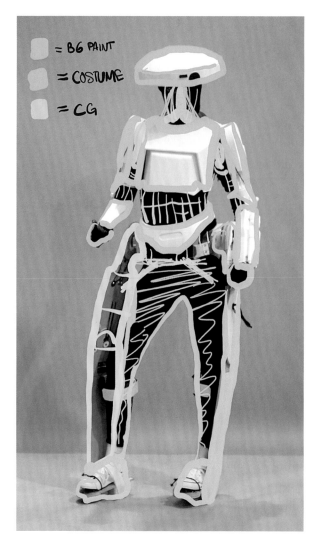

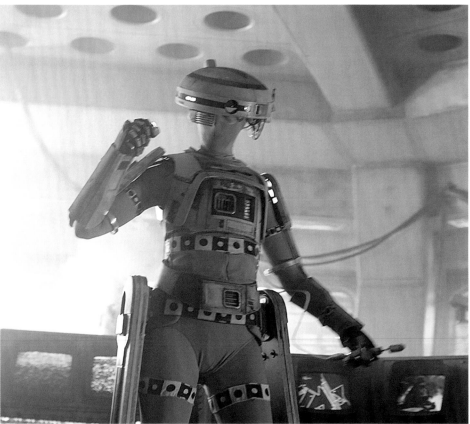

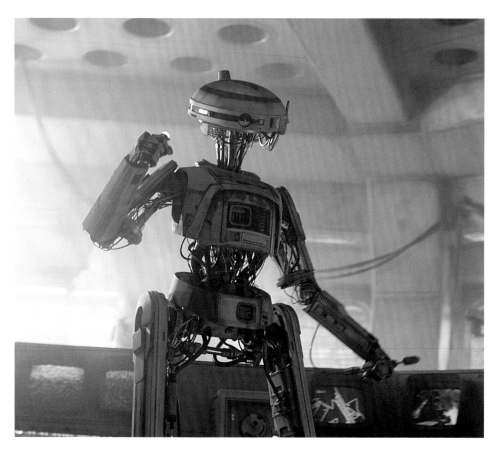

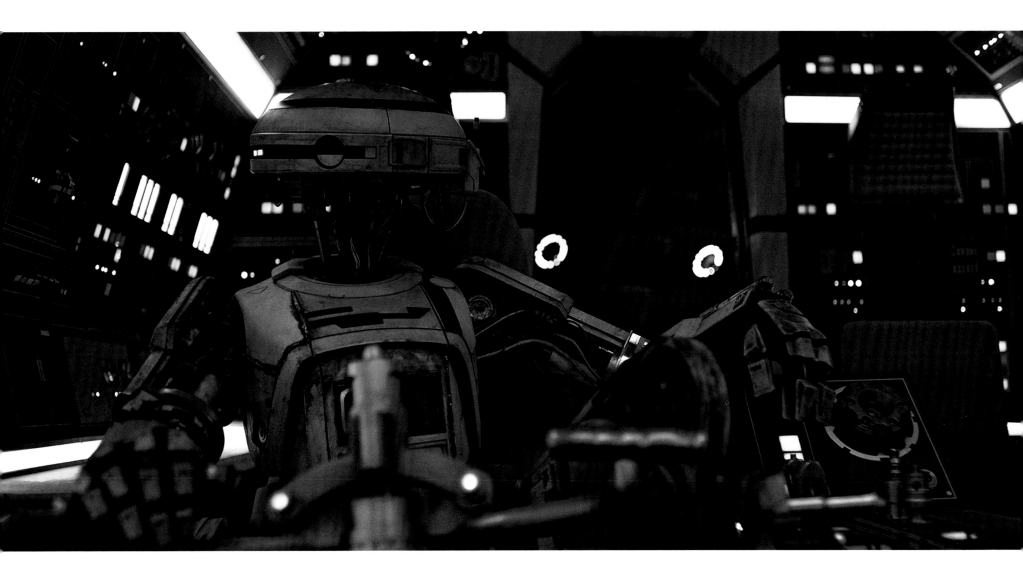

L3-37

OPPOSITE Phoebe Waller-Bridge in the practical suit as worn on set during the shoot (bottom left) compared to the final shot with the green suit removed and all the extra parts added digitally (bottom right). Artists also digitally painted back in anything the green suit covered, both on the suit and anything behind her.

TOP An early shot of L3 to be completed for the film, which set the level of integration and careful attention to detail needed for the character throughout the movie.

L3-37 is one of my favorite characters in the film, and creating her was truly a collaborative process. Initial designs for L3 came from the creatures department, costumes, and visual effects. In the end, the designs that everyone fell in love with were drawn by Glyn Dillon, co-costume designer, who built her off the idea that L3 was originally an astromech droid who is now becoming a woman—a self made woman. It really fit with her character in the film and was the inspiration that finally cracked the design of this character. Costumes designed a practical suit with her chest rig, hips, legs, arms, and head that all played on camera. VFX would take over to digitally erase Phoebe Waller-Bridge and add all the connecting bits and infrastructure that makes L3 actually work.

When Phoebe was cast, the elements all came together. We definitely benefited from her collaboration with us—I did some early tests with

Phoebe where she would wear the suit and try different walks and poses and I simply keyed out her green suit to show her an approximation of the final result. That gave Phoebe a chance to see the robot parts without her body in the suit, and we both saw that her strong, simple movements would read really well on camera. Phoebe's presence on set was fantastic for the performance—she's a remarkable actor and improviser, so she was always cracking people up. And of course, the rest of the cast could play off her just like any other actor in the scene. The decision to use a partially practical suit and finish her off with VFX really contributed to the final feel of the character on screen.

227

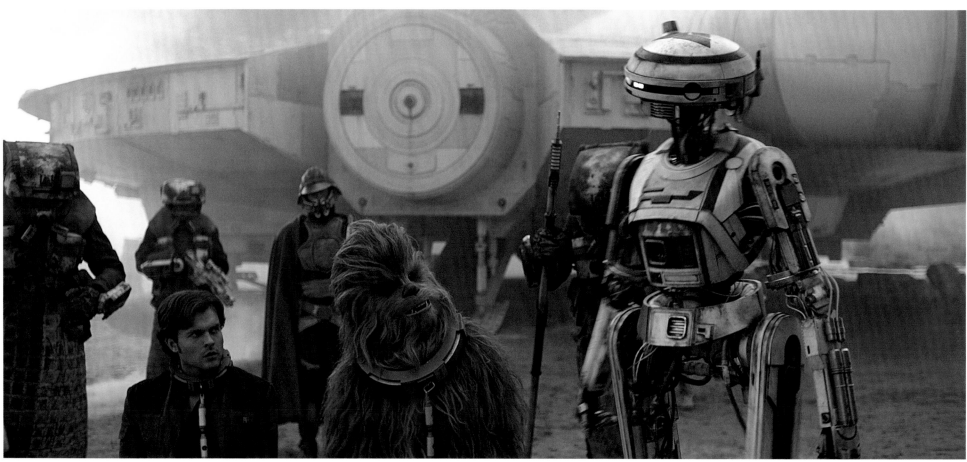

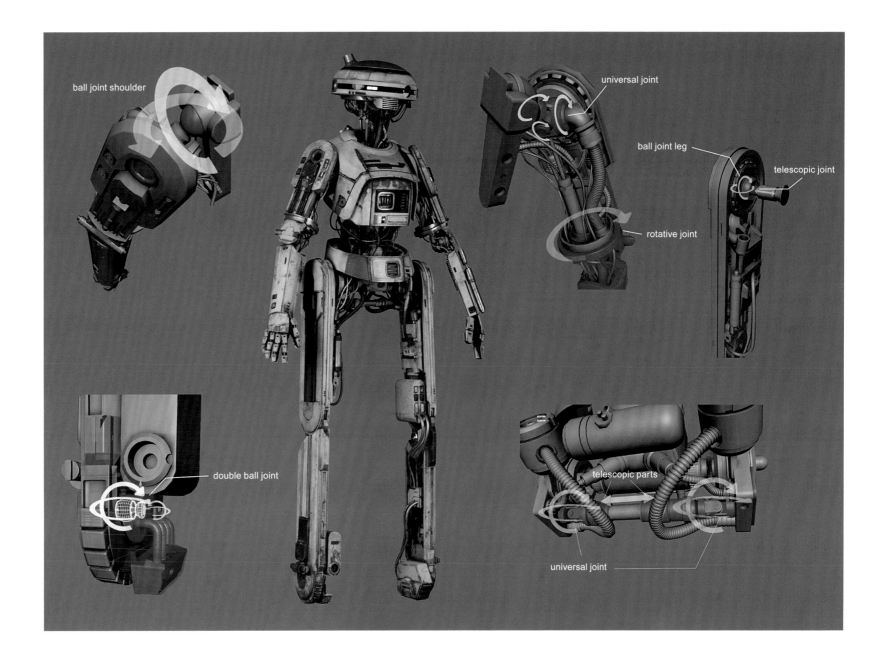

ball joint shoulder

universal joint

ball joint leg

telescopic joint

rotative joint

double ball joint

telescopic parts

universal joint

L3 had an incredibly complex series of wires, rods, panels, lights, and textures. In addition, the practical maquette reference on set and the partial physical suit worn by Phoebe were not exactly the same. Depending on the wear and tear on the shoot day, even the practical suits had variants! So our CG model and paint teams and I spent many days arbitrating the best version of her details that we would render for the hundreds of shots ahead of us that L3 played in.

From there, it was the rigging and layout teams' turn to get a little crazy. Because Phoebe brought such a unique, physical performance to the character, we were tasked with making a droid that had joints that could actually function. We had to be able to both match Phoebe's performance and animate pieces in a plausible way or no one would ever believe the character, and the pieces would be crashing through each other in a tangled mess.

We worked for months on perfecting the look and her performance. We held off for quite a while from showing a completed shot because we knew that if we screwed it up, Ron could potentially lose faith in the process of tracking Phoebe's performance. That might lead to questioning the success of the character or hand-animating hundreds of shots.

When we finally showed the first shot, an almost 2000-frame monster render between Qi'ra and L3 in the cockpit talking about Lando's "feelings" for her, the entire room was silent for a good long while. I thought for a few torturous moments that we were doomed . . . until I realized that everyone seemed to instantly forget that she was a VFX trick at all, and they were just attentively watching and listening to her—taking her as seriously as any other actor.

"Wow!" "Amazing!" "Unbelievable!" was the chorus of ecstatic responses from Ron and producer Simon Emmanuel. Bells were rung (as is our tradition for a VFX final) and we watched it over and over again, laughing at how yet another droid with a soul was bound to play a legendary starring role in a Star Wars story.

— Patrick Tubach, visual effects supervisor, ILM

THE HOLOCHESS TABLE

On *Solo*, we animated the holochess game in the same way it was done on the original *Star Wars*: with stop-motion.

We were very pleased that Phil Tippett (pictured right), who worked on the original film and *The Force Awakens*'s holochess scenes, and his team re-created the scene once again from the original armatures and molds. The process was much the same as it was in the 70s, but now the animators were able to monitor their work with digital cameras and improved software and, of course, digital compositing. This time we also had a lot more shots and opportunities for a couple of new surprises.

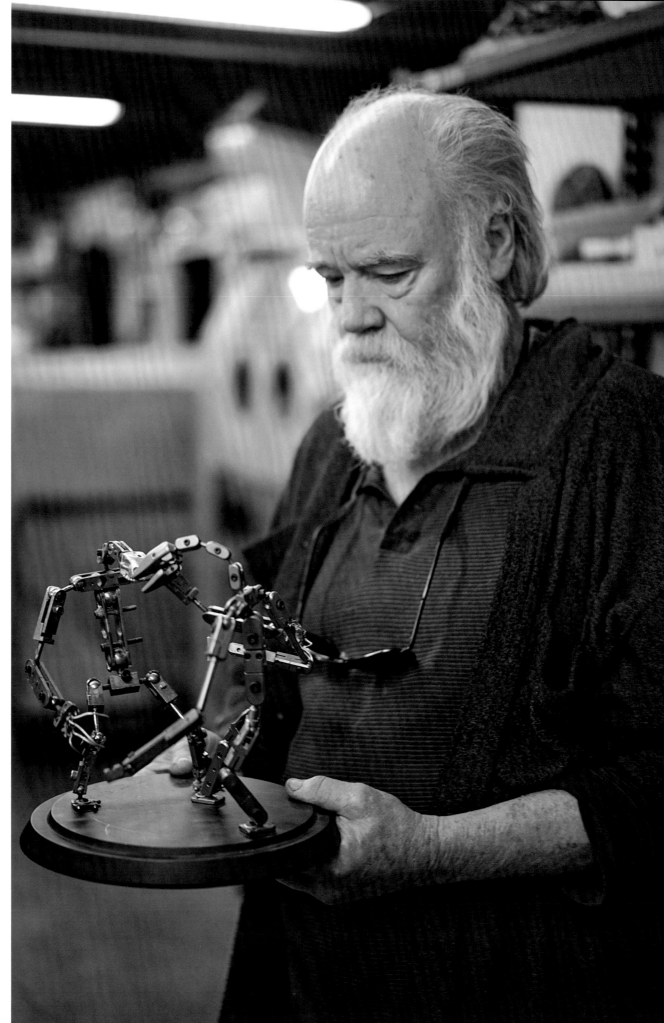

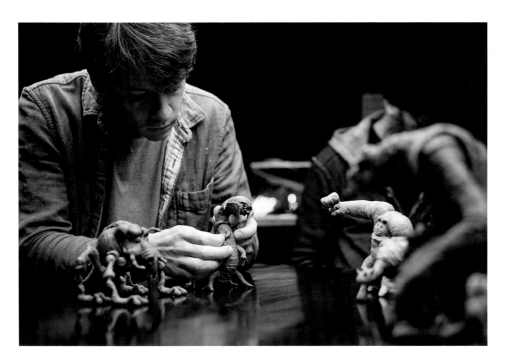
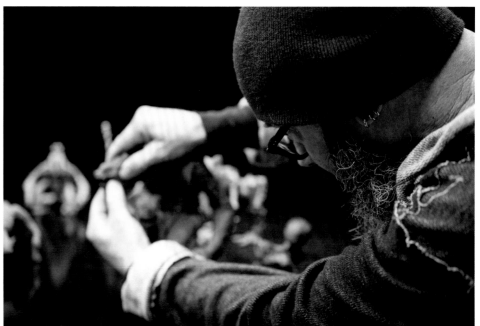
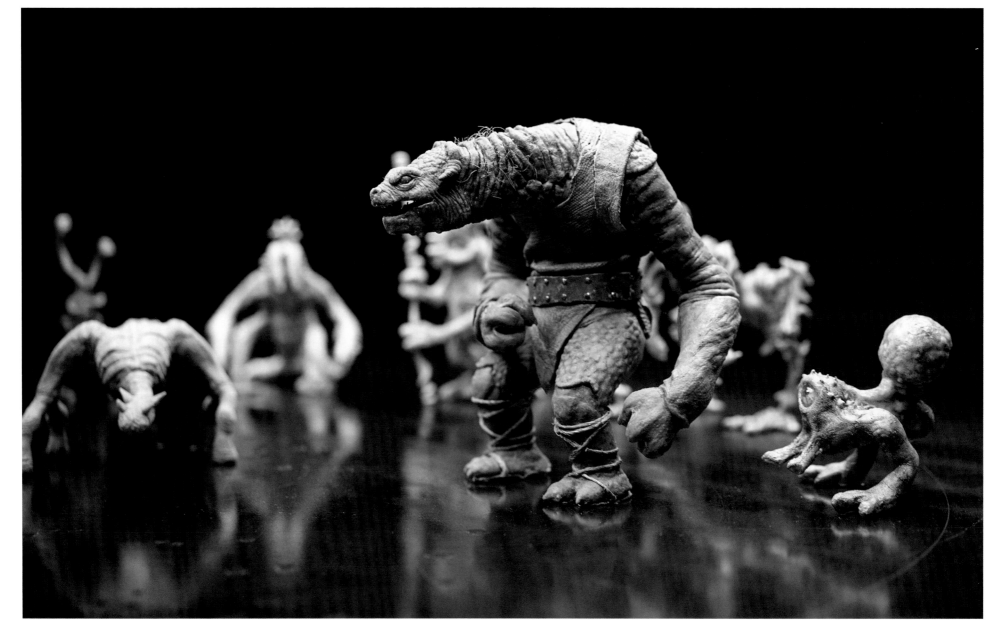

In Phil Tippett's first meeting with me for *Solo*, he recalled that originally there were a couple of extra characters on the chess board. When George Lucas saw the board filled, he thought it was a little crowded, so Phil removed two of the characters. Phil still had those designs. We both loved the idea, so he pitched adding them back to Ron, who loved it, too. Everything in Lando's *Falcon* was a step fancier, so this fit right in with the tone of the ship.

In the scene, Chewie gets frustrated trying to learn a game that he will struggle with for the rest of his life and takes a swipe at the table. On set, we hadn't even noticed that a couple of the buttons popped off the table when Joonas hit it. We used this opportunity to imagine that Chewie had shorted the game, accidentally wiping out two of the characters. If you watch carefully in the sequence, those two characters disappear, forever to be lost to holochess history. We had a lot of fun with the details of this little scene.

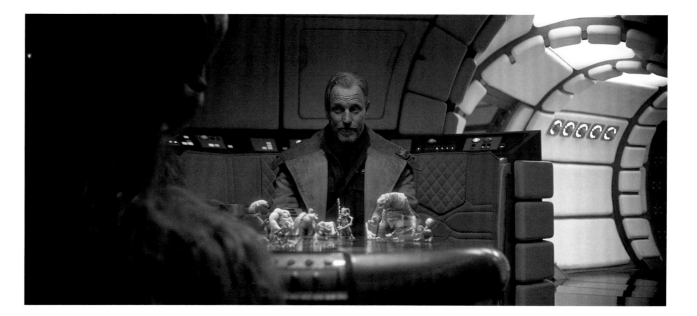

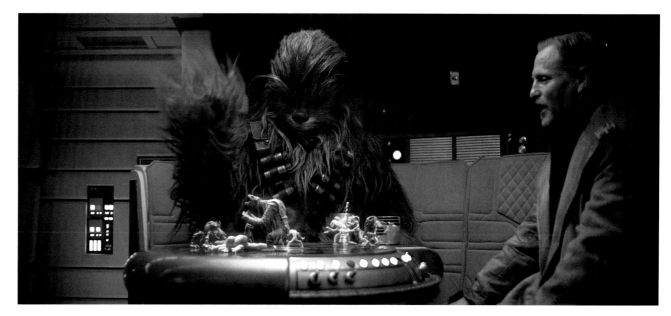

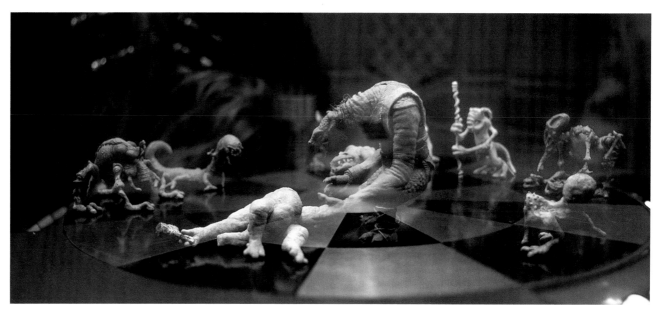

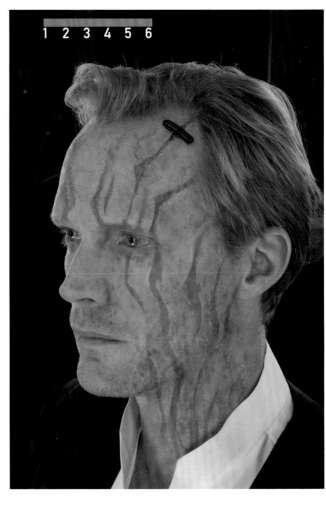

Solo is the sixth Star Wars film that I've worked on. Every Star Wars film is different, and each director brings us new challenges.

For example, I was asked to help create the setup for Dryden's face; filmed without any special makeup, ILM was tasked with adding prominent scars and dry skin to his face, forehead, and neck. Compositing supervisor Jay Cooper and I came up with a technique that combined match-animated geometry and 2-D processing to make painted mattes (by Daniel Perez) stick to Dryden's face, no matter what facial expression Paul Bettany made. Then, I created color corrections through those tracked mattes to create the dry skin and the scar tissue. As I was creating the setup, I thought to myself, "Without a doubt, this is something I've never done before."

With every new Star Wars film, there are always opportunities for ILMers to do something they've never done before. The Dryden face shots were ultimately completed by ILM artists around the world who did a terrific job on all the details.

—Todd Vaziri, lead artist, ILM

When Ron Howard shot Paul Bettany in the role of Dryden he knew he'd be amazing on camera even without being an alien. We shot the scenes without any augmentation beyond an unusual scar near Dryden's hairline.

When we got into post-production, Ron screened the film for composer John Powell. John was the one to first prompt Ron to think about some augmentation for the character. Paul was so handsome and charming he wondered if VFX could augment him in some way to add to make him more intimidating. The challenge was, there was hardly any time left, and there was no time to reshoot the scenes with any practical modifications.

Our team got right on a series of designs and quickly settled on scars across his face. When we showed Ron several different variations of "strength," he got the idea that the scars could evolve during the shots, matching Dryden's level of anger. This would be a huge tell for his emotions and give the audience another clue to understanding the stakes of the complicated scenes.

The VFX team then devised a methodology to add the dynamic "digital makeup" on every shot featuring Dryden—130 of them in total. It required very careful tracking and artistry, leveraging an enhanced version of the technique ILM first developed for the bear attack scene in *The Revenant* to track scars onto Leonardo DiCaprio. No tracking markers or extra cameras on set meant the artists had their work cut out for them, but with the new techniques ILM developed, the result tracks seamlessly across his entire performance.

TOP The unwrapped texture of the face was used both to paint on the scars and also as part of the custom tracking process used for this effect.

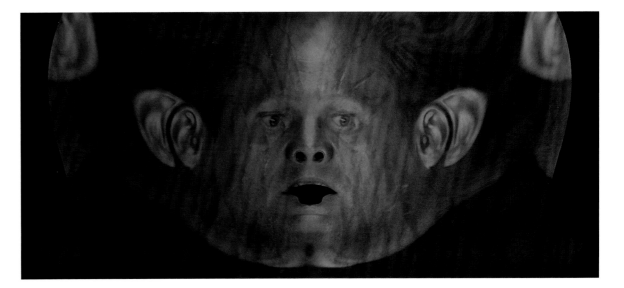

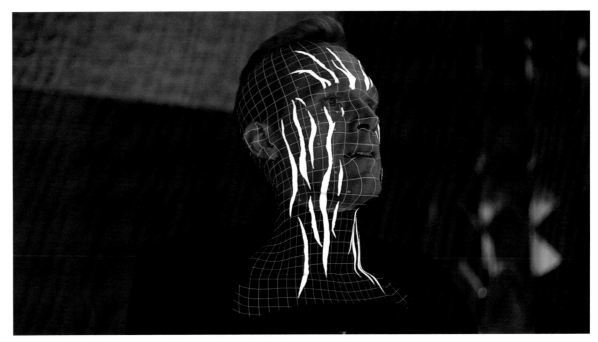

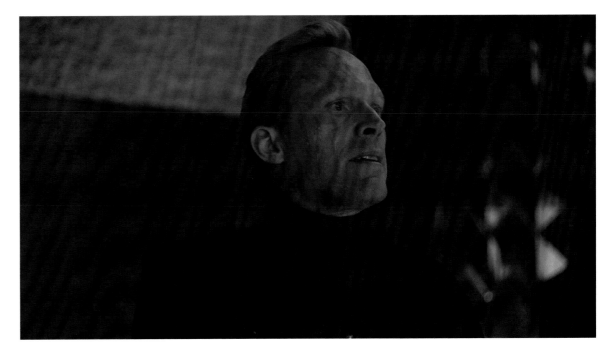

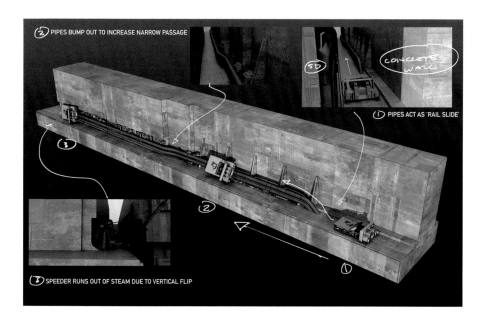

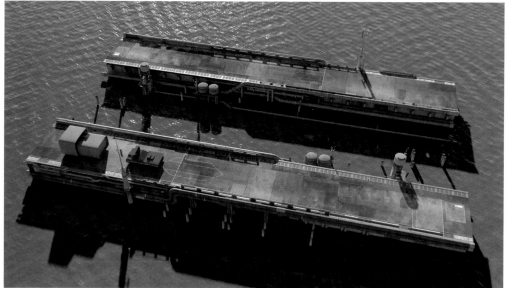

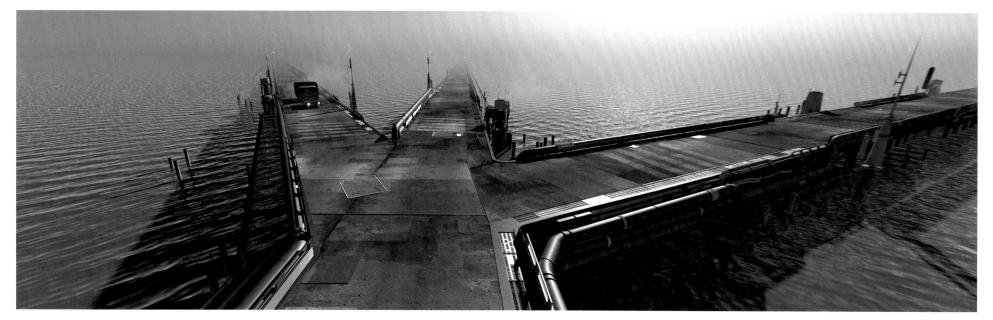

For the Speeder Chase, we got to design a huge portion of the Corellian seascape to back the sequence. We laid out the sequence from end to end to give us a good place to start the geography and designed it all to fit on top of the existing photography.

One of the shots is more than fifteen seconds long and consists of five different shots captured by our stunt team and seamlessly stitched together at ILM. Probably the most fun thing about the shot is that it ends with the camera right on the faces of Alden and Emilia, hopefully "proving" that we did it all for real. Which we sort of did!

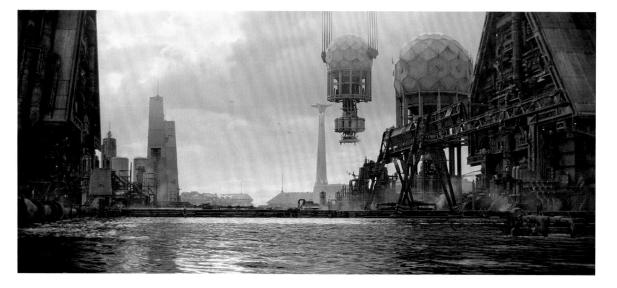

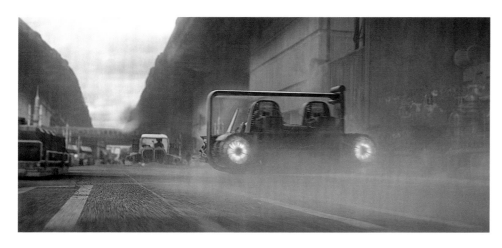
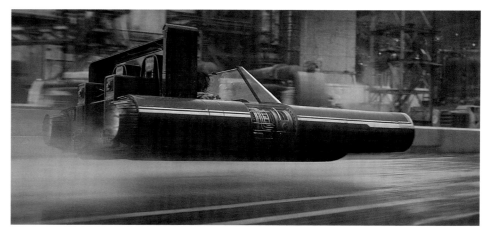

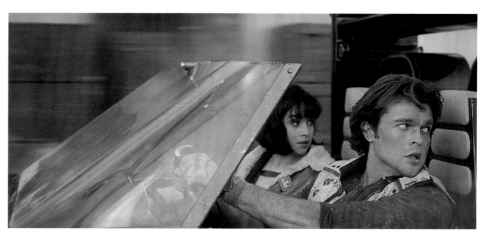
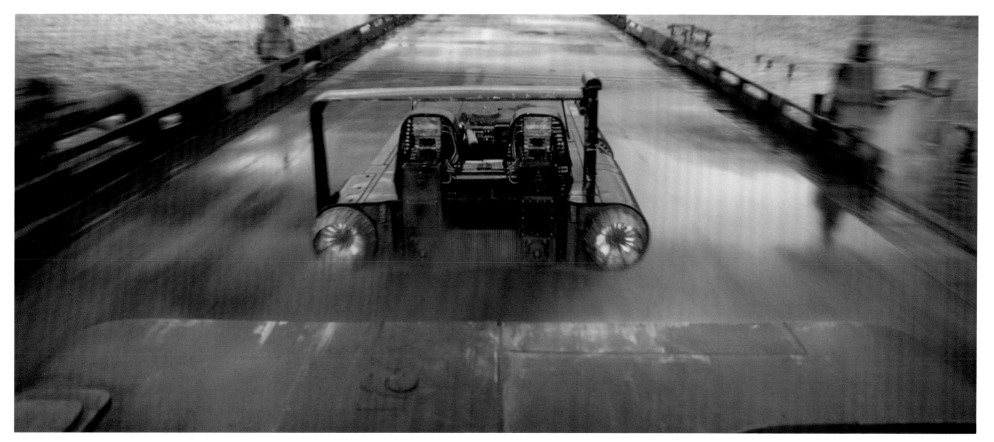

Kit Lens: 45mm #632

One of the trickiest bits of the Train Heist sequence was its sheer scope. With more than 350 individual shots making up the complex action, it was a lot to manage and ensure we kept everything up to top quality.

On set, Bradford and I strategized together on the lighting approach. He chose a predawn time that we could create synthetically on the sound stage to match the photography I had captured in the Dolomites.

We also provided real-time compositing on set to provide the director and the camera department feedback on where the train was for every shot along with exactly how the mountain was positioned. This really helped with tracking the complicated beats of the scene and kept everyone on the same page.

The artists at ILM then combined the background footage and additional photo-modeled mountains, along with carefully designed atmospheric effects and flakes of snow to help integrate the stage elements into the final plates.

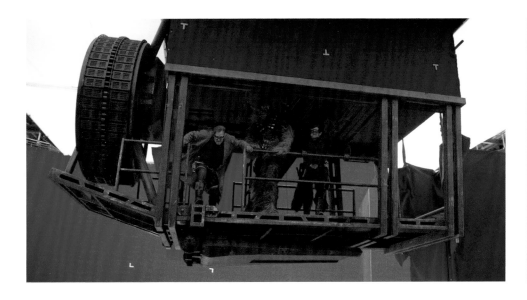

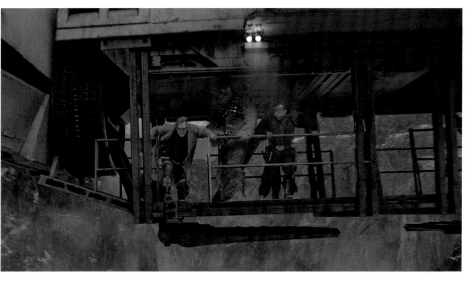

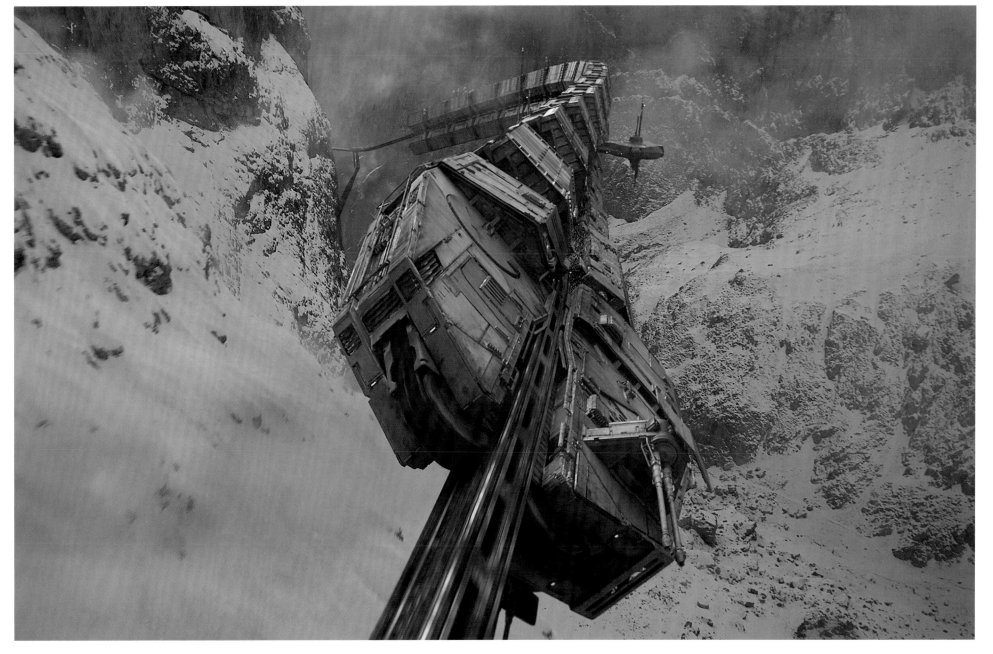

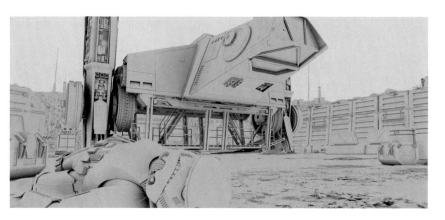
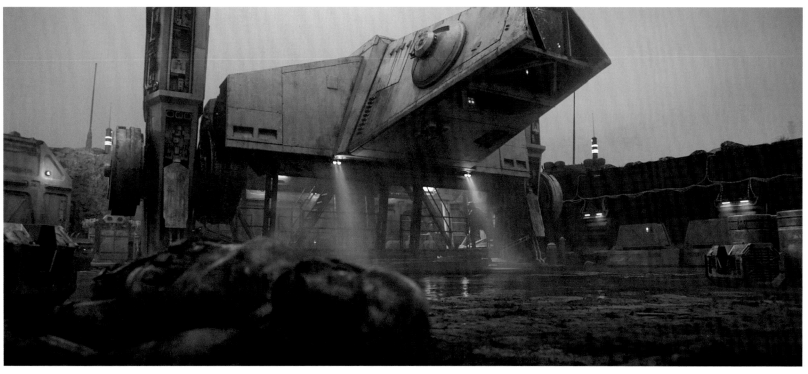
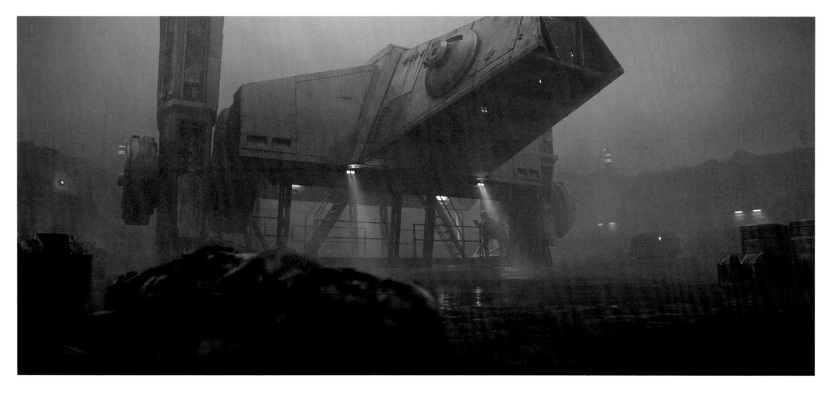

The Mimbanese battle was shot on a huge soundstage filled with smoke. The SFX department gave us a great starting point with giant explosions, squibs, and dirt flying through the air. Our artists then added more and more layers until we felt like we were in the middle of the war.

One of my favorites is this shot early in the sequence where an AT-hauler drops in an AT-DT (All-Terrain Defense Turret) right near Han and it immediately gets into the action. You can see the careful integration work required to get the CG elements in behind the live action—especially considering no process screens (green screen or blue screens) would work in the foggy environment of Mimban.

OPPOSITE For this particular shot, the only photographed element ended up being Thandie Newton's Val body double as she walks up the boarding ladder of the AT-Hauler. The remaining elements are all CG modeled, painted, lit, and composted by the artists at Industrial Light & Magic.

SKYWALKER RANCH

After we finished our picture edit at the Disney lot in Burbank, we moved post-production up to Skywalker Ranch in Marin, California. George Lucas built this ranch as a filmmaker's oasis, and it lives up to his vision to this day. My favorite stage of the film is when the final sound and picture are married for the first time. At this point, we had only about two hundred visual effects shots remaining (out of a total of more than two thousand) and we were on track to completing on time at a level of quality that I was very happy with.

The sound team at Skywalker Sound is absolutely world-class. I was busy setting up visual effects reviews, but every time I had a spare moment I'd stop by the mixing stage to hear the amazing sound design, score, and mix coming together. After hearing temp work for more than a year, it's absolutely a game changer to get the full sound mix on the picture.

While the mix was ongoing, Bradford Young, Joe Gawler, and I worked in the Digital Intermediate (DI) to finalize the color of the film. Small adjustments to tone, contrast, tint, and hundreds of other tweaks make all the difference to how the film plays.

Bradford was really focused on the response of the low end—the dark parts—of the exposure. The subtlety of his photography really comes out when it's tweaked in the DI. I had the pleasure of joining many of the DI sessions, and Brad and Joe welcomed my input. Final color is a subjective thing, and conflicting opinions can sometimes arise, but fortunately all of us were seeing the same things and really supporting the look Bradford had been aiming for during the entire shoot.

YRB3AF_9__SERIES

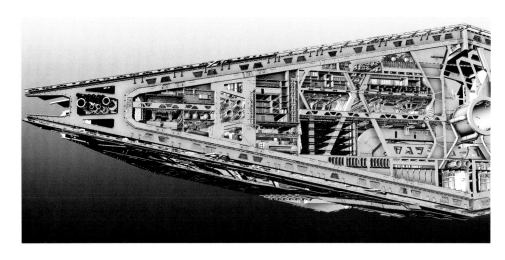
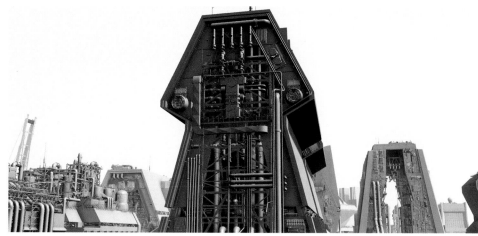
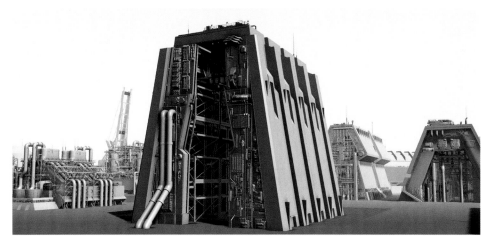
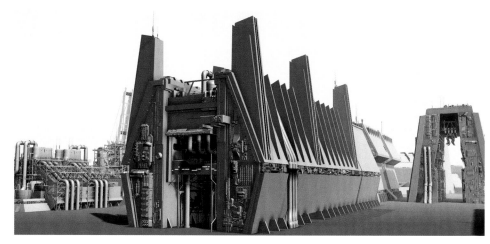

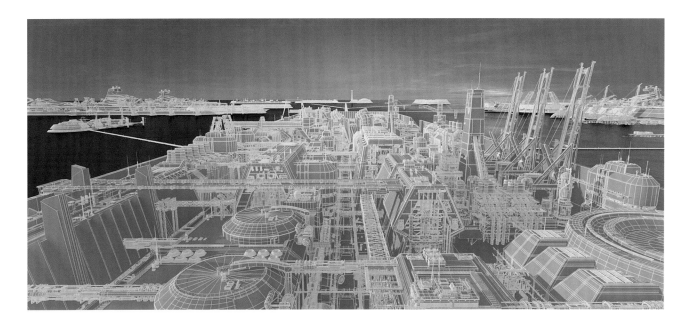

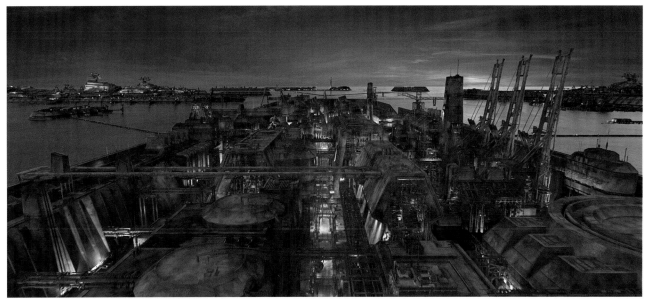

Some of the last shots for us to final at Industrial Light & Magic were actually some of the first shots in the film. We tried a few different ideas for the opening sequence before settling on the big tilt-up to the Star Destroyers (opposite) followed by the big down shot of Han's speeder escaping the industrial island where we first meet him in the film. We also layered on the title treatment and helped with a subtle transition from the name "Solo" straight to Han's face.

As you can see from these images, there was plenty to design, build, texture, light, and render to bring these few moments of the film to life.

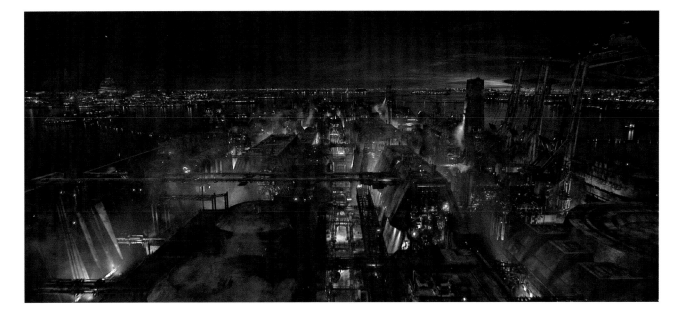

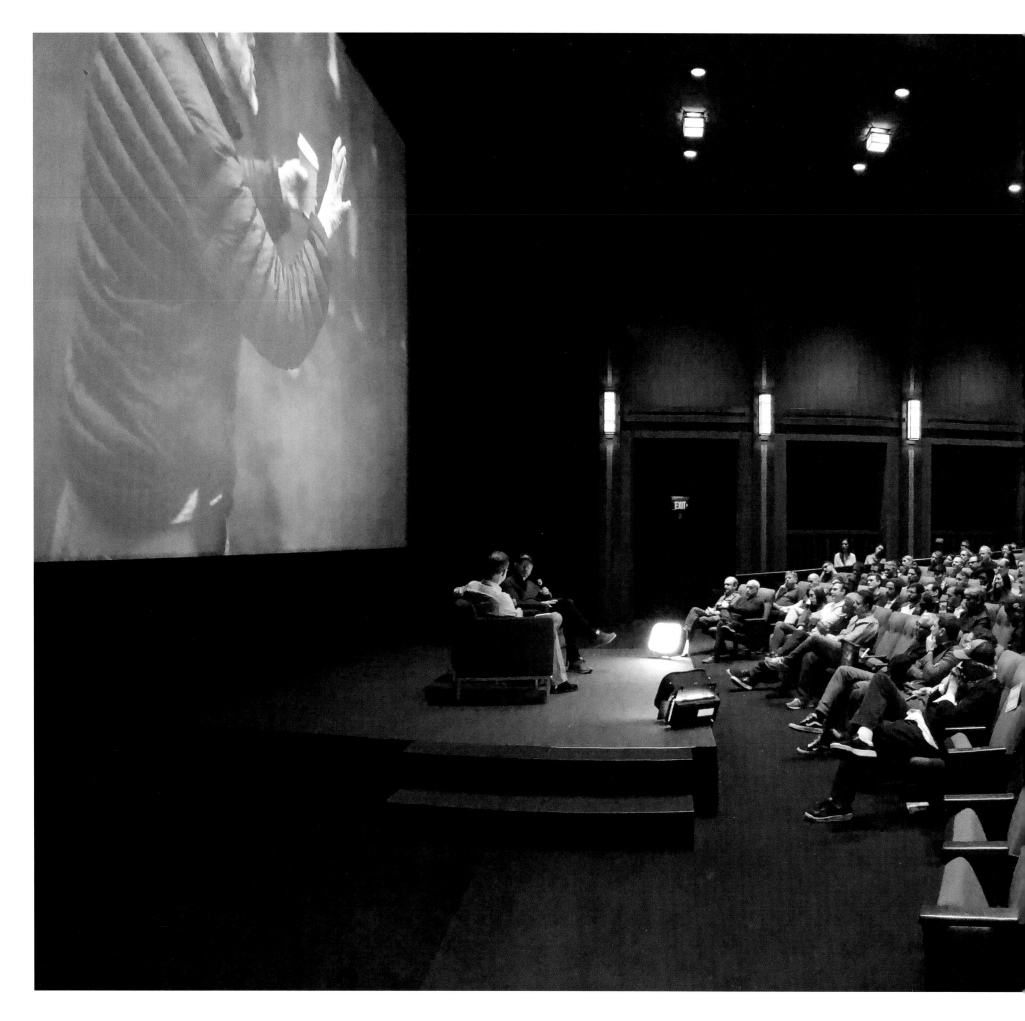

Ron Howard and me thanking the crew of Industrial Light & Magic at the very end of the production for their hard work on the film.

Wrap

Working on this film was the opportunity of a lifetime. As I write this, we have just finished the very last visual effects shots in the film. We've revisited all the CBBs (shots that "could be better"), improving little details that had been bugging us—we weren't sure if we'd have time to address these before the deadline, but we got to all of them. It's rare to complete all the CBBs. It's a real testament to the clear direction we got from Ron, and the talented production team and artists at Industrial Light & Magic, that we not only finished the film, but got to put the finishing details on all the work. We beat the clock, and the team executed it beautifully. We were done. Or so we thought.

As we were listening to one of the final sound playbacks, editor Pietro Scalia caught one new CBB. Somehow all of us had missed one shot. When Emilia turns on the final hologram in the film, we accidentally cut in a shot where she was talking when she was supposed to be listening. Her lips were moving at the wrong time. That Monday night, Pietro called me, exasperated that we missed this detail and it was probably too late to change. Fortunately, we already had the frames online at ILM. It was late at night, but our artists in Singapore were just starting their day.

They painted on top of the composited shot to ensure her performance matched the context and shipped the files back to artists in San Francisco, who finished the last touches and delivered the shot to post-production minutes before the final reel locked. Final CBB done just in time.

On my first day at Pinewood Studios, I got my credentials, which included a camera pass. In those first meetings, I realized I was the only one in the room who had the access and a camera around my neck. I started shooting. It's part of my job to provide photo reference for our artists who can't be on set, but there's also an unstoppable creative force in me that gets inspired to make images when I see something I love. I remember one night, I got back to my hotel after a particularly long day of prep, and I looked through some of the images I had shot. I realized if I kept shooting when those moments called, I might end up with enough good photos to provide a unique view—my view—into this story. Now, 23,953 photos later, you're holding the result of that inspiration.

I hope it will be as inspiring to you as that original AT-AT image was to me many years ago.

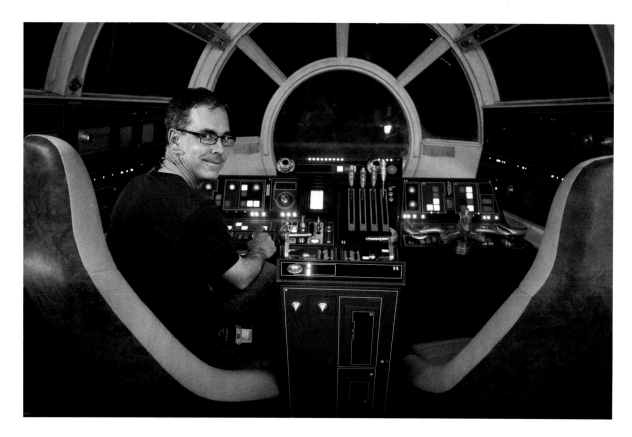

Acknowledgments

The night that Chris Miller and Phil Lord first asked if I would join *Solo* as the visual effects supervisor, we had a family meeting. My daughters were just going into the fifth and ninth grades—leaving the country for a year to travel to London to make a film would greatly affect their lives. My wife, Jill, and youngest daughter, Allison, were excited about the adventure, but my oldest, Abigail, would be missing her freshman year of high school, and that's a hard year to miss. After thinking about it a bit, she said, "I think I'd be really disappointed in a few years if we didn't go to Europe because I was going to miss my friends for a year." She's a smart kid. Thank you Jill, Abby, and Allison for setting aside your lives to be a part of this adventure around the world. And thank you Chris and Phil for inviting me to be part of the film.

Thank you to Ron Howard, who asked me to continue as his VFX supervisor when he joined the picture, and also invited me to be a part of his rich creative process. It was an honor to learn from you and to be part of your filmmaking team.

Thank you Kathy Kennedy, for your encouragement to make this book. I remember standing on the side of the muddy Mimban set with you, scrolling through some photos on my iPad, talking about the book. At the time, some people were a bit concerned about making a behind-the-scenes book about a movie with behind-the-scenes challenges. You replied, "That's about the stupidest thing I've ever heard. We're making this book." Thank you, Kathy, for your relentless support of this idea.

Our brilliant producers Janet Lewin, T.J. Falls, Dan Carbo, Erin Dusseault, Chris Bannister, and Luke O'Byrne, who not only figured out how to make the budget and schedule work on this film, but were an incredible support through the entire journey. Thanks to VFX supervisors Pat Tubach, Julian Foddy, Nigel Sumner, and Greg Kegel, who did such spectacular work on the film. I appreciate each of your support of this book as well.

I want to thank Dan Lobl and Sunny Solomon, who took time out of their busy schedules while delivering the film to carefully collect and process hundreds of images from ILM for this book. Thank you, Kathleen Rodriguez and Jill Bredow, for transcribing the audio interviews for me.

And thank you to Michael Siglain at Lucasfilm Publishing, who understood my vision for this book and helped form it into a complete thought, helping with every step of the process. Thank you for your editorial insight.

And thanks to those who read early drafts and provided feedback, including Jon Kasdan, Janet Lewin, Pat Tubach, Pablo Hidalgo, and my wife, Jill Bredow.

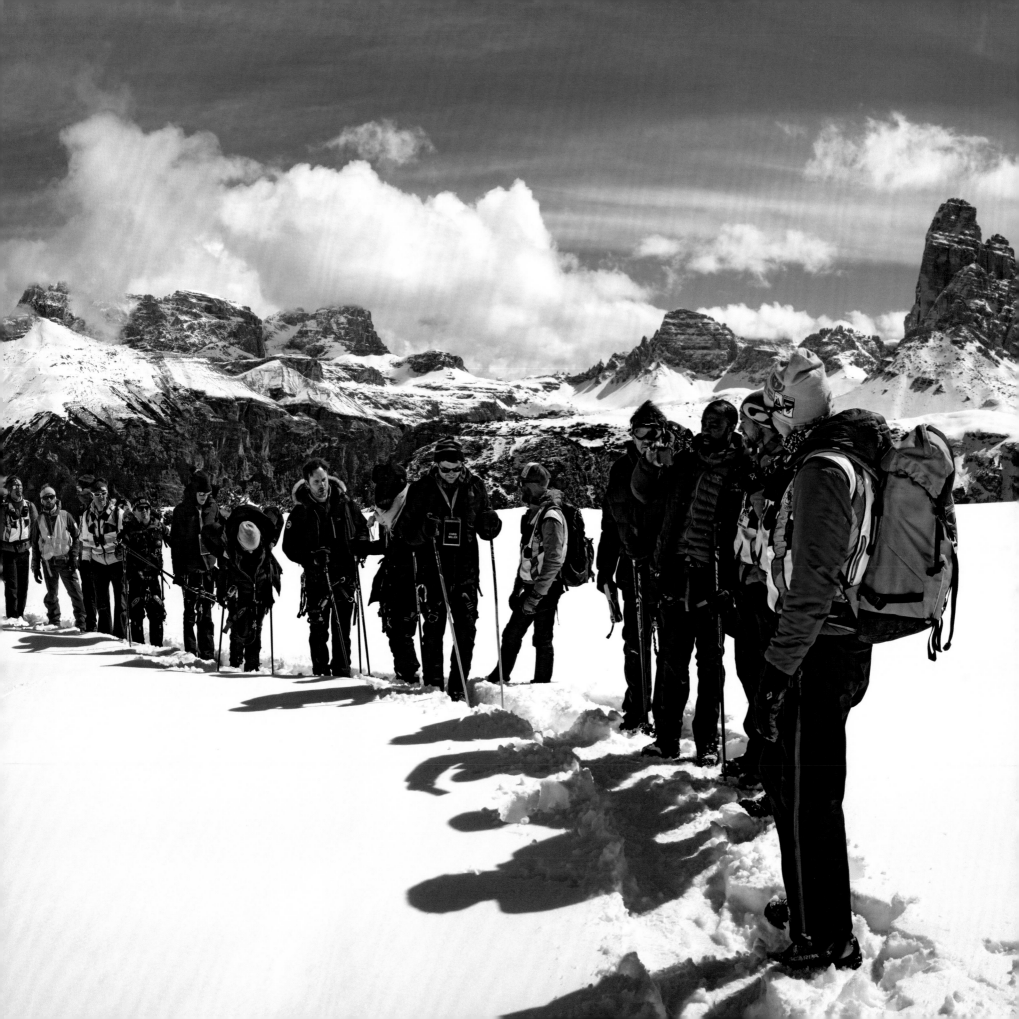

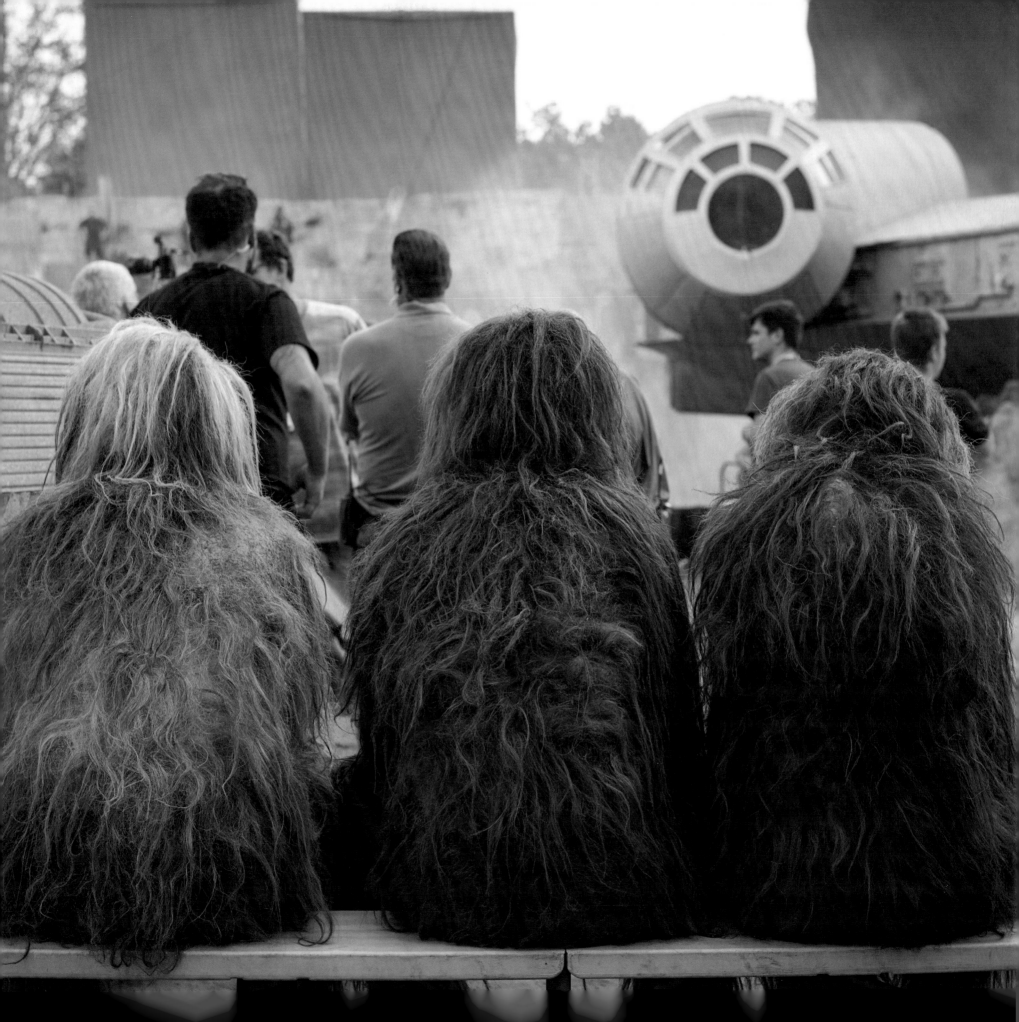

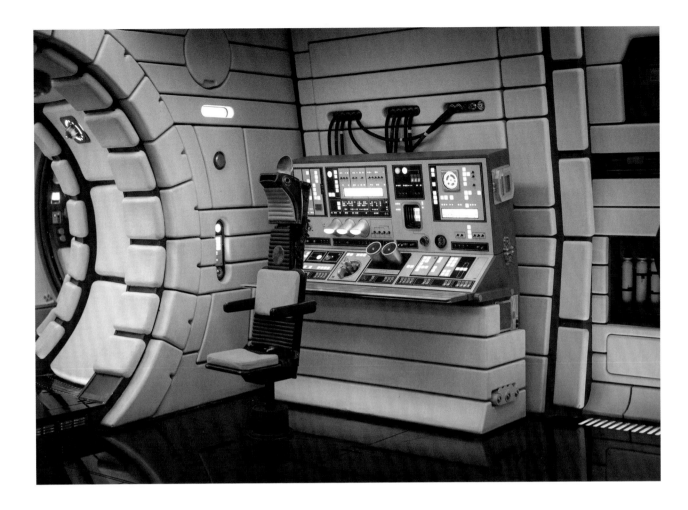

ABOUT THIS BOOK

Unless otherwise noted, the photos in this book were
photographed by me, Rob Bredow. I shot with a Sony
A7Rii and Sony A7R. For lenses, I relied on a Sony
55mm f1.8 prime, and when in close quarters I used
the 35mm f2.8 prime. There are several images from
my iPhone. This book was set in Skolar, Kievit, and Adobe
Garamond Pro typefaces.

For Lucasfilm Ltd.

Assistant Editor: Samantha Holland
Creative Director: Michael Siglain
Art Director: Troy Alders
Story Group: Pablo Hidalgo
Art Department: Phil Szostak
Image Unit: Steve Newman, Tim Mapp,
and Gabriel Levenson

For Abrams

Executive Editor: Eric Klopfer
Designer: Liam Flanagan
Production Manager: Denise LaCongo

Library of Congress Control Number: 2018955109

ISBN: 978-1-4197-3753-4

10 9 8 7 6 5 4 3 2 1

Abrams books are available at special discounts when
purchased in quantity for premiums and promotions as well
as fundraising or educational use. Special editions can also
be created to specification. For details, contact specialsales
@abramsbooks.com or the address below.

Abrams® is a registered trademark of Harry N. Abrams, Inc.

ABRAMS The Art of Books
195 Broadway, New York, NY 10007
abramsbooks.com